MODERN ART
19th & 20th Centuries

MODERN ART
19th & 20th Centuries

SELECTED PAPERS

Meyer Schapiro

GEORGE BRAZILLER
New York

Published in the United States in 1978 by George Braziller, Inc.

Library of Congress Cataloging in Publication Data
Schapiro, Meyer, 1904–
 Modern Art.
 (His Selected papers; v. 2)
 1. Art, Modern—19th century. 2. Art, Modern—20th century.
I. Title.
N6447.S33 709'.04 78–6831
ISBN 0–8076–0899–8

Printed in the United States of America
Rose Printing Company, Inc.,
Tallahassee, Florida

First Printing, 1978
Second Printing, 1979
Third Printing, 1979
Fourth Printing, 1979

Designed by Wanda Lubelska

Acknowledgements

For their cooperation and, where necessary, permission to publish, the Author and Publisher wish to express their sincere thanks to all those listed below.

Art News Annual, XXXIV, 1968, "The Avant-Garde," (The Apples of Cézanne: An Essay on the Meaning of Still-life"), pp. 34–53.

Journal of the Warburg and Courtauld Institutes, Vol. IV, 1941, "Courbet and Popular Imagery," pp. 164–191.

View, Edited by Charles Henri Ford, Series VII, No. 1, Fall, 1946, "On a Painting of Van Gogh," pp. 8–13.

Art News, Vol. 57, No. 2 April 1958, "New Light on Seurat," pp. 22–24, 44–45, 52; Vol. 56, No. 4, Summer 1957, "The Liberating Quality of Avant-Garde Art," ("Recent Abstract Painting"), pp. 36–42.

Verlag Philipp von Zabern, Essays in Archaeology and the Humanities (In Memoriam Otto J. Brendel), Mainz, West Germany, 1976, "Picasso's Woman With a Fan: On Transformation and Self-Transformation," pp. 249–254.

Verve, Bible—Marc Chagall, Vol. VIII, Paris, 1956.

Alfred A. Knopf, Inc., America in Crisis, 1952, "The Introduction of Modern Art in America: the Armory Show," pp. 203–242, 356–357.

The Whitney Museum of American Art, Arshile Gorky by Ethel K. Schwabacher, New York, 1957, "Introduction," pp. 11–14.

American Academy and Institute of Arts and Letters, 38th Blashfield address delivered by Meyer Schapiro at the annual Ceremonial of the

American Academy of Arts and Letters and the National Institute of Arts and Letters on May 20, 1959, and first published in the *Proceedings of the American Academy of Arts and Letters and the National Institute of Arts and Letters*, Second series, No. 10, 1960, "On the Humanity of Abstract Painting," pp. 316–323. (Chapter 9.)

Contents

List of Color Plates

Prefatory Note

The essays in this volume are a selection from my writings on the art of the nineteenth and twentieth centuries. I hope to be able to bring out separately several unpublished articles on this art and also books, more comprehensive and general, based on my lectures at Columbia University and elsewhere.

Having been written over a period of forty years, these selected papers reflect changes in my views. Certain observations and arguments in the article, "The Nature of Abstract Art" (1937), I now regard as inadequate or mistaken. I include it here, nonetheless, because it contains enough that I still hold to. The changes will be evident from the later writings reprinted in this volume. As in the previous one, corrections are almost entirely of language. In two articles I have replaced the titles which were given by former editors.

Like the *Selected Papers* on Romanesque art, those on modern art were prepared for the press by my wife, Lillian Milgram (M.D.), to whom I'm indebted especially for the index. I wish to thank as well the staffs of George Braziller, Inc., and the various museums and galleries that have been helpful in providing and documenting the photographs I have used for illustrations.

THE APPLES OF CÉZANNE
An Essay on the Meaning of Still-life
(1968)

I

Among Cézanne's mythological paintings there is one that is repeatedly called *The Judgment of Paris* although the postures of the figures and other details seem incompatible with the Greek myth (Fig. 1).[1] The male figure, supposedly Paris, presents an armful of fruit to one of three nude females. How could Cézanne, who was aware of the legendary apple, illustrate the Judgment by an offering of so many apples? Besides, the recipient of the prize is the least conspicuous of the three nudes. A second figure, taller and more mature, stands beside her and touches her shoulder with a friendly protective hand while extending the other hand to the approaching male; a third nude, crouching, turns her back to the others. These are hardly the postures of three goddesses competing for a prize for beauty. A further difficulty is the presence of a fourth woman, partly clothed and standing alone at the right. One might imagine that she is the nymph, Oenone, whom Paris abandoned for Helen; she has also been identified as Helen, the reward promised to Paris by the grateful Venus.[2] But in a drawing for this composition, all four women are grouped together at the left; two crouch and two stand (Fig. 2). And in another sketch on the same sheet the postures of the three (and perhaps four) nudes, without a male figure and superposed as in Cézanne's pictures of *Baigneuses*, are no less difficult to explain as those of the rival divinities.[3]

My naïve impression of the scene has been that it is a fanciful

pastoral subject: a pagan figure, a shepherd, makes an offering of fruit to a shy beloved girl. One may suppose a source in the Latin poetry that Cézanne read at school and continued to quote in later years. His letters, especially of his youth, contain many classical allusions.[4] As late as 1878 he quotes Horace in writing to Zola[5] and signs another letter: "Pictor semper virens."[6] Virgil's Eclogues were a familiar reading to the young Cézanne, who had translated, probably into verse, the second eclogue on Corydon's wooing of Alexis.[7] His love of Latin poetry was known among the painters. In a letter of 1885 Gauguin described Cézanne: "A man of the south, he spends days on the mountain-tops reading Virgil and gazing at the sky."[8]

I have found in Virgil's second eclogue nothing adequate to the picture, but a passage in the third has led me to a more likely source in Propertius. In one of his elegies (Book II, elegy 34, lines 67–71) Propertius chants the love of a girl won by ten apples. Addressing Virgil, whom he hails as greater than Homer, the poet writes:

> *Tu canis umbrosi subter pineta Galaesi*
> > *Thyrsin et adtritis Daphnin arundinibus;*
> *Utque decem possent corrumpere mala puellam,*
>
> >
>
> *Felix, qui viles pomis mercaris amores!*

(You sing beneath the pines of shady Galaesus
> Of Thyrsis and Daphnis with the well-worn pipes;
And how ten apples can seduce a girl,

.

Happy man, who can buy love cheaply with apples!)

The idea of the verse: *Utque decem possent corrumpere mala puellam,* was evidently inspired by Virgil's third eclogue, lines 70, 71:

> *Quod potui, puero silvestri ex arbore lecta,*
> *Aurea mala decem misi; cras altera mittam.*

(. . . ten golden apples, picked from a woodland tree,

I sent to my dear boy, and will to-morrow send some
 more.)

In another elegy (lib. III, 13, lines 25 ff.) Propertius returns to
the theme of the pastoral age when fruits and flowers were the young
shepherd's riches and offerings of love:

Felix agrestum quondam pacata juventus,
 Divitiae quorum messis et arbor erant!
.
His tum blanditiis furtiva per antra puellae
 Oscula silvicolis emta dedere viris.
.
Nec fuerat nudas poena videre deas.

(Happy the peaceful country lad
 Whose only riches were the trees and harvests!
.
By these gifts a sylvan youth could win
 A maiden's kisses in the dark of a cave.
.
Nor was it a sin to gaze at a naked goddess.)

While the verses of Propertius might account for the youth
in shepherd's clothes bringing apples to the girl, they leave unex-
plained the role of the other figures in the painting. One can regard
them as accessories—like the landscape itself with its indeterminate
trees, sky and stream—that evoke the poetic site of the action, the
ambiance of classic pastoral with its divinities and shepherds. By
their collective presence they assure the innocence of the shepherd's
gesture and allude to an imaginary world where nakedness is natural
and the shepherd's desire is admitted. The more specific choice of the
figures and their postures is not only personal to the painter—an indi-
vidual formation of conscious and unconsciously delivered elements as
in day-dreams—but also in part conventional, with residues of older

pictures of erotic myth (including perhaps a Judgment of Paris) as well as of his own compositions of bathers. In these Cézanne had long excluded the mixing of the sexes; here a male intrudes, bearing gifts to one of the girls.

Cézanne could more readily respond to this classic pastoral theme, since in his own youth a gift of apples had indeed been a sign of love. In his later years he recalled in conversation that an offering of apples had sealed his great friendship with Zola. At school in Aix Cézanne had shown his sympathy for the younger boy who had been ostracized by his fellow-students. Himself impulsive and refractory, Cézanne took a thrashing from the others for defying them and talking to Zola. "The next day he brought me a big basket of apples. 'Ah, Cézanne's apples!' he said, with a playful wink, 'they go far back.' "[9]

In telling this story to his admirer, the young Aixois poet Joachim Gasquet, the son of a schoolmate and friend of the painter, Cézanne was not only joking about the origin of a theme of his pictures. He was remembering the painful rupture of his long friendship with Zola that followed the revelation, in the latter's novel *L'Oeuvre* (1886), of Zola's view of his old friend as a painter *raté*. Cézanne, in recounting the golden episode of their youth, is saying: There was a time when Zola could think of no finer expression of gratitude and friendship than a gift of apples; but now he rejects *my* apples. Twenty years before, Zola, in dedicating to Cézanne his brilliant first venture into art criticism, *Mon Salon*, had written: *"Tu es toute ma jeunesse, je te trouve mêlé à chacune de mes joies, à chacune de mes souffrances."*[10]

At an age when into the friendship of boys is channeled much of their obstructed feeling for the other sex, Cézanne confided to his closest companion, Zola, his poems of erotic fancy. But he shyly withheld his translation of Virgil's second eclogue on the shepherd Corydon's love of the boy Alexis. *"Pourquoi ne me l'envoies-tu pas?"* wrote Zola. *"Dieu merci, je ne suis pas une jeune fille, et ne me scandaliserai pas."*[11]

As Propertius converted the theme of the offering of apples in Virgil's third eclogue to one of heterosexual love, so one may regard

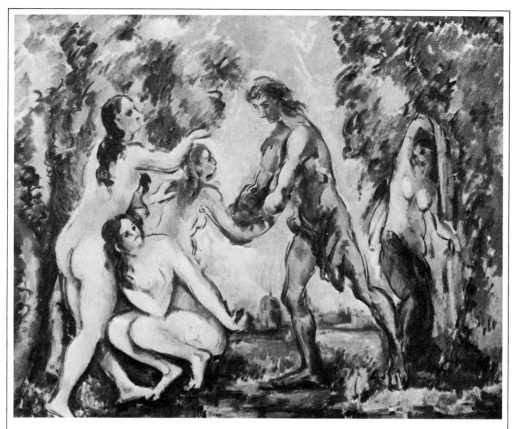

Fig. 1 Cézanne: *The Amorous Shepherd*, mistitled *The Judgment of Paris*, 1883–85. 20¼″ high. Present owner unknown.

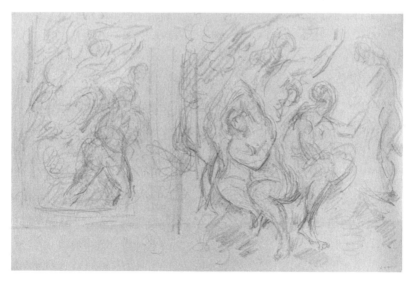

Fig. 2 Drawing for *The Amorous Shepherd*. Collection Adrien Chappuis, Aix-les-Bains.

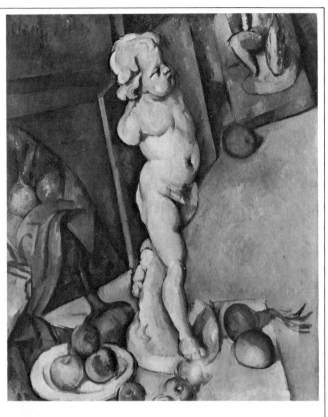

Fig. 3 Cézanne: *Still-life with Plaster Cast of Amor*, ca. 1895. 27⅝″ high. Courtauld Institute Galleries, London.

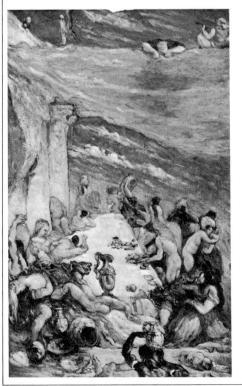

Fig. 4 Cézanne: *The Orgy*, 1864–68. 50¾″ high. Collection R. Lecomte, Paris.

Cézanne's picture as a transposition of that boyhood episode with Zola to his own dream of love.

It is impossible today to reconstruct the occasion of the painting of *The Amorous Shepherd*, the affective moment itself. One may conjecture that in the early or middle '80s, where the picture is generally placed, Cézanne, while painting still-life habitually, was reminded by a reading of the Latin poets that a gift of apples could win a girl in those ancient days when mortals were permitted to look at a naked goddess. And this thought, corresponding to his deep wishes, suggested a picture of the pastoral theme of Virgil and Propertius. One can imagine, too, that the Latin verses revived an unspoken hope that his own painting might bring him love.

It would be interesting to know whether this picture was done before or after the publication of Zola's novel, which no doubt awakened memories of their boyhood friendship. There is also the possibility that the painting was connected with an episode of the spring of 1885, a love affair of which the traces appear in the unfinished draft of a pathetic letter that the tormented Cézanne wrote to an unknown woman on the back of a drawing and in several letters to Zola shortly after.[12]

Whatever its immediate occasion, *The Amorous Shepherd* has a challenging sense for Cézanne's art as a whole. The central place given to the apples in a theme of love invites a question about the emotional ground of his frequent painting of apples. Does not the association here of fruit and nudity permit us to interpret Cézanne's habitual choice of still-life—which means, of course, the apples—as a displaced erotic interest?

One can entertain more readily the idea of links between the painting of apples and sexual fantasy since in Western folklore, poetry, myth, language and religion, the apple has a familiar erotic sense. It is a symbol of love, an attribute of Venus and a ritual object in marriage ceremonies.[13] *Fructus*—the word for fruit in Latin—re-

tained from its source, the verb *fruor*, the original meaning of satisfaction, enjoyment, delight. Through its attractive body, beautiful in color, texture and form, by its appeal to all the senses and promise of physical pleasure, the fruit is a natural analogue of ripe human beauty.

In Zola's novel, *Le Ventre de Paris* (1873), which has been called *"une gigantesque nature-morte"*—the story is set in the great food market of Paris, the Halles Centrales—fruit is described in a frankly erotic prose. *"Les pommes, les poires s'empilaient, avec des regularités d'architecture, faisant des pyramides, montrant des rougeurs de seins naissants, des épaules et des hanches dorées, toute une nudité discrète, au milieu des brins de fougère."* The young woman who presides over the fruit is intoxicated by its fragrance and in turn transmits to the apples and pears something of her own sensual nature. *"C'était elle, c'étaient ses bras, c'était son cou, qui donnaient à ses fruits cette vie amoureuse, cette tiédeur satinée de femme . . . Elle faisait de son étalage une grande volupté nue . . . Ses ardeurs de belle fille mettaient en rut ces fruits de la terre, toutes ces semences, dont les amours s'achevaient sur un lit de feuilles . . . au fond des alcôves tendues de mousse des petits paniers."*[14]

In associating the woman and the fruit in this lush description, Zola follows an old *topos* of classic and Renaissance poetry. In pastoral verse since Theocritus the apples are both an offering of love and a metaphor of the woman's breasts. In Tasso's *Aminta* the satyr laments: "Alas, when I offer you beautiful apples you refuse them disdainfully, because you have more beautiful ones in your bosom."[15] The classic association of the apple and love has been fixed for later art, including Cézanne's, through the paraphrase by Philostratus, a Greek writer of about 200 A.D., of a painting of Cupids gathering apples in a garden of Venus. The Cupids have laid on the grass their mantles of countless colors. Some gather apples in baskets—apples golden, yellow and red; others dance, wrestle, leap, run, hunt a hare, play ball with the fruit and practice archery, aiming at each other. In the distance is a shrine or rock sacred to the goddess of love. The Cupids bring her the first-fruits of the apple trees.[16]

This text of Philostratus is the source of Titian's painting of the

cult of Venus, with its frolicking crowd of putti playing with apples, and indirectly of Rubens' picture of putti carrying a garland of the fruit. Cézanne, we shall see, has twice set up a cast of Puget's *Amor* in the midst of a still-life of apples (Pl. I, Fig. 3).[17]

Long before he painted *The Amorous Shepherd* the young Cézanne had expressed his sexual fantasies in verses of an idyllic pastoral tone. In a poem addressed to Zola, which he called an elegy, written the year before his translation of Virgil's eclogue, the 19-year-old Cézanne asked: "*Quand donc une compagne/ . . . viendra, grands Dieux, soulager ma misère?*" He dreams of a shepherdess and rhymes "*compagne*" with "*campagne.*"[18] In another poem to Zola, a year later, he writes: "*Tu me diras peut-être:/ Ah! mon pauvre Cézanne/ Quel démon féminin/A dèmonté ton crâne.*"[19] A timid, deeply inhibited boy, Cézanne found in the reading and imitation of classic poetry a means to express his frustrated desires.

The subject of love came up often in his youthful correspondence with Zola as a question of idealism versus realism, idealism being the name for platonic love and realism for the physical experience Cézanne could only imagine. Zola at first encouraged his unhappy friend to persist in romantic fantasies of ideal love; he himself had never loved except in dreams. He proposed to write a novel about young love, the birth of love, and to dedicate it to Cézanne, "*à toi, qui le ferais peut-être mieux que moi, si tu l'ecrivais, à toi dont le coeur est plus jeune, plus aimant que le mien.*"[20] A year later a changed Zola wrote from Paris in a different vein, recommending the painter's life in Paris as a career of freedom and the studio as a place of uninhibited sex.[21]

In Paris, it seems, the ardent Cézanne remained as shy and fearful of women as in Aix. From the obsessed imagination of the unwillingly chaste artist came paintings of a crude sensuality, even of rape, orgy and murder (Fig. 4). In the later '60s he adapted to his tense desires the new idyllic imagery of advanced contemporary art. It was a

conversion of the mythical pastoral world of Renaissance paganism and the *fêtes-champêtres* of Rococo painting into the picnics and Sunday outings of the Parisian middle class which were enjoyed also by the painters and poets. This common festive theme had been anticipated in the delightful woodcuts that illustrate the popular books on Parisian life in the decades before Impressionist painting arose.

Cézanne's versions were anomalous in two respects: the nude women among the clothed men at a picnic—a romantic fancy in a realistic picture; and the violence of contrasts, the pervading restlessness in images of holiday pleasure. In one of these paintings (Fig. 5) the desires implied in the paired figures of the naked and the clothed reverberate in the erotized thrust of the trees and clouds and their reflections in the river, and in the suggestive coupling of a bottle and a glass.[22] Inspired by Manet's recent *Déjeuner sur l'Herbe* (Fig. 6), and perhaps also by Giorgione's *Concert* (Fig. 7) in the Louvre, Cézanne's picture has nothing of the original's coolness and air of detachment. There are in his version a moodiness and a vehemence of execution that betray the artist's uncontrollably intense feelings. Cézanne was no doubt attracted to the older masterly works by their imagery of sex as well as by their art. Through the pairing of the nude and the clothed, Manet's picnic belongs with Giorgione's pastoral more than with Raphael's pagan group of nymphs and river gods (Fig. 8) from which Manet took three of his figures; but it lacks completely the warmth of feeling that glows in the Venetian work. His strange picture de-sacralized the female nude. Now the nude could be contemplated in nature by soberly clothed modern men as in the artist's studio without passion or self-conscious interest or moral guilt.

In Raphael's conception no line is drawn between the sexes; male and female are naked dwellers alike in a primordial nature.[23] In Giorgione's *Concert* the duality is social and aesthetic and cuts across the sexes. The two men are distinguished as shepherd and noble, rustic and urban, like their instruments, the pipe (held by the woman) and the lute. The shepherd's head resembles the great oak in its shaggy silhouette, the young courtier's with its hat is like the distant villa. The two nude women are correspondingly models of the

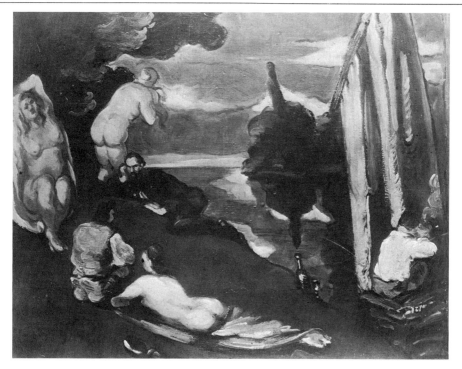

Fig. 5 Cézanne: *Pastoral,* or *Luncheon on the Grass,* 1870. 25⅜″ high.
Collection R. Lecomte, Paris.

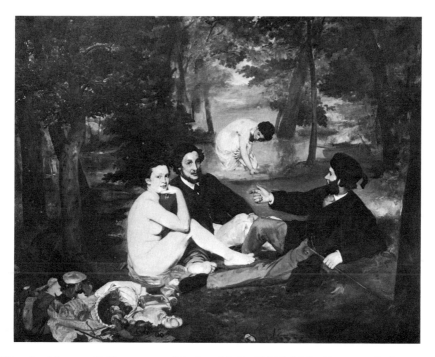

Fig. 6 Manet: *Déjeuner sur l'herbe,* 1863. 83⅛″ high. Louvre, Paris.

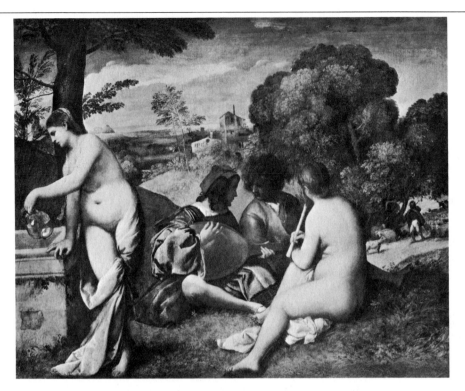

Fig. 7 Giorgione: *Concert*, ca. 1500. 43¼″ high. Louvre, Paris.

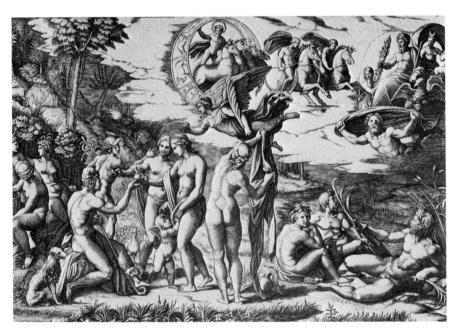

Fig. 8 Marcantonio Raimondi: Engraving of Raphael's *Judgment of Paris*, ca. 1515.

robust and the elegant, the earthy and the refined, in female beauty. The painting intimates a comparison of nature and artifice in love. But a deep unity of the forms binds the opposed figures to each other in harmony with the paradisal landscape.

With Manet the contrast of the sexes becomes obtrusive through the detachment of the figures; it is an abrupt opposition in mode of being, social as well as biological, and is reinforced for the eye by the setting in the cavernous green landscape. Woman here is an impersonal sexual object, with a wonderfully painted still-life of pears, apples, cherries and a brioche beside her;[24] man is a cultured figure of dialogue and thought. Manet's painting does not simply translate Giorgione's and Raphael's imagery into modern clothes; the meaning of clothes and of nakedness as signs has changed. No current of feeling unites the sexes and nothing of the model's myth and music remains. The starkness of naked white flesh is allied to the equal starkness of the men's black clothes. The woman's glance is addressed to the spectator and calls for his own glance, as if her nakedness in this context of conversing Parisian men represented her normal social self. Behind Manet's conception lies unacknowledged his teacher Couture's celebrated salon success, *The Romans of the Decadence*, in which clothed men and naked women mingle in a public orgy above a profuse still-life of fruit and clothes.[24a]

Manet's painting was for Cézanne like a dream image that he could elaborate in terms of his own desires. There is a contemporary picture of a true dream that shows a similar dependence, I believe, on Manet's work. In a book on dreams by Hervey de St. Denys published anonymously in 1867, the frontispiece includes, beside some examples of "abstract" hypnagogic forms, a drawing of a clothed man and a naked woman entering a dining room where a family sits at table (Fig. 9). It illustrates with a banal daylight objectivity a dream of the author in which "M.D. . . . , *le peintre qui fut mon maître . . . arrive en compagnie d'une jeune fille absolument nue, que je reconnais pour l'un des plus beaux modèles que nous ayons eus jadis à l'atelier.*"[25]

In several early works by Cézanne, inspired by Manet, sexual gratification is directly displayed or implied. In one, called A

Modern Olympia, a man, much like the painter in his ungainly form, sits in the foreground gazing at a naked woman crouching on a bed, while a servant brings a tray with food and drink, instead of flowers as in Manet's *Olympia*.[26] Another, with the same title (Fig. 10), shows the negress unveiling the nude, and a funny little dog replaces Manet's cat. In several versions of a more plainly erotic picture a man and a woman, both naked, lie beside or across each other; here again a servant offers food and drink and a still-life of fruit and bottles is set on a stand nearby.[27] Striking is the regular presence of still-life in these scenes of debauch. One painting of that series was titled exotically: *Un Après-Midi à Naples*, or *Le Grog au Vin* (Fig. 11), another: *Une Nuit à Venise*, or *Le Punch au Rhum*.[28] We are reminded of young Cézanne's poem *Songe d'Annibal* in which the hero is scolded by his father for *"ce cognac et ces femmes lascives."*[29]

These overtly sexual themes disappear from Cézanne's work by the end of the 1870s. In his later paintings of bathers the nudes are either young men at the river—a reminiscence of his boyhood holidays in Provence—or women alone; he avoids the confrontation of the sexes in the new idyllic pictures. The exceptional painting of a *Bacchanal* with four pairs of nude women and men struggling with each other in the landscape is a scene of explosive violence (Pl. II, Fig. 12), in which appears as a representative of pure animality the famous dog, Black, who is named in the artist's letters as a companion of the outdoor play of the students in the fields and at the river.[30] In the *Bacchanal*, too, a masculine theme is transposed; for in one of the wrestling pairs the posture of the hands locked over their heads has been borrowed, I believe, from Delacroix's *Jacob Wrestling with the Angel*, a work that Cézanne, a passionate admirer of the great Romantic, had undoubtedly studied in the chapel at St. Sulpice.

Cézanne's pictures of the nudes show that he could not convey his feeling for women without anxiety. In his painting of the nude woman, where he does not reproduce an older work, he is most often constrained or violent. There is for him no middle ground of simple enjoyment.

The Amorous Shepherd is all the more remarkable at its later

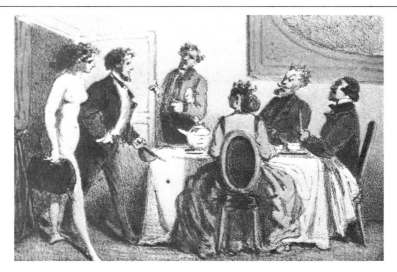

Fig. 9 Frontispiece (detail) of Hervey de St. Denys' book on dreams, *Les Rêves et les Moyens de les diriger*, 1867, Paris.

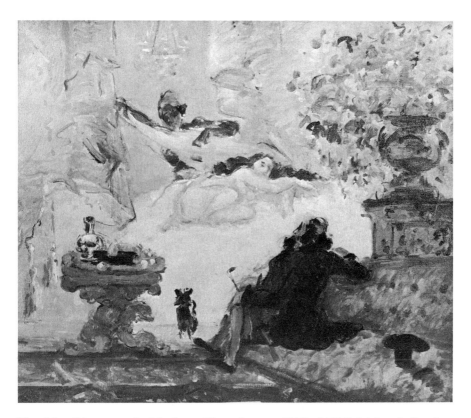

Fig. 10 Cézanne: A *Modern Olympia*, ca. 1873. 17⅞" high. Collection particulière, Jeu de Paume, Paris.

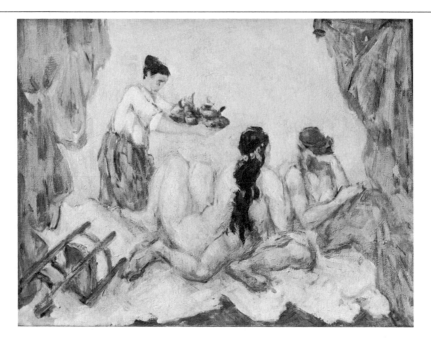

Fig. 11 Cézanne: *Un Apres-midi à Naples* or *Le Grog au Vin*, 1870–72. 4″ high. Jeu de Paume, Paris.

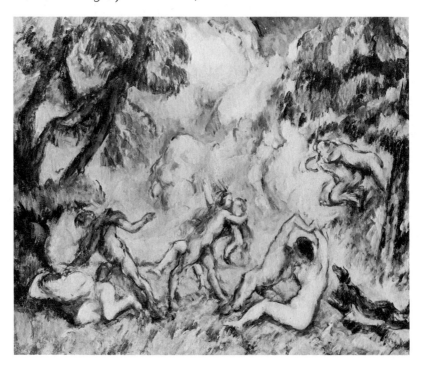

Fig. 12 Cézanne: *The Battle of Love (Bacchanal)*, ca. 1875–76. Oil, 15″ x 18½″. National Gallery of Art, Washington, Gift of the W. Averell Harriman Foundation in memory of Marie N. Harriman.

time in the confrontation of the male youth and the nude women; bearing the gift of apples in an ancient pastoral theme, the courting figure embodied Cézanne's wish in a doubly distanced form.

When he allowed himself in another exceptional work, the still-life in the Courtauld Institute (Pl. I, Fig. 3), to introduce human beings beside the apples, these figures are objects of art once and twice removed from the living nature represented in the fruit: a plaster statuette of Puget's *Amor* and a drawing of a cast of the *Ecorché*, an inwardly tormented nude, his upper part cut by the frame. We may regard this free and perhaps unreflective association of apples, Cupid and a suffering nude man as an evidence of the connection of the apples and the erotic that we recognize in *The Amorous Shepherd*. In the Courtauld canvas the apples are grouped with onions—contrasted forms as well as savors, that suggest the polarity of the sexes.[31]

Again, on a sheet of drawings from the late '70s, Cézanne has placed beside his self-portrait a nude striding bather, an apple, a second nude reclining and a copy of another head: Goya's etching of himself in profile (Fig. 13).[32] On the lower half of the sheet, under a fold, are a man and woman sitting on a sofa. Here, in the context of the portraits, the nudes and the apple appear as related personal objects, freely associated elements tied to the male self. The virile head of Goya represents an ideal of confident and redoubtable masculinity —perhaps a father image—for the shy, troubled painter. The assembly of random images is the cast, real and symbolic, of an interior drama.

Of the association of fruit with an erotic figure in a process of displacement or substitution there is a fascinating example in a picture of a nude from the late '80s (Fig. 14).[33] This figure is so much like the woman in Cézanne's painting of *Leda and the Swan* (Fig. 15) that one cannot doubt the intention to represent Leda a second time.[34] But instead of the swan he has painted a puzzling fragmentary still-life; the S-curved outlines and red stripe of the tablecloth reproduce the sinuous lines of the swan in the first work, and two large pears resemble the swan's head and bill. The still-life here has been described as the remnant of an earlier painting on this canvas and

its odd position in the upper left corner explained by the inversion of the canvas when re-employed for the nude figure.[35] But the accord of the forms of the still-life and the nude is so evident that I cannot regard the still-life as merely an accidental vestige of an earlier painting. In spite of the anomalous look of the table and pears, the still-life is a deliberated essential part of the new composition. Invert the picture, and the table and its cover will appear even more unreal in perspective and drawing. The whole painting calls for further study with the help of X-ray photos to determine the original state. But in its present aspect, I believe it can be viewed as an intended whole—with unconsciously projected features—in spite of its contradictions and exceptional character among Cézanne's works. If the artist began with a still-life from another project in that corner, he has clearly modified it and finally incorporated it in the Leda image by means of concordant shapes that also assimilate the table cover and pears to the missing swan. It is a striking instance of the defusing of a sexual theme through replacement of a figure by still-life objects.

From the place of the still-life objects in these paintings and drawings, one may suppose that in Cézanne's habitual representation of the apples as a theme by itself there is a latent erotic sense, an unconscious symbolizing of a repressed desire.

This sketchy formulation, suggested by psychoanalytic theory, leaves much unexplained, I must admit, in the painter's devotion to still-life. It abstracts a single factor from a largely hidden, complex and changing process of artistic work. It does not tell us why and how Cézanne shifted from the direct expression of his feelings in erotic pictures that include some remarkably uninhibited images, to his expression by means of innocent disguising objects. It ignores the changed situation of Cézanne in his 30s, the circumstances in which the apples became a favored and constant theme. One cannot overlook his permanent liaison with Hortense Fiquet and new domestic state, especially after the birth of his son; nor his tutelage by Pissarro whom he

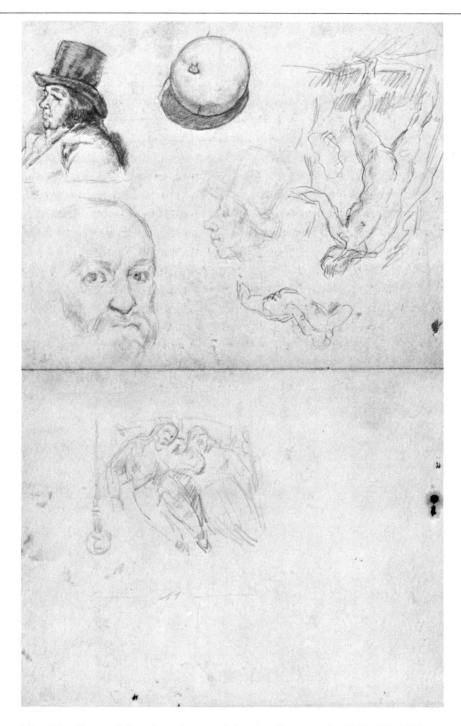

Fig. 13 Sheet of drawings from a Cézanne sketchbook, 1883–87. 19½″ x 11¾″, showing a self-portrait, a sketch of Goya's self-portrait etching, an apple, bathers and other figures. Collection Sir Kenneth Clark, Hythe, Kent.

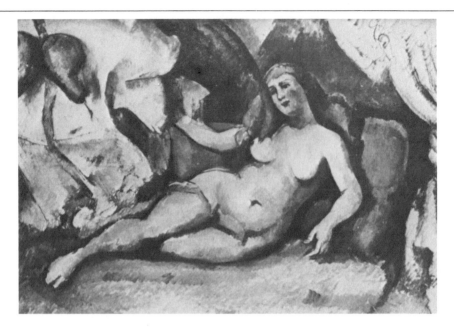

Fig. 14 Cézanne: *Female Nude,* 1886–90. 23⅝″ high. Collection Baron von der Heydt, Wuppertal.

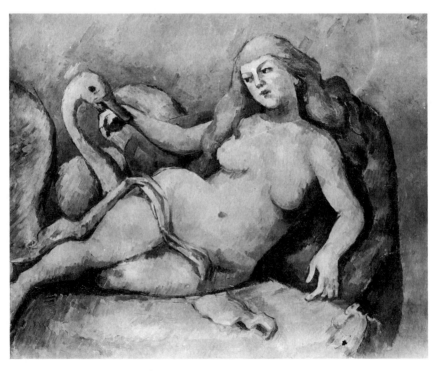

Fig. 15 Cézanne: *Leda and the Swan,* 1886. 15⅝″ high. Collection R. Lecomte, Paris.

revered as a father; nor the radically transformed character of his art with its objective and studied approach. One must look into the different functions that the still-life objects served in the growth of his art; in a painting no element exists for one purpose alone but must satisfy a multitude of requirements, certain of which change from work to work. The painting of apples may also be regarded as a deliberately chosen means of emotional detachment and self-control; the fruit provided at the same time an objective field of colors and shapes with an apparent sensuous richness lacking in his earlier passionate art and not realized as fully in the later paintings of nudes. To rest with the explanation of the still-life as a displaced sexual interest is to miss the significance of still-life in general as well as important meanings of the objects on the manifest plane. In the work of art the latter has a weight of its own and the choice of objects is no less bound to the artist's consciously directed life than to an unconscious symbolism; it also has vital roots in social experience.

If we allow the displacement as an unconscious factor in Cézanne's choice, we must recognize too that this process in his art presupposes the practice of still-life painting in his milieu. He did not create still-life as a genre, but found in the existing art this attractive field which he re-shaped in his own way to satisfy both conscious and unconscious needs. He shared the painting of still-life with most of the Impressionists and with many artists of the next generation in France. A medieval painter would have been unlikely to transpose his sexual fantasy to a still-life of apples, though he sensed in Eve's apple the erotic connotation of the forbidden fruit.[36] He might, however, introduce in the religious subjects, which he was charged to represent, some accessory element, some accent and expression, that projected his unconscious desires while serving at the same time the requirements of the assigned task.

When still-life emerged as a valued independent genre, complete in itself, after having appeared in the background of religious paintings in a realistic vein, the objects, as free choices of the painter in an intimate sphere, could more readily provide latent personal symbols and envelop such feelings as have been inferred from Cézanne's

works. It was because he painted both still-life and nudes that he was able in the idyllic and the pure still-life paintings to symbolize his desires through the apples as elements with a vague analogy to sexual themes. (In a related way, on a conscious level, poets in a society where the soldier is the admired model of manliness choose metaphors of war to describe episodes of love, but also metaphors of love to describe war.)[37]

From the beginning, as a student, Cézanne was attracted by still-life; one of his first works is of a plate of peaches, copied from a painting in the museum at Aix.[38] But most of his early still-lifes are not of fruit, even at the time when he paints fruit in figure compositions. The objects assert directly or through a conventional symbolism his emotion and distinct personal concerns. When he sets up for painting a skull, a candlestick with burnt-down candle, an open book and a rose, we see the ensemble as the imagery of the romantic student with thoughts of love and death.[39] When he paints a dark-toned still-life of bread, eggs, onions, a milk pot and a knife, we imagine the bohemian painter at his improvised meal.[40] Before he fixes on the apple as his motif *par excellence*, he paints the famous still-life of the black clock and the giant sea-shell with reddened mouth—exceptional objects that invite divination of a strange mood.[41]

The later still-lifes of apples and rumpled tablecloths have no such allusiveness. We cannot so readily make of them anecdotes or symbols of a personal state. They have seemed to many observers no more than arbitrary assemblages of the studio, pure instrumentalities of the painter, like the casual objects with which a philosopher illustrates on his desk a point about perception and empirical knowledge.[42]

The shift to the ineloquent, unassertive still-life of fruit took place in the early 1870s when Cézanne, under Pissarro's wing, passed from a dark, heavily-charged tonal painting with frequent violence of contrast to the gentler Impressionist rendering of an enjoyed luminous scene. By this change Cézanne freed himself from the turbulence of the passions in his work. Though he painted some frankly erotic pictures during the '70s, they were not a continuing primary interest.[43] But parallel to the still-life of apples[44] as a major theme is the

already-mentioned, repeated painting of groups of bathers,[45] almost always of the same sex; in the representation of these nudes appears little if any overt erotic suggestion.

In the 1870s and '80s he often isolates a few apples or pears for patient study of their form-shaping color. A remark of Van Gogh points to the tranquilizing effect of such still-life painting on the artist himself: "*Il faut faire, fût-ce des études de choux et de salade pour se calmer et après avoir été calmé, alors . . . ce dont on sera capable.*"[45a]

It would seem to us altogether incompatible with Cézanne's temperament, culture and taste, that he should choose cabbage and lettuce as the means. Van Gogh, too, painted still-lifes with apples; but their heaping and abundance tell of the peasant's harvest rather than of the intimacy of the bourgeois home. In France, under the spell of the Impressionists, his still-lifes became sparser; they decorate their light-filled space like flowers in a cheerful interior.

Not only in the importance of still-life in general for Cézanne's art, but also in his persistent choice of the apples we sense a personal trait. If he achieved a momentary calm through these carefully considered, slowly ripened paintings, it was not in order to prepare for a higher effort. These are major works, often of the same complexity and grandeur as his most impressive landscapes and figure compositions. The setting of the objects, the tables and drapes, sometimes suggest a large modeled terrain, and the tones of the background wall have the delicacy of Cézanne's skies.

An artist's habitual choice of a type of theme points to a connection of its qualities with what are loosely called his values or outlook. But in a type of theme may be found many qualities and connotations; to say which of these has attracted the painter is no easy task. Besides, in explaining the prevalence of a field like still-life—as of landscape or of subjects from religion, myth and history—we look for the common interests that give that field importance for artists of the most varied temperament and make it a characteristic choice during a period of history. With still-life the grounds of interest are more problematic. The painting of still-life has in fact been regarded as altogether a negation of the interest in subject matter, and for this point

of view Cézanne's art has been a familiar argument. The apples to which he gave almost life-long attention are still cited as proof of the *insignificance* of the objects represented by the painter. They are nothing more, it is supposed, than "pretexts" of form. The late Lionello Venturi has expressed the common view in a question and answer: "Why have so many apples been painted in modern times?— Because the simplified motif gave the painter an opportunity for concentrating on problems of form."[46]

It is surprising that a critic who has been so attentive to Cézanne's probing study of the delicately varied shapes and colors of the apples and has responded to the richness of their image on the canvas should speak of the apples as a "simplified motif," as if they were schematic spheres or circles. But apart from this misapprehension of the "motif," Venturi's answer, which appeared obvious to a generation of painters who believed in "pure art" and prized form as a self-sufficient harmony (while continuing to represent objects), will not satisfy those who see in imagery in modern art and especially in the recurrent themes of a painter a personal choice of what Braque has called "the poetry of painting."

Yet this concept of the object as a "pretext" of form and color might have been Cézanne's own during his early years. It was affirmed as a self-evident truth by his closest friend, Zola, in defending Courbet and Manet and the young Impressionists in 1866 and '67. No doubt that when he says of painters in general: *"le sujet pour eux est un prétexte à peindre,"*[47] he has the assurance of reporting the views of the young advanced artists whom he knows and admires and who are revolting against a public and official taste addicted to sensational and curious subjects. Of Manet he wrote in the same work: *"S'il assemble plusieurs objets ou plusieurs figures, il est seulement guidé dans son choix par le désir d'obtenir de belles taches, de belles oppositions."*[48] Even in the provocative *Déjeuner sur l'Herbe*, Zola sees simply an instance of searching for *"des oppositions vives et des masses franches."*[49]

Six years later this notion of the purely aesthetic painterly interest of the objects was embodied in Zola's novel, *Le Ventre de Paris*, from

which I have quoted the amorous descriptions of fruit. He has introduced here as an observer an artist, Claude Lantier, modeled in part on the young Cézanne, who strolls through the streets and pavilions of Les Halles admiring ecstatically the vegetables and fruit.[50] "*Il rôdait sur le carreau des nuits entières, rêvant des natures mortes colossales, des tableaux extraordinaires. Il en avait même commencé un où il avait fait poser son ami Marjolin et cette gueuse de Cadine, mais c'était dur, c'était trop beau, ces diables de légumes, et les fruits, et les poissons, et la viande! . . . il était évident que Claude en ce moment-là, ne songeait même pas que ces belles choses se mangeaient. Il les aimait pour leur couleur.*"[51]

One cannot follow in Zola's novel his own enthusiasm before the spectacle of the markets with their overwhelming, organized heaps of food, and also in his notes for that book his avowal of the deeper sense of its setting in Les Halles, without feeling that the artist-observer—a character with little importance in the action—has been reduced in stature and depth; he sees in this colossal manifestation of urban life nothing more than pretexts for painted color. In fact poor Claude, dissatisfied with his own canvases which he often destroys, longs to come closer to this reality by shaping it more directly. He admits as his one accomplishment as an artist, his masterpiece, the ephemeral window - dressing at a pork-butcher's shop that he arranges on a Christmas eve—the goose, the puddings and hams providing him with his scale of tones.[52] For Zola himself, however, Les Halles are rich in meaning: a gigantic social image, the belly of Paris, and "*par extension la bourgeoisie digérant, ruminant, cuvant en paix ses joies et ses honnêtetés moyennes . . . le contentement large et solide de la faim . . . la bourgeoisie appuyant sourdement l'Empire parce que l'Empire lui donne la patée matin et soir . . . jusqu'au charnier de Sedan.*" And further: "*Cet engraissement, cet entripaillement est le côté philosophique et historique de l'oeuvre. Le côté artistique est Les Halles modernes, les gigantesques natures mortes des huits pavillons.*"[53]

Should we not grant to the painter the depth of awareness that we admit in the poet who celebrates the same objects? Not the very same feelings and perceptions as Zola's, of course; it was the writer

and not his real painter-friend, Paul Cézanne, who looked enraptured at the piles of cabbage which seemed to Claude Lantier more beautiful than the tattered Gothic buildings of the quarter.[54] That masterpiece of pop art in the window display, crowned by the white goose, is hardly in Cézanne's taste; the judgment of its superiority to the paintings betrays the great novelist's failure to distinguish between the work of the brush and the real model. The lapse amazes one after reading Zola's earlier defense of Manet and the young Impressionists. Yet it springs from a mania for reality that might be avowed by a romantic painter questing for an ultimate in his art.

The meaningfulness of still-life, that Zola cannot see in the painter's choice, he asserts and elaborates at length in his own writing. But he needs the pure painter's response to confirm the intrinsic beauty, what he calls *"le côté artistique,"* of this monstrously exuberant world of still-life. In the novelist's depiction of the food in the market are expressed his great appetite for life and his awe before the boundless fertility of a nature that embraces human society as well. It affirms also his concept of man as a biological phenomenon in a constructed mechanical milieu, the market in which men daily sell and buy the means of life. Here instinct and art, raw nature and advanced technical modernity, converge in a materialist image of social reality. Zola perceives a voracious humanity engrossed by food and, with the same spontaneity, creating for the products of nature—the fruits and vegetables and meats—a magnificent rational environment of iron and glass that overshadows the Gothic churches of the quarter. Bringing Hugo up-to-date, he has Claude say: *"Ceci tuera cela, le fer tuera la pierre."*[55] These buildings of Les Halles, he is sure, foretell the architecture of the twentieth century.

We see that Zola, while denying to the still-life objects in painting any significance other than their use as a source of tones, in his own novel monumentalizes still-life and reveals its enormous fascination as a part of existence and as a symbol of the animal forces in social behavior.

Still-life as a type of theme in painting corresponds, it is clear, like landscape, genre and portraiture, to a field of interest outside art;

and we sense this, without having to refer to a particular cause, when we note the separation of still-life as an independent subject (or object) matter in the sixteenth century. Landscape, too, was disengaged then as a major theme with its own completeness after having served for centuries as a setting for human figures. The objects chosen for still-life painting—the table with food and drink, the vessels, the musical instruments, the pipe and tobacco, the articles of costume, the books, tools, playing cards, *objets d'art*, flowers, skulls, etc.—belong to specific fields of value: the private, the domestic, the gustatory, the convivial, the artistic, the vocation and avocation, the decorative and sumptuous, and—less often—in a negative mood, objects offered to meditation as symbols of vanity, mementos of the ephemeral and death. There is, besides, in still-life a range of qualities congenial to a broad outlook which is less distinctly embodied in other kinds of themes. Simply to note these qualities is to suggest a kind of world-view. Still-life, I have written elsewhere,[56] consists of objects that, whether artificial or natural, are subordinate to man as elements of use, manipulation and enjoyment; these objects are smaller than ourselves, within arm's reach, and owe their presence and place to a human action, a purpose. They convey man's sense of his power over things in making or utilizing them; they are instruments as well as products of his skills, his thoughts and appetites. While favored by an art that celebrates the visual as such, they appeal to all the senses and especially to touch and taste. They are the themes *par excellence* of an empirical standpoint wherein our knowledge of proximate objects, and especially of the instrumental, is the model or ground of all knowledge. It is in this sense that the American philosopher, George H. Mead, has said: "The reality of what we see is what we can handle."[57]

Often associated with a style that explores patiently and minutely the appearance of nearby things—their textures, lights, reflections and shadows—the still-life objects bring to awareness the complexity of the phenomenal and the subtle interplay of perception and artifice in representation.

The still-life comes to stand then for a sober objectivity, and an

artist who struggles to attain that posture after having renounced a habitual impulsiveness or fantasy, can adopt the still-life as a calming or redemptive modest task, a means of self-discipline and concentration; it signifies to him the commitment to the given, the simple and dispassionate—the impersonal universe of matter. In the mid-nineteenth century, in reaction against the anecdote in Salon painting, one said that a pebble could serve as a sufficient theme in painting.[58]

Once established as a model domain of the objective in art, still-life is open to an endless variety of feelings and thoughts, even of a disturbing intensity. It can appeal to artists of different temperament who are able through the painting of small objects to express without action or gesture the intimate and personal. They may be instruments of a passion as well as of cool meditation.

Still-life engages the painter (and also the observer who can surmount the habit of casual perception) in a steady looking that discloses new and elusive aspects of the stable object. At first commonplace in appearance, it may become in the course of that contemplation a mystery, a source of metaphysical wonder. Completely secular and stripped of all conventional symbolism, the still-life object, as the meeting-point of boundless forces of atmosphere and light, may evoke a mystical mood like Jakob Boehme's illumination through the glint on a metal ewer.

(I shall not go into the question of how far the vogue of still-life in Western art depends on the point of view of the bourgeois whose strong interest in portable possessions and inclination toward the concrete and practical should make still-life an appealing theme in art. The description I have given of still-life, while it ranges beyond those aspects, will suggest to some readers a connection with other features of a bourgeois outlook. Yet even where the bourgeois has been dominant for centuries and the belief in the dignity of still-life and landscape as themes and their equality to historical subjects has appeared as a democratizing trend in art that gives a positive significance to the everyday world and the environment, even there still-life painting has not been specially favored by middle class patrons of art. It has become important mainly through the achievements of Chardin,

Cézanne and the Cubists. The still-life painters have had to contend with the prejudice that their art is of a lower order because of the intrinsic inferiority of its objects; noble and idealized themes, like idealistic philosophies, have won more approval even after all kinds of themes were admitted in principle to be equal and value was located in the quality of the painter's art. One should not conclude from this fact that the growth of still-life painting has been independent of the conditions of social life. An art like Chardin's or Cézanne's is unthinkable outside of Western bourgeois society. The great difference between ancient Roman still-life painting, with its bare and indeterminate space, and that of later times which has a broader range of personal objects located in an intimate domestic or other private space shaped by the viewpoint of a real observer, reflects the changed character of society.)

Early in our own century still-life was a preferred theme of an art of painting that aimed at a salient concreteness of the medium through a more tangible brush-stroke and surface, even attaching real objects to the canvas beside the traditional pigment—a culmination of a tendency to view the painting itself as a material thing and to erase by various means the boundaries between reality and representation. The work of art then is itself an ostensible object of handling like certain of the simulated and real objects that compose it. Without a fixed place in nature and submitted to arbitrary and often accidental manipulation, the still-life on the table is an objective example of the formed but constantly re-arranged, the freely disposable in reality and therefore connate with an idea of artistic liberty. The still-life picture, to a greater degree than the landscape or historical painting, owes its composition to the painter, yet more than these seems to represent a piece of everyday reality.

In each modern school that has admitted still-life—Cubist, Expressionist, Fauve, New Objectivity, Classicist and the most recent art—one can discern in the selection of objects some revealing correspondences to the style and mood of the individual artist. Reversing Marvell's lines: "The mind, that ocean where each kind / Does straight its own resemblance find," we may call the world of still-life

an ocean where each mind its own resemblance finds. On the common ground of the intimate and manipulable in still-life there is an immense span of choice; many different temperaments—and not only among the empirically-minded—discover in it their unique responding things. One can distinguish Gris from Léger, Matisse from Picasso, Soutine from Bonnard, by their most frequently painted still-life objects which make up for each artist a highly personal, unexchangeable assembly. No wonder Picasso is said to have doubted the authenticity of Rousseau's *Sleeping Gipsy* (1897) with its precocious mandolin, so typical in Cubist painting![59]

Yet the single still-life object is not the bearer of a unique note. It offers a complex of qualities from which the artist can take any one as a dominant or for its effect in the company of other objects. Just as a blue may attract a painter by its coolness, its recessive aspect, its transparency or by its darkness and depth when saturated, so an object —a bottle or fruit—presents to different artists a range of qualities; and in combining the object with others, a particular quality may be reinforced and become more evident.

Baudelaire, who more than most writers of his time insisted on the independent value of language, color and form, and believed passionately that beauty in art was an end in itself, could also write: "*On a souvent répété:* Le style, c'est l'homme; *mais ne pourrait-on dire avec une égale justesse:* Le choix des sujets, c'est l'homme?"[60] But can one properly speak of still-life as a "subject"? Baudelaire, I believe, would not have thought so. In conceding a personal significance to the subject, he had in mind works like Delacroix's in which an imagination, akin to the poet's, conceived a theme of action or at least a virtual human presence. He regretted in the art of his time a decline of culture due to the emergence of a new type of painter—an artisan temperament indifferent to the great themes of poetry and history while concerned with painting as purely an art of the skilled hand and the eye.

To determine the meaning of a picture with a "subject" one required then a title and sometimes a long explication, such as Delacroix furnished for his murals at St. Sulpice. And where these were

lacking, one scrutinized the image in the light of other, better-known or more fully deciphered representations, and especially those of literature. For most still-life paintings such comparison with an imaginary sphere would be irrelevant; the objects represented belong to the everyday world, not to literary culture; we feel that we have grasped the image when we have recognized the elements in their self-evident reality. Unlike the religious or historical picture, the still-life painting, representing a most familiar here-and-now, needs no proper name or title that denotes the unique association of individuals in a particular (often imaginary) time and place. It is, in a sense, timeless, and the space is no labeled locality. Completely undramatic, the still-life objects do not communicate with each other; their represented positions, as I have said, are largely arbitrary, subject only to physical laws and to accidents of manipulation. So the flowers on the table are no longer on their natural ground and might be replaced by artificial plants. Like the commodities in the windows of a shop they are a world of things, nature transposed or transformed for man. Genre painting, too, lacks the element of unique eventfulness, but offers postures, gestures and facial expressions that we read directly as the spontaneous movements of fellow-beings in a familiar sphere in which we ourselves participate.

Yet still-life, as much as landscape and sometimes more, calls out a response to an implied human presence. Each still-life painting has not only a unique appearance as a whole; the represented objects, in their relation to us, acquire meanings from the desires they satisfy as well as from their analogies and relations to the human body. The still-life with musical instruments refers to the musician; the table with fruit and wine recalls the dinner or banquet; the books and papers are the still-life of the writer, the student or scholar and may find their place in his portrait. The small objects in old portraits, reducing the austerity of an empty space, humanize the milieu and stamp it as the domain of the portrayed individual.

They are a symbol or heraldry of a way of life. In *Madame Bovary*, when Léon thinks of going to Paris to study law, he imagines his career there embellished by still-life. "*Il se meubla, dans sa tête, un*

appartement. Il y mènerait une vie d'artiste! Il y prendrait des leçons de guitare! Il aurait une robe de chambre, un béret basque, des pantoufles de velours bleu! Et même il admirait déjà sur sa cheminée deux fleurets en sautoir, avec une tête de mort et la guitare au-dessus."[61]

Or the still-life may evoke the mood of a reflective moment by shaping allusively a setting for introspection:

My fiftieth year had come and gone,
I sat, a solitary man,
In a crowded London shop,
An open book and empty cup
On the marble table-top.[62]

It might be supposed that in still-life painting the meaning of the work is merely the sum of the denotations of the separate parts, while in paintings of action (history, myth, religion) to name the figure is still not to reach the sense of the whole; and that this arbitrariness in the assembly of still-life objects accounts in a painting for the shallowness of its spiritual content. Yet in still-life, too, there may be connotations and a comprehensive quality arising from the combined objects and made more visible and moving through the artistic conception. Not a text or an event but some tendency of feeling directing the painterly imagination will determine here a coherent choice of a family of objects.

There is in still-life a unity of things like the unity of a scene of action; but to grasp this unity of still-life one must recognize the context of the objects in reality, their connection with a mood or interest or type of occasion.[63] And just as in the religious or historical picture the artist's reading of a text introduces meanings and values peculiar to his imagination, so in a still-life of fruit, vessels and dishes we distinguish an individual conception in both the choice and grouping of objects. The painter's habitual selection comes in time to stand for the artist and is recognizably his. The imitators, in devotion to Cézanne as a composer, represent the same apples and cloth and

table, in spite of their belief that the structure of form and color alone gives Cézanne's painting what value it has.[64] This involuntary homage to the objects does not carry with it, however, an insight into the choice itself. The latter is taken for granted, and even if Cézanne's choice is admitted to be personal, it is not explored for deeper meanings or grounds.[65]

I have written elsewhere of Cézanne's unique detachment from both social formality and appetite in the conception of the objects on the domestic or studio table.[66] They are never set as for a meal; the fruit is rarely if ever cut or peeled; the scattering of the still-life and the random spread and fall of the linen in irregular folds imply a still unordered world. The fruit, I have observed, while no longer in nature, is not yet fully a part of human life. Suspended between nature and use, it exists as if for contemplation alone. What appears most ordered in the still-life picture issues from the painter's visible brush-strokes and alludes hardly at all to the purposes that give neatness and charm to the table in ordinary life. He endows these strokes with a subtle cohesion and a harmony of colors that transfigure the whole as a work of art while intensifying in the objects the appearance of the existent and familiar.

In Cézanne's painting of landscape, too, and sometimes of the human being, we recognize within the steadfast commitment to the visible that same distinctive distance from action and desire. In his contemplative view he seems to realize a philosopher's concept of aesthetic perception as a pure will-less knowing. But is not the style of "knowing," however personal, shaped in part by the character of the objects of attention, their meaning and interest for the responding mind? True, he painted also landscapes, portraits and nudes which are no less personal in conception than the still-lifes, but have quite other qualities that contradict the idea of Cézanne's mature art as always devoid of passion and concern. We cannot, however, imagine Poussin devoting himself to still-life as Cézanne did, nor Chardin representing landscapes and mythological subjects. The variety of Cézanne's themes is itself characteristic of his responsive modern sensibility; it is typical of a certain line of French artists: painters who are not special-

ists in a genre but are broadly open to life and sensation in their art
and hence paint people, places and things, though rarely actions and
symbols. Yet what is most distinctive and accomplished in Courbet,
Manet, Renoir and Monet will not be learned through their still-lifes;
but if we lacked Cézanne's, something essential would be missing, a
range of qualities of colors and forms bound to a unique conception
of things near at hand.

It is this central place of still-life in his art that encourages us to
explore more fully his choice of objects. That it is indeed personal and
not "accidental" becomes more obvious when we compare his objects
with those in the still-lifes of his contemporaries and successors.[67] It
is hard to conceive of Cézanne painting the epicure Manet's salmon,
oyster and asparagus, or Van Gogh's potatoes, sunflowers and shoes.[68]
The apples of Cézanne will appear in some works by other original
artists; but in the totality of his still-life paintings the apples stand out
as a habitual motif, while in the works of those contemporaries they
are incidental and possess other qualities through the different con-
text, the accompanying objects. In the paintings of apples by Courbet
the fruit is not only strikingly larger than Cézanne's, but retains a
stem and leaves that give to the whole the aspect of a living segment
of nature plucked by a man of gigantic sensuous appetite. For Cour-
bet, who ordinarily allowed to still-life a minor place as an indepen-
dent theme in his art which includes among its most impressive parts
the magnificent rendering of natural textures—fur, stone, wood, metal
and foliage—with a depth of tone and a weight of substance that
only a loving vision of objects could evoke, for Courbet the painting
of these extra-large or magnified apples during his imprisonment after
the Commune was, I believe, not simply a substitute for the usual
figures and outdoor world from which he was cut off; it may be seen
also poetically as a literal enactment of the phrase of his old friend and
countryman, the poet Buchon, who had written of Courbet that "he
produced his paintings as simply as an apple-tree produced apples"—a
judgment that recommended as well the virtues of his provincial
character, his naïveté, robustness and peasant strength, qualities that
one discerns also in his painting of the fruit.[69] For Cézanne, too, who

admired Courbet and kept a photograph of the *Enterrement à Ornans* on his studio wall beside one of Poussin's *Arcadia*—though he found Courbet *"un peu lourd comme expression"*[70]—I venture to say the apple was a congenial object, a fruit which in the gamut of qualities in nature's products attracted him through its analogies to what he felt was his own native being. In reading the accounts of Cézanne by his friends, I cannot help thinking that in his preference for the still-life of apples—firm, compact, centered organic objects of a commonplace yet subtle beauty, set on a plain table with the unsmoothed cloth ridged and hollowed like a mountain—there is an acknowledged kinship of the painter and his objects, an avowal of a gifted withdrawn man who is more at home with the peasants and landscape of his province than with its upper class and their sapless culture. This felt affinity, apart from any resemblance to his bald head, explains perhaps the impulse to represent an isolated apple beside a drawing of himself (Fig. 16).[71]

Cézanne's prolonged dwelling with still-life may be viewed also as the game of an introverted personality who has found for his art of representation an objective sphere in which he feels self-sufficient, masterful, free from disturbing impulses and anxieties aroused by other human beings, yet open to new sensation. Stable, but of endlessly shifting, intense color, while offering on the small rounded forms an infinite nuancing of tones, his still-life is a model world that he has carefully set up on the isolating supporting table, like the table of the strategist who meditates imaginary battles between the toy forces he has arranged on his variable terrain. Or the still-life of Cézanne may be likened to a solitary pictorial chess, the artist seeking always the strongest position for each of his freely selected pieces.

One should not underestimate, however, Cézanne's feeling for the beauty and poetic connotations of the things he represented. Contrary to the view of his art as indifferent to the sensuousness of fruit —a view that seems justified when his earlier still-lifes of apples are compared with the more pronounced textures in paintings by other artists—Cézanne's apples (and also his less frequent pears and peaches) are often the objects of a caressing vision, especially in the

later works. He loves their finely asymmetrical roundness and the delicacy of their rich local color which he sometimes evokes through an exquisite rendering rarely found in his painting of nude flesh.[72]

That Cézanne's approach to still-life undergoes a change in the 1880s and '90s has often been observed. It may owe something to his aging and to the masterful serenity achieved through the ripening of his art. Among the later still-lifes are works of a festive sumptuousness and formality, with more abundant objects, bouquets of flowers, draped curtains and ornamented table covers. Yet his original conflicts were never completely resolved. During this period of greater self-confidence his bathing women remain as distant as before, though presented on a larger scale, and a work like the great still-life with the *Amor* and the *Flayed Man* attests to a continuing inner struggle.

The view of the mature Cézanne as an artist who saw in the objects he painted only a plastic problem, disregarding and even neutralizing their meaning or natural charm, is not borne out then altogether by his practice or his comment in letters and conversation. He wrote admiringly of the landscapes of his native Provence, which he represented in his pictures with a verifiable fidelity to their objects and their enchanting aspect. And in studying the old paintings and sculptures in the Louvre he chose to copy mainly figures of nobility, beauty and pathos. When he spoke of an etching by van Ostade as *"l'idéal des désirs"* and transposed it to canvas, he did not mean, as was recently said, that he found in the etching a purely artistic ideal of composition, but rather that the old picture touched him as a perfect image of an ideal family life.[73] In Cézanne's copy the most carefully and fully reproduced elements of the original are the mother feeding the child in her lap at the great fireplace in the foreground, with the father and a second child sketched more vaguely behind them. The etching, we may suppose, awakened in him an old longing for a tender family world. Over thirty years before, at the beginning of his career, Cézanne had painted naïvely just such a picture of maternal love, perhaps after a contemporary print.[74] This return to affecting early memories is not exceptional in his art; I have already noted several themes

from his boyhood experiences and fantasies that reappear in later pictures. The unerasable impress of the mother and of the child's conflicting relations to the parents underlie, perhaps, his copying of Delacroix's *Medea Killing her Infants*[75] and *Hagar and Ishmael in the Desert*.[76] It may be that Cézanne's interest in still-life goes back to unknown early fixations in the home, well before the episode with Zola.

Of this interest there are intimations in Cézanne's letters and juvenile poems. But the reference to objects of still-life in certain of these texts—which are also works of fantasy—calls for interpretation like the paintings themselves. At 19 Cézanne wrote and illustrated a macabre piece about a father dividing for his children a severed head at table.[77] One may connect the later pictures of skulls[78] with this morbid fantasy and with a poem of the same time in which *"crâne"* is rhymed with "Cézanne."[79] Many years afterwards the painter, transposing his boyhood concern, represented a young man, perhaps his own son, sitting at table before a skull.[80] In all these expressions we are not sure what belongs to intent and what to unconscious residues and reactions. The original fantasy of the young Cézanne is set in hell like the story of Ugolino, which was also a theme of Rodin and Carpeaux and of a bitter poem by Laforgue. Instead of devouring his children, the bald father is pictured sardonically offering them portions of his own head. One might interpret this image as an unspoken wish for the father's death which will give the young Cézanne the freedom and means for an independent career. If he addressed the letter with this text to his friend Zola, it was perhaps because Zola was a fatherless boy who could receive with sympathy the play about a grim constraining parent.[81]

A second text with a still-life image appears in the poem of 1858 that he called *"Songe d'Annibal."*[82] The young hero misbehaves at a banquet, gets drunk, and in falling under the table brings to the ground with the tablecloth all the food and drink and dishes; he is violently reproved by his stern parent. It is this poem that once led me to conjecture that in Cézanne's intense concern with still-life there was

an effort of reconciliation, of restoration of order to the family table, the scene of conflicts with the father and of anxiety about his own shameful desires.[83]

The apple is unmentioned in these early writings which point to an emotional history behind certain of Cézanne's still-life themes. But an allusion of Cézanne many years later (ca. 1895) brings us back to our main object; he declares to the admiring critic, Geffroy, that he wishes to astonish Paris with an apple.[84] In this pun—really no strict pun—he plays on the theme of his career, fusing in the name "Paris" both the hoped-for success of his art and the myth of fortune that delivers the prize of Helen to the judge of beauty. (Did he perhaps think also that he would surprise with an apple Zola, the friend who first brought him to Paris from Aix?) At that time, Cézanne was studying with profound care the colors and forms of the apple as an exemplary motif. It is the grand order of certain of those works, composed with great draperies and complex balanced groups of fruit, that justifies the idea that the apple was for him an equivalent of the human figure. Cézanne, it is known, desired to paint the nude from life but was embarrassed by the female model—a fear of his own impulses which, when allowed free play in paintings from imagination, had resulted at an earlier time in pictures of violent passion. Renoir recalled to his own son years afterwards a conversation with Cézanne in which the latter had said: "I paint still-lifes. Women models frighten me. The sluts are always watching to catch you off your guard. You've got to be on the defensive all the time and the motif vanishes."[85] Later when he carried out a large composition of women bathers in postures remembered for the most part from the art schools and the museums, he imposed on the faceless nudes a marked constraining order (Fig. 17). It is this picture above all that has misled observers to think of Cézanne's art in general as schematic and abstract.

In paintings of the apples he was able to express through their more varied colors and groupings a wider range of moods, from the gravely contemplative to the sensual and ecstatic. In this carefully arranged society of perfectly submissive things the painter could pro-

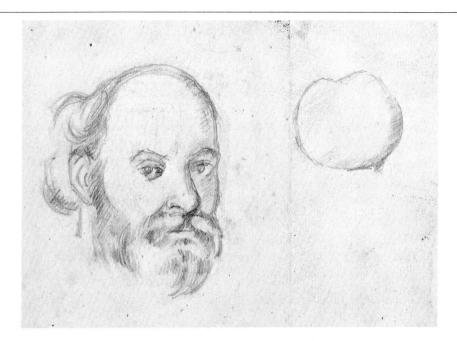

Fig. 16 Cézanne: *Self-portrait and Apple*, 1880–84. Pencil Drawing, 6⅞″ x 9″. Cincinnati Art Museum, Gift of Emily Poole.

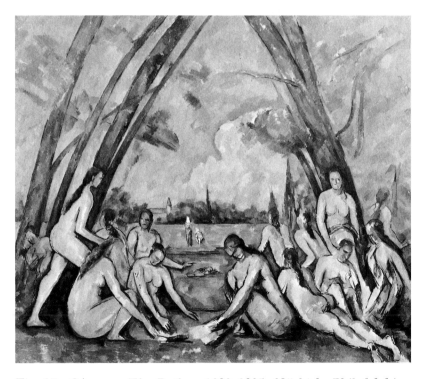

Fig. 17 Cézanne: *The Bathers* 1898–1905. 82″ high. Philadelphia Museum of Art.

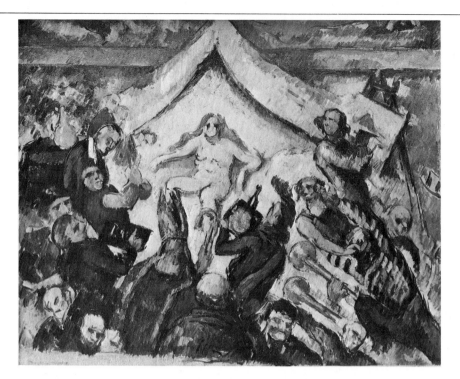

Fig. 18 Cézanne: *Homage to Woman* or *L'Eternel Féminin*, 1875–77. 17″ high. Collection Harold Hecht, New York.

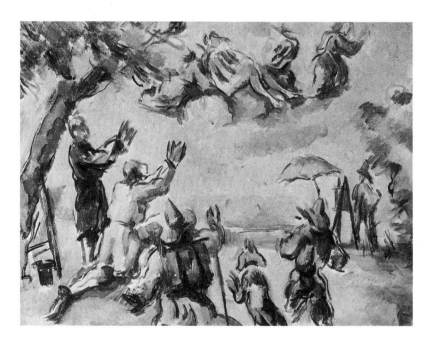

Fig. 19 Cézanne: *Apotheosis of Delacroix*, 1873–77. 10½″ high. Collection R. Lecomte, Paris.

ject typical relations of human beings as well as qualities of the larger visible world—solitude, contact, accord, conflict, serenity, abundance and luxury—and even states of elation and enjoyment. The habit of working expressively in this way with still-life objects reflects a root attitude that had become fixed at an early point in his career, before the apples were a major theme. But from the remark about Paris and the apple we divine the seriousness of Cézanne's special concentration on the fruit that was to serve him as an instrument for the highest achievement. He not only proclaims that his homely rejected self will triumph through a humble object. By connecting his favored theme with the golden apple of myth he gave it a grander sense and alluded also to that dream of sexual fulfillment which Freud and others of his time too readily supposed was a general goal of the art-ist's sublimating effort.[86]

If, in spite of the significance of spontaneous word-play for hidden thoughts and feelings of a speaker, especially when it concerns himself, one dismisses Cézanne's remark on Paris as an obvious joke inspired by the circumstance of his visit to the capital and the first one-man show of his work, with the consequent recognition of the long-ignored painter by his fellow artists, there remains the evidence of his awareness of a connection between the nude and the apple in the work which has been misnamed the *Judgment of Paris* and also in the canvas of Cupid and the apples.

Among Cézanne's pictures are two others from which may be inferred his consciousness of a problem and a choice in the conflict between the passions and his goal in art. One is the satirical *Homage to Woman* (Fig. 18)[87]—called also *Apotheosis of Woman* and *L'Eternel Féminin*—and the other is the *Apotheosis of Delacroix* (Fig. 19).[88] The first was painted in the mid-'70s; the second was on Cézanne's easel in 1894, but the conception may be attributed to a time near the first—at least the costumes belong to the '70s.[89] They are related compositions, with a group of adorers below and an object of adoration above. In the first the nude woman is enthroned under a canopy with parted converging drapes—a redundant feminine form—and is confronted by devotees from different arts and occupations,

among them a mitred bishop. In a watercolor sketch for this work the figure closest to her brings apples and wine on a tray, a typical Cézanne still-life and a constant motif in his pictures of debauch.[90] At the right stands a painter at his easel.[91] The *Apotheosis of Delacroix* (Fig. 19), which survives as a sketch for a large composition that Cézanne still had in mind in 1904, is like a Baroque assumption of a saint to heaven. Artists and one kneeling admirer are shown below in the landscape, looking upwards. One among them, with a paint box strapped to his back and with a broad-brimmed hat, recalls a photograph of Cézanne in the 1870s.[91a] The dog Black, the companion of his boyhood holidays in Provence and a figure in several of his idyllic pictures, appears beside him. At the right, a painter who has been identified as Pissarro stands at an easel as in the *Homage to Woman*.[92] Seen together, these two pictures are like the alternatives in the Choice of Hercules, a theme that had inspired a poem of the young Cézanne.[93] In one he renounces woman by mocking her cult, in the other he identifies himself and several of his fellow-painters with the great romantic master.

In picturing Delacroix as his god, Cézanne satisfied his youthful taste for an imagery of love and death but also his devotion to painting as an art of color with a noble order. On the back of a watercolor sketch for the *Apotheosis of Delacroix* are some verses by Cézanne describing a beautiful nude: *"Voici la jeune femme aux fesses rebondies . . ."*[94] He had given up that imagery almost entirely in his later art, allowing it, we have seen, only an occasional place.

His copies of Delacroix's *Medea* and *Hagar and Ishmael* show the continuing call of the emotional side of the master's conceptions to Cézanne. The romantic's passions were not imaged directly in his art, as in Cézanne's realistic erotic scenes in which he acted out his desires. Delacroix's were transmuted through remote figures of poetry and history and the expressiveness of color and a dramatic composition. In passing from the painting of fantasies to the discipline of observation, Cézanne made of color—the principle of art allied to sensuality and pathos in romantic painting but undeveloped in his own early pictures of passion—the beautiful substance of stable, solid

object-forms and a deeply coherent structure of the composition. It is extremely doubtful that he could have reached this goal had he followed Delacroix in his choice of subjects. But in the self-chastening process, the painting of still-life—as latent symbol and intimate tangible reality—was, perhaps more than his other themes, a bridge between his earlier and his later art.

NOTES

I wish to thank my colleague Prof. Theodore Reff and Dr. Miriam Bunim for help in finding the sources of several statements in the literature on Cézanne. For photographs I am indebted to Profs. Reff, Wayne Andersen and Anthony Blunt, M. Adrien Chappuis and Mr. Philip Adams, director of the Cincinnati Museum of Art.

1 Cf. L. Venturi, Cézanne, son art, son oeuvre, Paris, 1936, I, Catalogue, no. 537, "1883–85." The picture was in the Josse Bernheim–Jeune collection, Paris, but disappeared during the last war. It is reproduced in color by Joachim Gasquet, Cézanne, Paris 1921, pl. opp. p. 156. For a study of the picture, see Theodore Reff, "Cézanne, Flaubert, Saint Anthony and the Queen of Sheba," The Art Bulletin, XLIV, 1962, 113–125, and especially 118 ff.; also the same writer's "Cézanne and Hercules," ibid., XLVIII, 1966, 35–44, with further remarks on our picture on p. 39. A watercolor version, 9″ by 11¾″, was reproduced in color in the catalogue of an auction at Sotheby's, London, April 30, 1969, with the title, Le Jugement de Paris,—Catalogue of Impressionist and Modern Paintings, Drawings and Sculpture, no. 42.

2 Reff, 1962, p. 118.

3 These drawings are reproduced by Reff, 1966, fig. 7, and discussed on p. 39 as stages of a composition for a Judgment of Paris. He ignores the fact that in the drawing at the right there are four nude women. Another drawing for this picture, in a notebook in M. Chappuis' collection, is clearly not a Judgment of Paris. While the male figure offers something to a crouching nude, a second nude crouches with her back to the first; and a third, with both arms raised, is not engaged with the main action and recalls one of Cézanne's typical bathers; a fourth at the right turns her head to look back at the advancing male (see A. Chappuis, Dessins de Paul Cézanne, Paris, 1938, pl. 7).

4 See Paul Cézanne, Correspondance recueillie, annotée et préfacée par John Rewald, Paris, 1937, 30–32, 36, 42, 45–47, 57, 59, 63, 69, 77, 137, 156, and pl. 4.

5 Ibid., p. 137 "Qualis ab incepte processerit, et sibi constet" (Ars Poetica, 127).

6 It is to his friend Roux, ibid., p. 156 and pl. 24; the editor has misread the last word as "virus."

7 Ibid., p. 69, and E. Zola, Correspondance, Lettres de jeunesse, Paris, 1907, p. 189 (December 30, 1859).

8 Paul Gauguin, Lettres à sa femme et à ses amis, ed. Malingue, Paris 1946, p. 45 (letter to Schuffenecker, January 14, 1885).

9 Gasquet, op. cit., p. 13.

10 Reprinted in E. Zola, Mes Haines, Paris 1923, p. 258. The depth of their friendship may be seen, too, in Zola's choice of names for characters who represent himself and Cézanne. Claude, the Christian name of Lantier, the painter in L'Oeuvre, is also

that of the narrator-hero in Zola's early autobiographical novel, *La Confession de Claude* (1865). It is then Zola's *nom de plume* for his writings on art in 1866. In 1873, in *Le Ventre de Paris*, Cézanne is pictured in the person of Claude Lantier as the spokesman of Zola's visual sensibility. All this has been noted before (cf. J. Rewald, *Paul Cézanne, a Biography*, New York, 1948, p. 143), but I may add that the association appears in *L'Oeuvre* even in the name of Claude Lantier's friend, a novelist-observer who is clearly Zola himself. He is called Sandoz, an obvious joining of "Zola" and "Cézanne."

The episode at school in Aix was evidently the basis of Zola's account of the friendship of the two boys in chapter III of his novel, *Madeleine Ferat*, which was dedicated to Manet. Guillaume loves the older Jacques "like a first mistress, with an absolute faith, a blind devotion." In other details of the story one will discover an interchange of Cézanne's life and Zola's.

[11] See note 7.

[12] *Correspondance*, pp. 199–200, pl. 28, and pp. 200, 201, 203.

[13] Cf. Otto Gruppe, *Griechische Mythologie und Religionsgeschichte*, Munich, 1906, I, 384 ff. and passim—see *Sachregister s.v. Apfel*; H. Bächtold-Stäubli, *Handwörterbuch des deutschen Aberglaubens*, Berlin-Leipzig, 1927, I, *s.v. Apfel*, 510 ff.; Hans Aurenhammer, *Lexikon der christlichen Ikonographie*, Vienna, I, 1959, 171 ff.

The emblem books of the Renaissance are explicit on the erotic symbolism of the apple—cf. I. P. Valerianus, *Hieroglyphica*, lib. LIV (Cologne 1631, 674–679—*De Malo*).

[14] *Oeuvres Completes*, IV, Paris 1927, 242, 243.

[15] Act II, scene 1. I quote from the translation by Louis E. Lord, London 1931, p. 132. Cf. also the chorus, p. 130.

[16] *Imagines*, lib. I, 6.

[17] See also note 31.

[18] *Correspondance*, p. 36 (July 9, 1858).

[19] Ibid., p. 55 (July 1859).

[20] Zola, *Correspondance, Lettres de jeunesse*, p. 2 (January 1859), 187, 188 (December 30, 1859).

[21] Ibid., p. 255—"*on les dessine le jour, et la nuit on les caresse*" (October 24, 1860).

[22] Venturi no. 104 (1870). See also M. Schapiro, *Paul Cézanne*, New York (1952), corrected edition, 1958, p. 22. In the drawings for this picture apples are represented—A. Chappuis, *Die Zeichnungen von Paul Cézanne*, Kupferstichkabinett der öffentlichen Kunstsammlungen, Basel. *Katalog der Zeichnungen*, Band II, Olten—Lausanne, 1962, nos. 55, 56. Cf. also V 107, reproduced in color in Schapiro, op. cit., 34–35.

[23] For the Raphael drawing, which is known through the engraving by Marcantonio Raimondi (B. 245), see Gustav Pauli, "Raffael und Manet," *Monatshefte für Kunstwissenschaft*, I, 1908, 53–55; Oskar Fischel, *Raphael*, London 1948, II, pl. 294; and on the relations of Manet to Giorgione in this work, see Jacques Mesnil, "*Le Déjeuner sur l'Herbe* de Manet ed *Il Concerto Campestre* di Giorgione," *L'Arte*, 37, 1934, 250–257.

[24] For the apples in Cézanne's studies for his picture see Chappuis, op. cit., nos. 55, 56.

[24a] It is not out of place, I hope, to refer here to Baudelaire's remarks in his *Le Peintre de la vie moderne* (1863) about the representation of a contemporary courtesan. The poet was certain that if the artist is inspired in such a work by a painting of Titian or Raphael "*il est infiniment probable qu'il fera une oeuvre fausse, ambiguë et obscure.*"

L'étude d'un chef-d'oeuvre de ce temps et de ce genre ne lui enseignera ni l'attitude, ni le regard, ni la grimace, ni l'aspect vital d'une de ces créatures que le dictionnaire de la mode a successivement classées sous les titres grossiers on badins d'impures, de filles entretenues, de lorettes et de biches . . . Malheur à celui qui étudie dans l'antique autre chose que l'art pur, la logique, la méthode générale!" (Oeuvres, Ed. de la Pléiade, II, 337). Yet Manet's picture impressed an admirer and defender in 1867 as a work of pure art, a matter of masses and tones; and for the scandalous coupling of the naked and the clothed he could point to Giorgione's *Concert* in the Louvre as a precedent (Zola, *Mes Haines*, 1923, 355–356). It did not occur to Baudelaire that an original modern painter might find in the old examples not just a lesson in form or the logic of composition but the conception of the subject, the postures of individual figures, and in the allusion to that art of the museums a mask for meanings in his own work—a mask that adds to the ambiguity of the whole. Baudelaire had criticized those like Gérome who painted modern life in ancient costumes. Here Manet painted an ancient scene in modern dress.

[25] *Les Rêves et les moyens de les diriger*, Paris 1867, p. 381.

[26] Venturi no. 106 (1870); another version, Venturi no. 225.

[27] Ibid., nos. 223, 224, 820, 822, and drawings, nos. 1176, 1178, 1179, 1181–83. See also A. Chappuis, op. cit., 1962, nos. 69–73.

[28] Venturi, no. 820.

[29] *Correspondance*, p. 44 (November 13, 1858).

[30] Venturi no. 380, and an earlier version, no. 379; Schapiro, op. cit., p. 48, 49, for color plate and commentary. The dog is present also in an early painting of a river scene with a fisherman and an embracing man and woman (Venturi no. 115). In a drawing (ibid., no 1520a) which may be a sketch for Venturi no. 115, are two nude women on one bank and a clothed fisherman on the opposite bank with a rod extending across the river to the women.

[31] Venturi no. 706; there is another version in the Stockholm National Museum (Venturi no. 707) with pears and apples and without the drawings of the *Ecorché*.

[32] See Gertrude Berthold, *Cézanne und die alten Meister*, Stuttgart 1958, catalogue no. 275. Venturi no. 1474 reproduces only the self-portrait. It will be discussed in a forthcoming book on Cézanne's drawings by Prof. Wayne Andersen.

Note also in Berthold no. 290, a drawing in the Albertina, Vienna, a putto mounted on a centaur above three large apples; below, inverted, is the same striding nude figure as in the Clark drawing.

[33] Venturi no. 551.

[34] Ibid., no. 550.

[35] Ibid., in catalogue description of no. 551.

[36] I may note here as relevant to the symbolism of the apple that the identification of the tree of knowledge in Genesis, chap. 3, as an apple tree was probably inspired by pagan Greek mythology and folklore that associated the apple with the erotic—an association reinforced in Western Christianity by the Latin pun: "malum" = apple, evil. It might have been influenced too by the classic images of the apple tree of the Hesperides with the serpent coiled around the trunk, as in the vase painting in Naples (W. Roscher, *Lexikon der griechischen und römischen Mythologie*, I, 2, col. 2599). The sexual symbolism of the apple as well as of the serpent in the Fall of Man was asserted in the 17th century in the once prohibited book of Adrian Beverland, *De peccato originali*, London 1679, pp. 36 ff.—a work that contains interesting anticipations of psychoanalytic ideas.

In earlier Jewish writings the fruit of the tree of knowledge was said to be the grape or the fig; it was also identified as wheat, palm and nut, and eventually the ethrog

or lime. For the Jewish texts, which also influenced some early Christian and gnostic writings on this point, see Louis Ginzberg, *Die Haggada bei den Kirchenvätern und in der apokryphischen Litteratur*, Berlin 1900, 38–42, and the same author's *The Legends of the Jews*, Philadelphia 1925, V, n.70, pp. 97–98, and n.113, p. 119. For an early Christian text on the apples of the Tree of Knowledge, cf. Commodianus (4th century ?), *Instructiones*, who contrasts the apples that brought death into the world with Christ's precepts—apples that bring life to believers. *Gustato pomi ligno mors intravit in orbem / . . . /In ligno pendit vita ferens poma, praecepta: / Kapite nunc (vobis) vitalia poma credentes/ . . . / Nunc extende manum et sume de ligno vitali.* (Hans Lietzmann, *Lateinische altkirchliche Poesie*, Berlin 1938, p. 43, no. 41).

[37] Cf. Otto Rank, "Um Städte Werben," in *Der Künstler und andere Beiträge zur Psychoanalyse des dichterischen Schaffens*, Leipzig-Wien-Zürich, 1925, 158–170.

[38] Venturi no. 12.

[39] Ibid., no. 61.

[40] Ibid., no. 59.

[41] Ibid., no. 69; Schapiro, op. cit., 36, 37 (colorplate).

[42] The apple is the model object for illustrating the dialectic of sense-experience and knowledge already for Macrobius (*Saturnalia*, lib. VII, cap. 14, on vision), ca. 400 A.D. He shows how knowledge is validated through the accord of the different senses, one alone being fallible. An interesting modern parallel, with the apple as the object, may be found in the discussion ca. 1907 between Lenin and N. Valentinov, an ex-Bolshevik follower of Mach (*Le Contrat Social*, Paris, IV, 1960, 202–204). It is not far-fetched to cite these examples in a study of Cézanne who, whatever the analogies of his outlook with that of Bergson and Kant proposed by interpreters of his art, stated repeatedly in letters and conversation that in art as in knowledge he recognized only two sources: logic and observation (*Correspondance*, pp. 253, 262; Emile Bernard, *Souvenirs sur Paul Cézanne*, Paris 1925, 102); and observation for Cézanne meant "sensations."

[43] Cf. Venturi nos. 106, 112, 121, 123, 124, 223–25, 240, 241, 1520 k.

[44] Ibid., nos. 185–214, 337–357, 494–510, 512, 513.

[45] Ibid., 264–276, 381–392.

[45a] *Verzamelde Brieven van Vincent Van Gogh*, edited by J. Van Gogh-Bonger, Amsterdam and Antwerp 1953, III, 458 (September 10, 1889, letter 605, to Theo).

[46] Lionello Venturi, *Art Criticism Now*, Baltimore 1941, 47. His statement begins with the remark that since 1860 "the prevailing interest has been the study of form. This study may be symbolized by the pictures of apples."

[47] In his essay on Manet (1867) reprinted in *Mes Haines*, Paris 1923, p. 356. See also his article "Proudhon et Courbet" (1866), in the same volume, p. 36.

[48] Ibid., p. 344.

[49] Ibid., p. 355.

[50] *Oeuvres Complètes* (ed. M. LeBlond), IV, 1927, 23 ff.

[51] Ibid., p. 29.

[52] Ibid., 217, 218.

[53] Ibid., 335 (*Ebauche du Ventre de Paris*).

[54] Ibid., p. 29.

[55] Ibid., p. 216.

[56] *Paul Cézanne*, p. 14.

[57] George H. Mead, *The Philosophy of the Act*, Chicago 1938, 103 ff. and *passim* (see index s.v. "manipulatory"). In this context it is worth reading what Diderot wrote on Chardin as a philosophical painter in his Salon of 1765.

[58] E. Feydeau in *Revue internationale de l'art et de la curiosité*, 1869, I, 7, 8—

"*Qu'est-il donc besoin de chercher des sujets si neufs? La plus grandiose et la plus splendide nouveauté du monde sera toujours de représenter un caillou qui ait véritablement l'air d'un caillou, qui résume si bien toutes les idées qui peuvent naître dans l'esprit au sujet d'un caillou . . .*" Cf. also pp. 3, 4, 8, on other still-life themes.

59 I repeat what I have heard from André Breton.

60 In his essay, "La Double Vie par Charles Asselineau," *Oeuvres*, Ed. de la Pléiade, II, 456 (ca. 1859).

61 *Deuxième partie*, VI—Ed. de la Pléiade, I, 432.

62 William Butler Yeats, *Vacillation*, stanza 4.

63 Charles de Tolnay has published some medieval still-life paintings from Tuscan churches, which show the sacred vessels and books of the Roman Catholic liturgy as isolated objects in real or simulated niches in the choir or sacristy. In these rare surviving examples of what must have been a common practice, we see the connection of still-life with the instruments of a profession; they are not represented as theological symbols but as the valued paraphernalia of a priestly status or a way of life which has become, so to speak, conscious of itself and its special world ("Postille sulle origini della natura morta moderna," *Rivista d'Arte*, XXXVI, 1963, 3–10).

64 The classic statement on this taste for Cézanne's apples is by the late Wyndham Lewis: "No doubt the example of Cézanne, who was admired as a magnificent creator of pure form, inspired the abundance of representation of apples in the decade after his death. More apples have been painted during the last fifteen years than have been eaten by painters in as many centuries"—*The Caliph's Design*, London 1919, 50.

65 I judge from conversation of Alberto Giacometti, who painted apples all his life, that he regarded the choice of the still-life object as an essential value and not as a "pretext" of form. In certain of his later paintings the apple has the air of a personal manifesto or demonstration—perhaps inspired by understanding of Cézanne's concern—as if he wished to assert dramatically, against the current indifference to the meaning of the still-life object, his own profound interest in the apple's solitary presence as a type of being.

66 Op. cit., 14, 15.

67 Compared with Chardin (who is closer to the pantry and kitchen and alludes often to the work of preparing the meal, to the skills of the cook and the housewife, and correspondingly to the instruments of the artist) Cézanne's still-life objects, including the jars and bottles and glasses, belong more obviously to the table and appear less used, less subject to an on-going manipulation. Where Chardin paints fruit he places beside them other objects foreign to Cézanne and the whole still-life is set more formally on a stone base or shelf. In studying Chardin's extraordinary *La Raie*, in the Louvre, Cézanne copied from it only the jug and metal pot, but ignored the ray, the cat, the fish and oysters. (See G. Berthold, op. cit., figs. 23, 24.)

68 I have discussed the self-reference in Van Gogh's painting of his shoes in an article: "The Still-Life as a Personal Object—A Note on Heidegger and Van Gogh," in *The Reach of Mind: Essays in Memory of Kurt Goldstein, 1878–1965*, Springer Publishing Co., New York, 1967.

69 The text is quoted by Charles Léger, *Courbet*, Paris 1929, 65 ff.

70 See A. Vollard, *Paul Cézanne*, Paris 1914, pp. 75, 77.

71 Prof. Wayne Andersen has called my attention to this drawing of which only the head was reproduced by J. Rewald, *Paul Cézanne*, New York 1948, 163, and in reverse.

72 An example is the still-life of peaches on a white plate in the Barnes Foundation, Merion, Pa. (Venturi, no. 614).

[73] Fritz Novotny, "Zu einer 'Kopie' von Cézanne nach Ostade," *Pantheon*, XXV, 1967, 276–280.

[74] Venturi, no. 9 ("ca. 1860").

[75] Ibid., no. 867.

[76] Ibid., no. 708.

[77] *Correspondance*, p. 49 and pl. 3.

[78] Venturi, nos. 61, 751, 753, 758, 759, 1567. In no. 758 the skull is set in a still-life of fruit.

[79] *Correspondance*, p. 55 (July 1859).

[80] Venturi, no. 679. Note also his copy ca. 1873 of Delacroix's lithograph of Hamlet contemplating Yorick's skull (Berthold, op. cit., nos. 244–245).

[81] Cf. Schapiro, op. cit., 22.

[82] *Correspondance*, 42 ff. (See also Th. Reff, "Cézanne's Dream of Hannibal," *The Art Bulletin*, XLV, 1963, 148–152.)

[83] Schapiro, op. cit. 23.

[84] Gustave Geffroy, *Claude Monet*, Paris 1922, 198—"*Ce que j'aimais surtout en lui, c'étaient ses enthousiasmes: Avec une pomme, proclamait-il, je veux étonner Paris.*"

[85] Jean Renoir, *Renoir, My Father*, London 1962, 106.

[86] In Cézanne's early *Judgment of Paris* (Venturi, no. 16, "1860–61"), an extremely odd conception of the subject, Paris' own prize is Venus herself. The nude goddess sits at the feet of Paris who caresses her shoulder; he is dressed in romantic troubador style. In an early drawing in the High Museum of Art, Atlanta, Ga., published by Prof. Reff (*The Art Bulletin*, XLVIII, 1966, 38 and fig. 6) the figures of Paris and Venus sit together with legs intertwined; they seem to hold an apple jointly in their raised hands and Paris embraces Venus with his left arm. But are these figures surely Paris and Venus as Prof. Reff supposes?

[87] Venturi, no. 247; also nos. 895, 904, 1207 for the sketches for the painting.

[88] Ibid., no. 245; and the sketch, no. 89r.

[89] Venturi, at no. 245; the photograph of Cézanne working on this picture is reproduced by Rewald in *Correspondance*, pl. 33; see also Novotny, *Cézanne*, Phaidon, Vienna, 1937, pl. 93 and his catalogue for comment on the dating ca. 1894.

[90] Venturi, no. 895.

[91] The picture has been compared with a *Triumph of Woman* by Couture (B. Dorival, *Paul Cézanne*, Paris, New York, 1948, pl. VI, p. 39); there four young men pull a chariot in which stands the triumphant Woman. I see little if any connection of Cézanne's idea with this work. Both express a commonplace misogynist thought; for a militantly polemical counterpart in the mid-19th century, cf. Proudhon's posthumous book, *La Pornocratie*, 1868. There is, however, a Baroque *Homage to Venus* by J. A. Dyck in Karlsruhe with a nude Venus elevated and enthroned under a canopy like the woman in Cézanne's picture and with adoring figures around her. (A. Pigler, *Barockthemen, eine Auswahl von Verzeichnissen zur Ikonographie des 17. und 18. Jahrhunderts*. Budapest, 1956, II, 249).

[91a] Reproduced by Rewald, 1948, pl. 41 (1873).

[92] Venturi, no. 245. Venturi identifies the figures from right to left as Pissarro, Monet, Cézanne and Chocquet; a last figure is uncertain.

[93] *Correspondance*, 77. See also Reff, *The Art Bulletin*, 1966, 35 ff.

[94] *Correspondance*, 260 (May 12, 1904), note. Cézanne writes in this letter: "*Je ne sais si ma précaire santé me permettra de réaliser jamais mon rêve de faire son apothéose.*"

CÉZANNE

(1959)

II

After fifty years of the most radical change in art from images to free abstraction, Cézanne's painting, which looks old-fashioned today in its attachment to nature, maintains itself fresh and stimulating to young painters of our time. He has produced no school, but he has given an impulse directly or indirectly to almost every new movement since he died. His power to excite artists of different tendency and temperament is due, I think, to the fact that he realized with equal fullness so many different sides of his art. It has often been true of leading modern painters that they developed a single idea with great force. Some one element or expressive note has been worked out with striking effect. In Cézanne we are struck rather by the comprehensive character of his art, although later artists have built on a particular element of his style. Color, drawing, modelling, structure, touch and expression—if any of these can be isolated from the others —are carried to a new height in his work. He is arresting through his images—more rich in suggestive content than has been supposed— and also through his uninterpreted strokes which make us see that there can be qualities of greatness in little touches of paint. In his pictures single patches of the brush reveal themselves as an uncanny choice, deciding the unity of a whole region of forms. Out of these emerges a moving semblance of a familiar natural world with a deepened harmony that invites meditation. His painting is a balanced art, not in the sense that it is stabilized or moderate in its effects, but that

opposed qualities are joined in a scrupulously controlled play. He is inventive and perfect in many different aspects of his art.

In this striving for fullness, Cézanne is an heir of the Renaissance and Baroque masters. Like Delacroix, he retains from Rubens and the Italians a concept of the grand—not in the size of the canvas but in the weight and complexity of variation. His grandeur is without rhetoric and convention, and inheres in the dramatic power of large contrasts and in the frankness of his means. His detached contemplation of his subjects arises from a passionate aspiring nature that seeks to master its own impulses through an objective attitude to things. The mountain peak is a natural choice for him, as is the abandoned quarry, the solitary house or tree, and the diversity of humble, impersonal objects on the table.

The greatness of Cézanne does not lie only in the perfection of single masterpieces; it is also in the quality of his whole achievement. An exhibition of works spanning his forty years as a painter reveals a remarkable inner freedom. The lives of Gauguin and Van Gogh have blinded the public to what is noble and complete in Cézanne's less sensational, though anguished, career. Outliving these younger contemporaries, more fortunate in overcoming impulses and situations dangerous to art, he was able to mature more fully and to realize many more of his artistic ideas.

Cézanne's masterliness includes, besides the control of the canvas in its complexity and novelty, the ordering of his own life as an artist. His art has a unique quality of ripeness and continuous growth. While concentrating on his own problems—problems he had set himself and not taken from a school or leader—he was capable of an astonishing variety. This variety rests on the openness of his sensitive spirit. He admitted to the canvas a great span of perception and mood, greater than that of his Impressionist friends. This is evident from the range of themes alone; but it is clear in the painterly qualities as well. He draws or colors; he composes or follows his immediate sensation of nature; he paints with a virile brush solidly, or in the most delicate sparse water color, and is equally sure in both. He pos-

sessed a firm faith in spontaneous sensibility, in the resources of the sincere self. He can be passionate and cool, grave and light; he is always honest.

Cézanne's work not only gives us the joy of beautiful painting; it appeals too as an example of heroism in art. For he reached perfection, it is well known, in a long and painful struggle with himself. This struggle can be read in his work in the many signs of destructiveness and black moods, especially in his early phase; perhaps we may recognize it too even in the detached aspect of the world that he finally shapes into a serenely ordered whole. I do not doubt that the personal content of this classic art will in time become as evident as the aesthetic result.

This essay first appeared as the Foreword to the catalogue of the Loan Exhibition, Wildenstein & Co., New York, 1959.

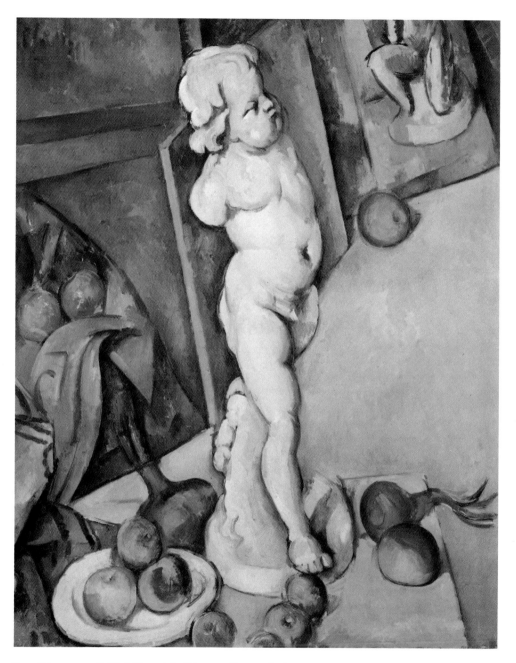

I. Cézanne: *Still Life with Plaster Cast of Amor*, Courtauld Institute Galleries, London.

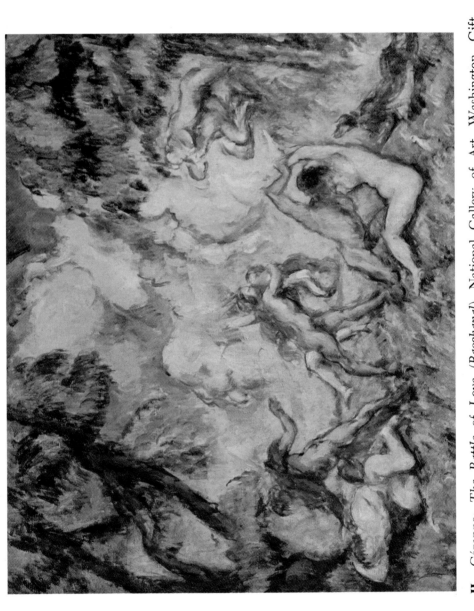

II. Cézanne: *The Battle of Love* (*Bacchanal*), National Gallery of Art, Washington. Gift of the W. Averell Harriman Foundation in memory of Marie N. Harriman. (Photo, Dick Harp)

III. Cézanne: *Pin et rochers au Chateau Noir*, Watercolor. 0.465 x 0.355 mm. The Art Museum, Princeton University.

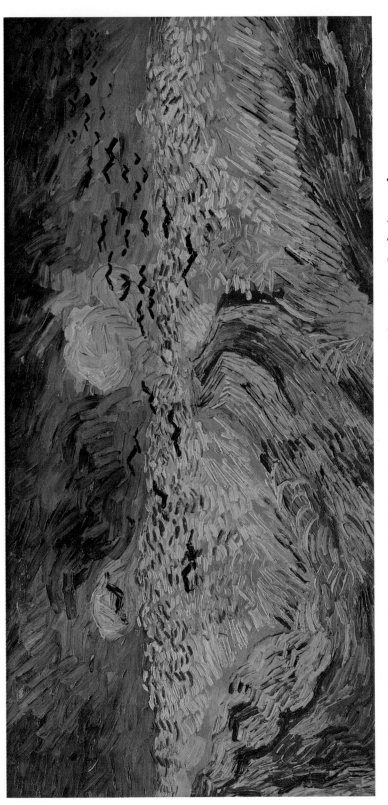

IV. Van Gogh: *Crows over the Wheat Field*, Collection, National Museum Vincent van Gogh, Amsterdam.

CÉZANNE
AS A WATERCOLORIST
(1963)

III

I t is one of the charms and also a mystery of the arts commonly grouped under the name of painting that a few pencil lines with some added washes of color, hardly filling the surface and made as a preliminary study for what is to be a fully covered canvas, can possess an intrinsic completeness, while the most surprising notes and outlines of the poet, the playwright and the novelist remain a pre-artistic prose. We do not have to interest ourselves in the workshop procedure of Cézanne to enjoy these offshoots of his process. Our admiration is independent of curiosity about method or technique, so compelling is the harmony of these incidental stages of his work, a harmony which is not to be confused with the values of an unfinished canvas. These modest notes achieve wholeness through the same operations of choice and perfected habit that determine the order of the most complex composition. Unlike the unfinished picture they say what they were meant to say—if only to the painter himself—and although a watercolor could have said more, they seem to us a perfect achievement just as they are.

It is easy to suppose that in marking the main features of a landscape or still life in watercolor and pencil, Cézanne was disengaging its "essentials" from the merely adherent detail. His watercolors, from such a viewpoint, would appear to be purer statements of the content of his oil paintings, distillations of their effective substance. I believe that it is a mistake, however, to distinguish in his painting an underly-

43

ing, aesthetically more potent, geometric form from the particulars of nature, a hidden reality from a less valid appearance of the represented objects. In Cézanne's work all that is there, all that we see, contributes to the beauty of the whole. If then the watercolor seems to be a sparse or condensed anticipation of an oil painting, it is not because the watercolor shows the future order in its nakedness. It is not an armature or diagram, like the schemas traced by art students in analyzing the composition of an old masterpiece. On the contrary, the watercolors are often vaguer in structure than the completed oils. They are a sketch of a large aspect of the natural shapes and colors, and include enough of both the formal and the free to recall the interplay of these opposed qualities in the final work.

The watercolor can be the swiftly noted idea of the intended canvas or a patiently conducted study of a single inciting feature of the motif—a peculiar branching of a tree, an interesting edge of rock, a relation of the colors of foreground and middle ground, brought out with scrupulous control. The watercolors are often a reconnaissance of the subject, the steps toward a fuller knowledge before the final engagement on the canvas. Cézanne did not simply draw what he already knew and recognized; he drew and painted in watercolor in order to isolate and absorb for the first time the discovered qualities of the object that, translated into his painter's medium, were right for the projected picture. What is fascinating in the watercolors as studies is the freshness of these first notations of the attracting features of a scene. They permit us to dwell in the intimacy of Cézanne's sensing of a pictorial aptness in things; we experience in these studies, which were not designed with finality and yet are consummate works of art, his attentiveness, his fine hesitations and scruples, his delicacy of touch, his anxious trial of sensations—the traits of an honestly receptive mind.

If watercolor as a preparatory study belongs to his method as a painter in oils, it also realizes a vision of nature, or at least an aspect of his vision of nature, that is less evident in the oils. Cézanne is not only a builder of forms with color, as he has come to be seen through the later trend of painting which he so strongly determined. His letters

show that he responds with passion to certain qualities of nature; he discerns and feels them deeply as connate with his own spirit. Watercolor is both a medium and occasion of this lyrical response. The paper and brushes, the conditions of the handling of liquid color, seem to bring into play attitudes that are specific to this context of work, as pencils of varying degrees of hardness in the hands of an artist will awaken latent dispositions, allied to different energies and pressures of the hand—like musical instruments which arouse in the composer distinct moods and suggest different constructions of sound. So the transparent color calls out indigenous harmonies and a special awareness of nature, perhaps not aimed at as a primary goal, but acknowledged as valid by the painter and perfected as it emerges in the course of work. The watercolors transpose certain rarities of tone, shape and feeling in the familiar world—the suspended and diaphanous, the airy-phantasmal and fluid, all presented as natural and as given directly to the solitary, contemplative eye, without any allusion to the extraordinary and fanciful-poetic.

So the diluted color evoked in Cézanne a poetic vision that otherwise might have found no place in his work. There is a genius of his watercolors other than the genius of his oils—perhaps it is better to speak of a temperament attuned to particular perceptions. The watercolors have a special fineness that seems to result from the medium in concert with a sensitivity it has awakened to the immaterial and delicate. In watercolor are realized more distinctly the light and tender in his own being. The same motif transported to the canvas and filled out to the edges, appears robust and solid. While masterful in execution, the painting in transparent tones with unfilled ground is free from the will to power in art, with its struggle for strength and completeness—the ruin of many artists—and is nearer to sensibility, spontaneous and joyful in its momentary attunement.

This essay first appeared as the Introduction to *Cezanne Watercolors*, Benefit Exhibition for the Scholarship Fund of the Department of Art History and Archaeology of Columbia University at M. Knoedler & Co., New York, 1963, pp. 11–15.

COURBET
AND POPULAR IMAGERY
An Essay on Realism and Naïveté
(1941)

The caricatures of Courbet's paintings reduce his work to the level of popular and unskilled art; they show his figures as stiff, schematic little *bonshommes* (Fig. 1a).[1] A child at a gingerbread stall, in a caricature of 1853,[2] cries to his mother: "Oh! maman, vois donc ces beaux courbets! Achète m'en! quatre pour un sou!" And the critics, from the forgotten reviewers to Théophile Gautier,[3] deride the primitive character of his art, the likeness to tobacconists' signs and the *images d'Epinal*; it is a *"peinture d'Auvergnat."*[4]

These criticisms are not simply a pattern of abuse applied to all innovating art. The Romantics before him and the Impressionists afterwards were attacked in another way. Their works were considered mad or chaotic, like certain paintings of our own time. They might also be criticized as childishly incompetent and ugly, but it is hard to imagine Delacroix's *Sardanapale* or Monet's street scenes caricatured as rigid in form. In the nineteenth century the charge of childishness was sometimes brought against classicistic or too synthetically composed forms.[5] Even Courbet, who had passed through the school of romantic art, spoke contemptuously of the figures of David as "bonhommes pour amuser les enfants au même titre que l'imagerie d'Epinal;"[6] and the same criticism is made in substance by Thackeray in his *Paris Sketch Book*,[7] when he draws the *Horatii* as rigid semaphores in a row. Relative to Courbet's atmospheric, tonal painting, the classical school is archaically stiff; but beside the mobility and pit-

toresque of romantic art, Courbet himself seems inert. In an essay on Courbet in 1856, Silvestre addresses the same reproach of immobility and lack of lively gestures to both Ingres and Courbet.[8] Hence, if the abusive criticism may be applied indiscriminately, it has sometimes a basis in positive qualities of the works attacked.[9]

The charge of primitiveness was provoked also by Courbet's themes. The W*restlers*, which recalls in its elaborate study of the muscles the effort of a Pollaiuolo, was ironically recommended as a background for the strong man in the circus.[10] Among the masculine nudes of contemporary painting, with their heroic, mythical or tragic meanings, the wrestling figures seemed a profane intrusion of the vulgar taste of the fairs.

Yet in characterizing his work as naïve, the unfriendly critics of Courbet agreed finally with his supporters. His chief defender, Champfleury, found in this naïveté one of the great qualities of Courbet's painting. He likened the *Enterrement* in its simplicity and force to the art of the folk *imagier*.[11]

> De loin, en entrant, l'Enterrement apparaît comme encadré par une porte; chacun est surpris par cette peinture simple, comme à la vue de ces naïves images sur bois, taillées par un couteau maladroit, en tête des assassinats imprimés rue Gît-le-Coeur. L'effet est le même, parce que l'exécution est aussi simple. L'art savant trouve le même *accent* que l'art naïf.[12]
> (Fig. lb)

What Champfleury had in mind here was that "synthetic and simplifying vision" which Baudelaire was to attribute later to Corot and Guys, and which he found also in Egyptian, Ninivite and Mexican art.[13] Courbet was obviously not trying to revive the conventions of popular imagery, as archaistic painters of the nineteenth century imitated those of antiquity or the middle ages. Yet in his composition, he shows unmistakable tendencies toward a more primitive form. With all their colorism and richness of pigment, with their advanced use of tones to build up the whole, his arrangements are

often simplified, with a clarity of grouping determined by the interest in the single objects. This is most evident when we set his larger canvases beside the baroque compositions of Delacroix, who was distressed by the mere juxtaposition of parts in Courbet's paintings, their lack of gestures and psychological interplay.[14] Delacroix's figures are learnedly "organized" and resemble the machines of the *Salons*; while Courbet's large paintings, according to Champfleury, "have the supreme quality of a horror of composition."[15] His drawing is often irregular in an earnest, empirical manner, unrefined by the *poncifs* and idealizations of a grand style, as if he were tracing a complicated shape for the first time; the creases and broken outlines of the clothes of the *Casseurs de Pierres* are examples of this mode of observation which was ridiculed as vulgar in 1850.

That Courbet was familiar with the traditional methods, we can judge from his early paintings; if he gave them up, it was because they were inadequate for his vision and subject matter. He was conscious of the larger pattern and the single shapes as qualities of the objects represented; and in rendering scenes of popular life, he sometimes accentuated the rusticity of the figures by his very mode of drawing and grouping them. The drawing of the *Aumône du Mendiant*[16] (Fig. 1c) seems naïve, even artless, and suggests certain figures of Van Gogh. In the *Enterrement* the stark contrast of red and black on the grey background and the clarity of the aligned, recurrent faces with their strong red tones, were conscious departures; before, he had painted similar heads in outdoor scenes with deep shadows and more subdued colors. That is why the portraits in the *Burial* gave the impression of a primitive, rustic taste. The distant heads are almost as bright as the nearer ones. They pleased the people in Ornans who had sat for them, but the Parisian critics, schooled in the contrasted, shadowy, atmospheric painting of the romantics, found the portraits not only ugly as human types, but plebeian in execution. The desire for shadowless, unatmospheric portraits, like the frontality, was a typical petit-bourgeois taste, which had been ridiculed by Monnier in his play *Le Peintre et les Bourgeois*.[17] The naïve spectator from the lower middle class responded to shadows on a portrait face no differ-

ently from the Chinese empress, who assured the Italian painter that the two sides of her face were of the same color.

In its content especially, the *Enterrement* resembles works of popular imagery. The first, or at least an early, stage, preserved in a sketch on paper in the museum of Besançon (Fig. 2a),[18] shows a procession to the cemetery moving from right to left. The grave-digger is at the extreme left, the rectangle in the center is a grave-stone, the landscape is less developed. This drawing is like a popular wood-cut of Courbet's youth, *Souvenir Mortuaire*, produced about 1830 in Montbéliard, a few miles from Ornans, which the country people attached to the wall after a funeral and inscribed with the name of the deceased (Fig. 2b).[19] It shows also the procession to the left, the grave-digger at one end, grave-stones in the foreground and the cross elevated above the horizon. In Courbet's final painting (Fig. 2c) the conception has been very much changed and deepened in content; the whole procession is arrested, the scene is concentrated about the central grave, and the form of the landscape adjusted to this new center. Around it are grouped the mourners, from the children at the left to the oldest men, in costumes of the seventeen-nineties. Even this version is related to popular engravings. For in the images of the *Steps of Life (Les Degrés des Ages)*, individuals graded in age form a clear semi-circle or arch around a scene of burial (Fig. 2d).[20] Before the French Revolution the central space was filled with a Last Judgment; later it was sometimes secularized by a simple hearse and a symbolic growth, a rose-bush, a sheaf of wheat, a vine—plants in various stages of development, from spring to autumn.[21] That Courbet copied such images is difficult to prove, but the resemblance is evident.

In 1850 he collaborated in the production of a "popular image." It is a lithograph rather than a wood-cut in the traditional manner, but even in its more modern technique it reproduces a type of popular art.[22] His image of the apostle, Jean Journet (Fig. 1d), is part of a broadside, including a poem in couplets, a "Complainte" to be sung to the "Air de Joseph."[23] Journet was an independent Fourierist missionary, a man of solemn and irrepressible candor in his radical evangelism; Champfleury has described him in his collection of

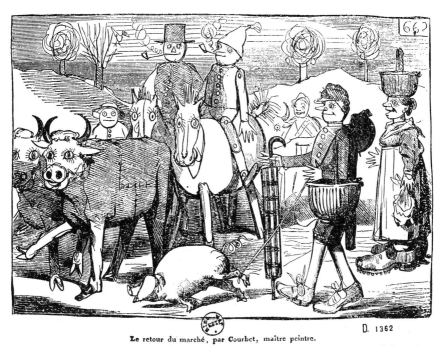

Le retour du marché, par Courbet, maître peintre.

Rien n'égale l'enthousiasme produit sur le public par les tableaux de Courbet. — Voilà de la *vérité vraie*, sans chic ni ficelles. — On ne sent point là le poncif de l'école, et les absurdes traditions de l'antique Tout y est naïf, heureux et gai. Courbet avait dix-huit mois quand il a peint ce tableau.

Fig. 1a Caricature of Courbet's *Retour de la Foire*.

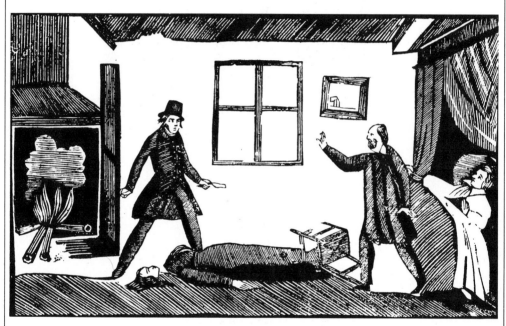

Fig. 1b Popular woodcut of an assassination, ca. 1850.

Fig. 1c Courbet: *L'Aumône du mendiant*.

Fig. 1d Courbet: *Jean Journet*. Lithograph, 9½″ x 6¾″. The
Metropolitan Museum of Art, Harris Brisbane Dick Fund, 1932.

Fig. 2a Courbet: Drawing for *L'Enterrement à Ornans*.
Musée des Beaux-Arts, Besançon.

Fig. 2b *Souvenir Mortuaire*. Popular woodcut, ca. 1830. Bibl.
Ste-Geneviève, Paris.

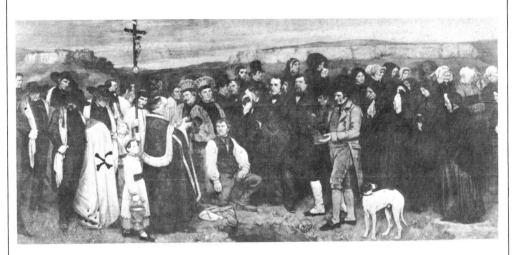

Fig. 2c Courbet: *L'Enterrement à Ornans*. Louvre, Paris.

Fig. 2d *Les Degrés des Ages*. French popular print. Early 19th century.

Excentriques.[24] Courbet shows him setting out to convert the world, advancing with staff in hand, like the *Juif Errant* of the popular prints. The form of the lithograph framed by the field of verses belongs to the broadsides of the early nineteenth century; there is in this secular apostle dominating the horizon something of the saints, and especially of the pilgrim Saint Jacques, of the religious broadsides.[25]

Courbet, moreover, made drawings for books addressed to a popular, sometimes uncultured and philistine, audience, unlike Delacroix who illustrated Goethe and Shakespeare. Courbet's illustrations are of cheap anti-clerical tracts, the "Death of Johnny the Rat-Catcher"[26] and the "Merry Tales of the Curés";[27] or of a book on petit-bourgeois types, *Le Camp des Bourgeois,* for which he provided drawings after photographs;[28] or images of workmen digging and sawing, to accompany the work-songs in a book of popular songs of the provinces, collected by Champfleury.[29]

His paintings of work repeat a common theme of popular art, the *Métiers.*[30] Courbet does not represent the advanced forms of modern industry—they had already appeared in paintings of the late thirties[31]—but the hand-work of the villages, the traditional occupations which had previously been represented on a small scale.[32] He monumentalizes the *Knife-Grinders,* the *Tinker,* the *Stone-Breakers,* the *Winnowers;* and besides these, he paints the *Hunter,* the *Poacher,* the *Vintner,* the *Harvesters* and the *Faggot-Gatherer.* In the late forties and fifties, the mere representation of labor on the scale of the *Stone-Breakers* and *Knife-Grinders* was politically suggestive. The lower classes, and especially the workers, had emerged as a factor in politics; and the slogan of the *Droit au Travail* was the chief one for the workers in the February revolution and in the disorders which followed.[33] Already in the forties there had appeared a book by de la Bédollière, *Les Métiers,*[34] illustrated with engravings (after Monnier) of the different popular occupations;[35] it was designed, as the author said, to awaken interest in the people, not from a radical viewpoint so much but to effect a philanthropic reconciliation of the opposed classes.[36]

Courbet's popular themes are therefore sometimes considered

merely tendentious and doctrinaire, the result of his friendship with Proudhon. This view disregards his identification with the people and the precise content of his pictures. Even his notorious anti-clerical painting of the drunken *curés*[37] has a popular rather than partisan origin. The representation of the peasants under an image of the Virgin on the roadside, amused by the drunkenness of the clergy, says nothing of the doctrines and sacraments of the church, but corresponds to the cynical proverbs and tales of the religious peasantry whose folklore, even in a Catholic country like France, reveals without exception an underlying malice and hostility to the clergy as a class.[38] If one compares Courbet's attitude with the erudite constructions of his admirer, the philosopher-painter, Chenavard,[39] who must locate the church in a vast cycle of world history in order to show its historical limitations, it becomes obvious how rustic and popular in feeling is Courbet's satirical image. Even Proudhon in his commentary on the picture had to admit that the criticism of the Church here was only implicit.[40]

2

Courbet's political radicalism, his relations with Proudhon and his part in the Commune seem to be secondary to his goal as an artist; but they are characteristic of his personality with its provincial and plebeian self-consciousness in the Paris of an age of great social struggles. His feeling of superiority as an artist was justified for him by his indigenous relation to the masses. In letters and public statements, he affirmed that he alone of the artists of his time expressed the sentiments of the people and that his art was in essence democratic.[41] He took a hearty delight in painting the landscape, the individuals and the life of his native village of Ornans on a monumental scale, and thereby imposed on the *Salon* spectator his judgment of the social importance of this world. Daumier, in a caricature of 1853, represented the stupefaction of countrymen before the paintings of Cour-

bet at the *Salon*;[42] but the artist himself wrote from Ornans to Champfleury of the *Casseurs de Pierres*: "Les vignerons, les cultivateurs, que ce tableau séduit beaucoup, prétendent que j'en ferais un cent que je n'en ferais pas un plus vrai."[43] While painting the *Enterrement*, he corresponded with his friends in Paris about the progress of the work, describing how he got his models, and how they posed for him; everyone, he said, wanted to be in the picture.[44] With the *curé* he argued about religion; and the grave-digger regretted that the cholera which had struck the nearby village had passed by Ornans and cheated him of a good harvest. He ends one of these letters with an account of the carnival at Ornans in which he took part.[45] In his large allegorical painting, the *Atelier*, he presents around him in the studio his two worlds, at the right, the world of art, including his patron Bruyas, his literary and musical friends, Baudelaire, Buchon, Champfleury and Promayet; on the other side, the people, in their homeliness, poverty and simple interests.[46] The German *brasserie* in Paris, where realism as a movement was hatched, is described by Champfleury as a Protestant village, in its rustic manners and conviviality.[47] The leader, Courbet, was a *"compagnon,"* a handshaker, a great talker and eater, strong and tenacious like a peasant, the precise opposite of the dandy of the thirties and forties. His behavior in Paris was consciously popular; he spoke in an evident *patois*, smoked, sang and jested like a man of the people. Even his technique of painting impressed academic observers as plebeian and domestic in its freedom; for he used knife and thumb, worked from jars, rubbed and scraped, improvising directly from memory, without applying the learned devices of the school. Du Camp wrote that he painted pictures, "comme on cire des bottes."[48] In Ornans he framed the *Enterrement* with plain boards of local fir; and it was shown in this village and the provincial center, Besançon, before being sent to the *Salon*. In a letter to his patron, Bruyas, in speaking of a plan for a private show in Paris, he draws across the letter in a naïve domestic style a view of the exhibition building, very much like the booth of a circus, with peaked roof and pennant.[49] (Fig. 3a).

3

Courbet's taste for the people was thoroughly personal and in his blood. But it was also nourished and directed by the artistic and social movements of his time. Before 1848, he had painted romantic, poetic subjects as well as his provincial world; after 1848, the realistic representation of the people became for him a conscious program. The early romantics had already created a sentiment for folk traditions; but they valued the exotic primitive, whether historically or geographically remote, more than the contemporary primitive of their own region.[50] Toward 1840, there arose a more insurgent taste for the people, as if in preparation for the coming struggles. Michelet, Louis Blanc and Lamartine published their histories of the French Revolution in praise of the heroism and the love of liberty of the French people. A new doctrinaire, evangelical fiction of popular life was created by George Sand, Lamartine and Eugène Sue, and the writings of workers were hopefully welcomed as the foundations of a coming proletarian culture. This literature might be sentimental, melodramatic and vague in its social characterizations; but to keener, independent minds the conflicts of the time, the material requirements of society and the impressive conquests of the scientific method gradually suggested a new standard of exactness in the observation of social life. There was a constant criticism of manners, institutions and ideas, and the awareness of the differences within society and the concept of a social mechanism and climate, enriched for the next half century most writing and insight into the individual. It is in this environment of the late forties that realism and the folk could be united in a common program. Even Flaubert who disavowed romantic taste[51] for the primitive and the "socialist" art of the forties, was nevertheless imbued throughout his life with the interest in the modern, the scientific, the popular and primitive which had occupied the young radicals of 1848.

In the immediate "realist" circle of Courbet, three young writers, Buchon, Dupont and Champfleury, were inspired by the life of the people and by the forms of folk art.

The poet, Max Buchon, was a friend of Courbet since their

school days in Besançon.[52] His first book of romantic verses had been illustrated by the painter in 1839.[53] They were both ardent admirers of their compatriot, Proudhon; and Buchon, for his active part in the Second Republic, was exiled by Louis Napoleon in 1851. He appears in the *Enterrement* and the *Atelier* and was also painted in a life-size portrait by his friend.[54] In Paris he was known at first as the author of *La Soupe au Fromage*, the battle song of the bohemian realists of the late forties, and for his translation of Hebel, a German poet who wrote in Allemanian dialect about peasant and village life. His own works describe the peasants and landscape of his native region, of which he collected the folk-tales and songs. Gautier speaks of him as "a kind of Courbet of poetry, very realistic, but also very true, which is not the same thing."[55] Buchon was not only attached to his native province as a poetic world; he believed that the character of the people was the source of individual creativeness. In a book on realism published during his exile in Switzerland in 1856, he wrote that "the most inexorable protest against the professors and pastiches is popular art."[56] The pre-eminence of Courbet and Proudhon within their different fields was due to their common "puissante carrure franc-comtoise"; and in describing the genius of Courbet, he introduces, perhaps for the first time in the criticism of a contemporary painter, the concept of an instinctive folk-creativeness as the ground of great individual art. Courbet's painting, he says, is calm, strong and healthy, the fruit of a natural and spontaneous productivity ("il produit ses oeuvres tout aussi simplement qu'un pommier produit des pommes"), rooted in his own characteristics and the qualities of his native province. Courbet is ignorant of books and entirely self-taught as a painter, but understands things through sympathy with plain people and through "an enormous power of intuition."

For a time almost as close to Courbet was the poet Pierre Dupont,[57] the author of *Les Boeufs* and of the *Chant des Ouvriers* (1846), which Baudelaire called the "Marseillaise of labor." They were good friends from 1846 and spent vacations in the country together.[58] Dupont was the leading writer of songs for the people, some of them political and militant, others more idyllic, about the

peasants and the country and the various occupations.[59] Like his friend's pictures, Dupont's songs were regarded as rustic and criticized for their naïveté, their clumsiness and realism.[60] The music, which he composed himself, was based on authentic folk melodies. His *L'Incendie: Chant des Pompiers,* is remarkably close in spirit to the great unfinished picture of the firemen by Courbet, interrupted by the coup d'état of December 2, 1851.[61] Other subjects of Courbet appear in the *Muse Populaire* of Dupont: the *métiers,* the hunters, the cattle, the landscapes, the scenes of country life, all pictured with great tenderness.[62] His political songs express in a collective language that radical democratic sentiment which we hear again in more blustering tones when Courbet speaks of himself as a sovereign individual, as a government opposed to the ruling state.[63]

> Où marches-tu, gai compagnon?
> Je m'en vais conquérir la terre;
> J'ai remplacé Napoléon,
> Je suis le prolétaire.[64]

Dupont's art is popular in more than theme and feeling; it is very simple in form, with short, easily sung stanzas, repeated phrases and primitive refrains. It has the freshness of old folk-songs and was appreciated for these qualities by Gautier[65] and Baudelaire.[66] It was in fact the songs of Dupont that suggested to Baudelaire that all poetry is essentially a utopian protest against injustice, a desire for freedom and happiness.[67]

Courbet, too, attempted to compose popular songs. An example has been published by Silvestre in his history of living artists.[68] They are trivial and crude, gay masculine songs of the *brasserie.* Courbet thought himself a musician and wanted to take part in the national competition for popular song in 1848.[69]

The third of Courbet's friends, the novelist and critic Champfleury,[70] was the leader of the young literary realists of 1850 and the author of the first general history of popular imagery.

Champfleury, like Courbet, was a provincial, but of a more cultured family; his father was the secretary of the municipality of Laon, and his brother, Edouard Fleury, was the leading archaeologist and local historian of the *département*. He came to Paris in 1839 at eighteen, only a little before Courbet, but they did not meet until 1848. His first writings belong to the late romantic style of the *école fantaisiste*. They are short stories and sketches about odd types and the corners of Paris life, alternately humorous and grotesque. Champfleury was anxious to succeed in Paris, where he shared the life of Murger's *Bohème* and followed closely the main literary movements of the forties. He felt himself to be an apprentice who had first to learn the trade and to acquire a journalistic *petite manière* which would enable him to earn a living. In his *Souvenirs* he tells how he was torn for a time by two interests, a Monnier-like realism and German romantic, sentimental poetry. In 1849 and 1850, he was caught up in the stream of insurgent realism with its taste for the contemporary and popular, and was able to maintain himself in it because of his first-hand experience of provincial life and his plebeian consciousness among the better educated Parisian writers. He had discovered the Le Nains (artists from his home town of Laon) around 1845, and in 1850 published a brochure in which he described them as painters of reality. The Le Nains were already objects of modern taste in the eighteen-forties; Charles Blanc in 1846 compares the brothers Leleux (Adolphe and Armand) with them:[71] they painted Breton peasant and work scenes and were considered realists. But Champfleury's conversion to realism seems to have been largely influenced by the example of Courbet's imposing art and by his friendship with Dupont and Buchon, who introduced him to folk literature and the artistic possibilities of themes of lower-class life.[72] The choice of such subjects was a central point in the realist doctrine, perhaps as essential as the ideas of the little realists about method and style, and was justified by Champfleury on several grounds.[73] The lower classes were the most important in society and it was in their life that the underlying social mechanism could be revealed. They were, moreover, a new and unlimited

subject, more attractive than the rich and the *élite* by their great sincerity, a virtue which for the realists was almost the whole of art. Finally, their own literature is valuable and suggestive; their songs and legends include masterpieces of realism. Champfleury admired the inherent good taste of the people and imagined that they would be spontaneous allies and appreciate the sincerity and vigor of modern realist works.

As the chief journalistic defender of Courbet in the early fifties, Champfleury was publicly identified as the apostle of realism, and assumed the responsibility of its theoretical defense, although he sometimes disavowed the name as misleading and vague; it was less adequate than the slogan of "sincerity in art" which he opposed to *l'art pour l'art*.[74] His own stories and novels took on a more intimate, realistic air, shedding the elements of fantasy and the grotesque that he had cultivated up to 1848. But he preserved always a humor and sentimentality that his writing had had from the beginning. Beside the large, robust painting of Courbet, his realism was a "little manner," and it is surprising now that they could be regarded in their time as similar expressions. During the eighteen-fifties Champfleury produced a regular stream of stories and novels which established him as a leader of the realistic movement in literature. But by 1860, he was dwarfed by Flaubert, and in the coming decades the works of the de Goncourts and Zola overshadowed his slight and often badly written novels. Historical studies took more and more of his time; he became an expert on old pottery and was appointed an official of the national factory at Sèvres, a post which he held until his death in 1889. During the last twenty-five years of his life, he published many volumes on the history of caricature, popular imagery, folk literature, patriotic faïences, romantic vignettes, Monnier and the Le Nains.[75] These books were based on extensive reading and search for original documents, and though very limited as historical studies, were pioneering works. In most of them his curiosity was directed by the original impulse of 1848 toward realism and popular art, however far he might have moved later from the ideals of that time.

4

What is most important for us in Champfleury's *History of Popular Imagery* is the fact that he attributes an absolute artistic value to the naïve engravings made for the peasants and villagers.

Popular poetry and songs had long before attracted the attention of writers; Montaigne, Molière and Malherbe spoke with enthusiasm of the songs of the common people and preferred certain of them to the most highly civilized works.[76] Their judgments, which were isolated in their time, became general in the eighteen-forties and fifties. Folk songs were intensively collected and studied then.[77] It was recognized that they did not follow the rules of modern European poetry and music; their rhythms were strange, the rhymes vague and imperfect, the combinations inharmonious, yet they were considered admirable—"il en résulte des combinaisons mélodiques d'une étrangeté qui paraît atroce et qui est peut-être magnifique," wrote George Sand.[78] Other forms of popular literature were enthusiastically investigated in the middle of the century. Nisard published in 1854 his pioneer work on the literature of colportage with illustrations of popular prints,[79] and about the same time Magnin brought out a history of marionnettes[80] to confirm the universality and dignity of a taste which was then cultivated by devotees of popular art, especially by George Sand and the young realist, Duranty.[81] Flaubert, who brought his friends, Turgenieff and Feydeau, to the fair at Rouen to see the puppet-play of the Temptation of St. Anthony, borrowed from it some lines for his own version of 1849.[82]

The corresponding taste for contemporary popular images came more slowly. Perhaps the directly representative character of the pictorial sign and the established standards of resemblance stood in the way. They were beginning to be noticed, however, by the writers and artists in the eighteen-thirties. In describing the interior of a farmhouse in Auvergne in the *Peau de Chagrin* (1830–1831), Balzac pointed to the images in "blue, red and green, which represent 'Credit is Dead,' the Passion of Jesus-Christ and the Grenadiers of the Imperial Guard" (the three bulwarks of society—commerce, religion and

the army). He knew also how to reveal the spirit of the countryside in characterizing the signboard of the village tavern in *Les Paysans* (1844-5).[83] Decamps reproduced a rustic religious print in a painting of a Catalan interior in the eighteen-forties.[84] And with a real awareness of the qualities of the primitive style, Töpffer illustrated one of his *Nouveaux Voyages en Zigzag* with a copy of a popular image, *Histoire de Cécile*, that he had seen on this trip.[85]

For these writers and artists, the popular images had only a relative value, or were interesting as parts of the environment that they were describing. Even Baudelaire, with his extraordinary perceptiveness and romantic respect for the primitive imagination, was still attached to norms of painting that limited his judgment of primitive styles. He might observe as Goethe did the infallible harmony of coloring of the tattooed faces of Indians, and recognize in their whole bearing a Homeric elevation.[86] Yet when he wishes to account for the mediocrity of modern sculpture (*Pourquoi la sculpture est ennuyeuse*),[87] he points to the more primitive character of sculpture as an art, as if in ironical reply to the classicist pretension that sculpture is the highest art;[88] it is rather the art *par excellence* of savages, "who carve fetishes very adroitly long before they undertake painting, which is an art of profound reasoning and requires for its enjoyment a special initiation."[89] "Sculpture is much nearer to nature and that is why our peasants who are so delighted by a piece of wood or stone that has been industriously turned, remain blank at the sight of a beautiful picture." In its highest state, among civilized peoples, sculpture is a complementary art, colored and subordinate to architecture; but now having lost this connection, it has become isolated and empty, returning to its primitive condition. Our contemporary sculptors, he says, are "Caraibes," fetishistic artisans.[90]

When he wrote these lines in reviewing the *Salon* of 1846, he apparently thought no better of the qualities of primitive painting. In his little known *Salon Caricatural*[91] of the same year, he resorts to the conventional parodies of archaic forms in ridiculing certain pictures as child-like or savage because of their rigidity or bright colors.

In contrast to those views Champfleury found in primitive and

contemporary folk arts qualities that justified their comparison with the highest civilized art. "The idol," he said, "cut in the trunk of a tree by savages, is nearer to Michelangelo's *Moses* than most of the statues in the annual salons."[92] The loud colors of the popular prints are disdained as barbarous, but they are "less barbarous than the mediocre art of our exhibitions in which a universal cleverness of hand makes two thousand pictures look as if they have come from the same mold." Modern folk art shares the qualities of the first wood-cuts of the fifteenth century. "The naïve execution of the Biblia Pauperum has an equivalent only in certain engravings of the Bibliothèque Bleue of Troyes. The stammering of children is the same in all countries . . . it offers the charm of innocence, and the charm of the modern *ima-giers* comes from the fact that they have remained children . . . they have escaped the progress of the art of the cities."[93]

In Champfleury's comparison of the savage idol with the *Moses* of Michelangelo, there is perhaps an echo of the posthumous work of Rodolphe Töpffer, *Réflexions et menus propos d'un peintre génevois*, which was published in 1848 and again in 1853 and 1865. In his sprightly, amiable style, Töpffer devotes two chapters to the drawings of children: *Où il est question des petits bonshommes*, and *Où l'on voit pourquoi l'apprenti peintre est moins artiste que le gamin pas encore apprenti*.[94] In the latter, he asserts: "il y a moins de dissem-blance entre Michel-Ange gamin griffonneur et Michel-Ange devenu immortel artiste, qu'entre Michel-Ange devenu un immortel artiste et Michel-Ange encore apprenti."[95] The beginnings of art are not to be found in the legendary effort to trace the profile of a lover, but in children's drawings. Art exists already complete in the latter. The same mannikin forms appear in Herculaneum and Geneva, in Tim-buctoo and Quimper-Corentin. But there are "petits bonshommes et petits bonshommes," the merely imitative of nature and the artistic expressions of a thought. Send the *gamin* to an art school and with his greater knowledge of the object, he will have lost the vivacity and the artistic intention he had possessed before; the attributes of the sign will replace the artistic beauty of which it is the sign. Savages, as artists, show the same force as the "gamins de nos rues et nos tam-

bours de regiment." As images of man, the idols of Easter Island with their hideous features and strange proportions resemble nothing in nature and hardly make sense. But considered as signs of a conception, "they are, on the contrary, cruel, hard and superior, brute divinities, but grandiose and beautiful; as signs they have clarity and meaning; they live, speak and proclaim that a creative thought has been infused in them and is manifested through them."[96]

Töpffer could arrive so early in the nineteenth century at this sympathetic judgment of the drawings of children because of his personality and special experience. That art was not imitation, but the expression of "ideas," that the natural forms were only "signs" of the conceptions of the artist, and historically relative to a time and place, all this was a commonplace of the aesthetic theory of his time. But Töpffer, as a gifted artist compelled by a defect of vision to give up in his youth the ambition to be a painter and to restrict himself to drawing; as a Swiss schoolmaster devoted to the boys with whom he had made his pioneer Alpine voyages in zigzag; as an illustrator of his own playful stories; and as an original caricaturist who had reflected on his art and exploited the primitive graffitesque side of caricatural drawing,[97] he was more readily able to see the universality of art as a spontaneous expression of an idea in the child as well as the professional painter. In his enthusiasm for the child, there is perhaps also a connection with the enlightened, advanced traditions of Swiss pedagogy.

Töpffer's book was well known in Paris where he was warmly recommended as a writer by Sainte-Beuve[98] and discussed at length by Théophile Gautier in his *L'art moderne* (1856).[99]

Gautier regretted that Töpffer had attacked the theory of *l'art pour l'art* as a senseless formalism; but he was enchanted by his assertion of the superiority of children's art. He now discovered in Töpffer's own drawings the very qualities Töpffer had found in the children's. Comparing him with Cruikshank, Gautier wrote: "There is in the Genevan less wit and more naïveté: one sees that he has studied very attentively the little *bonshommes* which children chalk on the walls with lines worthy of Etruscan art in their grandeur and

simplicity. . . . He must have been equally inspired by the Byzantines of Epinal. . . . He learned from them the art of rendering his thought in a few decisive strokes without losing any of its strength."[100]

We see here that the primitive is regarded not only as an example of a universal naïveté, but as the source of a conscious naïveté in modern art. Yet only a few years before in 1851 Gautier had dismissed Courbet's *Enterrement à Ornans* as rustic and had compared it with tobacconists' signs.[101] Between 1851 and 1856, taste had apparently changed, and Töpffer's book, with its revelation of the creativeness of children, undoubtedly had much to do with this new opinion. Champfleury's first articles on popular images had also begun to appear since 1850.[102]

How radical were these judgments which extended the concept of the ideal primitive (a generation before the circle of Gauguin and the first scientific writings on children's art) to include the *art* of children, the lower classes and savages, may be gauged from the attitude of Baudelaire. No French writer of the nineteenth century has written with more passion of the child as the prototype of the painter and poet of genius.[103] Yet the art of the child or the savage has no interest for him; it is clumsy, imperfect, the result of a struggle between the idea and the hand. When Guys began to make pictures for the first time, in his maturity, he drew, according to Baudelaire, "like a barbarian, like a child, angry at the clumsiness of his fingers and the recalcitrance of his tool. I have seen a great number of these primitive daubs and I confess that most people who know, or think they know, painting, would not have been able to divine the latent genius which dwelt in these tenebrous sketches. . . . When he comes upon one of these early efforts, he tears it or burns it with a most amusing shame and indignation."[104] Nevertheless, in learning by himself all the tricks of the trade, Guys preserved "from his first ingenuousness what was necessary in order to give an unexpected seasoning to his rich gifts."[105] With a paradoxical rhetoric, Baudelaire describes the genius of this dandy and acute observer of the elegances of Parisian society as child-like and barbarian in its most subtle aspects and presents the child as the pure archetype of the "painter of modern life." The child is no

longer for Baudelaire, as for the romantics and Töpffer, an example of free imagination, but is now regarded as a creature who, in opening his eyes on the world, discovers and remembers the appearances of things with an incomparable intensity of feeling. In Baudelaire's child, the direct vision of unsuspected colorings and shapes is an ecstatic experience. "L'enfant voit tout en *nouveauté*; il est toujours *ivre*."[106] But in this intoxication of the visual, the child automatically preserves an ideal and barbarian clarity. "I wish to speak of an inevitable, synthetic, infantile barbarism, which often remains visible in a perfect art (Mexican, Egyptian or Ninivite) and which is derived from the need to see things in the large and to consider them especially in the effect of their ensemble."[107] Baudelaire thus attributes to the child two moments of vision: the synthetic, and the more realistic, discriminating perception of details; he speaks of the joy of the child—destined to become a celebrated painter—who discovers the variegated, nuanced color of the father's naked body.[108] If he is indifferent to the drawings of the child, Baudelaire has transformed him, however, into a modern sensibility, penetrated and obsessed by the beauty of the external world.[109] His imaginary child, stirred by the shock of sensation, forecasts impressionism and the later theories of art as a purified, intense visibility. It owes something to the realism of the fifties, which in restricting the scope of painting to the immediately apparent, deepened the awareness of the visual.

Courbet himself belongs to the period of transition from the cultured artist of historical painting, who moves with an elaborate baggage of literature, history and philosophy and whose works have to be understood as well as seen, to the artist of the second half of the nineteenth century, who relies on sensibility alone, working directly from nature or from feeling, an eye rather than a mind or an imagination. Beside the great masters of the preceding period, this newer type of artist was for a critic like Baudelaire a mere artisan, ignorant and plebeian. Baudelaire, who belonged to the generation of Courbet and was twice painted by him, was still attached to the aristocratic view and despised realism; he speaks often of the difference between Delacroix as a sovereign, universal mind, the consort of Shakespeare and

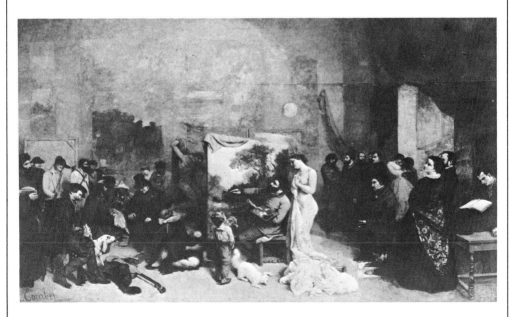

Fig. 3a Courbet: Letter to Bruyas with Sketch of Circus Pavilion.

Fig. 3b Courbet: *L'Atelier*. Louvre, Paris.

Fig. 3c Courbet: Detail from *L'Atelier*. Louvre, Paris.

Goethe, and the rude *manœuvres* whose works now fill the *Salons*. To enjoy Courbet in 1850, one had to accept works with banal subjects, painted without an evident rhetoric of classical or romantic beauty, and revealing a personality whose response to nature and social life, however decided and hearty, seemed uncultured and even boorish beside the aristocratic inventiveness of Ingres and Delacroix.[110] The imaginative aspect of his art was not at once apparent in the meanings and gestures of the objects painted; it had to be discovered in the very fabric of the painting (as Delacroix later recognized); so that Courbet, who vigorously opposed *l'art pour l'art* and spoke of expressing his time, could also become for the young artists of the sixties the modern example of a pure painter.[111] To his positive conception of nature as given completely in sense experience corresponded his conception of the painting as a self-sufficient material object.

In his painting of the *Atelier* (Fig. 3b) where Baudelaire is shown in the right corner, absorbed in a book, Courbet has represented with great tenderness and an admirable naïveté a little child drawing a *bonhomme* on a sheet of paper stretched out on the floor (Fig. 3c). Since he calls this work an *Allégorie Réelle*[112] of the most significant aspects of his life during the past seven years and challenges the spectator to divine the sense of all the parts, we can be sure that the child has a symbolic meaning for Courbet. In the center is the painter himself at work, at the right is the world of art, which he calls the living world,[113] formed by his closest friends, including Baudelaire and Buchon; nearest to him sits Champfleury, and at the feet of his defender is the child drawing its mannikin figure.[114] A second child gazes at the painting of Courbet. On the other side he has placed on the ground a bandit's plumed hat, a dagger and a guitar, the cast-off paraphernalia of romantic art.[115] In painting the child in this manner at the feet of Champfleury, the student of folk art, Courbet affirms, I think, Champfleury's defense of his work as naïve and his conception of naïveté as the ground of all creativeness. Perhaps this circumscribes Courbet's intention too narrowly, but there is undoubtedly here a metaphor of the painter's avowed originality and naïveté.[116]

Champfleury's interest in the art of the child, the peasant and the savage goes back to his first years in Paris, before his meeting with Courbet. In his story, *Chien-Caillou*, written in 1845 about the engraver, Rodolphe Bresdin, he tells how the hero, having run away from his brutal father, fell in with a group of *rapins*. "He was only ten years old; he drew in so naïve a fashion that they hung up all his works in the studio . . . he thought of making engravings, but his engravings resembled his drawings; there was something of the primitive German, the Gothic, the naïf and the religious which made the whole studio laugh . . . he was an artist like Albert Dürer with as much naïveté."[117]

In his own writing, Champfleury tried to attain naïveté also; the letters to his mother describe his assiduous efforts to cultivate this quality. "I have arrived at naïveté, which is everything in the arts," he tells her in 1849.[118] He read Diderot especially as a model of unaffected directness in prose.[119] He admired the simple strength of popular songs and found in them a great truth to life. The simplest, the most naïve art was also the most veracious; in judging a song the peasant does not say it is beautiful, but it is true.[120] Hence Champfleury could believe that realism and naïveté, far from being antagonistic, are complementary and united in the single concept of sincerity.[121]

Yet in his taste for popular prints and songs, Champfleury seems to contradict his notion that realism is the indispensable art of *modernity*. In his book on popular images (1869), he recommends in the concluding chapters on the art of the future two opposed things: the preservation of popular imagery as a conservative didactic instrument, conciliation being the "supreme goal" of art, and the further development of realism by vast murals of modern industry in the railroad stations and public buildings.[122] On the one hand, realism is the lyric of modern progress; on the other hand, the primitive art and the sentiments of the peasantry are the bearers of an eternal wisdom. Thus the movement, attacked for its positivism and materialism, also promoted the taste for primitive arts which were to serve later as an example in the repudiation of realism and the idea of progress.

It is true that some critics looked on realism in its positivist aspect as the product of a peasant mentality, the peasant being described as sceptical and narrowly focused on the here and now. "The exclusive love of exactness is the root of the character of peasants, usurers and liberal bourgeois,—realists in the full sense of the word, who always make an exact count."[123] But the art of the peasant is hardly realistic in this sense, and the notion that realism springs from a peasant mind disregards its precise content and the complexity of its forms. The peasant or lower middle class origins of the realist painters and authors may have determined the direction of their art, but they determined it only in Paris, where these writers and artists encountered a higher culture and consciousness of social life. The detailed and exact description of contemporary manners which was for Champfleury one of the criteria of sincerity in modern prose is inconceivable in the literature of the folk. The interest of Courbet and Champfleury in folk art never entailed for them the imitation of its simpler, shadowless styles. The seemingly regressive tendencies in the looser and more static compositions of Courbet are bound up with unprimitive conceptions of a new coloristic, tonal and material unity of the painting and prepare the way for Impressionism. Champfleury had a presentiment of this when he compared the freer groupings of Courbet, his "horror of composition," with the work of Velasquez. And he expressed the same idea in arguing that the novel, relatively formless but realistic and open to an unlimited range of experience, was the truly modern art, as against the artificially contrived verse and the narrow scope of the romantics.

The seeming contradiction in Champfleury's twin program of folk art and murals of industry arises, I think, from the unstable, problematic character of the social movements which promoted realism and which terminated in the dictatorship of the Second Empire.

In the beginning, the realism of Champfleury's circle was the art that discovered the life of the lower classes; it derived from their growing consciousness and importance a great self-confidence as a progressive and necessary art. Since these classes threatened the existing order, the sympathetic preoccupation with them in art was a radical interest. And at a time when critical observation of social life was a

revolutionary force, the ideals of directness and realism in painting or literature were politically suspect. The mere presentation of the lower classes on the monumental scale of former images of history was an aggressive act, a displacement of the ruling class by its chief enemies.[124] In 1850, the difference in scale alone already distinguished Courbet from the contemporary painters of peasant genre. Like the great size of his signature,[125] the size and energy of his paintings were an irritating provocation to his conservative critics.

But this initial radical aspect of the realist movement was very short-lived. In his judgments of folk art in 1850 and even during 1848, Champfleury was already affected by the political reaction and the desire for peace. Within a few years the people, that vague undifferentiated mass on which the radical leaders of the forties had placed their hopes for the emancipation of society, had changed its face and color. The events of 1848 to 1851 had made clear the sharp differences of interest among them, the stratification of peasants and small proprietors, of factory workers and artisans, the first group attached to its soil, conservative, often religious; the others, without possessions, brought together in work and more apt to independent resistance and struggle. If the immediate likelihood of socialism was shattered by the events of these four years, for the first time the working class appeared as a revolutionary force, concerned with its own interests. The defeat of the Paris workers in June 1848, the establishment of the dictatorship of Louis Napoleon in 1851, rested in part on the support given to the upper classes by the mass of the peasantry, frightened by the spectres of revolution.[126] Champfleury, whose art moved between two regions, the Paris bohème and the petit-bourgeois life of his native province, had never been secure in his political views and vacillated constantly with the broad movement of events. Before 1848 he had written attacks on the Fourierists and socialists, criticizing all partisan or tendentious art.[127] In February 1848 he was editor with Baudelaire of the *Salut Public*, a republican newspaper of only two issues, with confused radical and religious slogans.[128] At this time he was an admirer of Proudhon.[129] But in June of the same year he became co-editor of *Le Bonhomme Richard, Journal de Franklin*,

with Wallon, who supported a new Holy Alliance of Germany, Russia and France.[130] A few months later, in August, he was among the collaborators of *L'Evénement*, the moderate journal of Victor Hugo.[131] He wrote then to his mother about the literary advantages of this association and his indifference to politics.[132] In February 1849, although detached from politics, he declared himself anti-bourgeois and "red, rather than reactionary";[133] the bourgeoisie, he said, is still master under the Republic, but cannot last. He was invited in December 1849 to contribute to Proudhon's socialist journal, *La Voix du Peuple*, and published there his story, *Les Oies de Noël*.[134] He still felt himself to be completely unpolitical, but he wrote at this time: "Nous autres travaillons pour le peuple, et nous nous dévouons à cette grande cause."[135] The coup-d'état of December 1851, however, endangered him because of the censorship and his connection with the formerly republican journals.[136] To protect himself he turned for a while from literature to historical research on folk art and poetry.[137]

But instead of abandoning the ideas about art which he had formed under the impact of 1848, he changed their content and tone. He was still attached to reality and the "people," but the latter were now regarded as the unchanging element in the nation and their own art as a profound lesson in resignation to life and the conciliation of opposed interests.[138] The eternal tasks of the peasant were recommended as a happy alternative to the inconstancies and revolutions of urban society. Already in 1848, while with Wallon, he had planned a series of articles on "all the poets who have sung the family";[139] and it was in the same year that he conceived the work on popular imagery and legends in order to calm the people in a period of insurrection and to teach them, as he said, the lesson of reconciliation by recalling their own traditional acceptance of destiny.[140] In this reaction to the violence of the barricades, he is a little like his friend Monnier's *Joseph Prudhomme* who retires in 1848 to his country estate and addresses the gardeners: "Bons villageois! hommes primitifs qui avez gardé, malgré les révolutions, le respect des supériorités sociales, c'est parmi vous que je veux couler mes jours."[141]

The disillusionment of Baudelaire, who had passed through the same experience of the Republic, took the form not only of a complete renunciation of politics, but a total disgust with society,[142] from the bourgeoisie to the people, and a violent critique of the idea of progress. The material advance of society, he argued, adds nothing to its intellectual or spiritual resources; on the contrary, the present industrial age is also a period of cultural decay.[143] Champfleury's criticism was less bitter and drastic, for he felt less victimized than Baudelaire and could achieve his limited ambitions in the cosiness of his library. Whatever the implications of his doctrine, with its lower-class themes and direct, impersonal style, his own realistic writing from the beginning had been concerned mainly with the amusing or sentimental banalities of provincial life; the vast, disturbing spectacle of modern society and the struggles and process of social or self-discovery of sensitive individuals lay outside his art. In his books on popular art, he identified himself with the tranquil resigned villager, with his traditional wisdom, his sincerity and good humor, his unromantic fantasy, formed of emblems and ancient symbolic personages, like the *Bonhomme Misère* and the Wandering Jew, vehicles of timeless, simple truths. He finds in the conclusion of the *Bonhomme Misère*—"Misery will exist as long as the world exists"—and in this peasant's contentment with his little cabin a profound lesson for all humanity.[144] And he concludes his study of popular images with an account of Rethel's *Triumph of Death* of 1849 which teaches the people the futility of revolt.[145] The study of history, which in the beginning of the nineteenth century in France, was inspired by the great social struggles and the experience of change as a law of the present, the present being regarded as a crucial historical moment, was converted by Champfleury into a study of the persistence of the lower levels of culture, of the timeless arts and ideas of the people.[146] In this conversion he resembles his contemporary, Heinrich Riehl, the German historian of popular culture who undertook in the fifties a related investigation, literary and social, of the common people, especially the peasantry.[147] He, too, came to these studies as a result of the uprisings of 1848; but whereas Champfleury had been for a while

republican and never lost a certain conventional respect for the ideal of freedom, Riehl discovered in the events of 1848 a confirmation of his inborn conservatism and undertook the task of teaching the German nation that its true strength lay in its conservative peasant masses.

In proposing two arts, a traditional, popular art and a more realistic urban art, one conservative and didactic, the other reproducing the spectacle of modern progress, Champfleury satisfied perfectly and in the language of an official adviser the requirements of the regime of the third Napoleon by whom he had just been decorated.[148] This regime rested on the support of the peasants and on the extraordinary economic expansion and prosperity of France between 1850 and 1870. The latter assured the final triumph of realism, not in its plebeian or insurgent aspect, but as a personal aesthetic tendency toward the representation of the privately experienced and matter-of-fact world which culminated in Impressionism; the former determined the taste for the arts of the static peasantry and primitive cultures which in the crises and social pessimism at the end of the century could replace realism as models of a personal style.

The change in Champfleury affected his relations with Courbet. As the writer became more conservative, the painter grew more radical, although his art in the sixties had less political significance than in the early fifties, when the memory of the Republic and its suppression was still green. But it should be observed that in their first relationships, Courbet was also unstable politically like Champfleury. They probably had already met in February 1848 when Courbet drew the headpiece, a barricade scene, for the newspaper of Champfleury and Baudelaire.[149] In his later writings, though he often mentions the painter, Champfleury never speaks of the *Salut Public* or this work of Courbet and indicates as their first contact his "discovery" of Courbet at the *Salon* of the spring of 1848.[150] In a review of that exhibition, he had singled out for its promise a painting of a Walpurgis Night (inspired by Goethe) over which Courbet subsequently painted his *Wrestlers*.[151] At that time they were both romantics, and Courbet's

barricade drawing was no more the issue of a strong political convic-
tion than Champfleury's editorship of the *Salut Public*. The painter
wrote home that same spring and during the June fighting that he was
opposed to the uprising, and that he preferred the method of
intelligence.[152] By 1851, Courbet seems to have become firmly
republican.[153] When, in 1850–1851, he showed his new and more
powerful pictures, the *Stone-Crushers*, the *Return from the Fair* and
the *Burial at Ornans*, it was Champfleury who defended him in print
and justified his new realism on artistic and social grounds. For several
years their names were linked as the chief protagonists of realism, in
spite of the great difference in the quality of their work; and there is
little doubt that the possibility of defending Courbet helped to shape
Champfleury's career as a writer. Courbet corresponded with him for a
few years, painted his portrait and included him in a prominent place
in the *Atelier*. Champfleury in turn wrote a novel, *Les Demoiselles
Tourangeau*, about the family of Courbet, the fruit of a vacation in
the Juras in 1856.[154] But by that time, they had begun to diverge and
their relations were becoming strained. Champfleury, who was now
accepted by the conservative *Revue des Deux Mondes*,[155] was
embarrassed and exasperated by the personality of Courbet, his enor-
mous, naïve vanity, his political associations and belligerence, which
the public confused with realism as an aesthetic doctrine. In writing
about Courbet in 1855, Champfleury could still quote Proudhon
approvingly three times in the same article.[156] However, at the open-
ing of Courbet's private Pavilion of Realism, he found the company
of Proudhon at the exhibition boring and ridiculous.[157] He was also
displeased with the *Atelier* because of the way in which he was repre-
sented, although in writing about the picture he criticized it on moral
grounds.[158] He himself had annoyed Courbet by caricaturing the per-
sonality of his patron, Bruyas, in a novel.[159] By 1860, Champfleury
was completely hostile to Courbet's work, but continued to publish
articles about his old friend.[160] This champion of "sincerity in art"
found the *Girls by the Seine* "frightful, frightful,"[161] and wrote to
their common friend, Buchon, that Courbet was finished as an
artist;[162] he grudged him any talent beyond a mechanical compe-

tence in painting. In 1867 Champfleury accepted from the emperor, who had exiled Buchon and was despised by the writers and artists of his old group, the ribbon of the Legion of Honor; in 1870 the same award was rejected by Courbet with resounding publicity. Within a year, the painter was to take part in the Commune and to suffer for the destruction of the Vendôme column, which was maliciously attributed to him. Champfleury remained silent and did nothing for his former friend. And when, after the death of Courbet, a publication of his letters was planned, Champfleury refused to cooperate and perhaps destroyed some which might in the future throw an unpleasant light on his relations with Courbet.[163]

Yet if Champfleury and Courbet moved farther apart politically, as artists they followed a similar path from an originally aggressive conception of realism, with something of the social preoccupations of the second Republic, toward a more personal, aestheticized view.[164] Courbet may pretend in the sixties that he is going to paint "socialist" pictures,[165] but this is a vague wish without substance or possibility of fulfillment. His marines of this period represent his true artistic impulse; and Champfleury, now remote from realism as a movement, could approve of them as the fruits of solitude and introspection and the vision "of something immaterial beyond Reality which detaches itself from the human heart and gives birth to élans that observation alone is incapable of rendering."[166] But this former realist enemy of didacticism in art[167] now recommended to the state as the most reliable instrument of social harmony the folk images with their old conservative teachings.

There is already in Courbet's great *Enterrement* a trace of the double attitude of Champfleury to the events of 1848 and 1849. During a period of revolutionary violence and momentous political change, Courbet assembles the community about the grave. He was to say that "the only possible history is contemporary history,"[168] but here the history of man is like natural history and assumes a timeless and anonymous character, except in the costumes which show the historical succession of generations. The funeral custom replaces the occasion, the cause and effect of an individual death. The community

at the grave absorbs the individual. The anti-romantic conception implies too the tranquil, resigned spirit of reconciliation, that Champfleury considered the "supreme goal of art," and found only incompletely realized in Rethel's *Dance of Death*, a work that names Death as the only victor of the barricades. Thus the consciousness of the community, awakened by the revolution of 1848, appears for the first time in a monumental painting, in all its richness of allusion, already retrospective and inert.

NOTES

[1] They have been collected by Charles Léger, *Courbet selon les caricatures et les images*, Paris 1920. See especially pp. 13, 15, 19, 20, 34, 74, 79, 85. Two are also reproduced by John Grand-Carteret, *Les Moeurs et la Caricature en France*, Paris, n.d., pp. 550, 551.

[2] Léger, *op. cit.*, p. 20, from the *Journal pour Rire*.

[3] The opinions are collected by Riat, *Gustave Courbet*, Paris 1906, pp. 86, 87; Léger, *op. cit.*, pp. 34, 37; Estignard, *Gustave Courbet*, 1897, pp. 27–30. The critic of the *Revue des Deux Mondes*, Louis Geoffroy, wrote on March 1, 1851: "Evidemment M. Courbet est un homme qui se figure avoir tenté une grande rénovation, et ne s'aperçoit point qu'il ramène l'art tout simplement à son point de départ, à la grossière industrie des maîtres imagiers." On the criticism of realism in the *Revue des Deux Mondes*, see the dissertation of Thaddeus E. Du Val, Jr., *The Subject of Realism in the Revue des Deux Mondes* (1831–1865), Philadelphia 1936; and for criticism of realism in general in this period, the dissertation of Bernard Weinberg, *French Realism: The Critical Reaction, 1830–1870*, The University of Chicago Libraries, Modern Language Association of America, 1937.

[4] Léger, *op. cit.*, p. 34. "Peinture d'Auvergnat" is the phrase of Victor Fournel, who some years later wrote sympathetically on popular spectacles and on the street songs and singers of Paris: *Ce qu'on voit dans les rues de Paris*, Paris 1858; *Les spectacles populaires et les artistes des rues*, Paris 1863. Cf. also de Banville's poem (1852):
"... Je suis un réaliste,
Et contre l'idéal j'ai dressé ma baliste.
J'ai créé l'art bonhomme, enfantin et naïf."
Cited by P. Martino, *Le roman réaliste sous le Second Empire*, Paris, 1913, p. 76.

[5] Especially Ingres; see L. Rosenthal, *La peinture romantique*, Paris 1900, p. 82.

[6] This is recorded by Philibert Audebrand, *Derniers Jours de la Bohème*, Paris, n.d., p. 110, but more than fifty years after the occasion.

[7] In the essay "On the French School of Painting," 1840. In the same work, he criticizes the primitivism of the new Catholic school in France for its archaic forms and compares them with English playing cards.

[8] Théophile Silvestre, *Histoire des Artistes Vivants, Etudes d'après nature*, Paris

1856, p. 269: "Le geste lui manque, ses scènes sont inerts" (on Courbet), and "Ingres est mort. Cette immobilité fait la honte de l'art."

⁹ This was recognized by Baudelaire when he remarked in his study of Guys: "Many people have accused of barbarism all painters whose vision is synthetic and simplifying, for example Corot, who begins by tracing first of all the main lines of a landscape, its framework and physiognomy." *Le peintre de la Vie Moderne*, in Baudelaire, *Oeuvres*, Paris, N.R.F., 1938, II, p. 338 (all citations from Baudelaire will be from this edition).

¹⁰ Léger, *op. cit.*, p. 20. The painting is shown on a circus booth behind the strong man and the flutist. The legend reads: "Qui est-ce qui demandait donc à quoi pouvait servir la peinture de M. Courbet?" In his Journal, on April 15, 1853, Delacroix criticizes the *Wrestlers* as "lacking in action." It is interesting that it was painted over a romantic picture of a Walpurgis Night that Courbet had exhibited in the *Salon* of 1848.

¹¹ From an article in *Messager de l'Assemblé*, 1851, reprinted in Champfleury's *Grandes Figures d'hier et d'aujourd'hui*, Paris 1861, p. 244. At the same time "naïveté" was also discovered in David. See Delécluze, *David, son école et son temps*, Paris, 1855, p. 176, who speaks of the *Tennis Court Oath*, the *Lepelletier*, the *Marat* and the *Dead Barra*, as a return to naïveté. See also for the same view, Jules Renouvier, *Histoire de l'art pendant la Révolution*, Paris, 1863, p. 77.

¹² For an example of a contemporary print of the rue Gît-le-Coeur, see Duchartre and Saulnier, *L'imagerie populaire*, Paris 1925, p. 108—"*L'horrible assassinat . . . par un mari jaloux*" (Pl. 38b).

¹³ See p. 64 and note 9 above.

¹⁴ See his Journal, April 15, 1853, and August 3, 1855.

¹⁵ "Ils n'ont pas le charme voilé des oeuvres poëtiques de Corot; mais ils ont la qualité suprême de l'horreur de la composition," Champfleury, *Souvenirs et Portraits de Jeunesse*, Paris 1872, p. 173, quoted from his review of Courbet's work at the *Salon* of 1849. Champfleury attributes the same quality to the Le Nains in his monograph of 1862.

¹⁶ See Th. Duret, *Courbet*, Paris 1918, Pl. XXXII.

¹⁷ The same idea in Victor Fournel, *Ce qu'on voit dans les rues de Paris*, Paris 1858, pp. 384 ff., and especially p. 390 on the petit-bourgeois fear of shadows as spots on the face (*La portraituromanie, considérations sur le Daguerréotype*).

¹⁸ In charcoal on bluish paper. It is reproduced and described by Léger, *Gustave Courbet*, Paris 1929, p. 47, and Riat, *op. cit.*, p. 79.

¹⁹ I reproduce it after the example in the Bibliothèque Ste.-Geneviève in Paris. It is described by Duchartre and Saulnier, *op. cit.*, p. 141, who say it is a unique example of a very special genre. On the importance of Montbéliard in the production of images in the early nineteenth century, see the same book, pp. 138 ff.

²⁰ On this theme, *ibid.*, p. 11, 70, 103; it was introduced in wood-cuts between 1800 and 1814. For the older tradition, see R. van Marle, *L'iconographie de l'art profane*, II, *Allégories et Symboles*, 1932, pp. 156 ff., and A. Englert, *Zeitschrift des Vereins für Volkskunde*, XV, XVII.

²¹ My illustration is taken from an article by Dr. Hoppen, "The Decades of Human Life," in *Clinical Excerpts*, New York, X, 1936, no. 7, p. 5.

²² It was printed by Vion, 27 Rue St. Jacques, Paris. The Rue St. Jacques had been since the seventeenth century one of the chief centers of production of popular imagery in France; the copper engravings of the Rue St. Jacques were the source of

many of the popular wood-cuts, and a special class of "imagerie de la rue St. Jacques" is distinguished by Ducharte and Saulnier (*op. cit.*, pp. 29, 33, 87 ff.). In the second third of the nineteenth century, it was the center of a "semi-popular" lithographic imagery.

23 On this combination of image and "complainte," see Duchartre and Saulnier, *op. cit.*, p. 58, and illustrations, *passim*.

24 *Les Excentriques*, Paris 1856.

25 The lithograph was made after a painting by Courbet which belonged to Jean-Paul Mazaroz, a compatriot from Lons-le-Saulnier in the Juras. It is interesting that Mazaroz, a collector and friend of Courbet, known especially for his *meubles d'art* and his radical ideas, was the son of a bookbinder who made popular images at Lons-le-Saulnier, early in the nineteenth century. On the father, see Duchartre and Saulnier, *op. cit.*, pp. 142, 143.

26 *La Mort de Jeannot—Les frais du culte, avec quatre dessins de Gustave Courbet, Exposition de Gand de 1868*, Bruxelles 1868.

27 *Les Curés en Goguette avec six dessins de Gustave Courbet. Exposition de Gand de 1868*. Bruxelles 1868. The *Return from the Conference* is reproduced as the frontispiece.

28 Etienne Baudry, *Le Camp des Bourgeois*, Paris 1868. For a description of the book and the history of Courbet's collaboration, see Théodore Duret, *Gustave Courbet*, Paris 1918, pp. 140, 141.

29 *Les chansons populaires des provinces de France*, notice par Champfleury, accompagnées de piano par J.-B. Wekerlin, Paris 1860. Courbet also illustrated Alfred Delvaus, *Histoires anecdotiques des cafés et cabarets de Paris*, Paris 1862. The three last books were all published by Dentu, who brought out in the eighteen-sixties a large series of works on popular themes, including Champfleury's histories of caricature and popular imagery. The illustrations of Courbet have been catalogued by Duret, *op. cit.*, pp. 138–141.

30 For an example see Duchartre and Saulnier, *op. cit.*, p. 68, a print from the region of Lille. The *Semeur* is almost identical with Millet's conception.

31 By Bonhommé in the *Salons* of 1838, 1840. Chassériau had already represented the Le Creusot mill in 1836. See L. Rosenthal, *Du romantisme au réalisme*, Paris 1914, p. 389, and Bénédite, *Chassériau*, 1931, p. 41.

32 Cf. for example *Le Rémouleur* by Decamps in the Louvre. In the forties, during the beginnings of realism in painting, work subjects are very common. The Leleux brothers especially represent the road workers and woodcutters (Rosenthal, *op. cit.*, pp. 383, 384). Perhaps significant for the tendentiousness of such realist choice of themes is the frequency of the poacher (*Le Braconnier*) and the smuggler (*Le Contrebandier*) in the painting of the forties; the poacher is an anti-authoritarian figure. Cf. the anecdote told by Jules Janin in *L'Eté à Paris*, 1843, p. 29: a poacher stopped by a guard in the royal forests replies, "Le roi, c'est le peuple; or, je suis du peuple, donc je suis le roi."

33 The leading theoretician of the "droit au travail," Victor Considérant, author of the *Théorie du droit au travail et théorie du droit de propriété*, 1839, was a compatriot of Courbet, having been born in Salins.

34 Emile de la Bédollière, *Les industriels métiers et professions en France*, avec cent dessins par Henri Monnier, Paris, 1842.

35 The *Rémouleur* on p. 206 recalls the paintings of Decamps and Courbet.

36 "Cet ouvrage a pour objet de peindre les moeurs populaires, de mettre la classe aisée en rapport avec la classe pauvre, d'initier le public à l'existence d'artisans trop méprisés et trop inconnus."

[37] The destroyed original is reproduced by C. Lemonnier, *Courbet et son oeuvre,* Paris 1878, and by Léger, *Gustave Courbet,* Paris 1929, p. 97.

[38] Cf. P. Sébillot, *Le Folk-lore de France,* IV, 1907, p. 231—"The 'good curé' seems unknown in French paremiology. Both in the general collections of proverbs and in those of which the materials come from the regions most renowned for their religiosity, I have searched in vain for proverbs praising the churchmen, whereas those which criticize them are found by the dozens. A special questionnaire confirms this conclusion; none of my correspondents could remember a single proverb which wasn't satirical. Although the same holds for the nobility (which was never popular), it is less surprising than in the case of the secular clergy; the country priests who are loved by their parishioners and who merit it, are not rare."

[39] On Chenavard, see T. Gautier, *L'art moderne,* Paris 1856, and Silvestre, *op. cit.,* pp. 105–145.

[40] P. J. Proudhon, *Du principe de l'art et de sa destination sociale,* Paris 1875, chaps. XVII, XVIII, and p. 280.

[41] Cf. the letter to Bruyas, 1854, reporting his conversation with the Director of Fine Arts, to whom he said that "moi seul, de tous les artistes français mes contemporains, avais la puissance de rendre et ma personnalité et ma Société—P. Borel, *Le roman de Gustave Courbet d'après une correspondance originale du grand peintre.* Paris 1922, pp. 68, 69.

[42] Léger, *Courbet,* 1929, p. 57; the legend reads "grands admirateurs des tableaux de M. Courbet."

[43] Champfleury, *Souvenirs,* Paris 1872, p. 174.

[44] *Ibid.,* pp. 174, 175; Riat, *op. cit.,* p. 76.

[45] Léger, "Documents inédits sur Gustave Courbet," *L'Amour de l'art* XII, 1931, p. 385 ff.

[46] He describes it in letters to Bruyas (Borel, *op. cit.,* pp. 56, 57) and Champfleury (catalogue of the exhibition, *L'Atelier du Peintre,* Galerie Barbazanges, Paris, n.d. 1919).

[47] Champfleury, *Souvenirs,* pp. 185 ff., and Audebrand, *Derniers Jours de la Bohème,* pp. 77–212: La Brasserie de la Rue des Martyrs.

[48] Léger, *Courbet selon les caricatures,* p. 37; see also Léger, *Courbet,* 1929, p. 27.

[49] Borel, *op. cit.,* Pl. p. 96.

[50] On the primitivism of the romantics, see N. H. Clement, *Romanticism in France,* New York 1939, chap. X, pp. 462–479.

[51] Cf. the early version of *L'Education Sentimentale,* c. 1843–1845, where he says of his hero, Jules (apparently the young Flaubert): "En somme, il fit bon marché de tous les fragments de chants populaires, traductions de poèmes étrangers, hymnes de barbares, odes de cannibales, chansonnettes d'Esquimaux, et autres fatras inédits dont on nous assomme depuis vingt ans. Petit à petit même, il se défit de ces prédilections niaises que nous avons malgré nous pour des oeuvres médiocres, goûts dépravés qui nous viennent de bonne heure et dont l'esthétique n'a pas encore découvert la cause."

[52] On Buchon (1818–1869) and his writings, see Emile Fourquet, *Les Hommes célèbres de Franche-Comté,* 1929; on his part in the realist movement, see the excellent work of Emile Bouvier, *La Bataille Réaliste* (1844–1857), Paris 1913, p. 183 ff.

[53] The lithographs are reproduced by Léger, *Courbet,* 1929, p. 25.

[54] *Ibid.,* p. 18 (in the museum of Vevey); there is a second portrait in the museum of Salins.

55 Gautier, *Histoire du Romantisme, Les progrès de la poésie française depuis 1830*, Paris 1872.

56 Max Buchon, *Recueil de dissertations sur le réalisme*, Neuchâtel, 1856; it is quoted by Léger, *Courbet*, 1929, pp. 65–67.

57 On Dupont (1821–1870), see Bouvier, *op. cit.*, p. 165 ff. A poet of very similar interests and also close to both Dupont and Courbet was Gustave Mathieu (Bouvier, p. 173 ff.); for his portrait by Courbet, see Léger, *op. cit.*, p. 144.

58 His portrait by Courbet is in the museum of Karlsruhe, Léger, *op. cit.*, Pl. 51.

59 His collected poems are published in *Muse Populaire, Chants et Poésies*, of which I have used the sixth edition, Paris 1861.

60 Bouvier, *op. cit.*, p. 171.

61 See his *Muse Populaire*, pp. 286 ff.

> En ces calamités publiques,
> Toujours les premiers à courir,
> Nos pompiers, soldats pacifiques,
> Savent aussi vaincre et mourir.

and the refrain:

> Au feu! au feu!
> L'incendie éclate,
> La flamme écarlate
> Rougit le ciel bleu.
> Au feu!

For a reproduction of Courbet's painting in the Petit Palais, see Charles Léger, *Gustave Courbet* (Collection des Maîtres), Paris 1934, fig. 24.

62 Interesting also for Courbet, are the *Chant de la Mer, Muse Populaire*, p. 45, and *Le Cuirassier de Waterloo* (*ibid.*, p. 226, on the painting by Géricault—"Géricault, ta mâle peinture . . .").

63 Cf. Courbet's statement to the Minister of Fine Arts in 1854, recorded in his letter to Bruyas: "Je repondis immédiatement que je ne comprendis absolument rien à tout ce qu'il venait de me dire, d'abord parce qu'il m'affirmait qu'il était un gouvernement et que je ne me sentais nullement compris dans ce gouvernement, que moi aussi j'étais un Gouvernement et que je défiais le sien de faire quoi que ce soit pour le mien que je puisse accepter." (Borel, *op. cit.*, pp. 67, 68.)

64 It is the refrain of *Les Deux Compagnons du Devoir, Muse Populaire*, p. 233 ff.

65 In his *Histoire du Romantisme*.

66 See his preface to Dupont's *Chants et Chansons*, 1851, reprinted in his *L'Art romantique, Oeuvres*, II, pp. 403–413, and a second essay in 1861, *ibid.*, pp. 551–557.

67 *Oeuvres*, II, p. 412.

68 *Op. cit.*, pp. 248, 249.

69 Riat, *op. cit.*, p. 53 (letter of April 17, 1848).

70 The nom de plume of Jules Fleury (1821–1889). On his life, writings and part in the realist movement, see Bouvier, *op. cit.*; P. Martino, *Le roman réaliste sous le Second Empire*, Paris 1913; J. Troubat, *Une amitié à la d'Arthez, Champfleury, Courbet, Max Buchon*, Paris 1900 (not available to me); the same writer's edition of the letters of Champfleury, *Sainte-Beuve et Champfleury*, Paris 1908.

71 Cited by L. Rosenthal, *Du Romantisme au Réalisme*, Paris 1914, pp. 383–386.

72 In his *Souvenirs*, 1872, p. 185, Champfleury attributes the beginning of the movement of realism to Courbet in 1848. His dependence on Courbet, Dupont and Buchon is made clear by Bouvier, pp. 165–256, especially pp. 244, 245 on Courbet. He

already knew Buchon and Dupont by 1847, before he met Courbet; he began his studies of folk literature and art around 1848 or 1849 (see his *Histoire de l'imagerie populaire*, Paris 1869, 2nd ed., pp. xliv, xlv), and published an article on the legend of the *Bonhomme Misère* in 1850 (Bouvier, p. 180). His novel, *Les Bourgeois de Molinchart*, 1855, was dedicated to Buchon. Courbet also helped Champfleury in his studies of folk art. In a letter to Champfleury about his work at Ornans in 1849 or early in 1850, Courbet speaks of collecting "des chansons de paysans" for Champfleury: "je vous porterai les Bons Sabots de Besançon," he adds. See *L'Amour de l'Art* XII, 1931, p. 389.

[73] They are stated in the prefaces to his novel and collection of short stories (*Contes Domestiques, Les Aventures de Mariette*) and in *Le Réalisme*, 1857, and have been brought together by Bouvier, pp. 311, 312.

[74] See the articles collected in *Le Réalisme*, 1857, and especially p. 3 ff.

[75] The chief works are: *Histoire de la caricature*, in 5 volumes (1865–1880); *Histoire de l'imagerie Populaire*, 1869; *Les chansons populaires des provinces de France*, 1860; *Histoire des faïences patriotiques*, 1867; *Les vignettes romantiques*, 1883; *Les Frères Le Nain*, 1862; *Henry Monnier, Sa Vie, Son Oeuvre*, 1879; *Les Chats*, 1869; *Bibliographie céramique*, 1881.

[76] The history of the taste for popular poetry and songs is sketched by Champfleury, *De la poésie populaire en France*, extr. n.d. (c. 1857), pp. 137–182. For a more recent and fuller account, see N. H. Clement, *Romanticism in France*, New York, 1939.

[77] See the bibliography of recent publications from 1844 to 1857 in Champfleury's article, p. 137.

[78] In a letter to Champfleury quoted in the same article, p. 157; other mid-nineteenth century opinions with the same content are quoted on pp. 156–159. In an article of 1853, reprinted in *Le Réalisme*, 1857, pp. 186, 187, Champfleury also speaks of French folk music in relation to exotic (Chinese and American Indian) music. He remarks on the peculiar coincidence of the originality of folk music with the most recent refinements of civilized taste: "Depuis deux ou trois ans des esprits distingués cherchent à introduire le *quart de ton* dans la musique moderne. La musique populaire est une mine d'intervalles harmoniques imprévus, sauvages ou raffinés, comme on voudra." And also on the melodies of popular songs which are "toutes en dehors des lois musicales connues; elles échappent à la notation, car elles n'ont pas de mesure; une tonalité extravagante en apparence, raisonnable cependant, puisqu'elle est d'accord avec une poésie en dehors de toutes les règles de prosodie, ferait gémir les didactiques professeurs d'harmonie."

[79] *Histoire des livres populaires, ou de la littérature du colportage depuis le XVe siècle jusqu'à l'établissement de la Commission d'examen des livres du colportage* (30 nov. 1852), Paris 1854. Also important for the interest in popular arts is Charles Nisard's *Des Chansons populaires chez les anciens et chez les Français; essai historique suivi d'une étude sur la chanson des rues contemporaine*, Paris 1867, 2 volumes. Volume 2 had already been published in great part as *La Muse pariétaire et la Muse foraine*, Paris 1863. Nisard also published a book on the language of Paris: *Etude sur la langue populaire ou patois de Paris*, 1872.

[80] Charles Magnin, *Histoire des Marionnettes en Europe*, 2nd ed. 1862.

[81] Edmund Duranty, *Théâtre des Marionnettes du jardin des Tuileries, Textes et compositions des dessins par M. Duranty*, Paris n.d. (1863). It is illustrated by two kinds of colored lithographs, one in the style of the early sixties, with rococo qualities, the other reproducing the naïve style of the marionnettes and their settings in illustra-

tions of the marionnette shows. On the judgment of children's dolls and toys, see Baudelaire's essay, *Morale du Joujou* (1853), in *Oeuvres*, II, pp. 136–142.

[82] See the introduction to his *Oeuvres*, ed. A. Thibaudet and R. Dumesnil, Paris, N.R.F., 1936, I, pp. 42–45, and Edouard Maynial, *La Jeunesse de Flaubert*, p. 137 ff.

[83] *Oeuvres*, N.R.F., Paris, 1937, p. 45.

[84] *The Card Players*, in the Louvre.

[85] *Nouveaux Voyages en Zigzag*, Paris 1854, p. 38 (written before 1846).

[86] *Salon de* 1846, *Oeuvres*, II, p. 90, and *Salon de* 1859, *ibid.*, II, p. 255.

[87] *Salon de* 1846, *ibid.*, II, p. 127; the same ideas in *Saion de* 1859, *ibid.*, II, p. 275.

[88] In the same *Salon*, speaking of Delacroix, he says that sculptors have railed against Delacroix's drawing unjustly. They are partial and one-eyed people, whose judgment at the most is worth half the judgment of an architect. "La sculpture, à qui la couleur est impossible et le mouvement difficile, n'a rien à démêler avec un artiste que préoccupent surtout le mouvement, la couleur et l'atmosphère. Ces trois éléments demandent nécessairement un contour un peu indécis, des lignes légères et flottantes, et l'audace de la touche" (p. 79).

[89] *Ibid.* The idea that sculpture is the first and the most primitive art is also Winckelmann's: "for a child also can give a certain form to a soft mass, but he cannot draw on a surface; for the first, the mere concept of a thing is sufficient, but for drawing much more knowledge is needed."—*Geschichte der Kunst des Altertums*, Erster Teil, Das erste Kapitel.

[90] Baudelaire does not have in mind here, as one might suppose from the passage quoted in note 88 above, a distinction between the plastic and the picturesque, the tactile and the optic, in the modern sense, in order to deduce the necessary inferiority of the sculpture in a period of impressionistic taste. On the contrary, he declares that sculpture, though "brutal and positive like nature, is at the same time vague and intangible, because it shows too many sides at once" (*Oeuvres*, II, pp. 127, 128); it lacks a unique point of view and is subject to accidents of illumination. What he condemns above all in sculpture is its vulgar artisan reality, that efficient industrial character which in the mid-nineteenth century gave savage handicraft some value to Victorian taste. Cf. Melville, *Moby Dick*, chap. LVII on the "ancient Hawaiian war-club or spear-paddle" which is "as great a trophy of human perseverance as a Latin lexicon"; cf. also the "beautiful New Zealand paddle," that Owen Jones admires in the first chapter of his *Grammar of Ornament* (1856). It is the skill rather than the fantasy of the savage that Baudelaire despises.

[91] *Le Salon Caricatural critiqué en vers et contre tous illustré de 60 caricatures dessinées sur bois*. Première année. Paris 1846. Reprinted in facsimile in Ch. Baudelaire, *Oeuvres en Collaboration*, with introduction and notes by Jules Mouquet, Paris 1932, cf. pp. 9, 15, 17.

[92] *Histoire de l'Imagerie populaire*, 2nd ed. 1869, p. xii. In the 1886 edition, he changes "most" (plupart) to "many" (bon nombre).

[93] *Ibid.*, p. xxiii.

[94] Livre 6éme, chap. xx, xxi, pp. 249–255 of the Paris 1853 edition. That Champfleury was acquainted with Töpffer's books appears from the reference in his *Histoire de la caricature antique* (n.d.—1865?), p. 189, to Töpffer's *Essai de Physiognomonie*, Geneva 1845, *a propos* Töpffer's studies and reproductions of children's drawings in this book. However, Champfleury is probably mistaken in calling the ancient graffito he reproduces opposite p. 188 a child's drawing.

95 *Réflexions et menus propos,* pp. 254, 255.

96 *Ibid.,* chap. xx.

97 See his delightful albums, which are the true forerunners of the comic strip and the animated cartoon: *Historie de M. Jabot, Le Docteur Festus, Histoire d'Albert, Histoire de M. Cryptogame,* all of which were reprinted in Paris.

98 See Sainte-Beuve's preface to his *Nouveaux Voyages en Zigzag,* Paris 1854: *Notice sur Töpffer considéré comme paysagiste* (also in the *Causeries du Lundi,* VIII). Sainte-Beuve speaks of the "caractère à la fois naïf et réfléchi de son originalité," and cites Töpffer's maxim "Tous les paysans ont du style" and his interest in the "langage campagnard et paysanesque."

99 See pp. 129–166, *Du beau dans l'art.*

100 *Ibid.,* pp. 130, 131.

101 Riat, *op. cit.,* p. 88, Gautier speaks of the "étrangeté caraibe du dessein et de la couleur."

102 His first article on the legend of the *Bonhomme Misère* was published in *L'Evénement,* October 26, 1850.

103 "Le génie n'est que *l'enfance retrouvée* à volonté" (*Oeuvres,* II, p. 331); and in the *Salon de* 1846: "Il est curieux de remarquer que, guidé par ce principe—que le sublime doit fuire les détails,—l'art pour se perfectionner revient vers son enfance" (*ibid.,* II, p. 100).

104 *Ibid.,* II, p. 329.

105 *Loc. cit.*

106 *Ibid.,* p. 331.

107 *Ibid.,* p. 338.

108 *Ibid.,* p. 331—"un de mes amis me disait un jour qu'étant fort petit, il assistait à la toilette de son père, et qu'alors il contemplait, avec une stupeur mêlée de délices, les muscles des bras, les dégradations de couleurs de la peau nuancée de rose et de jaune, et le réseau bleuâtre des veines." On the child as potential colorist, see also his remarks in *L'Oeuvre et la Vie de Delacroix, ibid.,* II, p. 305. But Baudelaire could hardly approve the drawings of children, since he required that drawing "doit etre comme la nature, vivant et agité . . . la simplification dans le dessin est une monstruosité" (*Oeuvres,* II, p. 163), and protested against the classicistic taste for stable, closed, simplified forms as a prejudice of savages and peasants (*Oeuvres,* II, p. 305). Interesting in this context is Delacroix's dislike of children (*ibid.,* p. 320); in his paintings, they are sometimes blood victims.

109 Baudelaire's conception of the child as endlessly observant and curious reappears as an original scientific observation some fifteen years later in Taine's article on the Acquisition of Language by Children, in the first number of the *Revue Philosophique,* January 1876; it was translated into English in *Mind,* II, 1877, and inspired Darwin to publish his own famous article on the development of the child in the same volume of *Mind.* Taine says of the twittering of a little girl: "its flexibility is surprising; I am persuaded that all the shades of emotion, wonder, joy, wilfulness and sadness are expressed by differences of tone; in this she equals or even surpasses a grown up person." And of the wonderful curiosity of the infant: "No animal, not even the cat or dog, makes this constant study of all bodies within its reach; all day long the child of whom I speak (at twelve months) touches, feels, turns round, lets drop, tastes and experiments upon everything she gets hold of; whatever it may be, ball, doll, bead, or plaything, when once it is sufficiently known she throws it aside, it is no longer new, she has nothing to learn from

it and has no further interest in it. It is pure curiosity. . . ." This article was reprinted in Taine's *De l'Intelligence*, Volume I, Note 1. In the same book, he speaks of infancy as the most creative period of the intelligence (Liv. IV, chap. 1, ii).

110 Delacroix could say of the *Bathers* of Courbet that "the commonness and uselessness of the thought are abominable." *Journal*, April 15, 1853.

111 See Théodore Duret, *Les peintres français en 1867*, Paris 1867, chapter on Courbet.

112 The full title in the catalogue of the exhibition of 1855 was: *L'Atelier du Peintre, allégorie réelle determinant une phase de sept années de ma vie artistique* (Léger, *Courbet*, 1929, p. 62). For Courbet's ideas about the meaning of his work, see the letter to Champfleury, published in the catalogue of the exhibition of the painting at the Galérie Barbazanges in Paris in 1919; and the letter to Bruyas (Borel, *op. cit.*, pp. 56, 57).

113 "les gens qui vivent de la vie" . . . He specifies them also as "les actionnaires, c'est-à-dire les amis, les travailleurs, les amateurs du monde de l'art" (letter to Champfleury).

114 He is not mentioned in the letter (nor is the child who looks at Courbet's painting). But it is surprising that Champfleury in an essay on Courbet in 1855 (published in *Le Réalisme*, 1857, pp. 279, 280) describes the little boy as playing with some prints. This incorrect observation of the realist, who prided himself on the exactness of details in his own writing, arises, I think, from his vexation with Courbet for having made his portrait in an unflattering manner, "like a Jesuit general," he wrote to Buchon (April 14, 1855—see "Lettres inédites de Champfleury," *La Revue Mondiale*, 133, 1919, p. 532); but instead of reproaching the painter for his portrait, he finds fault with the conception of the little boy at his feet: "Is M. Courbet really certain," he asks, "that a little child of a rich bourgeois would enter the studio with his parents when there is a nude woman present?"; and characteristically enough he converts the child from an artist into an amateur. The question is all the more surprising in a book in which Champfleury criticizes the prudery and hypocrisy of the French bourgeoisie in disliking the popular song, "La Femme du Roulier" (*Le Realisme*, p. 188 ff.); here the little children of the unfaithful waggoner tell their grieving mother that they will do as their father when they grow up.

115 Courbet calls them "les défroques romantiques" in the letter to Champfleury.

116 Between Courbet as a child and Courbet as a master, there was no Courbet "apprenti": in the catalogue of the exhibition of 1855, he adds the following footnote to no. 1, *L'Atelier du Peintre*: "C'est par erreur que, dans le livret du Palais des Beaux-Arts, il m'est assigné un maître: déjà une fois j'ai constaté et rectifié cette erreur par la voie des journaux; . . . Je n'ai jamais eu d'autres maîtres en peinture que la nature et la tradition, que le public et le travail." (The full text of the catalogue is reproduced by Léger, *Courbet*, 1929, pp. 61, 62.)

117 A similar conception appears in *Moby Dick* (1851), where Melville compares the workmanship of a savage and a sailor in bone-carving: "full of barbaric spirit and suggestiveness, as the prints of that old Dutch savage, Albert Dürer" (chap. LVII).

118 Troubat, *Sainte-Beuve et Champfleury*, p. 92.

119 Champfleury, *Le Réalisme*, p. 194 ff.

120 *De la poésie populaire en France*, p. 141, quoted from M. de la Villemarqué and the Grimm brothers.

121 On his ideas on sincerity in art, see *Le Réalisme*, 1857, pp. 3 ff.

122 *Histoire de l'imagerie populaire*, 1869, pp. 286–301 (L'imagerie de l'avenir),

especially, p. 290 on the murals. He had already proposed such murals in his *Grandes Figures d'hier et d'aujourd'hui*, 1861. This was a typical St. Simonian and Fourierist idea, and was discussed in 1848 at the meetings of the socialist group of the *Démocratie Pacifique*, led by Courbet's countryman, Victor Considérant. According to Estignard (G. *Courbet*, 1897, pp. 104, 105), Courbet spoke to Sainte-Beuve, with whom he spent much time in 1862, of his desire to decorate the railroad stations with such murals. This was also an ambition of Manet's. The importance of former St. Simonians in the development of the French railroads during the Second Empire may have contributed to the interest in such projects.

123 Silvestre, *Histoire des artistes vivants*, 1856, p. 277.

124 Courbet said in 1861: "Le réalisme est par essence l'art démocratique" (Estignard, *Courbet*, pp. 117, 118).

125 This is ridiculed by Bertall in his caricature of the *Enterrement* (Léger, *Courbet selon les caricatures*, p. 15).

126 The political and social history of France from 1848 to 1851 has been brilliantly written by Karl Marx, *The Class Struggles in France* (1848–1850), and *The Eighteenth Brumaire of Louis Bonaparte*.

127 Bouvier, *op. cit.*, pp. 30 ff.

128 It has been republished in facsimile with a preface by Fernand Vandérem (*Le Salut Public*, no. 1–2, *Paris* 1848), Paris n.d. (1925?). Wallon, *Le Presse de 1848, ou revue critique des journaux*, Paris, 1849, p. 6, calls it a "journal de fantaisie démocratique."

129 See his *Souvenirs*, p. 298.

130 It had only three numbers, June 4, 11, 18. On its contents, see Wallon, *op. cit.*, pp. 70–72, and p. 125.

131 Wallon describes it as "moderate reactionary," with "hatred of anarchy, tender and profound love of the people."

132 See Troubat, *Sainte-Beuve et Champfleury*, p. 77.

133 *Ibid.*, p. 90. He also supported the republic, he said, because of its friendly attitude to writers and artists. *Ibid.*, p. 93.

134 *Ibid.*, pp. 100, 101, letter to mother, December 1849; see also Bouvier, *op. cit.*, p. 277 ff. on this novel, the first of his realistic works, and very much influenced by Dupont and Buchon.

135 Troubat, *op. cit.*, p. 101.

136 *Ibid.*, letter of December 14, 1851, p. 131, and December 31, p. 133. But he did not wholly disapprove of the censorship; "je n'aime le journalisme, je ne l'ai jamais aimé et tout ce qui pourra comprimer son bavardage, je l'approuve" (p. 131), he wrote before the censorship was actually applied to his own works. He also said: "je crois, malgré n'importe quels événements, que la littérature doit vivre, qu'il y ait un Empire ou un Comité de Salut Public. Je ne crains rien, ne m'occupant pas de politique" (p. 131).

137 "Ce fut alors que, par un brusque sobresaut, je me plongeai dans l'érudition pour échapper aux dangers de mon imagination qui avait failli suspendre deux importants journaux (*la Presse* et *l'Opinion nationale*)"—this statement by Champfleury in a notice on Buchon in 1877 is quoted by Troubat in *La Revue*, Paris, vol. 105, 1913, p. 35.

138 See his brochure, *De la littérature populaire en France, Recherches sur les origines et les variations de la légende du bonhomme misère*, Paris 1861; and the conclusion of the later version of the same study in the *Histoire de l'imagerie populaire*, 1869, pp. 177–180.

[139] Bouvier, *op. cit.*, p. 180. He planned to begin with Hebel, whose work he knew through the translations of his radical friend, Buchon.

[140] See *Histoire de l'imagerie populaire*, 1869, 2nd ed., pp. xlv, xlvi. He had already published an article on the "bonhomme misère" in *L'Evénement* in October 1850.

[141] Henry Monnier, *Grandeur et décadence de Monsieur Joseph Prudhomme*, in *Morceaux Choisis*, Paris 1935, p. 211; the comedy was first played in 1852.

[142] He writes in 1849 of the "socialisme des paysans,—socialisme inévitable, féroce, stupide, bestial, comme un socialisme de la torche ou de la faulx" (*Lettres 1841–1866*, Paris 1906, p. 16); and after the coup-d'état: *"Le 2 Décembre m'a physiquement dépolitiqué. Il n'y a plus d'idées générales. . . . Si j'avais voté, je n'aurais pu voter que pour moi. Peut-être l'avenir appartient-il aux hommes déclassés?"* (*ibid.*, p. 31). In 1848, Baudelaire had been somewhat more constant than Champfleury. See Wallon, *op. cit.*, pp. 109, 114, on his contributions to radical journals and Wallon's admonitions on politics and poetry, addressed to Baudelaire.

[143] See his essay on progress in *Exposition Universelle de 1855*, *Oeuvres*, II, pp. 148 ff.—"Il est encore une erreur fort à la mode, de laquelle je veux me garder comme de l'enfer.—Je veux parler de l'idée du progrès . . ."

[144] See his studies of the *Bonhomme Misère*, cited above in note 138. "Alas, neither pistol shots nor bloodshed will abolish misery. The sweet plaint of the story-teller who shows the *bonhomme* resigned, contented with his lot, asking only to gather the fruits of his pear tree, is more persuasive than a cannon. Yes, misery will remain on the earth as long as the earth exists" (*Histoire de l'imagerie populaire*, 1869, pp. 177, 178). He contrasts the immortality of works like this legend with the merely ephemeral "wars, social movements, industrial transformations" (*Histoire*, p. 180, and *De la littérature populaire en France*, 1861, conclusion). On p. 178 of the *Histoire*, he identifies the "bonhomme misère" as a "petit propriétaire," and adds: "La philosophie de nos pères est inscrite à chaque page du conte et il serait a regretter qu'elle ne restât pas la philosophie de nos jours. La situation du peuple s'est largement améliorée depuis un siècle; elle fait maintenant plus que jamais de rapides progrès. Elle ne sera réellement fructueuse qu'avec des goûts modestes et peu de besoins. C'est pourquoi le bonhomme Misère prêtera toujours à méditer, et je ne doute pas qu'un Franklin, s'il avait eu connaissance d'un tel conte, ne l'eût vulgarisé parmi ses compatriotes" (*Histoire*, p. 179). Champfleury has not forgotten altogether his editorship of *Le Bonhomme Richard* with Wallon in 1848.

[145] *Histoire*, pp. 268–285.

[146] *Ibid.*, pp. 179, 180, on the greater durability of the ideas and literature of the peasantry.

[147] Wilhelm Heinrich Riehl (1823–97), *Die Naturgeschichte des Volkes als Grundlage einer deutschen Sozial-Politik*, 4 vols., 1851–1864.

[148] On page 140 of the *Histoire de l'imagerie populaire*, 1869, he indicates why the peasant tale and image are more effective in teaching the people than any official instruction. "The lesson flows from the story itself without being marked by the puerilities of the didactic literature with the aid of which the rulers in moments of trouble think they can appease irritated minds and which the people reject, finding the doctrine too often heavy and pedantic."

[149] It is reproduced by Léger, *Courbet*, 1929, p. 40.

[150] *Souvenirs*, p. 171.

[151] *Ibid.*

152 "Voilà deux ans que je fais la guerre de l'intelligence" (June 26, 1848), Riat, *op. cit.*, p. 50.

153 In that year he wrote: "Je suis non seulement socialiste, mais bien encore démocrate et republicain, en un mot partisan de toute la Révolution" (Estignard, *op. cit.*, p. 123).

154 It was published in 1864.

155 His *Sensations de Josquin* was accepted by the *Revue* in 1855; but Buchon, with the aid of Champfleury, was already printed there in 1854. On the attitude of the *Revue* to realism, see Thaddeus E. Du Val, Jr., *op. cit.*

156 The article, "*Sur M. Courbet, Lettre à Madame Sand,*" is published in *Le Réalisme*, 1857, pp. 270–285.

157 See his letter to Buchon, *La Revue Mondiale*, 1919, vol. 133, pp. 533, 534; also his *Souvenirs*, 1872, on conversations with Proudhon *c.* 1860. In spite of his insensibility to art and the vague idealism of his aesthetic theories, Proudhon was respected by Baudelaire as an independent personality and as an economist interested in the plight of the small debtor under capitalism. See Baudelaire's *Lettres*, Paris 1906, pp. 404, 409, 410, 425.

158 See above, note 114.

159 In the *Sensations de Josquin*, 1855, 1857. See Léger, *Courbet selon les caricatures*, 1920, p. 118.

160 *Grandes Figures*, 1861, pp. 231–263; *Souvenirs*, 1872 (written 1862, 1863), pp. 171–192 and *passim*. In the latter he speaks of "1852, époque de notre séparation" (p. 192), although on pp. 245, 246, he refers to his vacation with Courbet in Ornans in 1856, and on p. 317 says that he lived a dozen years with Courbet and "his menagerie of vanities."

161 In letter to Buchon: *La Revue Mondiale*, 133, 1919, p. 544 (1857).

162 *Ibid.*, pp. 540, 705 ff.

163 See Léger, *Courbet selon les caricatures*, p. 118 ff.

164 In 1857 already, soon after publishing *Le Réalisme*, Champfleury thought that realism was finished—"the public is tired of novels of observation. *Madame Bovary* will be the last bourgeois novel. One must find something else" (*Souvenirs*, p. 246).

165 "Je vais partir pour Ornans et faire encore quelques tableaux nouveaux bien sentis et socialistes," he wrote in 1868 to Bruyas (Borel, *op. cit.*, p. 108). On his relations with Proudhon, see Riat, *op. cit.*, p. 208 ff.

166 *Souvenirs*, p. 191.

167 *Grandes Figures*, pp. 236 ff. "Woe to artists who wish to teach by their works . . . or to associate themselves with the acts of some regime."

168 Silvestre, *Histoire des artistes vivants*, 1856, p. 266, in a summary of Courbet's ideas on realism and historical painting.

ON A PAINTING OF
VAN GOGH

(1946)

Among Van Gogh's paintings the *Crows over the Wheat Field* (Pl. IV, Fig. 1) is for me the deepest avowal. It was painted a few days before his suicide, and in the letter in which he speaks of it we recognize the same mood as in the picture. The canvas is already singular in its proportions, long and narrow, as if destined for two spectators, an image of more than the eye of one can embrace. And this extraordinary format is matched by the vista itself, which is not simply panoramic but a field opening out from the foreground by way of three diverging paths. A disquieting situation for the spectator, who is held in doubt before the great horizon and cannot, moreover, reach it on any of the three roads before him; these end blindly in the wheat field or run out of the picture. The uncertainty of Van Gogh is projected here through the uncertainty of movements and orientations. The perspective network of the open field, which he had painted many times before, is now inverted; the lines, like rushing streams, converge towards the foreground from the horizon, as if space had suddenly lost its focus and all things turned aggressively upon the beholder.

In other works this field is marked with numerous furrows that lead with an urgent motion to the distance. These lines are the paths of Van Gogh's impetuous impulse towards the beloved object. Recall how Cézanne reduced the intensity of perspective, blunting the convergence of parallel lines in depth, setting the solid objects back from

the picture plane and bringing distant objects nearer, to create an effect of contemplativeness in which desire has been suspended.[1] Van Gogh, by a contrary process, hastens the convergence, exaggerating the extremities in space, from the emphatic foreground to the immensely enlarged horizon with its infinitesimal detail; he thereby gives to the perspective its quality of compulsion and pathos, as if driven by anxiety to achieve contact with the world. This perspective pattern was of the utmost importance to Van Gogh, one of his main preoccupations as an artist. In his early drawings, as a beginner struggling with the rules of perspective and using a mechanical device for tracing the foreshortened lines which bewildered and delighted him, he felt already both the concreteness of this geometrical scheme of representation and its subjective, expressive moment. Linear perspective was in practice no impersonal set of rules, but something as real as the objects themselves, a quality of the landscape that he was sighting. This paradoxical scheme at the same time deformed things and made them look more real; it fastened the artist's eye more slavishly to appearance, but also brought him more actively into play in the world. While in Renaissance pictures it was a means of constructing an objective space complete in itself and distinct from the beholder, even if organized with respect to his eye, like the space of a stage, in Van Gogh's first landscapes the world seems to emanate from his eye in a gigantic discharge with a continuous motion of rapidly converging lines. He wrote of one of his early drawings: "The lines of the roofs and gutters shoot away in the distance like arrows from a bow; they are drawn without hesitation."

In his later work this flight to a goal is rarely unobstructed or fulfilled; there are most often countergoals, diversions. In a drawing of a ploughed field (Fig. 2), the furrows carry us to a distant clump of bushes, shapeless and disturbed; on the right is the vast sun with its concentric radiant lines. Here there are two competing centers or centered forms, one, subjective, with the vanishing point, the projection of the artist not only as a focusing eye, but also as a creature of longing and passion within this world; the other, more external, object-like, off to the side, but no less charged with feeling. They belong together,

Fig. 1 Van Gogh: *Crows Over the Wheat Field*, 1890. Oil, 19⅞″ x 39½″. Collection, National Museum Vincent van Gogh, Amsterdam.

Fig. 2 Van Gogh: *Ploughed Field and Rising Sun*. Drawing, Black chalk, reed pen and ink, 18½″ x 24½″. Staatliche Graphische Sammlung, Munich.

like a powerful desire and its fulfillment; yet they do not and can not coincide. Each has its characteristic mobility, the one self-contained, but expansive, overflowing, radiating its inexhaustible qualities, the other pointed intently to an unavailable goal.

In the *Crows over the Wheat Field* these centers have fallen apart. The converging lines have become diverging paths which make impossible the focused movement toward the horizon, and the great shining sun has broken up into a dark scattered mass without a center, the black crows which advance from the horizon toward the foreground, reversing in their approach the spectator's normal passage to the distance; he is, so to speak, their focus, their vanishing point. In their zigzag lines they approximate with increasing evidence the unstable wavy form of the three roads, uniting in one transverse movement the contrary directions of the human paths and the sinister flock.

If the birds become larger as they come near, the triangular fields, without distortion of perspective, rapidly enlarge as they recede. Thus the crows are beheld in a true visual perspective which coincides with their emotional enlargement as approaching objects of anxiety; and as a moving series they embody the perspective of time, the growing imminence of the next moment. But the stable, familiar earth, interlocked with the paths, seems to resist perspective control. The artist's will is confused, the world moves towards him, he can not move towards the world. It is as if he felt himself completely blocked, but also saw an ominous fate approaching. The painter-spectator has become the object, terrified and divided, of the oncoming crows whose zigzag form, we have seen, recurs in the diverging lines of the three roads.

And here, in this pathetic disarray, we begin to discover a powerful counteraction of the artist, his defense against disintegration. In contrast to the turbulence of the brushwork and the smallest parts, the whole space is of an unparalleled breadth and simplicity, like a cosmos, in its primitive stratified extension. The largest and most stable area is the most distant—the rectangular dark blue sky that reaches across the entire canvas. Blue occurs only here and in fullest

saturation. Next in quantity is the yellow of the wheat field, which is formed by two inverted triangles. Then a deep purplish red of the paths—three times. The green of the grass on these roads—four times (or five, if we count the thin streak at the right). Finally, in an innumerable series, the black of the oncoming crows. The colors of the picture in their frequency have been matched inversely to the largeness and stability of the areas. The artist seems to count: one is unity, breadth, the ultimate resolution, the pure sky; two is the complementary yellow of the divided, unstable twin masses of growing corn; three is the red of the diverging roads which lead nowhere; four is the complementary green of the untrodden lanes of these roads; and as the n of the series there is the endless progression of the zigzag crows, the figures of death that come from the far horizon.

Just as a man in neurotic distress counts and enumerates to hold on to things securely and to fight a compulsion, Van Gogh in his extremity of anguish discovers an arithmetical order of colors and shapes to resist decomposition.

He makes an intense effort to control, to organize. The most elemental contrasts become the essential appearances; and if in this simple order two fields are apart in space, like the sky and the roads, they are held together by additional echoing touches of color which, without changing the larger forces of the whole, create links between the separated regions. Two green spots in the blue sky are reflections, however dimmed, of the green of the roads; many small red touches on the wheat field along the horizon repeat the red of these paths.

In the letter to which I have referred, Vincent wrote to his brother: "Returning there, I set to work. The brush almost fell from my hands. I knew well what I wanted and I was able to paint three large canvases.

"They are immense stretches of wheat under a troubled sky and I had no difficulty in trying to express sadness and extreme solitude."

But then he goes on to say, what will appear most surprising: "You will see it soon, I hope . . . these canvases will tell you what I can not say in words, what I find healthful and strengthening in the country."

How is it possible that an immense scene of trouble, sadness, and extreme solitude should appear to him finally "healthful and strengthening?"

It is as if he hardly knew what he was doing. Between his different sensations and feelings before the same object there is an extreme span or contradiction. The cypress trees which he compared with an Egyptian obelisk for their beauty of line and proportion become restless, flaming shapes in his pictures. Yet he practiced his art with an extraordinary probing awareness; it was, in his own words, "sheer work and calculation." His letters contain remarkable illuminations on the problems of painting; one could construct a whole aesthetic from scattered statements in the letters. But when he looks at his finished work, he more than once seems to see it in a contradictory way or to interpret the general effect of a scene with an impassioned arbitrariness that confounds us. Sometimes it is a matter of the symbolism or emotional quality of a tone for which he possesses an entirely private code: "a note of intense malachite green, something utterly heartbreaking." In another letter he describes a painting of a wheat field with the sun and converging lines—a picture like the drawing mentioned above, perhaps of the same theme—as expressing "calmness, a great peace." Yet by his own account it is formed of "rushing series of lines, furrows rising high on the canvas"; it exhibits also the competing centers which create an enormous tension for the eye. To another artist, such lines would mean restlessness, excitement. Similarly, Van Gogh speaks of a painting of his bedroom in Arles as an expression of "absolute repose." Yet it is anything but that, with its rapid convergences and dizzying angularities, its intense contrasted colors and the scattered spots in diagonal groups. It is passionate, vehement painting, perhaps restful only relative to a previous state of deeper excitement, or as an image of his place of sleep.

In this contradiction between the painting and the emotional effect of the scene or object upon Van Gogh as a spectator, there are two different phenomena. One is the compulsive intensification of the colors and lines of whatever he represents; the elements that in nature appear to him calm, restful, ordered, become in the course of painting unstable and charged with a tempestuous excitement. On the

other hand, all this violence of feeling does not seem to exist for him in the finished work, even when he has acknowledged it in the landscape.

The letters show that the paradoxical account of the *Crows over the Wheat Field* is no accidental lapse or confusion. They reveal, in fact, a recurrent pattern of response. When Van Gogh paints something exciting or melancholy, a picture of high emotion, he feels relieved. He experiences in the end peace, calmness, health. The painting is a genuine catharsis. The final effect upon him is one of order and serenity after the whirlwind of feeling.

Yes, there is health and strength for Van Gogh in his paroxysmal rendering of the wheat field and the sky. The task of painting has for him a conscious restorative function. He believed already some time before that it was only painting that kept him from going mad. "I raced like a locomotive to my painting," he wrote, when he felt that an attack was coming. He spoke of his art as "the lightning conductor for my illness." It is customary to describe Van Gogh as an inspired madman whose creativeness was due to his unhappy mental condition, and indeed he admitted this himself. Looking back on the intense yellows in his work of 1888, he said: "To attain the high yellow note that I attained last summer, I really had to be pretty well strung up." But he saw also that he was not insane, although subject to attacks: "As far as I can judge, I am not properly speaking a madman. You will see that the canvases I have done in the intervals are restrained and not inferior to the others." Whatever may be said about the connection between his calling as an artist and his psychic conflicts, it remains true that for Van Gogh painting was an act of high intelligence which enabled him to forestall the oncoming collapse. In his own words, he "knew well what he wanted." The psychiatrist and philosopher, Jaspers, in a book on great schizophrenic artists, in which he examines the lives of Hölderlin, Strindberg, and Van Gogh, observes as a peculiarity of Van Gogh "his sovereign attitude to his illness," his constant self-observation and effort of control.[2] The painter, more than the others, wished to understand his own state. With a rare lucidity he watched his behavior to foresee the attacks

and to take precautions against them, until in the end his despair destroyed him.

If Van Gogh derived from internal conflicts the energies and interests that animate his work (and perhaps certain original structures of the forms), its qualities depend as much on his resistance to disintegration. Among these qualities one of the most essential was his attachment to the object, his personal realism. I do not mean realism in the repugnant, narrow sense that it has acquired today, and that is too lightly called photographic—photography has also a deeper expressive side in its fascinating revelation of things—but rather the sentiment that external reality is an object of strong desire or need, as a possession and potential means of fulfillment of the striving human being, and is therefore the necessary ground of art. When Van Gogh describes his paintings, he names the objects and their local colors as inseparable substances and properties, unlike an Impressionist painter who might be more acutely observant but would be less concerned with the object and would, on the contrary, welcome its dissolution in an atmosphere that carries something of the mood of revery without desire, as if a primordial separateness of man and the neutral things around him had been overcome through their common immersion in a passive state called sensation. For Van Gogh the object was the symbol and guarantee of sanity. He speaks somewhere of the "reassuring, familiar look of things"; and in another letter: "Personally, I love things that are real, things that are possible . . ." "I'm terrified of getting away from the possible . . ." The strong dark lines that he draws around trees, houses, and faces, establish their existence and peculiarity with a conviction unknown to previous art. Struggling against the perspective that diminishes an individual object before his eyes, he renders it larger than life. The loading of the pigment is in part a reflex of this attitude, a frantic effort to preserve in the image of things their tangible matter and to create something equally solid and concrete on the canvas. Personality itself is an object, since he is filled with an unquenchable love for the human being as a separate substance and another self; he is able then to paint himself and others as complete, subsistent objects and through such paintings to experience

their firmness and sure presence and to possess them. That is why, standing before the ominous sky and wheat field, with the oncoming crows, he is able to paint not only this sadness and solitude, but also the health and strength that reality alone can give him.

Yet can it give these to him? we must ask. Or is this a desperate effort to obtain from the landscape what it no longer possesses? Is Van Gogh perhaps the last great painter of reality and the precursor of an anti-objective art because his earnest attempt to integrate himself through the representation of things is hopeless? Is this the crucial personal failure, the tragic artistic success for which he pays with his life? We have seen how his devoted vision of the exterior world is disturbed by emotionally charged forms that subvert the perspective relations, how the convergence towards the horizon through which the whole space normally appears ordered with respect to the fixed gaze of the beholder, is confused by divergences and complexities arising from stresses within the artist which resist this harmony, this pre-established coordinating system in the glance. Nature is now foreign to man, its highest consciousness and reflector. It has ceased to be a model of inner harmony and strength. From this time on external reality will no longer offer artists "healthful and strengthening" objects of love, only random elements for dreams or aesthetic manipulation.

But dreams are just what Van Gogh avoided as the paths to insanity. "To think, not to dream, is our duty," he wrote. To his friend Bernard, who described to him his new religious pictures inspired by medieval Christianity, the former theological student and missionary replied that such an attempt in our age was an impossible evasion: "It's an enchanted territory, old man, and one quickly finds oneself up against a wall"; only the reality of our time could provide the ground of art and human satisfaction. But he himself could not survive on this ground. It implied faith in a social order of which he perceived the injustice and cruelty and growing chaos. At this moment already to artists of insight, "reality" meant for the most part the things that constrain or destroy us. Vincent observed that under modern conditions artists were bound to be somewhat crazy; "perhaps

some day everyone will have neurosis." Without irony he opposed to Bernard's painting of the *Garden of Gethsemane* his own picture of the garden of the hospital where he was confined. He would not turn to an inner world of fantasy that might console him, since he knew that for himself that surely meant madness. Towards the end he was drawn at times to religious fancies, but fought them off as unhealthy. The figure of the human Christ still attracted him. If he wrote of God as an artist whose one great creation, the world, was "a study that didn't come off," he revered Christ as the supreme artist, "more of an artist than all the others, disdaining marble and clay and color, working in the living flesh." But the few Christian themes that he painted while in the asylum were, without exception, copied from prints after other artists, and were significantly images of pathos, like the Good Samaritan and the Dead Christ. His sincerity, requiring always faithfulness to direct experience, kept him from inventing religious pictures. When inspired by the vision of the *Starry Night* (Fig. 3), he put into his painting of the sky the exaltation of his desire for a mystical union and release, but no theology, no allegories of the divine. He had written to Theo some time before, after describing his plan to do difficult scenes from life: "That does not keep me from having a terrible need of—shall I say the word—of religion. Then I go out at night to paint the stars." There is, however, in the gigantic coiling nebula and in the strangely luminous crescent—an anomalous complex of moon and sun and earth shadow, locked in an eclipse[3]—a possible unconscious reminiscence of the apocalyptic theme of the woman in pain of birth, girded with the sun and moon and crowned with the stars, whose newborn child is threatened by the dragon (Revelations 12, 1 ff.). What submerged feelings and memories underlie this work is hinted also by the church spire in the foreground, Northern in its steepness and acuity, a spire which in the earlier drawing (Fig. 4) is lost in the profusion of writhing vertical trees—the monotony of uncontrolled emotion—but is disengaged in the final work where a pictorial intelligence, in clarifying the form, strengthens also the expression of feeling.

This painting is the limit of Vincent's attempt to go beyond the

overtness of everyday objects, and it is, interestingly enough, an experience of the Provençal night sky, an image of the actual place and moment of religious incitation to his lonely soul. Here, in contradiction of his avowed principles and in spite of his fear of the vague, the mystical, and the passive surrender to God, he allows a freer rein to fantasy and hitherto repressed trends of feeling. Yet his vision remains anchored to the ground of the given, the common spatial world that he has lived with his own eyes. Thus even in this exceptional work of a spontaneous religious tendency we discern the tenaciousness of his objective spirit.

In the same way his effusive color symbolism—the "heartbreaking" malachite green or the deeper green which represents the "terrible passions of mankind" and the intense blue background which would evoke infinity in the portrait of an artist-friend whom he loves —all this concerns the qualities of particular visible objects and his feelings about them.

But his interest in symbolic coloring is already a shift in attitude. Together with it he resolves to paint less accurately, to forget perspective and to apply color in a more emphatic, emotional way. In this change which is legible in certain pictures and letters of the summer of 1888, I think we shall not be wrong in seeing a suggestion from the Paris milieu which Vincent had come to know the year before and with which he maintained his intimacy by correspondence all through 1888, especially with Gauguin and Bernard, the leaders of the new trend of Symbolism in painting. Vincent was a deeply receptive man, eager always for friendship and collaboration; while in Arles, far from his friends, he constantly stirred in his mind common projects which would reunite him with these Parisian friends. In the letter to Theo expressing his Symbolist ideas about color he attributes them to Delacroix; we can scarcely doubt that they are more recent and represent the viewpoint of the young *avant-garde* in Paris. If, in the following year, he criticizes Bernard severely for his religious paintings, Vincent in that same summer undertakes several himself, not so much to emulate Bernard and Gauguin—we have seen that his religious pictures are copies—but out of sympathy and brotherliness and a desire to

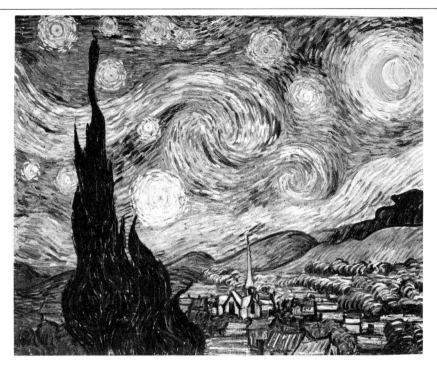

Fig. 3 Van Gogh: *Starry Night*, June, 1889. Oil on canvas, 29″ x 36¼″. Collection, The Museum of Modern Art, New York. Acquired through the Lillie P. Bliss Bequest.

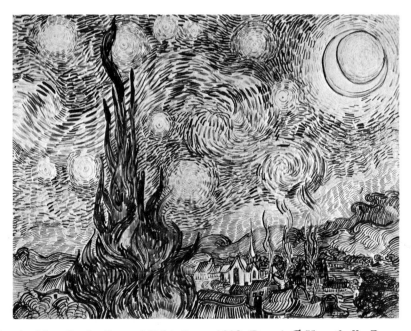

Fig. 4 Van Gogh: *Starry Night*, June, 1889. Drawing. Kunsthalle Bremen, Bremen.

share their problems. Yet these impulses toward religious themes are momentary and slight deflections. There is an inner growth in his art, so closely bound to his state of mind and the working out of his interior conflicts, so compulsive in its inventions, that he seems to originate Symbolism and Expressionism entirely from within, apart from all that is going on around him. Most likely he could not have formed his art without the spur of his Parisian experience and the contact with men whose congenial spiritual independence was joined to an attitude of artistic innovation, such as he had not suspected before he met them. He retained, however, to the end the fidelity to the world of objects and human beings that he had sworn at the beginning of his studies. The pictures of his last months, no matter how fantastic certain of their forms may appear, are among the most penetrating in their vision of things, their reality. His self-portrait, with the swirling, flamboyant lines of the background—one of the most advanced works of his time in the approach to an abstract Expressionism—is also a marvel of precise portraiture, with an uncanny liveness of the features. He had given his answer once and for all to Bernard in the summer of 1889, when most tormented by conflicting impulses: "Above all it's really a question of sinking onself anew in reality with no preconceived plan and none of the Parisian prejudices."

When the self at the edge of destruction holds on to objects so persistently, its protective reaction permits us to see that the painter's attachment to things is not passive or photographic, nor due simply to his origin in a period of naturalistic art, but is a constructive function with deep emotional roots. When he comes as a foreigner to Arles, a strange town, he paints everything—day and night scenes, people, children, whole families, houses, cafés, streets, his own room, and the surrounding country—as if to enter completely into this new milieu, unlike an Impressionist, who in painting at a resort or country site gives us little sense of material things and people. Even Van Gogh's choice of still-life objects, however trivial or incidental they may seem, is hardly indifferent; they constitute for him an intimate and necessary world. He needs objectivity, the most humble and obvious kind, as others need angels and God or pure forms; friendly faces, the unprob-

lematic things he sees about him, the flowers and roads and fields, his shoes, his chair and hat and pipe, the utensils on his table, are his personal objects, which come forward and address him. Extensions of his being, they image the qualities and conditions necessary for his health of mind. We may quote here what he said in another context: "It sounds rather crude, but it is perfectly true: the feeling for the things themselves, for reality, is more important than the feeling for pictures; at least it is more fertile and vital."

We understand then why he called imaginative painting "abstraction," although it was still an imagery of living forms, and why, on the other hand, the *Crows over the Wheat Field* for all its abstractness of composition represents with a tormented veracity an experienced landscape. But it is also a moment of crisis in which contrary impulses away from reality assert themselves with a wild throb of feeling. There is in the picture of the *Crows* something of the mood of the *Starry Night*. In its dark pulsating sky the great motor-storm of brush work and the green round spots over the horizon are like the animated clouds and stars of the night painting. After we have seen in the latter its startling, transfigured sky and have felt the pantheistic rapture stirring the immense bluish space with an overpowering turbid emotion, we are prepared to recognize in the later work the traces of a similar yearning. The endless sky of the *Crows* appears to us then an image of totality, as if responding to an hysterical desire to be swallowed up and to lose the self in a vastness. In the abnormal format there is already a submersion of the will. The prevailing horizontal is a quality of the mood more than of the frame or canvas; it has the distinctness and intensity of the blue and belongs to the deeper levels of the work. It is not required by a multiplicity of panoramic objects or a succession in breadth. In the common proportioning of pictures, approximating the golden section (0.618:1), the larger dimension has to contend with a strong subordinate, so that the relation of self and world, expressed in the contrast, is an opposition in which both elements are active and distinct. This is classical in spirit and corresponds to the accepted notion of the harmonious and normal in our own society. In Van Gogh's spontaneous, unconventional format, the hori-

zontal governs the space as an enormous dominant beside which the perpendicular hardly comes into being and is without an echo in the composition. (A similar one-sidedness, but ruled by the vertical, occurs in the *Cypress Trees* with moon and star, like two suns, an obsessive image of uncontainable excitement.) In his earlier landscapes the convergent lines in depth, intensifying the motion inward, gave a certain energy to the perspective flight; here the endless depth has been transposed into a sheer extension that exceeds the individual's glance and finally absorbs him.

NOTES

[1] On the character of Cézanne's perspective there is an admirable book by Fritz Novotny, *Cézanne und das Ende der wissenschaftlichen Perspektive*, Vienna 1938.

[2] The psychosis of Van Gogh, it should be said, is still obscure, and some medical investigators regard it as an epileptic process rather than schizophrenia.

[3] A student of mine, Richard Held, has pointed out the unnatural character of the moon. He observed that Van Gogh, in describing a previous painting of the night sky in a letter to Gauguin, speaks of the moon crescent as emerging from the earth shadow. But no lunar eclipse was visible in France in the years around 1888. It is therefore possible that the artist, who might have read of such an eclipse, has confused it with the explanation of the phases of the moon. Mr. Held has suggested further that the relation of moon, earth shadow, and sun in this painting symbolizes unconsciously a family—father, mother, and child—whence my own comparison with the apocalyptic incident, which is often represented with great splendor in the Middle Ages and identified with an eclipse.

SEURAT

(1958)

Admirers of Seurat often regret his method, the little dots. Imagine, Renoir said, Veronese's *Marriage at Cana* done in *petit point*. I cannot imagine it, but neither can I imagine Seurat's pictures painted in broad or blended strokes. Like his choice of tones, Seurat's technique is intensely personal. But the dots are not simply a technique; they are a tangible surface and the ground of important qualities, including his finesse. Too much has been written, and often incorrectly, about the scientific nature of the dots. The question whether they make a picture more or less luminous hardly matters. A painting can be luminous and artistically dull, or low-keyed in color and radiant to the mind. Besides, how to paint brightly is no secret requiring a special knowledge of science. Like Van Gogh, Seurat could have used strong colors in big areas for a brighter effect. But without his peculiar means we would not have the marvelous delicacy of tone, the uncountable variations within a narrow range, the vibrancy and soft luster, which make his canvases, and especially his landscapes, a joy to contemplate. Nor would we have his surprising image-world where the continuous form is built up from the discrete, and the solid masses emerge from an endless scattering of fine points—a mystery of the coming-into-being for the eye. The dots in Seurat's paintings have something of the quality of the black grains in his incomparable drawings in conté crayon where the varying density of the grains determines the gradations of tone (Fig. 1). This span from the tiny to the large is only one of the many striking polarities in his art.

101

If his technique depends on his reading of science, it is no more scientific than the methods of flat painting; it is surely not better adapted to Seurat's end than was the technique of a good Egyptian painter to his own special goals. Yet was Seurat's aim simply to reproduce the visual impression by more faithful means? Certain phrases in his theoretical testament—a compact statement of two pages—might lead us to think so; but some passages that speak of harmony and contrast (not to mention the works themselves) tell us otherwise. He was interested, of course, in his sensations and the means of rendering them, as artists of the Renaissance were passionately interested in perspective. When used inventively, perspective had also a constructive and expressive sense. In a similar way, Seurat's dots are a refined device which belongs to art as much as to sensation; the visual world is not perceived as a mosaic of colored points, but this artificial micro-pattern serves the painter as a means of ordering, proportioning and nuancing sensation beyond the familiar qualities of the objects that the colors evoke. Here one recalls Rimbaud's avowal in his *Alchemy of the Word:* "I regulated the form and the movement of each consonant," which was to inspire in the poets of Seurat's generation a similar search of the smallest units of poetic effect.

Seurat's dots may be seen as a kind of collage. They create a hollow space within the frame, often a vast depth; but they compel us also to see the picture as a finely structured surface made up of an infinite number of superposed units attached to the canvas. When painters in our century had ceased to concern themselves with the rendering of sensations—a profoundly interesting content for art—they were charmed by Seurat's inimitable dots and introduced them into their freer painting as a motif, usually among opposed elements of structure and surface. In doing so, they transformed Seurat's dots—one can't mistake theirs for his—but they also paid homage to Seurat (Figs. 9–10).

Seurat's dots, I have intimated, are a means of creating a special kind of order. They are his tangible and ever-present unit of measure. Through the difference in color alone, these almost uniform particles of the painter modulate and integrate molar forms; varying densities

in the distribution of light and dark dots generate the boundaries that define figures, buildings, and the edges of land, sea and sky. A passionate striving for unity and simplicity together with the utmost fullness appears in this laborious method which has been compared with the mechanical process of the photo-engraved screen. But is it, in the hands of this fanatical painter, more laborious than the traditional method with prepared grounds, fixed outlines, studied light and shade, and careful glazing of tone upon tone? Does one reproach Chardin for the patient work that went into the mysterious complex grain of his little pictures? Seurat practices an alchemy no more exacting than that of his great forebears, though strange in the age of Impressionist spontaneity. But his method is perfectly legible; all is on the surface, with no sauce or secret preparations; his touch is completely candid, without that "infernal facility of the brush" deplored by Delacroix. It approaches the impersonal but remains in its frankness a personal touch. Seurat's hand has what all virtuosity claims: certitude, rightness with least effort. It is never mechanical, in spite of what many have said—I cannot believe that an observer who finds Seurat's touch mechanical has looked closely at the pictures. In those later works where the dots are smallest, you will still discover clear differences in size and thickness; there are some large strokes among them and even drawn lines. Sometimes the dots are directionless, but in the same picture you will observe a drift of little marks accenting an edge.

With all its air of simplicity and stylization, Seurat's art is extremely complex. He painted large canvases not to assert himself nor to insist on the power of a single idea, but to develop an image emulating the fullness of nature. One can enjoy in the *Grande Jatte* (Fig. 2) many pictures each of which is a world in itself; every segment contains surprising inventions in the large shapes and the small, in the grouping and linking of parts, down to the patterning of the dots. The richness of Seurat lies not only in the variety of forms, but in the unexpected range of qualities and content within the same work: from the articulated and formed to its ground in the relatively homogeneous dots; an austere construction, yet so much of nature and human life; the cool observer, occupied with his abstruse problems of

art, and the common world of the crowds and amusements of Paris with its whimsical, even comic, elements; the exact mind, fanatic about its methods and theories, and the poetic visionary absorbed in contemplating the mysterious light and shadow of a transfigured domain. In this last quality—supreme in his drawings—he is like no other artist so much as Redon. Here Seurat is the visionary of the seen as Redon is the visionary of the hermetic imagination and the dream.

Seurat's art is an astonishing achievement for so young a painter. At thirty-one—Seurat's age when he died in 1891—Degas and Cézanne had not shown their measure. But Seurat was a complete artist at twenty-five when he painted the *Grande Jatte*. What is remarkable, beside the perfection of this enormously complex work, is the historical accomplishment. It resolved a crisis in painting and opened the way to new possibilities. Seurat built upon a dying classic tradition and upon the Impressionists, then caught in an impasse and already doubting themselves. His solution, marked by another temperament and method, is parallel to Cézanne's work of the same time, though probably independent. If one can isolate a single major influence on the art of the important younger painters in Paris in the later '80s, it is the work of Seurat; Van Gogh, Gauguin and Lautrec were all affected by it.

SEURAT AND PUVIS DE CHAVANNES

His art grows out of opposites: Puvis and the Impressionists. He had known both almost from the beginning of his career; his paintings as early as 1880 show acquaintance with Renoir's brushwork and color.

As he transformed the Impressionist sketchiness into a more deliberated method, so he converted the idealized imagery of Puvis into a corresponding modern scene which retained, however, something of the formality of a classic monumental style. In his lifetime already Seurat was called by Fénéon a *"Puvis modernisant."* The relation to the academic master is deeper than has been suspected. Seurat

Fig. 1 Seurat: *The Carriage*, ca. 1885. Conté crayon Drawing. Private Collection.

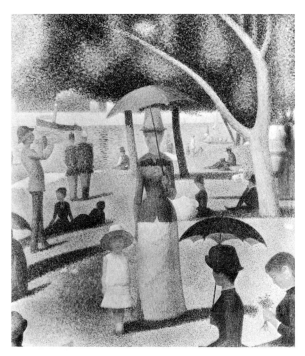

Fig. 2 Seurat: A *Sunday Afternoon on the Island of La Grande Jatte*, detail, 1884–86. Courtesy of The Art Institute of Chicago. Helen Birch Bartlett Memorial Collection.

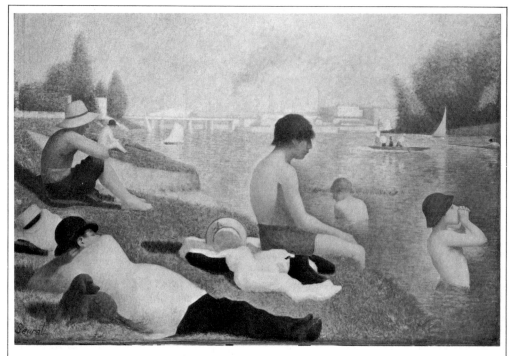

Fig. 3 Seurat: *Bathers*, 1883–84. Reproduced by courtesy of the Trustees, The National Gallery, London.

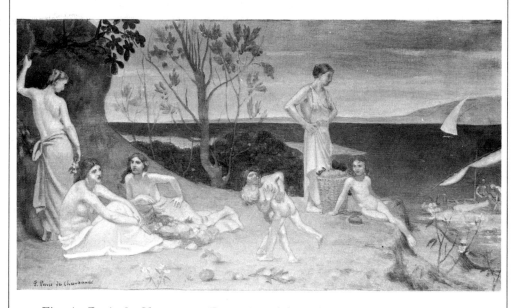

Fig. 4 Puvis de Chavannes: *Doux Pays* (also called *Pastoral*), 1882. Oil on canvas, 10⅛″ x 15⅝″. Yale University Art Gallery.

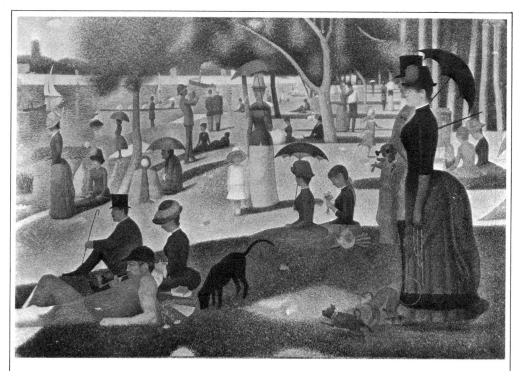

Fig. 5 Seurat: *A Sunday Afternoon on the Island of La Grande Jatte,* 1884–86, 81″ x 120⅜″. Courtesy of The Art Institute of Chicago. Helen Birch Bartlett Memorial Collection.

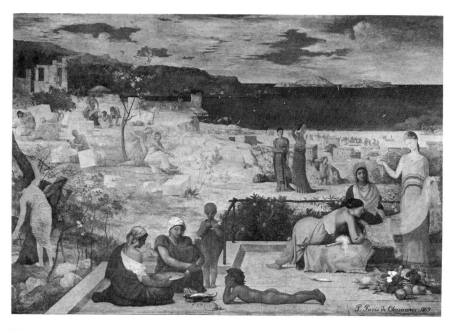

Fig. 6 Puvis de Chavannes: *Greek Colony,* Marseilles, 1869. Musée des Beaux-Arts, Marseilles.

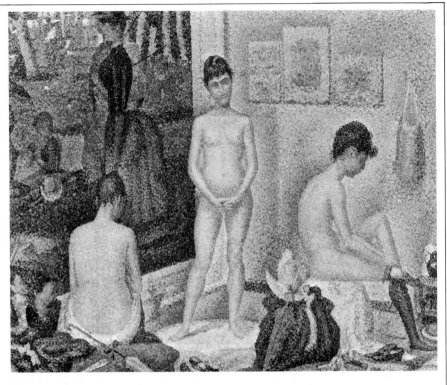

Fig. 7 Seurat: *Three models*
(*Les Poseuses*), 1888. Neue
Pinakothek, Munich.

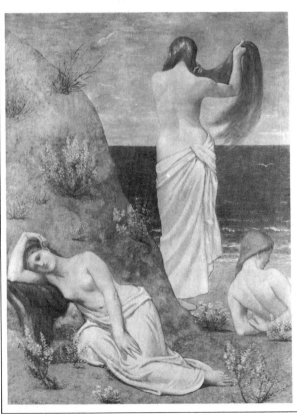

Fig. 8 Puvis de Chavannes:
*Jeunes Filles au Bord de la
Mer*, or *Women by the Sea*,
Salon of 1879. Louvre, Paris.

had made a sketch after Puvis' *Poor Fisherman* about 1882; but he resembles him too in several of his large compositions which have themes unknown to Puvis. The *Bathers* of 1883 (Fig. 3) recalls Puvis' *Doux Pays* (Fig. 4), shown at the Salon the year before; the *Grande Jatte* (Pl. V, Fig. 5) is like the older artist's vision of Greek Marseilles (Fig. 6); the *Poseuses* (Pl. VI, Fig. 7) repeats the idea of the three nudes of Puvis' *Women by the Sea* (Fig. 8)—the three-body problem which engaged painters, as the problem of solving equations for the motions of three mutually attracting heavenly bodies absorbed the mathematicians of the time. In this attachment to Puvis, the young Seurat responded to what was best and closest to him in the academic art of his schooldays, anticipating here the taste of the most advanced painters of the late '80s, such as Gauguin. The neo-classic tradition at the Ecole des Beaux-Arts was in complete decline then; in the official painting of the Salon it had become contaminated by romantic and realistic art, adopted without full conviction or understanding, much as academic art today takes over elements of abstract and expressionist style while denying the creative source. Puvis rose above his fellow academicians through his knowledge of past art and his serious desire for a noble, monumental style adequate to the conservative ideas of his time—comprehensive images of a stable community, austere and harmonious. But Puvis' order had too little spontaneity and passion. It was a cold idealism with no place in its system for the actualities and conflicts which it surmounts or proposes to resolve. Puvis' caricatures, not intended for exhibition, show the violence of feeling repressed in his greyed and balanced works.

Toulouse-Lautrec, at twenty, had pointed in a witty parody to the weakness of Puvis' art. Into Puvis' picture of the *Sacred Wood of the Muses*, exhibited in the Salon of 1884—a pallid landscape with white-robed classic figures and Greek columns—Lautrec had introduced a crowd of visitors in modern clothes, his own dwarf body among them—the reality of art as a world of living men with all their grotesque deformities. Seurat, too, rejected the myth of art; but holding to the artist's milieu and to recreation and the harmony of nature as the main themes of painting, he transformed the Golden Age, so

grey in Puvis' imagination, into a golden day, the familiar idyll of Parisians on the sunny banks of the Seine. In the *Poseuses* the three nudes, so often the vehicles of allegory and myth, are the models themselves represented in the painter's studio in their obvious function, posing or undressing in a setting of modern pictures and clothes. In the *Bathers* and the *Grande Jatte*, Seurat with a simple veracity represents on a monumental scale the happiness of his contemporaries in its collective aspect in the recurrent Sunday relaxation. These are paintings of a society at rest and, in accord with his own art, it is a society that enjoys the world in a pure contemplation and calm. He composes the paintings to realize this content; the main figures, walking or reclining, are turned in one direction (unlike the distracted individuals in Degas' crowds); they are a secular congregation, grave and ceremonious, in their holiday communion with the summer light and air. The perspective, too, is adjusted to this conception; in the *Grande Jatte* we move with the crowd from right to left, placing ourselves on the eye-level of each successive figure in the foreground.

In the late '80s and the '90s, other painters, also admirers of Puvis, impelled by the dream of a harmonious society, were to seek out their goal in an existing but distant primitive world in Brittany or the Pacific. Seurat remained attached to the elementary in the popular pleasures of Paris. In his later works the spectacles of the circus and music hall replaced the Sunday relaxation in the open air. The performer and his audience together became his chief subject and the immobility of his earlier figures gave way to the action of the acrobat and the dancer. There appeared now in his outlines, beside the large, smooth curves which respond to Ingres' norm of good drawing, a kind of Gothic in the angular, nicked and zigzag shapes which have a comic accent and suggest a popular taste. Such forms had occurred in the earlier paintings, but in the later '80s they become a principle, an element of structure repeated and diffused throughout the work, anticipating a common style of the 1890s. Seurat is attentive not only to the entertainers of the music hall, the side show and the circus, but also to the popular art that announces them on the streets of Paris, the large posters with their playful forms and lettering. His painting of the

V. Seurat: *A Sunday Afternoon on the Island of La Grande Jatte.* Courtesy of The Art Institute of Chicago, Chicago. Helen Birch Bartlett Memorial Collection.

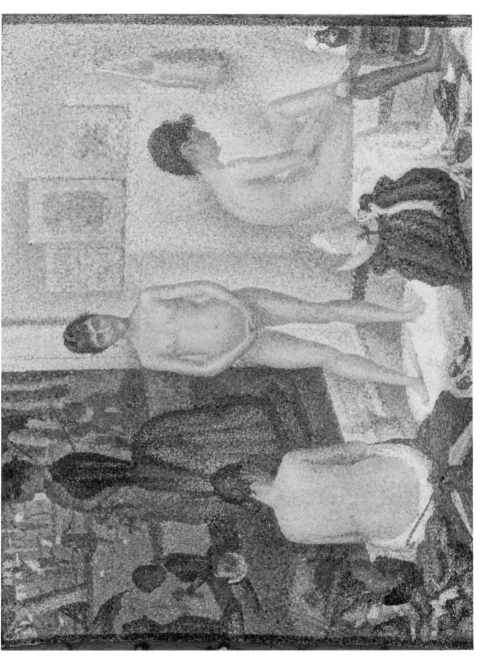

VI. Seurat: *Three Models (Les Poseuses)*, Neue Pinakothek, Munich. (Photo, Kunst-Dias Blauel)

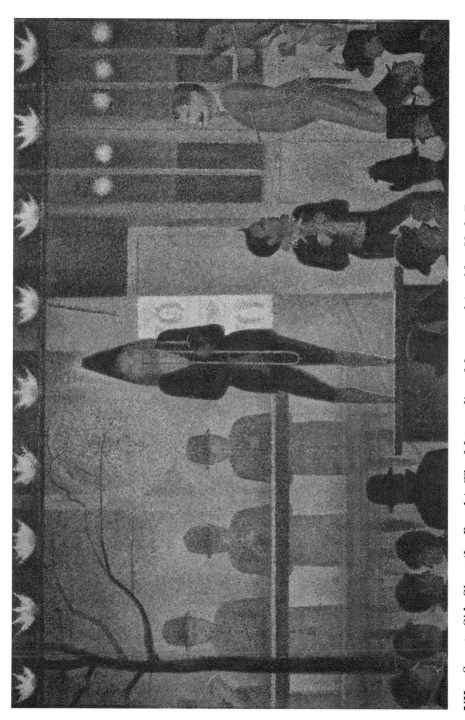

VII. Seurat: *Side Show* (*La Parade*), The Metropolitan Museum of Art, New York. Bequest of Stephen C. Clark, 1960.

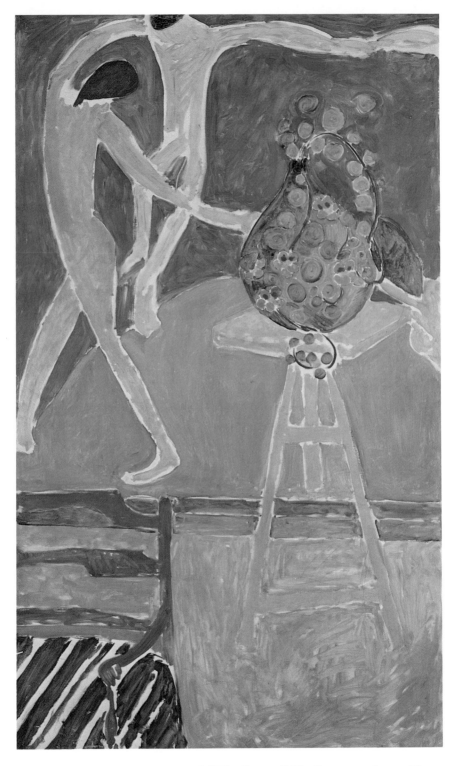

VIII. Matisse: *Nasturtiums and "The Dance," II, (Les capucines a "La Danse,"* 2me version), Worcester Art Museum, Worcester, Massachusetts. The Dial Collection, 31.750.

Fig. 9 Picasso: *Absinthe Glass*, 1914. Bronze, Painted with silver sugar strainer, 8½″ x 6½″. Collection. The Museum of Modern Art, New York. Gift of Mrs. Bertram Smith.

Fig. 10 Paul Klee: *In Copula*. Collection Edward Hulton, London.

Circus (Fig. 11) contains several figures based on posters of the day; the major theme of the bareback rider was probably suggested by the colored litho of the Nouveau Cirque (Fig. 12).

THE EIFFEL TOWER

In this spirit of modernity, Seurat was attracted by the Eiffel Tower that was to take its place among the chief spectacles of Paris.

In painting the Tower in 1889, even before it was completed, Seurat took a stand on an object of intense dispute among artists at the time. The enemies of the Tower included writers like Huysmans who saw in it only the *Notre Dame de la Brocante*—a vulgar assertion of the power of industry and trade. For Seurat the tower was a congenial work of art of which he had anticipated the forms in his own painting. Its clean, graceful silhouette has an unmistakable affinity with the lines of the trombonist in his *Side Show* (Pl. VII, Fig. 13) and the central nude in the *Models* (Fig. 14). Besides, the construction of this immense monument out of small exposed parts, each designed for its place, and forming together out of the visible crisscross and multiplicity of elements a single airy whole of striking simplicity and elegance of shape, was not unlike his own art with its summation of innumerable tiny units into a large clear form which retained the aspect of immaterial lightness evident in the smaller parts. In its original state the Tower was closer to Seurat's art than it is today; for the iron structure was coated with several shades of iridescent enamel paint—the poet Tailhade called it the "speculum-Eiffel." If the identity of the painter of Seurat's pictures were unknown, we could call him appropriately the Master of the Eiffel Tower.

Another contemporary painter, Henri Rousseau, a fellow-member of the Society of Independent Artists that Seurat helped to found, was equally drawn to the Eiffel Tower, the iron bridges, and the new airships which towards the end of the century spelled modernity for

the popular mind. Rousseau saw these marvels with the same wonder as the man in the street and painted them with the devoted literalness of a modern primitive—inserting them in the background of his self-portrait. For Seurat they had a deeper sense as models of structure and achievements of the rational mind. In his paintings of the Channel ports where he spent the summer months—landscapes of a wonderful delicacy and poetic vision—he not only chose to represent with a scrupulous precision the architecture of these sites—the moles, lighthouses, jetties and boats—but he gave to the paintings themselves something of the air of the exactly designed that he admired in those constructions (Figs. 15, 16 and 17). He is the first modern painter who expressed in the basic fabric and forms of his art an appreciation of the beauty of modern techniques. In Pissarro's and Monet's paintings of related themes, a haze of atmosphere and smoke veils the structure of the boats and bridges, and the simple lines of the engineers' forms are lost in the picturesqueness of irregular masses and patches of color. Seurat, in his sympathetic vision of the mechanical in the constructed environment, is a forerunner of an important current in the architecture and painting of the twentieth century.

He appears to us often, in spite of the note of revery in so many of his works, as the engineer of his paintings, analyzing the whole into standard elements, combining them according to general laws and the requirements of a problem, and exposing in the final form, without embellishment, the working structural members.

Seurat's taste for the mechanical and his habit of control extend also to the human. The dancer and the acrobat perform according to plan, with an increasingly schematic movement. The grave Seurat is drawn to the comic as a mechanization of the human (or perhaps as a relief from the mechanical). The figures in the late paintings are more and more impersonal and towards the end assume a caricatural simplicity or grotesqueness in expressing an emotion. They have no inner life, they are mannequins capable only of the three expressions—sadness, gaiety and neutral calm—which his theory of art also projects on the canvas as a whole in the dominance of the lines corresponding to the facial schemas of these three states—states which can be induced

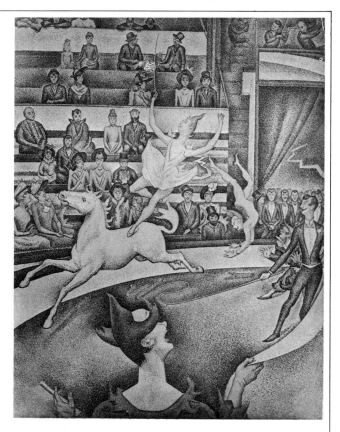

Fig. 11 Seurat: *The Circus*, 1891. Louvre, Paris. Bequest of John Quinn.

Fig. 12 Anonymous Poster for the *Nouveau Cirque*, ca. 1888.

Fig. 13 Seurat: *Invitation to the Side Show (La Parade)*, detail, 1887–1888. The Metropolitan Museum of Art, New York. Bequest of Stephen C. Clark, 1960.

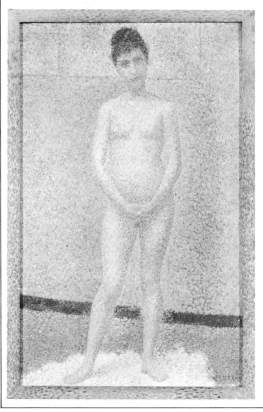

Fig. 14 Seurat: *Study for Three Models: The Standing Model*, 1887. Oil on canvas, 10¼″ x 6¾″. Louvre, Paris.

Fig. 15　Seurat: *The Eiffel Tower,* 1889. Collection Germain Seligman.

Fig. 16　*The Eiffel Tower.* Photograph by Les Editions d'Art Yvon.

Fig. 17 Seurat: *Port-en-Bessin*, 1888. Kröller-Müller Collection, Otterlo.

by the engineers of popular entertainment through the stimulus of the show in abstraction from individuals, counting rather on the statistical effect, the human average.

Much more can be said about this aspect of Seurat's art, which points to deeper layers of his personality and the social process of his time.

PICASSO'S
WOMAN WITH A FAN
On Transformation and Self-Transformation
(1976)

I n the *Bulletin of the Art Museum of Oberlin College* (Fall 1949),
Charles Parkhurst published a newly acquired drawing by the
young Picasso (Fig. 1a),[1] which has a special interest as a stage in
the conception of the *Woman with a Fan* (Fig. 1b). He observed that
the artist, having made the drawing from a model sitting before him
in a relaxed pose, changed it dramatically in the painting by raising her
right hand and by giving to the whole posture and costume a more
taut effect. These two works together are, as he recognized, an early
and striking example of Picasso's characteristic procedure in creating a
new picture by boldly transforming another. Though much was
retained of the original drawing, the expressive sense of the painting is
remarkably different. The formerly passive figure of a dancer at rest
has acquired an air of authority and importance. Her right hand, at
first laid weakly across the lap and blocking the movement of the left
arm, now rises in a commanding gesture. This new pose is strange to
the meaning of the original drawn figure of which the brooding gaze
under a heavy eyelid still marks her more robust incarnation. There is
in the new posture an aspect of energy and will: the isolated woman,
once self-enclosed in revery, now seems an actor in a world she con-
fronts as a leading participant in a solemn ritual; she is a priestess,
gravely conducting, directing, with her strong open right hand, and
pointing with the ceremonial instrument in her left.

It is hard to believe that a purely artistic decision, arising from a

felt inadequacy of the drawing—a need to fill the space more effectively or to strengthen the silhouette of the figure—could alone account for this radical change. The painted figure is a new personality, one that assumes a role, facing the world with a certitude lacking in the other. The drawn woman, with arms immobilized and defined by a contour of short tentative strokes, a being that recedes from her surroundings and seems to suffer the pressures and eroding forces of the space about her, has become in the painting an expansive organism. Her limbs reach out to the corners of the canvas; the silhouette of her back, while swelling towards the frame, maintains the erectness of the body as a column; and there is in the decided contours of the bent arms and hands a curious symmetry with respect to a horizontal axis, that gives her a more complete command of the space and reinforces the tectonic of her deliberately assumed posture. The drawn figure clearly sits, however vague the implied lower body and support which are veiled by the upper part of the skirt with its great arc of horizontal span. The rounded back and flattened drooping chest that together narrow to receive the long, thin, forward-tilted neck are enough to fix the seated position. In the painting we are uncertain whether the woman is sitting on a high post or stands with one leg advanced and raised on a block or step. In either case it is a tense erect bearing in which the latent energies of the body are implied. Her costume, too, close-fitting like an athlete's, sustains the impression of the pose.

What does this figure represent? It is exceptional among Picasso's works of that time in the arbitrariness of the pose. The meaning is not evident like that of a portrait or nude model in the studio, and we can guess at an implied sense only by imagining a larger whole from which the figure has been abstracted.

Years ago as a boy I saw in the Royal Museum in Brussels a similar figure that has remained vivid in my memory. It is Ingres' magnificent *Augustus* listening to Virgil read from the Aeneid (Fig. 2), a theme excerpted from his picture of *Virgil Reciting his Poem to the Imperial Family.*[2] Is it possible to doubt the inspiration of this work

in Picasso's painting of 1905? If so, one must admit a remarkable convergence of the works of two painters from different points of departure. Picasso had made a trip from Paris to Holland earlier that year, but did not see the original canvas then, I have been told.[3] Ingres, however, was a master congenial to the young artist who was attracted at that time by a classicist ideal of drawing.[4] But what was painterly in Picasso's work during the preceding years is still present in the new canvas in the accented touches of light and shadow on the contour of the figure as well as in the palpable brushwork of the background; the palette of that earlier art prevails in the cool somber tones, the blue and violet of the costume. The idea of form that recalls Ingres' great example commanded no thorough revision of Picasso's style and is more evident in the representation of an Ingresque posture than in a corresponding firmness of line.

The resemblance to Ingres' painting touches more than the plastic conception of that single figure. Common to Ingres and Picasso in this context is the representation of a dominant personality addressing an unportrayed but clearly implied observer—the object of the profiled figure's gesture and glance. What Ingres had done in giving to his family group a grander, more concentrated sculptural form by detaching Augustus and the two women from the occasion and setting —the poet in the palace reciting to them by lamplight his poignant verse, *Tu Marcellus eris*—and thereby fragmenting the episode of the original picture so that Augustus, in what appears as a less intelligible *morceau* of a history painting, seems to address a presence outside the field of the picture,—this transformation of a listening majesty into an active commanding one Picasso effects by addition rather than subtraction, in revising his single figure. The common subjective moment in both works includes the virtual responding or attentive person who is not represented but whom we are led to imagine; and while this shift is for Ingres a decided change from his life-long attitude in historical painting where he habitually presents together as on the stage of a theatre the speaker and the hearer, the leader and the led,[5] for the young Picasso, who had in the preceding years depicted so many

figures in solitude and in postures of torpid brooding, the isolation of a figure in profile was no change, yet its active communication with a partner beyond the picture field was indeed something new.[6]

In Picasso's transformation of the Oberlin drawing one may see an instance of a general process of his art at that time in the passage from the "Blue" to the "Rose" style. It is a step towards autonomy and strength not only through the more pronounced cohesiveness of forms but also through an increasingly impassive figure freed from the pathos of the depressed, socially marginal types set in self-enveloping postures, so frequent in the blue series. The self-absorbed, often outcast, homeless persons are replaced by figures of bodily charm who possess their space with the confident bearing of the admired beauty or the young athlete-hero, and display themselves victorious in public.

During that year 1905, Picasso often introduced in his paintings and drawings a figure with arms raised above the head or extended energetically beyond the core of the body. It is a woman, clothed or nude, who adjusts or combs her hair or lifts a baby in the air; a girl of the circus milieu who, in balancing herself on a round stone, raises her arms asymmetrically for equilibrium (Fig. 3, Chapter 9); a bareback rider with whip in outstretched hand; an acrobat supporting a smaller horizontal figure on one lifted arm.[7] Seen beside the dolorous types of the previous years, this new strength and expansion of the body is a noteworthy change. Those were most often conceived in self-inhibiting postures, reflexes of the limbs concurrent with the depressed faces and the moody atmosphere of the prevailing color, the overcast of blue. Among the works of this new phase are still pictures that maintain the contracted mood; what is called the "Rose Period" includes many paintings with a pronounced blue or with strong chords of blue and rose or with cool or finely neutralized red, just as the faces and even the bodies retain something of the earlier *tristesse*. But the trend is unmistakably towards the overcoming of the pathos of those works through a happier imagery of beauty, strength, agility and daring, in which even a large mass of blue acquires a more cheerful aspect through its context and the contrasts with neighboring tones. The masterful performer, the applauded virtuoso, the beautiful young man

Fig. 1a Picasso: *Woman with a Fan*, 1905. Drawing, black ink and pen, 12⅜″ x 8⅜″. Allen Memorial Art Museum, Oberlin College.

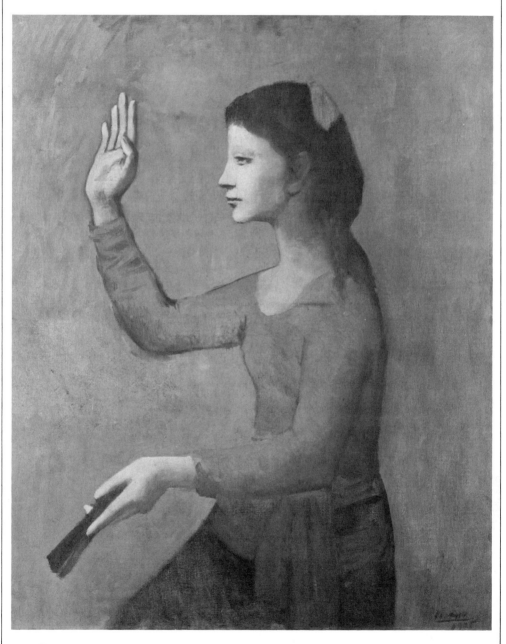

Fig. 1b Picasso: *Woman with a Fan*, 1905. Oil, 39″ x 31½″. National Gallery of Art, Washington, D.C.

Fig. 2 Ingres: *Tu Marcellus Eris*, 1819. Royal Museum, Brussels.

Fig. 3a Picasso: *Boy in Blue*, 1905. Oil on canvas, 39⅜″ x 32″. Photo: Courtesy, The Museum of Modern Art. Private Collection.

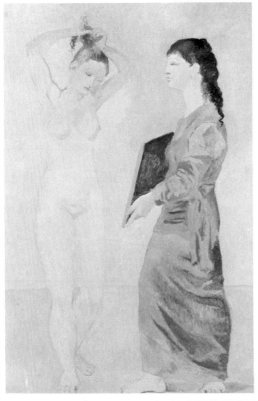

Fig. 3b Picasso: *La Toilette*, 1906. Oil on canvas, 59½″ x 39″. Albright-Knox Art Gallery, Buffalo, New York. Fellows for Life of 1926 Fund.

Fig. 4a Man Ray:
Photograph of Picasso,
1935.

Fig. 4b Picasso: *Young
Harlequin and Mother,*
1905. Staatsgalerie, Stuttgart.

or woman, emerges from the old sphere of the circus artists and the bohème, a community of fellow-sufferers steeped in melancholy induced by poverty and estrangement. A picture complementary to the *Woman with a Fan* and significant of the painter's growing sense of the accomplished and recognized artist-self is the *Boy in Blue* (Fig. 3a).[8] It is a stage in that growing emancipation, in which the old self is still discernible in traces of doubt and neurotic weakness. Here the fantasy of a surmounting effort, of a future strength and glory, endows the picture with the attributes of success; the wreath on the boy's head, the garlands of flowers decorating the wall behind him, spell out the painter's laureate consciousness. (In a drawing made not long before, Picasso portrayed himself in profile with pipe in hand in the same gesture as that of the *Boy in Blue*.[9]) In another painting of that year a youth, naked and frontal, like a bather by Cézanne, leads forward with an extended hand a noble horse in a graceful statuesque posture.[10] It is an art of youthful triumph, with an allusive elegance and suavity of line that recall the great masters of French and Italian tradition, the crowned art of the museums. But even then the young Spaniard's work retains in the delicately nuanced rose and grey a touch of sadness, the old pain of loss and solitude, despite the victory. In the *Woman with a Fan* the eye, narrowed by the heavy upper lids, is the sign of this still brooding spirit. Her limbs, while extended, are still rigid like the body as a whole, and the figure is essentially immobile; the hands with palms out are bent backward at the wrist, a posture of strain that appears also in the left hand of the *Boy in Blue*, holding the small pipe; his right, which in a preparatory drawing clasped the left arm in the habitual self-enclosing gesture, is allowed to hang limply between the parted legs.

There is another version of the figure with the fan in a picture called *La Toilette* in the Albright Museum (Buffalo), painted in the following year (Fig. 3b).[11] The clothed woman, who holds a mirror before the nude combing her hair, is in her upper body and particularly in the conception of the left hand and the strict profile of the head, as well as in the costume with the exotic sash, the sister of the

Woman with a Fan. Here she is the servant, immobile and impassive, of the graceful nude who contemplates herself in the mirror with hands raised above her head and combs her lifted hair. One can speculate on the significance of the contrast of the two figures: the nude beauty—frontal, blond, self-elongating, symmetrical, smoothly balanced—and the clothed, stiffly stationed maid in profile, with hair falling to her shoulder, as dark as the back of the mirror—a shape silhouetted like her hair—and with the awkward plant of the heavy feet, so unlike the lightened, pointed extremities of the nude. Two contending aspirations of the young artist are perhaps projected in this coupling of mistress and maid in which the latter maintains an air of ritual dignity and strength. We may see it as an allegory of art or at least as an automorph of the painter's striving; for the mirror is both palette and canvas and the shadowless nude is the idealized beauty that the artist would win and transpose to the canvas; the servant then is no menial secondary figure but the painter himself—a smaller, less glamorous, less beautiful being who in holding up the mirror to beautiful nature is resolute, firm, and solemnly engaged.

In later works variants of the posture of the *Woman with a Fan* reappear in other contexts and suggest a persisting importance of that conception as a root image of the artist. In his pictures of a painter and model—a theme obviously pertinent to an artist's self—the painter in strict profile holds a brush (or pencil) in his raised right hand and a palette in his lowered left.[12] In the *Woman at the Mirror* of 1932 the hand is extended high to the image, and the association with the multiplied doubling of the figure as body and mirror image, and as inner and outer body with a profile and a frontal head—one more apparent, the other shadowy or fantasmal—recalls the coupling of the nude and the servant in the *Toilette* and revives our question about the sense of that picture as a projection of a duality in the artist's self.[13]

I return to our starting-point: the transformation of the Oberlin drawing. It is not only a process of painterly invention, but a critical moment in the development of the self, that brings to the surface of the art a new relation of conflicting or at least opposed tendencies of

feeling. If we do not grasp the change in its inner unfolding or venture to explore it, we observe the results in the series of subsequent works. The painter of passive dolorous figures becomes, not long after, the far-reaching innovator, the revolutionizer of modern art, at first through more compact and austere, strongly cohesive forms, then through vehement, angular, abrupt shapes of a savage intensity, with brusque contrasts of rose, blue, and grey, as in the *Demoiselles d'Avignon* where we recognize postures and other elements of the Rose period but in a radical revision of the classic canon of the statuesque body as well as of the decorum of execution. A few years later the Cubist works inaugurate a new era of painting in which representation in its age-old sense is submerged in an art of autonomous construction with discontinuous lines and flecks and a complexity inherited from the most advanced naturalistic compositions. Yet far from holding to his basic invention, he moves freely afterward between a constructed, sometimes grotesque, figuration on one side and an imagery with classic forms and allusions on the other, in frequent oscillation. In all these variants there appears a vigorous, urgent, unrelaxing, imaginative play of two great powers: seeing and manipulation, the strong forces of the eye and the hand, both demonically alert, the one to singularities and concurrences of form in the work of art, and the other to the potentialities of the instruments and the materials as thoroughly plastic and submissive—the grounds of a perpetual passage from the natural to the artistic and from the artistic to the natural. To realize this capacity for transformation—and Picasso himself has spoken of his art as a sum of destructions—he had to overcome an earlier disposition to exploit a precocious virtuosity, a treasure of traditional skills—this he did by a bold sacrifice of the means which were the fruits of a long discipline of the school—and he had also to master the feelings that inclined him to his early themes of the depressed and estranged. All this he accomplished, without loss of spontaneity or of capacity for intense fantasy and expressiveness, in the sequence of styles between the Blue phase and the Cubist works through which he became the historic master with the originality and strength that we know.

A brilliant photograph of the artist made by Man Ray in 1935 is the clearest image of this self-transformation and its polar terms (Fig. 4a).[14] The tense self-binding posture, with head supported by a hand and an arm which is in turn held by the other arm, brings to mind certain pictures from his Blue phase and especially the painting of the *Young Harlequin and his Mother* (Fig. 4b).[15] But in contrast to the sad features, the veiled and averted eyes, and the delicate limbs of those frail, alienated artists of the circus—so strong and agile on the tight-rope and trapeze, so weak in common life—Picasso presents himself to the camera in that closed posture with a pair of unforgettable penetrating eyes and with the strong hands of a preternatural power of manipulation—the powers of the sovereign artist as an inventor and controller of forms, passionately intent on both the visible and the tangible as resources of his art.*

NOTES

[1] 7, 16–18. See also in the same periodical, Norma F. Broude, *"Picasso's Drawing, Woman with a Fan: The Role of Degas in Picasso's Transition to his 'First Classical Period',"* 29 (1972) 78–89. For variants of this drawing and studies for it, see the Zervos catalogue. *Supplément aux années 1903–1906*, 22 (Paris 1970) nos. 276–278, pls. 104–105.

[2] For the latter, painted in 1812 and now in the museum of Toulouse, see G. Wildenstein, *The Paintings of J. A. D. Ingres* (New York 1954) fig. 50, cat. no. 83, p. 179. There is also a later version on paper—*ibid.*, fig. 49, cat. no. 320, p. 178, and another dated 1822, reproduced by Norman Schlenoff, *Ingres, ses Sources Littéraires* (Paris 1956) pl. 12 and pp. 103–105. On the painting of 1819 in Brussels, see Wildenstein, *op. cit.* pl. 53 and no. 128.

[3] I owe this information to the kindness of my friend, Jean Leymarie, director of the Musée National d'Art Moderne, Paris.

[4] His picture, *The Harem* (1906) in the Cleveland Museum—Chr. Zervos, *Pablo Picasso 1, Oeuvres de 1895 à 1906* (Paris 1932), no. 321, pl. 143, and Paolo Lecaldano, *The Complete Paintings of Picasso, Blue and Rose Periods* (New York 1970) pl. 61— was apparently inspired by Ingres' *Bain Turc*—Wildenstein, *op. cit.* pl. 113—though so different in detail. It was the show-piece (no. 1) in the great retrospective exhibition of Ingres' works at the Salon d'Automne of 1905 before its acquisition by the Louvre. Picasso's painting *La Coiffure* in the Metropolitan Museum (Zervos 1, no. 313 and Lecaldano pl. 51) presents a motif from the *Bain Turc* in reverse and clothed.

[5] A similar excerpting from a larger composition is the nude *Angelica* (Wilden-

stein *op. cit.* pl. 16, cat. no. 287) which is taken from the *Roger and Angelica* (*ibid.* pl. 52, no. 224).

⁶ The figure in strict profile is common among his early paintings and drawings, often with an effect of withdrawal or introversion, though there are examples, too, of the impassive objective profile that brings to clearer view the nose and chin. Close in time to the *Woman with a Fan* is the half-length *Young Man with a Lace Collar* (Lecaldano [1905] pl. 45 no. 213), on loan at the Worcester Museum; the pose with hands at breast and hip isolates the figure completely as in a portrait.

A digression on this point, but not far from our main theme: For the posture of our figure a precedent in Picasso's earlier work is a drawing of 1901, called a parody of Manet's *Olympia* (Lecaldano, p. 84). Here he represents himself recognizably in strict profile in the right foreground, sitting at the bedside of the naked Negress, with extended right hand bent back and pointing towards her like certain foreground figures in religious pictures of the 16th and 17th century. There is a dog as well as cat on the bed, and the black servant of the original *Olympia* is replaced by the figure of Picasso's friend, Sebastian Junyer Vidal, carrying a platter of fruit and drink instead of the bouquet of flowers. Certain of these deviant details appear in Cézanne's adaptations of the *Olympia*: the figure with the tray of fruit and drink, the artist in the right hand corner, the presence of a dog—these are as in the well-known picture called *L'Après-Midi à Naples* (L. Venturi, *Paul Cézanne, son Art, ses Oeuvres* [Paris 1936] no. 225) and, with more overtly erotic variations, in the sketches for this work in which the man is naked and dark-skinned (*ibid.*, nos. 112, 223, 224, 820, 822, 1177, 1178, 1181). It seems likely that Picasso's drawing was inspired as much by Cézanne as by Manet, and this is all the more credible since he exhibited in 1901 at the gallery of Vollard, who owned several of those sketches of Cézanne and later reproduced some of them in his book (*Paul Cézanne* [Paris 1914] 60, 121). This allusion of Picasso to Cézanne in 1901 is an interesting evidence of the nature of the young artist's response to the still living and already greatly admired master—not at all a response to Cézanne's mature form and color, as in the years 1908–1909, but to his youthful fantasy and passion. In 1935 Picasso was to say in an interview: "What forces our interest is Cézanne's anxiety—that's Cézanne's lesson." (Alfred H. Barr, *Picasso, Fifty Years of his Art*, Museum of Modern Art [New York 1946] 274).

⁷ See Lecaldano, *op. cit.* nos 165, 173, 174, 176, 180, 182, 194, 203, 204, 241, 259, 271, 272, 275, 289.

⁸ For a color reproduction, see *ibid.*, pl. 46.

⁹ *Ibid.*, no. 152.

¹⁰ *Ibid.*, pl. 50 in color.

¹¹ *Ibid.*, pl. 60, in color.

¹² (1928) Barr, *op. cit.* (supra, n. 6) 156.

¹³ Barr, *op. cit.*, frontispiece in color. Cf. also the etching of this subject as an illustration for Balzac's *Le Chef-d'Oeuvre Inconnu* (*ibid.*, p. 145)—a work of 1927. Here the transformation of the model's form into an abstract tangle is the reverse of that in the painting where an abstract-looking model is converted by the abstract-looking artist into a natural profile. The girl in profile with raised or outstretched hand appears again in later works of Picasso: in the portentous etching, *Minotauromachie* (1935, *ibid.*, p. 193), with a lamp in one hand and flowers in the other; in *Guernica* (1937), with a lamp. But in this last example, in which the woman surmounts the scene of violence, there was perhaps a stimulus from a similarly placed figure on familiar monuments of the

French revolutionary past in Paris, works particularly suggestive to the artist on the occasion of his monumental canvas painted during the Spanish Civil War: the woman of the "*Marseillaise*" in Rude's sculpture on the Arc de Triomphe at the Place de l'Etoile, Delacroix's *Liberty on the Barricades*, and the angel with the torch in Prud'hon's painting of *Justice Pursuing Crime* (Louvre); in all of these appear other elements that recall *Guernica*.

[14] The photograph was reproduced originally in *Cahiers d'Art* (1936), frontispiece.

[15] For a color reproduction see Lecaldano, *op. cit.* (supra, no. 4) pl. 28. Cf. also the postures in the etching *Le Repas Frugal* (1904, *ibid.* p. 86), and other early works —*ibid.* nos. 1, 3, 4, 10, 11, 24, 138, and with features like Picasso's in 141.

* I wish to thank Dr. Miriam S. Bunim for her help in the preparation of this article.

CHAGALL'S
ILLUSTRATIONS FOR THE BIBLE
(1956)

I n undertaking to illustrate the Bible, Marc Chagall was moving against the stream of modern art. Most painters today do not take to a set theme; they prefer the spontaneous, the immediately felt, and often discover their subjects on the canvas while at work. Besides, the Bible belongs to a realm of ordained belief, a superpersonal world of ritual and laws, which would limit the freedom that is the indispensable condition of the artist today. (It is clear that this freedom entails for many artists certain strict taboos of subject and form.) Yet our culture is strongly attracted by the Bible—never has it been studied so much as in our time. Not only as poetry and myth, but as a revelation of essential humanity; its episodes and avowals have become a permanent part of our thought.

It should be said, too, that, apart from its poetic value, the Old Testament is a living book because of our open interest in the moral, the social, and the historical, whatever our beliefs. The Old Testament, in spite of its mixture of legend and fact, is history in a noble sense. It traces the formation of a community and its highest values, and recounts its fortunes and misfortunes, its great moments. The Old Testament includes also the *consciousness* of history, in referring back so often to the founding occasions and in the prophetic visions of the future, the setting of ideal goals. A striving toward right in purity of spirit, a feeling of commitment and fulfillment, pervade the book.

History here is not only of great exemplary individuals, but also

121

of a community to which they belong and for which their action is directed. The self is at its highest when acting for the community in a superindividual but personal bond. The prophet—the irrepressible man of moral courage, imbued with the most intense awareness of existence—speaks to the whole people.

Nothing of this seems to exist in modern art, yet the Bible is in many ways not far from our thought, although the conditions of life are so different. In spite of the brutality that has darkened the last decades, mankind is not less sensitive than in other ages; we feel today more than ever the oneness of humanity and the common need for justice, good will, and truth.

The painter who turns to the Bible as a subject matter in our time does so in another spirit than the artist of the Middle Ages. He is no longer bound to a precise religious meaning of the text. His choice of scenes does not have to suit the demands of an established creed. He reads the text by himself and responds according to his own feeling for its human and poetic sense. Not that the old artist was blind to other values besides the religious; the old Christian imagery of the Bible is an astonishingly varied reservoir of fantasy and emotion. But the medieval painter was held in fact to the system of interpretation developed during centuries of clerical scrutiny and comment. This could also be an advantage, perhaps; the themes he was called upon to represent were a common part of culture, their meaning was well established, so that the painter could concentrate on the artistic realization. Any departure in rendering would be perceived then, against the background of tradition, as a distinct vision of the familiar subject.

Medieval Christian art, broadly speaking, knew two kinds of selections from the Jewish Bible: one theological, the other more purely narrative. The first was based on a common symbolism, a so-called typology, which referred the episodes and figures of the Old Testament to the main themes of the New, as if the early prefigured the later, the New Testament being a completion or fulfillment of the Old. The Sacrifice of Isaac corresponded to the Sacrifice of Christ, and Samson Carrying the Gates of Gaza was an antetype of Christ's Resurrection. Adam's Temptation and Fall as the first sin was a cor-

nerstone in the Christian plan of the incarnation and redemption. These subjects of the two Testaments were often represented together.

The other kind of illustration, a continuous pictorial sequence of the episodes of the most important books, also betrayed at certain points the presence of Christian ideas in the greater weight of some symbolic themes.

In both cases more than one motive often prompted the choice of a theme. Every incident or figure had many values which emerged in the different pictorial interpretations; but there was a basic Christian meaning that assured the constancy of the theme or its relative importance.

For a modern painter—as for most artists in the past who were commissioned to illustrate the Bible—a complete representation is impossible; the Bible is too long and too rich in episode. He will represent only what has stirred him and what has stood out in this great mass of writing as he reads for himself, with his interests and peculiar imagination.

Here I may observe the great difference in scope between the Old and the New Testament that was important for both medieval and Renaissance art. The New Testament, and particularly the Gospels, is about a unique example of sacrifice and redemption; dealing with the life of one great figure and a group of followers within a single generation, it offers relatively few elements of everyday life. The Old Testament, on the other hand, is a whole literature, spanning perhaps a thousand years. It describes creation and the first men, the founding of peoples, institutions, laws, customs, and kingdoms. God is everywhere, and the relations of God and men fill its pages. If the Evangels are a drama, the Old Testament is an epic, although not without moments of high drama too. The New Testament isolates one region of experience, the religious, as the exclusive domain of the ideal; the Old Testament is about the totality of existence, the profane and the sacred—family, love, war, power, statehood, slavery and freedom, home and exile, are all there, in many landscapes. It is chronicle and myth, law and prophecy, and pure lyricism.

And how does Chagall envision the Old Testament? Let us look first at his themes. In his choice Chagall is attached to a few great figures. He represents the patriarchs: Noah, Abraham, Isaac, Jacob and Joseph; the story of Moses and the exodus from Egypt; Joshua, who led the Jews into Canaan; Samson, David, Solomon; then follow the prophets Elijah, Isaiah, Jeremiah, and Ezekiel. Much that is picturesque, delightful, and touching in the Old Testament and that is a familiar part of Jewish imagination has been ignored. Chagall does not tell the story of Adam and Eve, which had interested him early in his career; Cain's crime, the Tower of Babel, the earlier episodes of the Flood, are not here. The novelistic books of Ruth and Esther are omitted; absent, too, are Daniel, Jonah, Job, the Psalms, the Song of Solomon, the so-called Wisdom books, and the apocryphal Judith, Tobit and Maccabees.

Is this choice a random one, without a basic order? Anyone accustomed to study the great cycles of medieval imagery will recognize that Chagall, too, has created according to a plan. I do not mean to say that he followed an already established theological design in selecting the subjects for his plates. But his choices, with all their singular personal elements, fall into three significant groups: a) the great ancestors who founded the Jewish community and received from God a covenant and law; b) the achievement of nationhood with Joshua, Samson, David, and Solomon; and c) the prophets, in their integrity and solitude, their vision of God and prophecies of the misfortunes and consolations of Israel.

These together form a characteristic unity of Jewish awareness, with its strong ethical and communal content and longing for Zion. But in Chagall's Bible the worlds of the patriarchal, the heroic, and the prophetic, which seem to imply an austere imagery of solemn, grandiose figures, also include numerous scenes of the festive, the erotic, the joyous, the intimate familial, the miraculous and fantastic. Very little that has appeared in Chagall's painting fails to turn up somewhere in his images of the Old Testament. But there are in these etchings many things that could occur only in the context of the Bible.

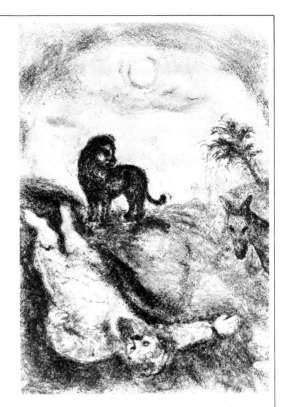

Fig. 1 A Prophet who had disobeyed the Lord is slain by a lion (*I Kings* 13:24–28).

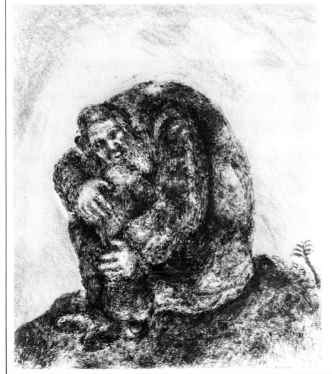

Fig. 2 Elijah at the top of Mount Carmel announces the coming of rain before a single cloud has appeared in the sky (*I Kings* 18:41–46).

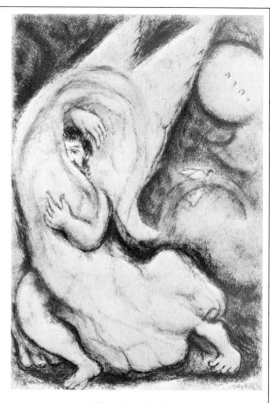

Fig. 3 God's mercy proclaimed to Jerusalem (*Isaiah* 58:8–11).

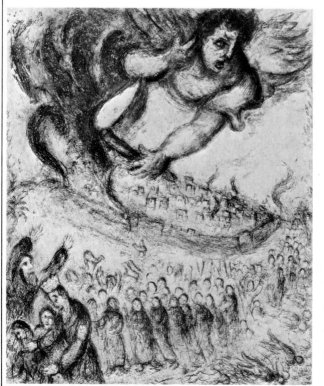

Fig. 4 Jerusalem is taken by Nebuchadnezzar in accordance with Jeremiah's prophecy (*Jeremiah* 21:4–7).

I have said that in this choice Chagall expresses a specifically Jewish vision of the Old Testament. But it is a personal choice and not the carrying out of an already existing systematic program. He has not followed an older set of pictures, though certain of his scenes may be found in medieval illustrated Hebrew manuscripts. Much here is new, and, even in the rendering of the traditional subjects, it is clear that Chagall has read the text for himself. Certain of his themes are highly original and arresting; it is hard to recall other Jewish or Christian representations like these. We recognize here a fresh approach to the Bible and the response of Chagall's poetic heart and fertile imagination.

It is interesting at this point to consider his etchings of themes from the prophets. He begins with the remarkable story from I Kings of the unnamed prophet who is killed by a lion after having violated his promise to God (Fig. 1). Gustave Doré had chosen this rarely illustrated episode, and it is instructive to compare his version with Chagall's, which breathes an incomparably deeper poetry as well as sentiment of form. The latter's is a scene in which the fatality of the prophet's calling and the uncanny watchfulness of God are beautifully rendered.

The scenes of Elijah's mission follow, a series that shows the prophet in action, his wandering, the miraculous force that works through his faith, his prayer on the mountaintop (Fig. 2), and his ascension to heaven. Something of Jewish folklore clings to these images of the homeless prophet of the desert who has left no book but is known through his action alone. Several of these scenes have been represented in the synagogue of Dura, though not the wonderful episodes of the prophet in the cave hearing the still small voice and alone on Mount Carmel.

Turning to the author-prophets, Chagall has selected from their extensive writings a few verses that distinguish them as individual minds and compose together a rounded view of the prophetic books. Isaiah is for him the prophet who has been purified by the burning coal placed on his lips by an angel; he speaks of God's love for sorrowing Israel and of the future consolations of peace and the restored

Zion. Jeremiah is the prophet of Israel's doom and suffering, and he himself suffers imprisonment for his words. Ezekiel is the visionary of God's numinous glory in the fantastic image of the four living creatures at the heavenly throne. Chagall evokes, too, the Jewish dedication to the sacred word in the scene of the roll given to Ezekiel to eat —a powerful image of magical absorption and inspiration.

One etching from Isaiah is an astonishing choice which is unknown to me in other. Biblical cycles. It is the etching of God's mercy proclaimed to Jerusalem (Fig. 3) and renders the following verses—a most unlikely text for illustration: "For the Lord hath called thee as a woman forsaken and grieved in spirit, and a wife of youth, when thou wast refused, saith thy God. For a small moment have I forsaken thee; but with great mercies will I gather thee. In a little wrath I hid my face from thee for a moment; but with everlasting kindness will I have mercy on thee, saith the Lord thy redeemer."

It is a haunting image of God as an angel veiling himself behind his robe, which is vaguely like a woman in his arms. The metaphor and its object have been condensed in a single figure. A grandiose Blakean rapture fills this page.

Another imposing etching is Jeremiah's prophecy of Jerusalem's doom (Fig. 4). God's wrath is pictured through the tremendous angel with the brand over the burning city and its fleeing people.

Although Chagall illustrates what he has read and knows by heart, his rendering is sometimes touched by memories of older works.

The *Sacrifice of Manoah* recalls Rembrandt's painting in the Louvre of the *Angel leaving Tobias*; and the *David Playing before Saul* seems to be a reversal of Rembrandt's great painting of this scene. The image of Solomon on his throne (Fig. 5), with the medieval scepter and globe—attributes of royal power—is perhaps based on a Carolingian or later conception of the ruler.

A more striking example of Chagall's use of a Christian detail is the horned Moses—a curious borrowing on which I may be allowed to digress. The odd rendering of the patriarch, familiar to everyone through Michelangelo's statue, is common in medieval art. It has been

supposed that in the medieval mystery plays horns were attached to the head of Moses to represent the rays that shone from his face (Exodus 34:29), and that the artists copied these horns from the theater in their paintings and sculptures. But the horned Moses had been represented in art long before the time of the first mystery plays. It is known that the horns of Moses come from Saint Jerome's mistranslation of the Hebrew word for ray—the same root k-r-n stood for ray and horn; the similarity to the Latin *cornu* and the existence of horned divinities in the ancient pagan world perhaps contributed to the error. Chagall has read the Hebrew text and also knows, no doubt, the Jewish legend that Moses' face shone already before his second descent from Mount Sinai—Moses wiped his forehead with the divine ink after writing the Torah on the mountain, and from this ink came the rays of light. In Chagall's pictures the rays are a permanent attribute of Moses; they appear before the revelation on Sinai in the scene of the Burning Bush (Fig. 6), although they are sometimes replaced by the horns, as in the *Plague of Darkness*, or assimilated to them in their form. Both attributes, the one heavenly, the other demonic, are expressively right. They give to the patriarch a superhuman aspect, a quality of the portentous and charismatic.

We discover in certain scenes the effect of the more recent historical approach to the Bible, but this is a matter of detail, an enjoyment of cultural perspectives and local color which never displaces the free play of the imagination. Chagall has travelled in the Near East, and like the artists of the last century has represented various figures in the costumes of the modern Bedouins, who were believed to retain the aspect and customs of the nomads of the Old Testament. He has set them in the original landscapes of Palestine and Egypt and he has recaptured the fragrance of the Near East, as in the *Tomb of Rachel* and the charming scene of the *Finding of the Infant Moses*. In some etchings, too, there is a hint of the archaeological remains of the Biblical period not only in material aspects of the figures, but also in their expression—the massive profile forms of God and the Just Man recall the gigantic bas-reliefs of the Assyrian and Babylonian temples.

But more often Chagall pictures the text with the same freedom,

unsophisticated by knowledge of history and ethnography, as the art-
ists of the Middle Ages, to whom it did not occur to distinguish
sharply between their own world and the long past world of the Bible.
It is in this spirit that he draws the recent Jewish emblem of the Star
of David in the scenes of the Old Testament, and decorates the Ark
of Covenant with the heraldic lions and the crown and star of the
Torah shrines of the East European synagogues he had known in his
youth.

What gives the strongest note of actuality and the air of authen-
tic spiritual life to his images of the Old Testament is the wonderful
veracity of the faces and bodies, taken from the ghettos of eastern
Europe.

The faces are profoundly, unmistakably Jewish and render with a
convincing accent the physiognomic of Chagall's people, their piety,
concern, and contemplativeness, all without idealization. He had no
need to idealize—the real persons he knew, who impressed his
memory indelibly, were so compelling and complete in their individ-
ual existence.

He has endowed these faces with bodies of a congruent nature—
lumpy, imperfect bodies of men who sit long at work, or live in prayer
and selfless thought; bodies of a clumsy articulation, the shoulders
hunched, the hands often clasped, without grace or firmness, the
opposite of the bland Greek and Renaissance figures which are so
well-muscled and balanced, so lithe and supple.

They possess a unique power of gesture; the whole body is itself a
gesture, like the prostrate Noah before God—a prayerful, humble
heap—or Elijah on Mount Carmel (Fig. 2). Awkward but never rigid,
these figures captivate us by the homely naturalness and sincerity of
their movements. If we had to relate these types to one of the great
historic styles, we could say that they are Jewish Gothic; they recall
to us the ties of their Yiddish speech to the German Middle Ages.

The figures of physical prowess—Samson, Jacob wrestling with
the angel—are no less awkward in their strength. They are rustic
strong men, massive and bovine rather than athletic, grasping or strik-
ing with inapt hands; it is amazing how clumsily they hold a sword or

Fig. 5 Solomon on his Throne (*I Kings 10:18–20*).

Fig. 6 God reveals himself to Moses in the Burning Bush (*Exodus 3:1–6*).

Fig. 7 The mantle spread over Noah who had uncovered himself in his drunkenness (*Genesis* 9:20–23).

Fig. 8 Noah sends the dove forth from the ark (*Genesis* 8:6–9).

weight. David's struggle with the lion is a dance, a duet, not a combat. Samson barely grapples with the lion; when he touches the pillars to bring down the palace, he seems to exert a magical more than a natural force, and the effect of the tumbling pillars is a little droll. But what grandiose force in the prophets and patriarchs! Not a force of the muscles, but of the moral person, who is often sheathed in a timeless robe which bounds an unarticulated bulk. A marvelous figure is Elijah on the mountaintop (Fig. 2) who "cast himself down upon the earth, and put his face between his knees." (I Kings 18:42). Faithful to the text, Chagall has drawn the prophet as a rounded mass in the most intense self-immersion, a human boulder within which the great head and hands alone can speak.

It is not from repudiation of the flesh in a spirit of shame or ascetic constraint that Chagall has produced these ungainly forms. Where the text requires it, as in the episodes of Noah's nakedness or Lot's daughters—the latter a scene of legitimate, rational incest, treated as a natural fact—he represents the naked body with innocent admiration as voluptuous and strong. But it is never the regular classic frame with its smooth, pre-established harmony, as we know it in Greek and Renaissance art; it retains always some fresh accent of the felt and imagined flesh—a still unanalyzed and unmeasured force. The young figures—Joseph, Rebecca, and David, bearers of a Biblical sentiment of pastoral beauty—have a plebeian or tribal grace; they are hardly elegant in the traditional Western sense and betray at some point a touching disproportion, a stress that singularizes the posture, prolonging an axis or weighting a limb.

In all his scenes, Chagall is deeply attentive to the momentary moods of his characters. Their faces change radically with their moral state, like Noah sober and drunk, David inspired and sensual, Joshua as warrior, teacher, and judge. How different is the mild animal face of the naked Noah, a Jewish satyr (Fig. 7), from the patriarch with his family and beasts in the Ark (Fig. 8) or in the scene of the Covenant! And the fierce barbaric Joshua girded for battle (Fig. 9) from his later manifestations! The action determines also the body's proportions and weight: Jacob wrestling with the angel becomes a more powerful

figure; the aspect of Moses is transformed remarkably from scene to scene with the content of his role. The personality is the action and must be grasped freshly at each stage; it is never a stereotype as in older art. This flexibility of conception applies, too, in Chagall's rendering of the angels and God.

Chagall feels awe before the divinity. How can he render God, who has forbidden all images? He has given the answer in the *Creation of Man* (Fig. 10). God's name is inscribed here in Hebrew letters in a luminous circle in the dark sky. A bearded angel—a figure strange to eyes accustomed to Christian art—holds the still inert body of the first man; his arm merges with Adam's arm and breast; looking back, he flies and is suspended at the same time. Note, too, that the angel is clothed and the beardless Adam nude—a reversed projection of the human upon the divine. By this ambiguity and tact of the imagination Chagall evokes the secret affinities of the human and divine. Adam's body seems in part a prolongation of his creator or his creator's angelic agent. He exists unconscious in the heavenly space before being cast into the terrestrial void. There is in this magnificent first image of the Bible a dreamlike atmosphere of the mysterious primordial and supernatural; man seems to come into being in darkness and abandonment but also in celestial hands.

The angelic and divine, I have said, appear throughout in ever-changing forms. In Chagall's Bible there is no set convention for the superhuman world. In some scenes, great circles of light and the inscribed name betoken the divine, and in the parallel scenes of Moses receiving the law and Ezekiel's vision of the book, the hands of God are depicted. But most often God is represented by mediating angelic beings of many faces and postures. With their rustic wings, they fly, rise, descend, float, approach, and recede, sometimes in dramatic foreshortenings; their bodies have a supernatural flexibility—they twist and lose their human contours in their prodigious motion; they are like pinwheels and stars, whirling and luminous phantoms. Chagall's lifelong command of the flying figure reaches here a climax of invention.

The perpetual dialogue between God or angel and man deter-

mines a dominant vertical in the vague depth of the picture (Fig. 10). Many scenes are without a horizon; man lives in a space of ascent and descent. And even where God is not present, the ground is often steep or tilted. Man walks with effort in a world of good and evil, ever conscious of what is above him.

I have spoken of these wonderful etchings so far mainly as images; they are no less fascinating as works of the hand.

These small pictures of great themes invite a close view not only of the details of the story, but also of the barely interpretable details of the artist's touch. They are etchings done from the standpoint of a painter who delights in color and the stroke of the brush, although they offer, too, a delicacy of drawing and other intimate qualities possible in etching alone. Chagall's engraved marks are a loving ornament of the page. In their minuteness they reveal the artist even more than the nature of the objects they combine to represent, as if the ultimate particles of this imagined world were a personal substance secreted by the artist's hand. The needle weaves an infinitely fine web of tiny points, hatchings, lines, grains of black—a shimmering veil, dense and soft, created with joy, filled with light and movement, often playful, sometimes grave, always captivating through its texture and tones. Its unit is the free stroke that has made etching since Rembrandt a modern art and was renewed in the later nineteenth century by Jongkind's fantastic scribbles of the clouded sky. Chagall's figures (and his larger fields) owe to this rich microscopic tissue of black their attractive warmth, their hairy, feathery forms, the hidden pulse of life which a strict outline could never bring. The broken touches build up scenes of monumental breadth and weight of contrast, or they evoke in their sparseness the softer notes of a lyrical theme.

In the composition of the scenes and interpretation of the text, Chagall seems to me to belong to the class of artists who may be called objective minds. This may seem strange to say of a painter distinguished above all by his daring fantasy. But we are considering here a trait that pertains to the imagination and can be found in realists and idealists alike. In general, there are among painters two approaches to the variety of their subjects. Some will give to the

varied subjects, whatever their sense, a common tone of feeling, whether of high excitement or passivity or some other state. El Greco and Piero della Francesca are clear examples. Others, like Giotto, Raphael, and Poussin, are more attentive to the quality of each episode in itself and seek for each a distinct order with a corresponding mood—to such a degree that they seem to have different styles for different kinds of themes. One imposes on all subjects the constant rhythm or tension of his own spirit; the other strives to express the theme as an objective fact, discovering through sympathetic imagination the necessary patterns for its basic sense. Chagall here is of this second type, and yet he is all feeling. But the same emotion does not dominate every episode alike. Confronted by the text, he is able to allow free play to his great receptiveness and understanding without loss of his essential qualities—his buoyant fantasy and warm, caressing touch.

The resulting range of the pictures is amazingly rich. I do not have to itemize what is clear enough in the plates—Chagall's capacity to create the sorrowful and gay, the grave and the charming, scenes of the most ingratiating lightness and the awesome apparitions of God. I believe that in this series his greatest achievement is in the images of the patriarchs and prophets, which possess the strongest contrasts, the densest areas of black and gray. In these plates he has responded most deeply perhaps to the major qualities of the text.

If you wish to see how astute and subtle is Chagall in discovering the expressive framework of an action, study in particular the scene of *Abraham's Sacrifice* (Fig. 12), where the knife is adjusted to the faggots on the altar and makes with Abraham's right arm a form like the parted wings of the angel above—a pattern of analogy and contrast which serves at the same time to express the impending action and to tie its elements into a firmer whole. Yet this is only a detail in the fuller, incalculable harmony of the work—so grandly simple and strong—which depends also on the massing of the tones with their rich nuances of dark and light. Throughout the book Chagall is especially inventive in composing the angelic and the human through the correspondences of wings and limbs. The *Creation of Man* (Fig. 10)

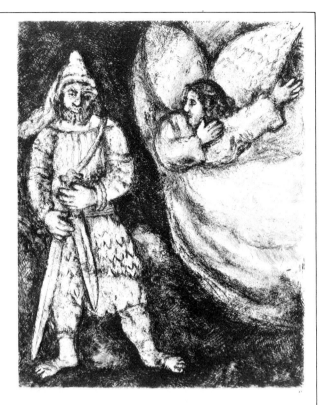

Fig. 9　Joshua, successor to Moses as leader of Israel, prepares to cross the Jordan under the Lord's order (*Joshua 1:1–6*).

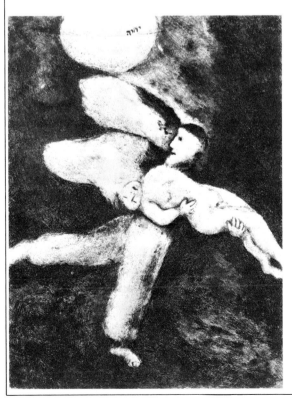

Fig. 10　God creates man and gives him the breath of life (*Genesis 2:7*).

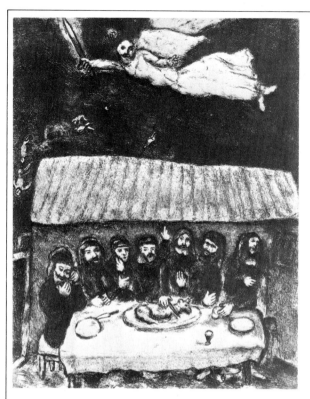

Fig. 11 While the angel of death passes over Egypt, the Israelites eat the paschal lamb (*Exodus 12:3–14*).

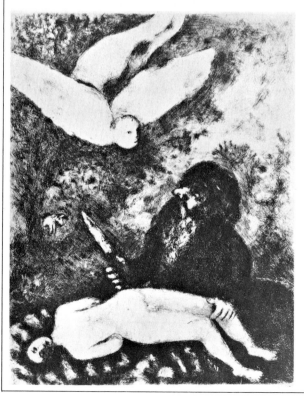

Fig. 12 Abraham ready to sacrifice his son in accordance with God's command (*Genesis 22:9–14*).

and *Joshua as a Warrior* (Fig. 9) are two great examples. The parted wings on a dark ground may serve as the emblem of the whole.

After the grandeur of early Christian and medieval art, after Rembrandt, the illustration of the Bible seemed a finished task. It is remarkable that in an age like ours an artist should risk this enterprise again.

Chagall is the chosen master for this task. The result owes much to the happy conjunction of his Jewish culture—to which painting was alien—and modern art—to which the Bible has been a closed book. Chagall was prepared for this achievement by his permanent receptivity of mind. He is a rare modern painter whose art has been accessible to the full range of his emotions and thoughts. This is less uncommon in poetry; but the painters in their enthusiasm for new and revolutionary possibilities of form and in their desire for an autonomous personal realm have come to exclude large regions of experience from their work. In the very beginning of Chagall's career, he pictured beside love and sorrow, the festive and the visionary, the extremities and high points of social life: birth, marriage, and death.

In accomplishing this work, he has surmounted, then, what seem to be the limits of his own and perhaps of all modern art.

He has represented themes of an older tradition not in a spirit of curiosity or artifice, but with a noble devotion. The work is wholly free from self-conscious striving; what is beautiful in it does not spring from a will to novel forms. Although these etchings are marvels of patient, scrupulous craftsmanship, there is no assertion here of skill or technical research, but an immersion in a subject which the artist convinces us often equals or transcends in value the work of art. The style seems natural and is submitted sincerely to the text, which comes to life in perfectly legible scenes, through Chagall's secure power of inventing expressive forms. In almost every image we experience the precise note of his emotion, his awe or sadness or joy, which is voiced in the melody of shapes and the tonal scale peculiar to each conception.

If we had nothing of Chagall but his Bible, he would be for us

a great modern artist, but also a surprising anomaly in the art of an age which otherwise seems so remote from the content and attitude of this work. It is a sign that modern artists have greater resources than modernity allows them to disclose—resources which are often unsuspected by the artists themselves, who would welcome, we may venture to suppose, the prospect of great walls to cover or monuments to erect, and would not be at a loss for subjects worthy of this scale, if their art were open to all that they felt or loved.

THE INTRODUCTION
OF MODERN ART IN AMERICA:
THE ARMORY SHOW

(1952)

T he great event, the turning-point in American art called the
Armory Show, was briefly this. In December 1911, some Amer-
ican artists who were dissatisfied with the restricted exhibitions
of the National Academy of Design formed a new society, the Amer-
ican Association of Painters and Sculptors, in order to exhibit on a
broader basis, without jury or prizes. The members did not belong to
a particular school of art; several of them had shown at the National
Academy itself. They came together not simply from opposition to
the aesthetic of the Academy (although there was a stirring towards
modernity among them) but from a collective professional need: to
create a more open market, so to speak, a means of exhibition acces-
sible to the unacademic and not yet established men. The most
active elements in the new society were the younger and more ad-
vanced artists; but not the most advanced ones, who seem to have
been less concerned about exhibitions or societies at that moment.

This aim of the Association was soon overlaid by another, which
none of the members perhaps foresaw. Their first exhibition, planned
as a great show of American painting and sculpture at the Sixty-ninth
Regiment Armory in New York—a show inspired by a new confidence
of American artists in the importance of their work and of art in gen-
eral—became an international show in which European paintings and
sculptures far surpassed in interest and overshadowed the American.
The change in the intention of the Show was due to the idea of the

president, Arthur B. Davies, to exhibit as well some recent European work. But while traveling abroad for this purpose, Davies and his collaborator, Walt Kuhn, were so impressed by the new European art, which they had known only slightly, and by the great national and international shows of the newest movements in art, held in 1912 in London, Cologne, and Munich, that they borrowed much more than they had first intended. They were caught up by the tide of advancing art and carried beyond their original aims into a field where they could not maintain themselves; their own work, while unacademic, was submerged by the new art. In the great public that attended the Show in New York, Chicago, and Boston in the spring of 1913, this foreign painting and sculpture called out an extraordinary range of feelings, from enthusiasm for the new to curiosity, bewilderment, disgust, and rage. For months the newspapers and magazines were filled with caricatures, lampoons, photographs, articles, and interviews about the radical European art. Art students burned the painter Matisse in effigy, violent episodes occurred in the schools, and in Chicago the Show was investigated by the Vice Commission upon the complaint of an outraged guardian of morals. So disturbing was the exhibition to the society of artists that had sponsored it that many members repudiated the vanguard and resigned; among them were painters like Sloan and Luks, who the day before had been considered the rebels of American art. Because of the strong feelings aroused within the Association, it broke up soon after, in 1914. The Armory Show was its only exhibition. For years afterwards the Show was remembered as a historic event, a momentous example of artistic insurgence. It excited the young painters and sculptors, awakened them to fresh possibilities, and created in the public at large a new image of modernity. It forced on many an awareness that art had just undergone a revolution and that much they had admired in contemporary art during the last decades was problematic, old-fashioned, destined to die. In time the new European art disclosed at the Armory Show became the model of art in the United States.

Because of the immense excitement provoked by the foreign works, it is easy to exaggerate the effect of the Armory Show upon

American art. The later course of art and public taste was undoubtedly the result of other factors besides this exhibition, although we can hardly estimate precisely how much any one of them counted in the end. It may be that, without the Armory Show, art today and our ideas about art would be much as they are. For some years before, there had been in New York a growing interest in advanced European art, supported and stimulated mainly by Alfred Stieglitz, the pioneer artist-photographer, at his gallery "291"; here were shown works by Rodin, Lautrec, Matisse, and Picasso, and by young Americans (Weber, Maurer, Marin, and Hartley) who had been abroad and absorbed the new art. American painters and sculptors had been going to Europe to study all through the last century, and the best of them had brought back the lessons of the latest European work. Paintings by several who belonged to the current of European modernism could be seen at the Armory Show. Since 1908 there had been a number of exhibitions in New York of artists who had banded together as "independents"; their work was hardly as advanced as what Stieglitz was showing, but it helped to prepare the public and the young painters for the newest art. Most important of all—although not easy to prove —the conditions that had disposed men to create a new kind of art in Europe were becoming more evident in the United States. The appeal of the new art coincided with a trend towards greater freedom in many fields. Modern art eventually came to satisfy a demand that was felt also in architecture, literature, music, and dance.

In this continuous process the Armory Show marks a point of acceleration, and it is instructive for the student of social life as well as of art to observe how a single event in a long series may acquire a crucial importance because it dramatizes or brings into the open before a greater public what is ordinarily the affair of a small group. The very scope and suddenness of this manifestation of the new art were a shock that stirred the sensitive more effectively than a dozen small exhibitions could have done. The Show, coming at a moment of intense ferment in European art, lifted people out of the narrowness of a complacent provincial taste and compelled them to judge American art by a world standard. The years 1910 to 1913 were the heroic

period in which the most astonishing innovations had occurred; it was then that the basic types of the art of the next forty years were created (Fig. 1). Compared to the movement of art at that time, today's modernism seems a slackening or stagnation. About 1913 painters, writers, musicians, and architects felt themselves to be at an epochal turning-point corresponding to an equally decisive transition in philosophical thought and social life. This sentiment of imminent change inspired a general insurgence, a readiness for great events. The years just before the first World War were rich in new associations of artists, vast projects, and daring manifestos. The world of art had never known so keen an appetite for action, a kind of militancy that gave to cultural life the quality of a revolutionary movement or the beginnings of a new religion. The convictions of the artists were transmitted to an ever larger public, and won converts for whom interest in the new art became a governing passion.

As a type of exhibition, the Armory Show was a challenging experience for the public which was placed here in a new role. It had to consider more than ever before an unfamiliar and difficult art. Its judgments were unprepared by the selections of an authoritative jury, nor could it rely on established criteria of its own. Through the Armory Show modern art burst upon the public like a problematic political issue that called for a definite choice. Taste as a personal decision assumed a new significance which was to affect the meaning of art as such. Until then the idea of great art had been embodied mainly in those solemn, well certified, old European works of fabulous price, transported from the palaces of the declining European aristocracy, together with objects from the treasure chambers of kings, to the homes of the American rich. After the Armory Show—for more than one reason, but especially because of the growth of modern art—the collecting of old masters began to lose its former prestige, just as the reproduction of Renaissance villas and châteaux gave way to the design of modern homes. The cultural dignity of modern painting and sculpture was also recognized by the law; within a year of the Show, one of its most enthusiastic supporters, the collector John Quinn, persuaded the government to remove the import duty on foreign works of contemporary art.

Fig. 1 Picasso: *Nude,* 1910.
Charcoal. The Metropolitan
Museum of Art, New York. The
Alfred Stieglitz Collection, 1949.

Fig. 2 Kandinsky: *Improvisation
No. 27.* Oil on canvas. The
Metropolitan Museum of Art,
New York. The Alfred Stieglitz
Collection, 1949.

Fig. 3 Bellows: *Cross-Eyed Boy*, 1906. Oil. Private Collection.

Fig. 4 Rouault: *Cross-Eyed Woman*.

The three hundred thousand or more visitors who saw the exhibition in the three cities were a far greater number than had attended the annual salons of the National Academy, although smaller than the public that wandered through the picture galleries at the World's Fairs. But the 1913 show was of art alone, unlike the Fairs where art was one spectacle among many, beside machines, manufactured goods, and popular amusements. Here one came for art itself, whether one took it seriously or to satisfy curiosity about a widely advertised sensational matter. And as art it was more pointedly contemporary, in a new and radical sense—unknown to previous exhibitions, and standard from then on for shows of independent art—namely, that modernity as such was a quality, so that people looking at these works were led to consider them as belonging to the moment, to the year 1913, like the new airplanes and automobiles and the current ideas of science or the aims of the advanced political groups. Indeed, the Armory Show had something of the role in art that the Halls of Machines, with their exciting display of new inventions, had for the public feeling about technology at the World's Fairs. The contemporary in art —or living art, as it was called—did not mean simply whatever was done at the time, since the old styles and the new, the imitative and inventive, were on view together, side by side. It meant rather the progressively contemporary, that which modified the acquired past and opened the way to a still newer future. And this sense of the growing present led to a revision of the image of the past, so that one could single out in history a family of the great moderns of the past, those artists whose independence had transformed art. For them, a room had been reserved at the Armory Show; Ingres, Delacroix, Corot, Courbet and the Impressionists, artists whom the academicians acknowledged as masters, were presented beside the modern insurgents as their ancestors, a line of great innovating spirits. The plan of the Show contained then a lesson and a program of modernity. It was also a lesson of internationalism, although the emblem of the Show was the native pine, a reminder of the American revolution as well as of the eternal greenness of the tree of art. Since the awareness of modernity as the advancing historical present was forced upon the spectator by the art of Spaniards, Frenchmen, Russians, Germans, English-

men, and Americans, of whom many were working in Paris, away from their native lands, this concept of the time was universalized; the moment belonged to the whole world; Europe and America were now united in a common cultural destiny, and people here and abroad were experiencing the same modern art that surmounted local traditions.

<center>II</center>

What was the nature of this new art? In what lay its novelty and its challenge to the art it came to supplant?

The great variety of this rapidly developing modern art obscured its character and inspired vague or onesided interpretations. How could one enclose in a single formula the clear, bright works of Matisse and the intricate *Nude* of Duchamp? The creators had no ultimate common goal, but advanced from canvas to canvas, following up new ideas that arose in the course of their work, hardly imagining what would emerge in the end; they seemed to be carried along by a hidden logic that unfolded gradually, yielding forms surprising to themselves. Those artists and critics who tried in writing to anticipate the future of this art turned out to be wrong. They were contradicted in a few years by unexpected diversities and reactions. We begin only now to see the process as a whole; and it appears to us very complex, a fluctuating movement that at times negates itself. But the vaguer interpretations were perhaps not altogether bad. The more precise definitions narrowed the field and led to sectarianism and indifference at a moment when what was most in question was the artist's freedom in exploring a new realm of possibility in his art. It must be said that the Armory Show helped to maintain the loose thinking and confusion about modern art. Cubists, Expressionists, Fauves, Orphists, Neo-Impressionists, Symbolists, Classicists, and Primitivizing Realists were exhibited side by side, and the greatest artists were presented on the same plane as the imitators and the lesser men. In the selection of the Europeans, Odilon Redon, a mystical painter of poetic and allegorical

themes, had the place of honor with forty-two works; there were fifteen by Puvis de Chavannes, an academic artist of the nineteenth century; the Englishman Augustus John, a quite secondary and occasional modern, received equal prominence with Matisse. By comparison, Picasso and Braque were poorly represented, and their invention, Cubism, the most important new art of the time, which was to determine much of the painting and sculpture of the next decades, was fixed in the public's mind through the pictures of Picabia and Duchamp, works that were marginal to the originators' central ideas. The European paintings had been chosen by men who had just come to modernism; their thinking had not ripened to the point of critical discrimination, and in their choice they had responded generously to the excitement of first discoveries and to suggestions from friends abroad. Yet by showing so many varied works, at the risk of presenting the new art as an incoherent chorus of odd individual voices, they set before the astonished public a boundless modernity in which an open mind could not fail to discover something to its taste. More fastidious groups, self-enclosed in their attachment to a particular ideal of art, although stimulating at first, often become ingrown and sterile; modern art required a varied audience and the enthusiasm of fresh talents in order to develop. And this need the Armory Show certainly helped to satisfy, in spite—or perhaps because—of its shapeless, uncritical modernity.

Friendly critics praised the courage and vitality and integrity of the modern artists—qualities that might have been found in the art of any time—without venturing to analyze the new styles. The hostile criticism—narrow and shortsighted as it was—in denouncing the deviations from past art, pointed more directly to the essential novelty: the image was distorted or had disappeared altogether; colors and forms were unbearably intense; and the execution was so free as to seem completely artless. It was in the advanced work of the Cubists and of Kandinsky and Matisse that these features stood out most; among the sculptors, Brancusi was the arch-modern. The nature of the new art was not sufficiently defined by these peculiarities—nor is it my purpose here to undertake a better definition—but through

them we may come closer to the issues in the conflicting judgments of the Show.

1. In only a few works had representation been abandoned entirely. But in many that preserved recognizable object-forms, these were strangely distorted. It is not easy to say which was more disturbing, nature deformed or the canvas without nature. Both seemed to announce the end of painting as an art.

For millennia, painting had been an art of image-making. The painter represented imaginary religious, mythical, or historical subjects, or he imaged the world before him in landscapes, portraits, and still-lifes. The word, "picture," which literally means: "what is painted," had come to stand for any representation, even a verbal or mental one. All through the nineteenth century, however, artists and writers had proposed that the true aim of painting should not be to tell a story or to imitate a natural appearance, but to express a state of feeling, an idea, a fancy, or, aspiring to the condition of music, to create a harmony of colors and forms. Yet the image remained the indispensable foundation of painting. The coming of photography about 1840 strengthened the conviction of artists that the purely aesthetic or expressive was the goal of art; but for sixty years afterwards image-painting continued and even became more realistic, exploring new aspects of appearance—light, atmosphere, and movement—a fact that speaks against the view that modern art arose as an answer to photography. In the twentieth century the ideal of an imageless art of painting was realized for the first time, and the result was shocking— an arbitrary play with forms and colors that had only a vague connection with visible nature. Some painters had discovered that by accenting the operative elements of art—the stroke, the line, the patch, the surface of the canvas—and by disengaging these from the familiar forms of objects, and even by eliminating objects altogether, the painting assumed a more actively processed appearance, the aspect of a thing made rather than a scene represented, a highly ordered creation referring more to the artist than to the world of external things. The picture also became in this way a more powerful, direct means of

conveying feeling or, at least, the interior patterns of feeling; the strokes and spots, in their degree of contrast, in their lightness or weight, their energy or passivity, were unmistakably "physiognomic." And in paintings that still preserved some representation, beside the new self-evidence of the painter's marks with their vague intimations and tendencies of feeling, the image acquired an aspect of fantasy or of some obscure region of thought. It was such positive effects rather than a search for some presumed absolute or long-lost ideal essence of art that guided the artists in their approach to abstraction. They were neither geometers nor logicians nor philosophers, but painters who had discovered new possibilities in the processes of their art. Much was said about purity or form in itself, but in practice this meant a particular economy and rigor in employing the new means.

The visitors at the Show had all seen nonrepresentational works of art before—geometric ornament is an example—and many who enjoyed the new art tried to justify it by the analogy of rugs and textiles. (To which Theodore Roosevelt in a critical, though not unfriendly review of the Show, answered that he preferred the Navajo rug in his bathroom.) But this explanation was unconvincing and obscured the nature of the new art. Decoration, even in its freer forms, is servile, bound to some practical object, and bears within its patterns the trace of adaptation. Ornament embellishes its object, makes it richer, more charming or prominent; it accents the marginal or terminal parts of its carrier—the surface, the base, the border, or crown—but has no intensity and rarely invites us into itself. We can imagine the pattern of a rug continued indefinitely or enlarged, without much loss of effect; but how would we respond to a Rembrandt portrait exactly repeated several times on the same wall? In past arts of ornament, the whole was legible at once as a simple structure; a particular unit was expanded in a fairly regular way; given a part of the work, one could easily reconstruct the whole. In the new art of "abstract" painting there is no obvious nuclear motif or simple rule of design. No less than in the latest image-painting, something intimate, close to the artist himself, was projected, which required of the spectator an active engagement and response. The unpredictable character

of the whole and of the details of form reflected the contingencies of
life itself, with its changing complication, conflicts and occasions of
freedom. (Not by chance had modern architects, who admired the
new painting and sculpture, eliminated all ornament from their build-
ings.) Only weak imitators who failed to grasp the organic complexity
of the new works, passive personalities who preferred the "decorative"
in image-painting as well, interpreted Cubism or abstract art as a kind
of ornament of the canvas. But for the unprepared or prejudiced
observer the strongest works were chaotic and illegible, without the
obvious course of an ornament; they possessed an intricacy very close
to the formless, hence requiring a most tense control by the artist. A
protest against formlessness and unintelligibility had been addressed
in the 1870's to the Impressionist masters whose pictures of land-
scapes were also informal in design, offering to the spectator a turbu-
lent surface of little brush-strokes, many of which could not be
matched with a represented object. The "impression" struck people
then as something arbitrary, and several decades passed before it came
to be widely recognized and enjoyed as the artist's elaboration of a
common experience. Impressionism was in fact the true forerunner of
this art in so far as it translated on the canvas the "subjective"
moment in vision (including the induced complementary colors), as
well as the shapeless, diffused, unlocalized components of the land-
scape due to the light and atmosphere, giving at the same time a new
tangibility and independence to the crust of pigment. But while the
vision of an Impressionist painter was tied to a moment and place
that could still be recaptured through the image of the subject (how-
ever much this subject had been transformed by the brushwork—and
the image was often most faithful through this vagueness), in the new
art the transformation was more radical and complete, and the start-
ing-point often something more distinctly personal than the impres-
sion of a landscape.

Imageless painting of this kind—without objects, yet with a
syntax as complex as that of an art of representation—was a revolu-
tion in the concept of art. The image had pointed to something exter-
nal to the artist, an outer world to which he conformed or from which

he took his most cherished values. It had not mattered whether the image was symbolical or accurate or free; whatever its style, it carried the spectator to a common sphere beyond art in nature, religion, myth, history, or everyday life. The represented objects possessed qualities that often provided a bridge to the qualities of the painting. But in the new art this kind of organizer of the observer's attention had largely disappeared. Now for the first time the content of the art was constituted by the special world of the artist, whether as personality or painter. His feelings, his operations, his most specialized and subtle perceptions, furnished the primary themes of his art. And he trained himself to perceive, feel, and design in such a way as to realize to the highest degree the freedom and self-sufficiency of his work, seeking for means that would contribute most to the desired independence and fertility of the artistic act.

The artists who abandoned the image completed a long process of dethronement of an ancient hierarchy within the subject-matter of art. In Western tradition, the greatest works had been judged to be those with the noblest subjects. Art with themes of religion, history, and myth was conceded an intrinsic superiority. By the middle of the nineteenth century, with the decline of aristocratic and religious institutions, the more intimate themes of persons, places, and things had come to be regarded as no less valid than the others; only the personal and the artistic mattered in judging a work of art. From the viewpoint of the artists who were aware of this development of the subjects, the new art was the most emancipated of all, the most advanced in the humanizing of culture, indeed the most spiritual too, since only what was immediately given in feeling and thought, unfettered by exterior objects, was admitted to the work of art.

It was objected that such an art would cut off the artist from others, that he would end by communicating only with himself. But the fact that so many painters and sculptors adopted this art and created freely within it, learning from one another and producing an astonishing variety of work, showed that abstraction had a common human basis; it was not so arbitrary and private as had seemed.

But even the artists who retained some links with the world of

objects, without submitting to the strict requirement of likeness, were criticized as eccentrics; they were told that if one accepted some natural forms, a consistent representation was necessary. In time it became clear that precisely this free play of object-forms and invented forms gave to such works their peculiar expressiveness; here too the active presence of the artist was felt in the power of the operative elements of stroke, spot, and surface, and in the transformation of the world of objects.

2. Besides taking the observer into a no-man's land of imageless painting, where he had great trouble in finding his way, the new art disturbed him by the intensity of its colors and forms. To many cultivated eyes, brought up on the old masters, these works were not only meaningless, but altogether without taste. An artist like Matisse, who represented objects and was respected for the skill of his drawings, employed shockingly strong tones and abrupt contrasts, and scored his outlines emphatically in black. The brush-strokes of a Kandinsky, a Rouault, or a Vlaminck were a violent assault on the canvas. The normally courteous critic, Royal Cortissoz, described a Kandinsky "improvisation" (Fig. 2) as "fragments of refuse thrown out of a butcher's shop upon a bit of canvas"; and another, more liberal writer spoke of Matisse's art as "blatantly inept" and "essentially epileptic." It is true that the qualities of intense works of art seem more drastic when first shown and in time lose their flagrancy; Romantic and Impressionist paintings that had appeared outrageous in their relative formlessness and high color today look obvious in composition and even subdued in tone. But in the art of the last sixty or seventy years, especially since Van Gogh, there has been a mounting intensity, of which the effect is not reduced by long acquaintance with the works. (At the other end of the spectrum of modern expressiveness is a kind of negative intensity, not always less difficult than the positive kind and no less striking, a search for faint nuances, for an ultimate in delicacy and bareness, that still surprises us; it appeared in Whistler, Monet, and Redon, and more recently in works of Malevich and Klee, among others.)

In the painting of the seventeenth to the nineteenth century the

elements were graded and tempered, and brought into a smooth harmony dominated by a particular color or key; the whole lay within a middle range and extremes were avoided. Light and shade softened the colors, the edges of objects were finely blurred in atmosphere and shadows, contrasts were mitigated by many qualifying tones, and objects were set back at some distance from the picture plane. Nothing was stated brusquely or loudly. The high examples of intensity of color were Titian, Rubens, and Delacroix, artists of mellowed aspect who subdued their strongest tones by light and shadow.

Beside this measured art, the new painters seemed to be coarse ruffians, and their art a reversion to barbarism. These artists were aware of their own savagery and admired the works in the ethnological museums, the most primitive remains of the Middle Ages, folk art and children's art, all that looked bold and naïve. In this love of the primitive as a stronger, purer humanity, the moderns built upon a novel taste of the nineteenth century; the realists of the 1840's and 1850's—lovers of the sincere in art and life—had discovered the beauty of children's drawings and popular imagery and the carvings of savages. But now for the first time the intensity and simplicity of primitive color and drawing were emulated seriously. Before that, even in Gauguin's art, the primitive qualities were still subject to the naturalism and tempering devices, the atmosphere, depth, and light and shade of civilized European art. These sophisticated means were not abandoned in the twentieth century, but they were no longer a rule. The primitive aspect was hardly a return to a savage or archaic art, as inattentive critics supposed. Comparing a Matisse or Picasso with a primitive painting, one recognizes in the moderns the sensibility of a thoughtful disciplined artist, always alert to new possibilities. The simplicity of the primitive is a fixed, often rigid style with a limited range of elements, and pervades his entire work; in the modern it is only a quality of certain aspects. Like the intricacy of composition already mentioned, which is not less complex than that of the most realistic art of the nineteenth century, the color includes besides the new intensities rare chords, off-tones, and subtle combinations—the heritage of the post-Renaissance palette applied with a new freedom. For

the moderns the saturated colors, the forceful outlines, and geometric forms were a rediscovery of elementary potencies of the medium. They were more than aesthetic, for through them one affirmed the value of the feelings as essential human forces unwisely neglected or suppressed by a utilitarian or hypocritically puritanic society. Together with this corrective simplicity and intensity, which seemed to revive a primitive layer of the self, like the child's and the savage's, and which gave a new vitality to art, the painters admitted to their canvases, with much wonder, gaiety and courage, uncensored fancies and associations of thought akin to the world of dreams; and in this double primitivism of the poetic image and the style they joined hands with the moralists, philosophers, and medical psychologists who were exploring hidden regions and resources of human nature in a critical, reforming spirit. The artists' search for a more intense expression corresponded to new values of forthrightness, simplicity, and openness, to a joyous vitality in everyday life.

3. A third disturbing innovation, related to the others, was the loosening of technique. It had begun even before Impressionism, which was attacked in the 1870's and '80's for its frightful daubing of paint. The later artists outdid this freedom, enlarging and weighting the brush-strokes and painting more sketchily, sometimes with an unconstrained fury. The old conception of painting as a magic art, the source of a jeweled, mysteriously luminous surface of impastos and glazes, was abandoned for simpler, franker means. The new painters were no less sensitive to the fabric of their work, but, concerned with immediacy of effect and with the elementary expressiveness of colors and forms, they found the inherited standards of *facture* an obstacle to their aims. As practiced by conservative contemporaries, the old craftsmanship had become an empty, useless skill, an elaborate cookery, that had lost its original savor. Some of the moderns adopted instead the bare coat of flat color, the house-painter's method, as better suited to their ends; or they devised still other sketchy techniques and new textures with a greater range of expression than the old. Just before the Armory Show, the Cubists, with a sublime daring or impudence, had begun to replace the sacred substance of oil paint by pasted paper,

newsprint, sand, and other vulgar materials, which were applied to the canvas with a playful humor. Among the sculptors, too, the traditional marble and bronze were losing their aura of intrinsic beauty; roughly finished stone and plaster, cast stone, wood, brass, and new alloys became more frequent in this art. Most astonishing of all were the open sculptures of metal without pedestal or frame, pure constructions like industrial objects, suspended from the wall or ceiling; these first appeared shortly after the Armory Show and have transformed the character of sculpture in our time. Just as there was no longer a superior subject-matter in art, the privileged techniques and materials were brought down to a common level of substances and means, including those of modern industry and everyday use. The new materials and processes of sculpture possess within their commonplaceness a poetic appeal, like that of the vernacular in modern verse; they have also awakened the observer to the qualities of materials in their native and processed states, and to the beauty of the technical as an inventive manipulation of forms.

III

It would be surprising if such an art, introduced full-grown to an unprepared public and to artists who were bound to tradition, met with no resistance.

The modernists took this for granted; they knew that all the advanced movements of the nineteenth century, since the Romantic, had been violently attacked, and it had become a platitude of criticism that in every age innovators have had to fight against misunderstanding. This view of the original artist as a martyr, and of the development of art as a bitter struggle between partisans of opposed styles, is hardly borne out by history. The great artists of the Renaissance who created the new forms were recognized early in their careers and received important commissions—Masaccio, van Eyck, Donatello, Leonardo, Raphael, and Titian are examples. Conflicts had indeed

occurred in the sixteenth century, but at no time in the past were they as acute as in the last hundred years, except perhaps in the medieval iconoclastic controversy that arose from factions in church and state, more than from artists or new styles of painting and sculpture. The hostility to novel contemporary art, the long-delayed public recognition of the most original recent artists, point rather to singularities of modern culture. Among these are the great span in the cultural levels of those who support art; the ideological value of competing styles as representative of conflicting social viewpoints; and the extraordinary variability of modern art, which requires from its audience a greater inner freedom and openness to others and to unusual feelings and perceptions than most people can achieve under modern conditions, in spite of the common desire for wider experience. But most important of all perhaps is the changed relation of culture to institutional life. Past art, attached to highly organized systems of church, aristocracy, and state, or to the relatively closed, stable world of the family, remained in all its innovations within the bounds of widely accepted values, and continued to express feelings and ideas that had emerged or were emerging within these institutions; while independent modern art, which constructs a more personal, yet unconfined world, often critical of common ideas, receives little or no support from organized groups and must find its first backers among private individuals—many of them artists and amateurs—for whom art is an altogether personal affair. The original modern art is usually far in advance of the public, which shares the artist's freedom and feeling of isolation (in both their agreeable and negative aspects), but has not discovered the sense of its new experience and aspirations still vaguely formulated within the framework of inherited and often contradictory beliefs, and must assimilate gradually—if it does so at all—and most often in a weakened, vulgarized form, the serious artistic expressions emanating from its own world. The inventions of the artist are in this respect unlike the novelties of physical science and technology. These make little claim on the feelings of lay individuals and are accepted at once as gadgets or ideas that can be utilized without personal involvement or shift in general outlook.

At the same time, the very mobility of our culture, the frequent changes of art in the nineteenth century, have weakened the resistance to new styles, although a generation or more is required for the modern forms to penetrate the originally hostile groups. In our day what is defended against the advanced art is itself something fairly recent that was at first equally difficult. The experience of the last hundred and fifty years and the historical study of art—which has its practical side in the widespread collecting of "antiques"—have accustomed people to thinking of every style as a phenomenon of its time, issuing from a unique set of conditions and ideals that were themselves possible only then and were soon to be replaced by others. Or if art was conceived as a self-generating process, its stages had their own necessity and limited tenure, unfolding new problems that the following age was to solve. To maintain in practice the art of an older period meant therefore to deny the principle that life itself is a permanent evolution, marked by occasional leaps or sudden advances; it implied a return to the outlook and circumstances of that time, and this was impossible. It was an avowal of impotence, which could only confirm the opinion of serious critics of the nineteenth century that modern society was decadent because it had produced no original style in architecture, the most social and symptomatic art. The necessary conclusion that all periods are equal in the eyes of God, provided they have their own style, dismayed many who could not easily give up in practice so much that they cherished in past art, and who found nothing of comparable nobility in their own time. What seemed to be a hopeless relativism in this eternal treadmill of stylistic invention—which appeared to some writers a cyclical motion, bringing art back to its primitive states—was surmounted, however, in the modernist's vision of the art of the last few centuries, and even of older art, as a process pointing to a goal: the progressive emancipation of the individual from authority, and the increasing depth of self-knowledge and creativeness through art. While few artists believed that there was progress in art as in science and industry or in social institutions, many were certain that there was, relative to the possibilities of the time, a reactionary and a progressive art, the latter being

engaged in a constant effort of discovery, as in science, although the genius of the old painters, like that of Newton and Galileo, was not surpassed. The great artist, in this view, is essentially a revolutionary spirit who remakes his art, disclosing ever new forms. The accomplishment of the past ceases to be a closed tradition of noble content or absolute perfection, but a model of individuality, of history-making effort through continual self-transformation. Far from being the destroyers of eternal values, as their opponents said, the new artists believed themselves to be the true bearers of a great tradition of creativeness. Movement and novelty, the working out of latent possibilities, were, they supposed, the essence of history. In this, as well as in the beauty of his work, lay the artist's dignity. The movement of modern art had therefore an ethical content; artistic integrity required a permanent concern with self-development and the evolution of art. This belief in a common historical role, dramatized by the opposition of a static, conservative art, gave the artists a solidarity and collective faith, a creative morale, that sustained them at a time when they were most cut off from the public and institutional life.

Following another and unhistorical line of thought, some modernists supposed themselves to be progressive and true heirs of the great tradition because they had rediscovered a principle underlying all art, one that had been lost in the dark centuries of naturalistic painting. What was ever valid in past art, they believed, was not its skill in representation—this was merely a concession to the demands of the literal-minded, philistine patrons before photography was available, and distracted artists from their nobler task—but its power of form and expression through which that old art still moves us today when we contemplate the old pictures and statues in ignorance of their religious or mythological sense; and in the modern search for this universal power they affirmed their continuity with a great tradition that had suffered a long decay. The fact is that the young moderns had an insatiable hunger for past art; the new movements were accompanied by a revaluation of forgotten epochs and an extraordinary expansion and deepening of historical research, often by scholars who

drew from their experience of modern art a quicker sympathy for the old.

These attitudes were supported by two peculiarities of the cultural situation. In many countries, indeed in most countries outside France, the new style replaced a stagnant backward art. In France, Matisse and Braque are not greater artists than Cézanne and Renoir, but for Spaniards, Picasso and Gris mark a genuine advance after the generations of uninspired painting following the time of Goya; and for Russia Kandinsky, Chagall, Lipchitz and the whole modern school in that country were a real revival of an art that had produced nothing of international significance since the days of the old icon-painters.

A second important fact is the unique intensity of the growth of styles of painting since the 1830's, more than of literature or the other arts, unless perhaps recent music. Every great painter in that period (and many a lesser one) is an innovator in the structure of painting. In poetry and the novel the great names, Tolstoy, Dostoyevsky, Yeats, are not innovators in form; in a style or conception of their medium which hardly goes beyond that of the preceding generation, they express a new experience or outlook. The serious innovators in form, like Mallarmé and Joyce, are few. It may be that the exceptional fertility of modern painting and sculpture in new forms is connected with the restriction of their content to the perceptual, the interior, and the aesthetic-constructive, the intensity of formal invention being an indispensable sign of the artist's power and depth; while the writer is still absorbed by the representation of a world in which the extra-artistic meanings have a considerable force.

Yet if the creation of new forms or the recovery of timeless essentials was the main task of the modern painters and sculptors, and art seemed to the public increasingly esoteric, a professional affair detached from the interests that had once furnished its subject-matter, this whole movement was felt by the artists and its defenders and even by some of its most vigorous opponents as part of a general modern outlook—a radical transformation of sensibility and thought.

The individual, his freedom, his inner world, his dedication, had become primary; and the self-affirming nature of the new art, with its outspoken colors and forms and more overt operations, was a means of realizing the new values, which were collective values, for individuality is a social fact, a matter of common striving, inconceivable without the modern conditions and means. The artists' values were, in a broad sense, general values of the time, asserted in different ways by philosophers and by ethical, religious, economic, political, and pedagogical thinkers, for whom the individual's self-realization was the central problem, however limited their thought. Pervading so many fields, dominating literature too, these concepts were a developing heritage of the nineteenth century. They appeared inevitable, the necessary ones for the new century, which seemed an age of unlimited possibilities, a historical epoch as distinct and gigantic as any in the past.

Contemporary thought was made up of different and even opposed strands; but several were remarkably like the new art. Whether the artists were affected by the philosophers or had come to their ideas independently in meditating their own problems and needs, does not matter to us here. What is interesting is that the philosophers, like the artists, did not regard the mind as a passive mirror of the world, a means of simple adaptation of the organism to the environment, but affirmed its creative role in the shaping of ideas. The new philosophy investigated the ideal constructions of thought by which man imposed an order on his sensations and controlled or modified the environment. As the Cubists broke up the painting into basic operations and relationships, the logicians analyzed knowledge into formal components, elementary and irreducible operations and structures, submitted to a few rules of deduction and consistency. Opposing the older philosophers and scientists who regarded knowledge as a simple, faithful picture of an immediately given reality, they observed in scientific law a considerable part of arbitrary design or convention, and even aesthetic choices—the immense role of hypothesis. A radical empiricism, criticizing a deductive, contemplative approach, gave to the experimental a programmatic value in all fields.

Still other philosophers affirmed the primacy of feeling and will, posing these as the sources of action and the clue to the creation of ideas. Psychology, splitting up into schools that investigated either the structured character of perception or the formation of personality in the course of conflicts between biological drives and social constraints, supplied theoretical bases for new interpretations of form, expression, and artistic creativeness. Certain of the philosophical ideas had been current for years, but in the period before the Armory Show they had become objects of fresh conviction and more systematic statement. No less significant than the content of philosophy and psychology was the form of science as an activity: the most impressive model of self-critical search and discovery, individual, yet cooperative, and without authority or fixed principles besides those of general method and logic. Its constantly revised picture of the world was highly imaginative, built of elements not directly given to the eye, but more adequate than older science in explaining phenomena. Its rapidity of change, its ceaseless productivity, suggested a corresponding creativeness in art and social life.

All these parallel intellectual currents, which have continued to our own time, are more or less external to art, yet produce a disposition favorable to the modern styles. It often happens that a mind radical in one field is conservative in the others, and indeed it may be questioned whether all these advanced views are compatible with each other. But where they coincide, they reinforce the common spiritual tendency, the sentiment of modernism itself as a value. They would have less effect on art, however, if they were not consistent with the individuality and intimacy of art which I have already mentioned.

Formerly tied to institutions and fixed times and places, to religion, ceremony, state, school, palace, fair, festivity, the arts are now increasingly localized in private life and subject to individual choice; they are recreations and tastes entirely detached from collective occasions. The superindividual and communal are not excluded; a looser but none the less effective bond unites people and confines their thinking and action. These common interests are approached, how-

ever, from the viewpoint of individuals who are free to explore their own beliefs, experiences, and relationships, to criticize them and transform them. The musical concert, the art exhibition, the film, the printed novel or poem, exist for a large community; but they are not bound to extra-artistic moments. Where the ancient drama was performed on a religious holiday and retained in its themes and spiritual attitude a tie with the solemn occasion, the modern film, also a collective work, is always on the screen, even when the hall is nearly empty; the film exists for distraction and is offered to the spectator as one among many films available at the same moment. After the book and the magazine, the phonograph, the radio, and television have made possible a greater privacy and self-ministration in the experience of the arts. This character of culture as a sphere of personal choices open to the individual who is conscious of his freedom and ideals, in turn affects the creation of new art, stimulating inventive minds to a fresh searching of their experience and of the resources of the art which enter into the sensory delight of the spectator and touch his heart. Among the arts, painting (and to a smaller degree, sculpture) have the unique quality of combining in a permanent state the immediately given or tangible, the material object of art, with the most evident signs of operativeness, the presence of the artist as the shaping hand and spirit. It is in this sense the most concrete art, but realizes this concreteness through forms of which the so-called "abstractness" has little to do with the abstractions of logic and mathematics.

The issues at stake in the Armory Show were not simply aesthetic problems isolated from all others. To accept the new art meant to further the outlook of modern culture as a whole. The rejection of the new art was for many an expression of an attitude to all modernism. The revolt of students against academic art was not only a break with the art of their elders, but also part of a more general desire for emancipation. People in 1913 overestimated the spiritual unity of the different examples of freedom or progress; they felt that all innovations belonged together, and made up one great advancing cause. Fewer thought, as we do today, that modernity is problematic and includes conflicting, irreconcilable elements.

IV

The new art was not received very differently here and abroad. We are observing a process that belongs to Western culture as a whole. In both the United States and Europe a few clairvoyant enthusiasts discovered quite early the little-known artists who in time became the acknowledged masters. On both continents were individuals who defended the new art on principle for its modern spirit without distinguishing original from imitative work. Attacks on the artists as madmen and charlatans, diagnoses of their styles as a symptom of social decay, were published everywhere. And in America as in Europe, compromisers or timid minds without full conviction tried to assimilate the modern by adding some of its elements to an older style.

Yet one can discern in the common reactions differences of degree, peculiarities that correspond to the cultural heritage and situation at the time. The English seemed more conservative and indifferent; the German collectors, museums, and writers showed an amazing enlightenment in supporting the new art, native and foreign; the Russians were perhaps the most enthusiastic of all. Germans, Russians, and Americans, even more than the French, were friends of the younger modern artists in Paris. In these comparisons, we have in mind, of course, the minority that is concerned with art.

In the reception in the United States, we are struck by a singular play of provincial backwardness and a generous disposition towards the most advanced forms. This was perhaps true in some other countries as well.

Unlike the Europeans we had no official art; there were no state museums and schools or ministers of fine arts to support an orthodoxy in art. The National Academy was a society of artists, independent of the government and centered in New York. There was nothing here like the French Salon or the annual exhibitions of the European Academies, which were patronized by an aristocracy influential in the state. In France the Academy had long ago lost the leadership in the artistic life of the nation; none of the great painters of the second half

of the nineteenth century had belonged to it, and as early as the 1820's the innovators had to withstand the opposition of the academic caste. In the United States the Academy was less dogmatic and authoritative; it included the outstanding men of the older generation (Ryder, Homer, Eakins, Twachtman) and several of the younger rebels of the group of the Eight (Henri, Bellows, and Glackens). On the eve of the Armory Show, its exhibitions were of declining interest, but their weakness was that of a stagnant rather than dogmatic art. Only late in our history, when academic art had been completely discredited in Europe, was a similar pseudo-classical style promoted in the United States to satisfy the demand for symbolic decorations in the immense projects of building for the federal and state governments and the new millionaires whose sumptuous homes were designed as copies of Renaissance villas and châteaux. A school for American prize-students was founded in Rome in 1905 to enable them to study the classic and Renaissance models at the source. But this sapless academic art, though well supported, attracted no able young artists. It was at best an adjunct to the imitative architecture, which had enjoyed a vogue since the 1890's at the expense of an emerging native style of building.

The world of art here was, on the whole, more liberal than in Europe where the antagonism of the official and the independent remained very sharp. The United States had not known the great artistic struggles of the last century in Europe; Romanticism, Realism and Impressionism were introduced from abroad with little conflict and without the accompanying political implications. The show of the French Impressionists in New York in 1886, sponsored by the National Academy, was received more warmly than the works of the same artists in Paris and London. And at the Armory Show, of the 1,600 works exhibited, about 300 were bought by visitors, a proportion that would be astounding today, when this art is better established. There was no old, native style here to defend against the foreign, and no great personality among American painters, with loyal disciples, constituting a school that would fight to maintain itself against a foreign mode. Our best painters were robust original counterparts of

minor European artists. If the absence of a powerful authority made it easier for painters to consider the new in art, the lack of an intense tradition with examples of high creativeness made the acceptance of the new often shallow or passive.

We are not at all sure that this provinciality accounts for America's minor place in modern art. Countries no less backward suddenly came to the fore then. The modern movement called upon artists of many nations. Paris was the generating center, but the leaders of the new art included men from Spain, Russia, Holland, Germany, Austria, Norway, Switzerland, Belgium, Italy and Rumania. Spain, in decline, contributed Picasso and Gris, and later Miró, but the United States and Britain produced no figure of world importance. Among the Americans who adopted the new forms and developed them independently were superior artists (Prendergast, Hartley, Marin, Weber, Davis, Maurer, Demuth), but none was of the stature of the great European innovators. It is not because they are imitators of the Europeans; they are unmistakable personalities, with their own savor, but their work does not seem to us as far-reaching as that of the pioneers abroad. There is no Melville or Whitman or James among our painters. Only recently an American, the sculptor Calder, created in his "mobiles" a personal style of international interest. And in the generation of modernists born since 1900, the leading American artists stand on the same plane as the best of the Europeans—a less gifted group than their revolutionary elders.

The backwardness of American painting and sculpture relative to Europe, their failure to pursue the possibilities and to grapple with the most serious and difficult problems, is a complex affair that demands a more delicate analysis than can be given here. The conditions of life that shape culture rarely affect all the arts uniformly; painting has special requirements and possibilities that distinguish its course from that of literature and music. There is nothing in Russian art of the nineteenth century that can be set beside the great Russian novels and poems. The differences between the arts of two countries at the same moment are often a matter of a few strong individuals, even a single one.

The reaction to European art at the Armory Show was probably affected by a real lag in American art during the two decades before. Many of our painters remained confidently and even militantly realistic, committed to the spectacle of the city, of activity, and to the picturesqueness of the environment, for some thirty to fifty years after this taste had declined in Europe. The most influential new styles practiced by Americans around 1910 came out of French Impressionism; the urban realists (Henri, Luks, Sloan, Bellows) used the methods of advanced French painting of the 1860's and '70's. More secure than the Europeans, less shaken by the course of modern history, and less free in spirit, we had ignored the art of Van Gogh, Gauguin, Seurat, and the later Cézanne, which belonged to the 1880's. Only a few alert young artists who had gone to Paris in the years before the Armory Show knew the works of that generation, from which the painting of the twentieth century had developed. Artists and public beheld the latter with a great amazement at the leap from Impressionism.

This lag was surely not due to the inaccessibility of the more recent art. Many Americans who traveled often to Europe were seriously devoted to painting. But while an earlier generation of travelers had brought home works of Millet, Corot, Courbet, and Manet, the collectors in the 1890's and beginning of the new century turned more often to the past, ignoring or underestimating the best contemporary art. This was true especially of the cultivated heirs of old established fortunes. Reacting against American vulgarity, they lost touch with the vital elements in both European and American culture. Freed from practical necessities, they conceived an aesthetic paradise of old architecture, gardens, and objects of art. The more refined, those who set the standards, had absorbed something of the fervor of Ruskin and his American disciples, Jarves and Norton, and were drawn to Italian late medieval and Renaissance art, which reconciled religious and worldly ideals. Whistler's fragile art, the "aesthetic movement" of the 1880's in England, the revived Pre-Raphaelitism of their youth, and the discovery of Far Eastern art, confirmed their taste for an art detached from the problematic present. We owe to this bias the mag-

nificent museum collections in Boston and New York, begun well before the Armory Show. The culture of these patricians was often broad, curious, and finely discerning, but it ignored the most vigorous contemporary ideas and was easily corrupted into snobbery and preciousness. Mr. Berenson, the leading American writer on Italian Renaissance painting, admiring the draftsmanship of Degas, regretted that it should be wasted on pictures of laundresses. Some might be drawn wholeheartedly to the Impressionists and Cézanne, who belonged to an older generation than themselves; very few had a sustained interest in their advancing contemporaries. For the symbolic mural decorations of the Boston Public Library, one called from Europe the fashionable portrait painter, Sargent, and the pallid Hellenist, Puvis de Chavannes. This caste of art-lovers, nowhere so much at home as in matters of decoration, supported—and perhaps was largely responsible for—the sterile vogue of historical forms in architecture at a moment when the leading European architects were moving away from it and a strong native style had arisen in the United States. The one American artist of world importance, the architect Frank Lloyd Wright, was ignored in the East during the great opportune activity of building at the time of the Armory Show, although his European colleagues had just published the first monograph about his work, which was to influence decidedly the European architecture of the new century. Fifteen years later, Wright was not even named in the history of American civilization by Charles and Mary Beard, authors who cannot be suspected of indifference to native genius, but who have been guided by academic opinion in their account of modern American architecture. This episode gives us the measure of the nostalgic taste for past art in our country.

Yet it should be said that this taste, striving to surmount the rawness of American culture, contributed to the ultimate acceptance and growth of the new art. It helped to create a serious interest in art as a sublime value, beyond skill in representation—a self-sufficient realm of forms in which perfection was a goal.

The American collectors who were attracted early to the new art, men like John Quinn, Adolph Lewisohn, and Leo Stein, came mainly

from outside the circle of that genteel aesthetic culture; a decade later, the largest museum of modern art in the world was formed by Albert Barnes, a pugnacious unsociable figure, whose modernism was indebted to the painter Glackens and to Leo Stein and John Dewey.

The introduction of modern art in this country has depended largely on the foreign-born or their immediate descendants. Its point of entry was the port of New York, which gave the Armory Show a much warmer welcome than Boston or Chicago. I have mentioned the leadership of Alfred Stieglitz in furthering the new art. Among the first artists to absorb the modern ideas were Max Weber, Abraham Walkowitz, Jacob Epstein, Joseph Stella, and Gaston Lachaise, all (except Epstein) foreign-born. The painters Marin, Demuth, and Maurer were native Americans who came from a milieu less touched by the self-conscious, backward-looking culture and close to the region of most intense mingling of peoples.

Women, it is worth noting, were among the chief friends of the new art, buying painting and sculpture with a generous hand. Art as a realm of finesse above the crudities of power appealed to the imaginative, idealistic wives and daughters of magnates occupied with their personal fortunes. But what is in question here is not simply the quicker disposition of American women to the fine arts, but their response to novel forms. At this moment of general stirring of ideas of emancipation, women were especially open to manifestations of freedom within the arts. A symbol of this period of insurgent modernism was the flamboyant personality of Isadora Duncan, an international figure who transformed the dance into a medium of ecstatic expression and release.

Modern art enjoyed also the friendliness of advanced political minds who welcomed a reforming or revolutionary spirit in art as an ally of their own aims. The issues of art were easily translated into the language of radical politics. Academic art, the cult of the past, tradition, rigid standards and rules, represented authority and privilege; the new art stood for growth, freedom, the individual, and the open future. As a young man, John Reed, who was later to report the Russian revolution, supposed that Futurism was the artistic corollary of

Socialism; who could foresee then the Fascist ties of this Italian movement which glorified action and violence as ends in themselves? But the Socialist leaders were most often conservative in art. Their minds fixed upon politics alone and expecting from artists works directly useful to their movement—easily legible images of misery, class struggle and the radiant Socialist future, or relaxing pictures of nature's beauty—they were repelled, like any conservative bourgeois, by what struck them as the "nihilism" of the new art.

V

From the account of the Show and the history of modern art, sketched here briefly, it is clear that the Show was no crisis for the American modernists, but a kind of triumphal entry. To have created these works, to have reached the public, to have gained supporters, was already an achievement. And with the example of victorious generations of modernists before them, these men were sure that their own work would be recognized before long. Their struggles and sufferings, the abuse to which they were subjected, rarely made them doubt their aims; they continued to work, and produced new forms; the external obstacles were no impasse.

In what sense then was the Armory Show a crisis in American art? Crises of culture, unlike those of economics, politics, and war, do not concern great multitudes. They have been until now the problems of a profession that for over a hundred years has lived in chronic uncertainty; and although they affect the spiritual life of the community, their issues are not urgent for the latter. Within the concerned group, however, the crisis may be an emergency in which the survival of the art itself or of some basic standard is in question.

It was mainly for those who attacked the new work as a monstrous degradation of art by lunatics and charlatans that the Armory Show was a crisis. Yet if their vehement criticisms were correct, the strange art should hardly have caused them concern. The exhibition

of mad or insincere work is no challenge to a serious artist. Incompetent painting is quickly forgotten. A true crisis would have been the failure of the aggrieved artists to produce any good art at all. It would then have been not only a crisis in their own art, but a total crisis of art, since they believed that the fate of American art was in their hands alone.

Yet many artists were deeply disturbed. Not simply because the wild men were enjoying the stage for a few months, and might seduce the public into accepting their work, but because the conservatives felt, in spite of their condemnations, that this art of the charlatans and madmen did have meaning and was a possible alternative to their own. It was for them no unexpected irruption; they had sensed it on the horizon for some time, and they had observed its advance in Europe. Its growing strength was clear from the response of able artists who had gone abroad to study and had been infected with the new ideas. The most talented young Americans were being drawn further in that direction. And these opponents of modernism were not unaware that they themselves had compromised with the modernism of an older generation, adopting some elements from it in their academic work. As defenders of tradition they knew also that their own art lacked the freshness and conviction they admired in the great painters of the past, and which these new men showed in an evident way, even if they broke all the rules. We suspect that to some more sensitive and intelligent conservative artists, the wildness of the new art, like the mysterious originality of the great masters who were beyond rules, seemed peculiarly demonic and inspired, even if crude.

If this new path was the right one, then the established American artists were on the wrong path. Their whole education seemed useless. For centuries the artist's training had been in the study of the nude figure, in drawing and painting from careful observation of the model, and in the copying of works of the old masters. All this severe preparation was now irrelevant. Of what good was the long practice in representation when the aim of the painter or sculptor was to create works in which the human figure scarcely existed or was deformed at liberty? The new art was the negation of the basic values of their own

art; it abandoned ideal forms, noble subject-matter, harmony, decorum, nature, the visible world.

The academic spokesman, Kenyon Cox, claimed for his side the example of the great artists of the past. But his familiarity with tradition did not help him to sense the quality of Cézanne, whom he characterized as "absolutely without talent and absolutely cut off from tradition. He could not learn to paint as others did, and he spent his life in the hopeless attempt to create a new art of painting for himself." The radical moderns, we have seen, also claimed tradition; but tradition meant to them what it meant to scientists—not the authority of a past result, but the example of an independent spiritual attitude that had created new forms. Not long after the Show, Cox, in a picture perhaps inspired by these polemics, symbolized Tradition as a maidenly figure carrying an oil lamp that had been lit at the everlasting torch of the beautiful, and Painting as a muse in ancient costume. It seemed to him that the rebels were about to spill the oil and extinguish the light, or to violate the beautiful muse. The history of art was for him a quiet succession of great masters—teachers and pupils—without conflicts or disturbing changes. For the academic artists, this new art meant a loss of certitude; relying on the past, they now saw themselves cut off from the future.

The style the conservatives were defending was not one they had themselves created. They were docile craftsmen who practiced with more or less skill a method that had never been for them a discovery, a torment, and a risk. Yet some of them were men of taste, with a reverent feeling for the excellences of old art. Their uncomprehending rejection of the new must not be compared with the negative attitude of masters like Cézanne and Renoir to younger art. To judge sympathetically the novel work of younger men is, in any case, exceedingly rare; but the academic critics of the new art condemned what now appears, even to the conservative, the best work of their own and the preceding generation. Their complaints were those of comfortable habit against the demands of life, of a dull, respectable, premature old age against the rowdiness of youth. They wanted for themselves a spiritual security that they had not earned. The young modernists could

admire the older original artists of the Academy, Ryder, Eakins and Twachtman, but not the pious, smooth imitators of French academic art. The plight of the conservative painters was hardly tragic, for nothing valuable had been lost; the academicians continued to enjoy wide prestige, many sales, and the control of the schools, while the victims of their attacks struggled against a hostile or indifferent taste.

The American artists of realistic tendency were also shaken, although their public criticism of the new art was more restrained. Vigorous in denouncing snobbery, conformism, and the backwardness of academic art, confident of the necessity of an art related to the movement of contemporary life, they were now faced by more radical conclusions drawn from their own appeal to freedom and modernity, conclusions they could not easily accept or even understand.

These reactions to the new art betray not only the limits of the conventional respect for the individual in a weak conservative culture, but also the precariousness of the liberal historical view of art. In the course of the nineteenth century, Classicism, Romanticism, Realism, Impressionism, following each other rapidly, had destroyed or at least weakened the older notion of a supreme model of style. It was recognized that art can create many different forms, that each age has its own kind of art, and that masterpieces, though rare, are possible in all of them. In consequence, the art of the past was re-examined, exclusive norms were abandoned, and the history of art—once a schematic picture of a landscape with a culminating peak, with predestined rises and falls—became a marvelous evidence of varied human creativeness nourished by new conditions of life. But confronted by the newest art of all, even this liberal view, which could admire both Raphael and Rembrandt, began to falter; opposed to a privileged content or style in the past, it could not do without the faithful image, and reviled the new artists as "inept" and "epileptic." Tastes were not to be disputed, provided they observed certain minimal rules. These opponents of modern art were like political liberals who, having overcome absolutism in a long struggle for "human rights," draw the line of liberty and equality to stop a more radical demand. They felt themselves now to be the defenders of a threatened heritage and, in the

name of all the past and sacred values, they opposed a new possibility of freedom in art.

The uncertainties that the new art introduced were to affect the modernists as well. Within a few years the creators of Cubism returned to representation, and Expressionism yielded in Germany and elsewhere to a dry veristic style. The history of the modern schools includes the renegades and penitents who abandoned the standpoint of the revolutionary art. But even where the search for new forms continued, the modern movement has provoked a perpetual uneasiness among its followers. In the past an artist of limited originality could rely on what he had learned and like a skilled artisan perfect for himself the style of his youth, confident that the public would find it valid. This is no longer true. The rapid changes of taste, the many competing forms, unsettle the young artist and disturb the mature one. It is necessary to take a stand, to respond to new ideas, to keep up with history. In the sea of modernism, the minor artists are tossed about dangerously by the waves of fashion created by the larger or swifter men. The new art of 1910–20 did not create this situation, which was already noted in Europe in the 1840's as a demoralizing peculiarity of modern art; but it has become more acute during the last decades. The original artist who holds to his personal method runs the risk of appearing uncreative. It seems a limitation of a great painter that his style has not changed appreciably in twenty years. The world-shaking art of the revolutionary period has become a norm; one expects a revolution in every decade. This strenuous ideal breeds in the artist a straining for modernity and a concern with the historical position of his work; it often prevents him from maturing slowly and from seeking depth and fullness as much as freshness and impact.

If the old school was bitterly opposed to the new, they had nevertheless a common ground in certain broad aims. By a slight turn in the accepted values of American art, one came upon the new European values, which seemed to contradict them. But the variable sense of these common values first became clear in the modern works to which they led. What was thought to be a universal language of colors and forms was unintelligible to many when certain conventions were

changed. The means—for one thing—were very different; and since in art the means are a visible element of the whole, not easily distinguished from the ends, the latter also seemed irreconcilably opposed. What the Classicists hoped to achieve through the precise forms of idealized statuesque figures—lines that had been criticized in the nineteenth century as "abstract"—the moderns reached more convincingly through geometric forms. The qualities of purity and rigor, of exactness in composition, of an impersonal order, are more evident to us today in the best Cubist paintings than in the work of any of the contemporary academic artists who fixed their eyes too long on Ingres and Greek sculpture. If there are eternal values in art, it seems they are preserved only by those who strive to realize them in a new content.

This conviction was the source of the vitality of the American Realists at the time of the Armory Show. These painters—Henri, Luks, Sloan, Shinn, Glackens, Bellows—loved the American scene, in particular the common types and the outwardness of city life. They approached their subjects with a rapid, sketchy, illustrator's style repugnant to the traditional draftsmen; often shallow, it was a frank style, adapted to the kind of perception their content required. Their awkward composition was less calculated than the composition of the schools, but more natural and with abrupt, surprising contrasts. This American art sprang from an ever growing sentiment of freedom, the joys of motion and the excitement of the city as an expanding world of gigantic creation and the ceaseless play of individual lives, which Whitman had celebrated and which now offered themes and a viewpoint to Dreiser's tragic novels.

These painters, affirming in retarded forms the living spectacle of modernity, made at least some part of the new European art accessible as a more radical interiorized manifestation of the same spirit. If Bellows, in defiance of the traditionalist's desire for beautiful models, painted the portrait of a cross-eyed boy (Fig. 3), the same theme in the early work of the Frenchman, Rouault, appears immeasurably more searching and forthright (Fig. 4). If they valued bright and deep color as more essential than delicate or sweet tones, Matisse offered them a palette of a hitherto unknown daring, with astonishing juxta-

positions of intense colors and off-shades (Pl. VIII, Fig. 5 & Fig. 6). If they adored the big city as an overwhelming spectacle of traffic and the dizzying rise of immense buildings in the sky, Delaunay's *Eiffel Tower* (Fig. 7) was a more striking expression of these qualities, which the American, John Marin, transposed to his views of the Woolworth Building (Fig. 8). If they valued movement in itself as an attribute of vitality and as the metaphysical opposite of the static in tradition, Duchamp's *Nude Descending a Staircase* was an exciting assertion of a dynamic principle, much like the philosopher Bergson's, or like the moralist Nietzsche's call to perpetual self-transcending action.

What raised the best of the new Europeans above the American artists was their greater seriousness about the qualities of painting; they probed the medium more deeply and were more inventive in their means. Their feeling for the objects they represented was also more imaginative.

The American landscape painters, too, coming after the French Impressionists of the 1870's and '80's, had educated American eyes to a less formal art in which the charm and poetic character of the intimate aspects of the native scene were translated by a method of painting in fine free touches of color, rather shapeless, but harmonized through light, atmosphere, and paint texture, in a manner strange to the tight academic methods. Those who were touched by this art could approach more readily the art of a Cézanne, a Bonnard, a Vlaminck, a Marquet, as a development of similar methods towards greater constructive force or a deeper lyricism. Those who grasped the art of Ryder, one of the greatest of living American painters, a poetic solitary who saw nature in large mysterious patterns of light and dark (Fig. 9), could be captivated by the French mystic Redon, and could approach those foreign artists who subdued details for the sake of strongly silhouetted forms. There was also in this country a heritage of contemplative idealism, religious and moral, which sparked in some a response to the spirituality of a Lehmbruck or a Brancusi.

The existing values of American life and art provided some ground, then, for this foreign art. But the number of hospitable

minds, it must be said, was not large. For the great mass of people, good painting and sculpture were an exceptional, rarely accessible, experience. Living on the farms or in small towns and in tenements of crowded cities in recently formed, often unstable communities, they had little if any artistic heritage, even of folk arts. Today, nearly forty years after the Armory Show, when art has become widespread, an enormous span separates the interest of the serious forward-looking lovers of art from the taste of the average, educated man. Painting and sculpture mean little to him, and he observes with suspicion whatever in art comes from beyond his horizon. Although in his profession or business he is often keyed to the new, and respects originality, he is satisfied in art with the conventional and obvious, and still worse. The fact that he is at home with mechanical things and loves the calculated and precise does not mean that he will respond to a painting by Mondrian or Léger. Modern art in its graver, more poignant aspects is a disturbing challenge, offering a model of a desired inner freedom and emotional release that he does not venture within himself, or for which he is spiritually unprepared. He has not the habit of savoring the style of things, the more or less of a quality that makes up the magic and perfection of a work of art. This uneasiness or indifference before modern art is known in Europe too; it is striking to observe in America where individuality and freedom are advertised as national traits. Outside the cultural professions, some exceptional men who feel a kinship with the artists through their imaginativeness and independent spirit are attracted to novel contemporary work. But relatively few of the wealthy in this rich nation support new art. One should not be misled by the great collections of the dead moderns of the pre-Armory Show period; these are now well-established traditional values; they are the past of modernism and image another world, easier and more relaxing than our own. In the collecting of this older art, motives of investment, fashion, and snobbery often play a role. Of those who buy such works, few risk an independent judgment or show a live curiosity about more recent art. There is, of course, a genuine conservative taste that meditates its choice old objects as a pure spectacle in detachment from all problems of living

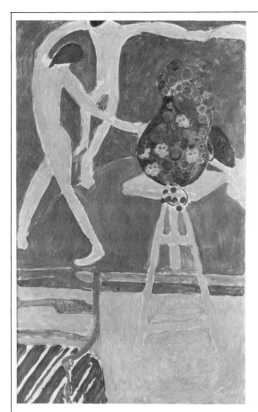

Fig. 5 Matisse: *Nasturtiums and the "Dance," II (Les capucines à "La Danse," 2me version)*, 1912. Oil on canvas. Worcester Art Museum, Worcester, Massachusetts. The Dial Collection, 31.750.

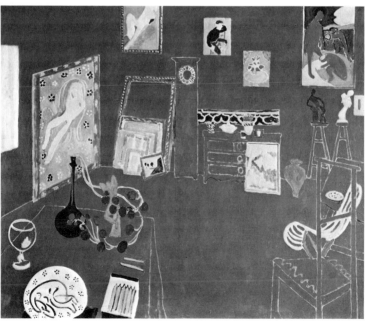

Fig. 6 Matisse: *Red Studio (L'atelier rouge; Le panneau rouge)*, 1911. Oil on canvas, 71¼″ x 84¼″. Collection, The Museum of Modern Art, New York. Mrs. Simon Guggenheim Fund.

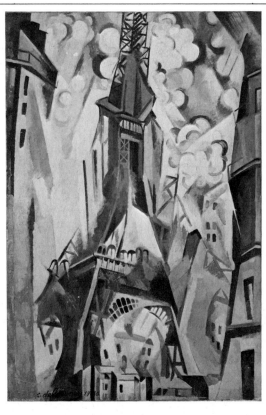

Fig. 7 Robert Delaunay: *The Eiffel Tower*, 1910. Oil on canvas, 105⅛″ x 159⅛″. Kunstmuseum, Basel (Emmanuel Hoffman Stiftung).

Fig. 8 John Marin: *Woolworth Building in Construction*, 1912. Watercolor, 19½″ x 15⅜″. Marlborough Gallery, Inc., New York.

Fig. 9 Ryder: *Moonlight—Marine*. Oil on wood panel. The Metropolitan Museum of Art, New York. Samuel D. Lee Fund, 1934.

art. It is mainly the young, intellectually active, freer personalities that are drawn to the uncertainties, surprises, and joys of the contemporary in art.

In the great crowds that came to see the Show, many were undoubtedly attracted not so much by the art as by the scandal it produced in the world of high culture. Art had meant the precious and solemn and costly, a fragile aristocratic beauty. The Armory Show suddenly exposed to view hundreds of framed and pedestaled works with oddly misshapen figures, raw paint, childlike drawing and noisy color —a bedlam or underground of the imagination. The nude figure, ordinarily forbidden to public view except as an object for refined aesthetic contemplation, dominated the Show in the puzzling guise of Duchamp's *Nude Descending a Staircase*—it was likened by a gay observer to an explosion in a slat factory. The same painter was to exhibit later a photograph of the Mona Lisa with a mustache, and to send the model of a urinal as a piece of sculpture to the Society of Independent Artists, which was formed soon after the Armory Show. Anticipating the ironic Duchamp, there was also in the popular response in 1913 a latent Dadaism, an assault on art as a highfalutin, pretentious cult. The caricatures of the Armory Show, the verse parodies and satires, betray a note of pleasure, an eagerness to participate in this crazy carnival of art in which the aristocratic muse had been dethroned. The explosive wrath of outraged academicians and arbiters of taste was not altogether disagreeable to the public. The press that lampooned the new art counted on the reader's enjoyment of distortion and violent expression. The caricaturists in ridiculing the Show by grotesque imitations of the exhibits produced drawings much more interesting and original than their ordinary work.

This public, not very attentive to art, came to accept certain of these strange forms some years later as a decorative and a comic style. They have become familiar to everyone through industry and trade. At first admitted in the factory, the airport, the office, and the window display of the store, they have entered the ordinary home, though piecemeal rather than as a consistently designed décor. Abstract painting and sculpture have directly or indirectly inspired the designers of

autos, furniture, packaging, utensils, and clothes. The Expressionist and Surrealist currents provided models for caricature, comic illustration, and gay advertising. The building arts more than the others show the impact of the modern movement. The environment, where it has been remade, has a new look that would not exist but for modern art. Modern art, we may say, has at last been domesticated in universally accepted mass-produced forms. These are a language, often a kind of pidgin-modern, with its special banalities and clichés, rather than a style in the stronger sense of an individual master's art or the art of sincere craftsmen employed on a collective task. They retain the broad connotations of certain currents within modern art—particularly the constructive-abstract, which is inspired by modern technology and is the most impersonal of all—but they lack the force or finesse of the individual paintings and sculptures, and hardly affect the life attitudes of those who accept this mass-modernism. This popular taste is rarely a conviction and determines no active, discerning habit of the eye, open to original contemporary art. A new convention has been created, which is accepted most quickly where the content makes the least demand. Only the small change of modernity circulates everywhere through these cheap adaptations.

It should be said, however, that the new decorative forms have not replaced the old. With all its advances and the wider public interest, modern art has been unable to establish itself in this country as the style of our time with the same necessity, completeness, and self-evidence as did in their day the Gothic or the Renaissance styles. Manufacturers today offer both "modern" and traditional designs; the modern is only one among many historical styles available to the consumer's choice. The symbolic value of the older styles as signs of rank, culture, and heritage has still a powerful hold. Public buildings are most often designed in some past idiom of form, and the furnishings of an American home are only exceptionally homogeneous in style.

The public that buys the undecorated, abstract-looking, mass-modern objects, still prefers the photographic and trivial, sentimental picture, with little regard to quality. To many who are conscious of the modern, a slightly accented, stylized imagery has the strongest

appeal. During the decades since the Armory Show, the academic art schools have continued to function, changing their methods very little; they have satisfied the demand for slick illustrators who impenitently produce debased versions of the styles of the later nineteenth century.

Although modern art appears to many as a highbrow, exotic taste, foreign to American plain-spoken and practical ways, it has resolved to some degree the old antagonism of the popular and the elite in American culture.

The most advanced taste in the United States about 1900 had been self-consciously aristocratic, hostile to American customs, and deeply attached to the aesthetic as a superior way of life. Its representatives, Whistler and Sargent, preferred to live abroad. These two painters were not in the vanguard of the world art of their time; but in their concern with a refined style and technique they were closer to the new European art than to the American. They lacked however the originality and robustness of the European innovators, their great appetite for life. It is the latter quality that becomes important in American paintings as in literature just before the Armory Show, but it is carried by men who are not fastidious artists. As painters, the vigorous American Realists of that time, with all their zest, were unimaginative and often crude. The Armory Show introduced Americans to a tradition of European painting in which a vernacular directness is allied with a great and aristocratic seriousness about artistic problems. After 1913 we discover more often in this country a type of painter who is both an inventive, scrupulous artist and a tough. In literature still more clearly, the polarity Henry James–Mark Twain is replaced by the artist-type of Hemingway and Pound.

This change in the model personality of the painter corresponded to the actual life of the artist. He had become in the course of the nineteenth century, particularly in Europe, distinct from the artisan, the professional, and the man of affairs. Unless he was an academician who had status through privileged membership in a recognized society, he lived in a world apart, most often poor, struggling, uncertain of the future, and sustained by his devotion to ideal ends

that were generally respected by the public in the great artists of the past (their established fame was a kind of success), but were not recommended in the present to the young of the middle class. His dress, his manners, his home, his outlook, were less conventional than those of the class from which he came. His reputation for irresponsibility and disorder extended to his morals. But in time this liberty became a model to others who could afford it. His bare studio with large windows and simple furniture, his informal ways and ready responsiveness to people and art, represented for many a better style of life. He was a leader in breaking down the rigidities and narrowness of older social customs, the stuffiness of Victorian life. He anticipated an ideal of openness and simplicity that became more general in the next decades, with the growth of the city and the greater mobility of individuals. It is easy to see that the new art was closer than the old to this condition of the artist. In America the introduction of modern art coincided with the prestige of Greenwich Village as an artistic bohème. It was not necessary that a Cubist be radical in politics, libertine in morals, and simple or careless in dress; what was important was the general atmosphere of gaiety and spiritual independence, an atmosphere indispensable for an artist's life.

The Armory Show, held just before the first World War, marked the end of an era. It took place at a high point of social idealism in America. Although much of this spirit lived on after the war, there was a notable shift in thinking to a more personal field and to faith in psychology. What may be called the idealistic individualism of the pre-1914 period was more keenly aware of institutions and of society as a whole, and was more confident of being able to shape them for humane ends. Faced by the great corporate powers, which had emerged from the smaller economic units of the nineteenth century and which now threatened the old liberties, democratic opinion in the first years of the century became more militantly radical. This active social sentiment waned after the first World War, at a time when freedom or at least mobility in personal life, in culture and recreation, decidedly increased. The advanced artist, in a corresponding way, reacted to the declining confidence in radical social aims or the social

group by asserting more forcefully the value of the personal world and of art. (This attitude had already become prevalent among advanced European artists before the end of the nineteenth century, probably because of the acuter crises of European social life.) While the new art seems a fulfillment of an American dream of liberty, it is also in some ways a negation. In suggesting to the individual that he take account of himself above all, it also isolates him from activity in the world and confirms the growing separation of culture from work and ideal social aims. But not altogether, for at certain moments of prosperity this art, through its geometrized forms, celebrates the beauty of machines and the norms of industry and science as a promise of ultimate harmony and well-being. Yet it does this uncritically, almost childishly, without deep awareness, detaching the technical from the fuller context of subjection and suffering, and surrendering the spontaneity of the person for the sake of an impersonal outward strength that comes to look inhuman.

But if the new art is in some respects a retreat from a more critical and positive conception of culture, it should be observed that a trend toward an art of intimacy and sensation was already well advanced here before the Show, although it was thirty years behind the corresponding French art. The American Impressionists, like the Europeans before them, took as their chief objects smaller and smaller bits of landscape, interesting for some personally savored nuance of color, light, and air. The painting of several of the leading members of the group of the Eight, which is often described as popular, activist, and American, in contrast to the aestheticism and foreignness of the later art, represented the city streets and docks as a pure spectacle, without meaning beyond the sheer animation or phenomenon of movement; it loved the merry-go-round, the theater, the circus, the prize-fight, the crowds at the beach and the park; the favored subjects of portraiture were picturesque or exotic—the foreigner, the gypsy, the actor, the kids from the slums, who in their oddity of dress and appearance embodied a freedom from sober American conventions. It was no searching or epic realism of American life, but an enjoyment of impressions of vitality and movement.

The revival of political radicalism during the depression of the 1930's led to criticism of modern art as too narrow and as incapable of expressing deeper social values. Many artists hoped then to find a bridge between their aesthetic modernism and their new political sympathies; but the weakness of the radical movement, the eventual disillusionment with Communism, and the effects of war, re-employment, and the growing role of the state in the 1940's, reduced the appeal of this criticism. Artists today who would welcome the chance to paint works of broad human content for a larger audience, works comparable in scope to those of antiquity or the Middle Ages, find no sustained opportunities for such an art; they have no alternative but to cultivate in their art the only or surest realms of freedom—the interior world of their fancies, sensations, and feelings, and the medium itself.

Today, almost forty years after the Armory Show, modern art is still a recurring problem for the public, although so many more painters and sculptors practice this art. The hostile criticisms made in 1913 have been renewed with great virulence. We hear them now from officials of culture, from Congress and the president. The director of the Metropolitan Museum of Art has recently condemned modern art as "meaningless" and "pornographic," and as a sign of the decay of civilization in our time. These criticisms are sometimes linked in an unscrupulous way with attacks on Communism, foreign culture, and religious doubt. They have a parallel in the attempts of the totalitarian regimes in Europe to destroy modern art as an unpalatable model of personal freedom of expression and indifference to the state. The Nazis suppressed this art as "cultural Bolshevism"; the Russian government and its supporters in the West denounced it as an example of "cosmopolitanism" or "bourgeois decadence"; Catholic spokesmen have rejected it as a manifestation of godless individualism. But no serious alternative has arisen to replace it. Those who demand a traditional and consoling art, or an art useful to the state, have nothing to hold to in contemporary painting and sculpture, unless it be some survivals of the academicism of the last century, or hybrid imitations of the modern art of fifty years ago by mediocre conforming painters, works that the enemies of the modern can hardly support with enthusiasm.

This essay was written in 1950 and its substance presented in a lecture at Bennington College in the winter of 1950–51 in a series by different scholars on crises in American History, published in 1952 in the volume *America in Crisis*, edited by Daniel Aaron.

BIBLIOGRAPHY

The catalogue of the Armory Show, which lists about 1,100 works by over 300 exhibitors, of whom more than 100 were Europeans, is incomplete. Many works added in the course of the exhibition were not catalogued, and groups of drawings and prints by the same artist were listed as single works. Mr. Walter Pach estimates that there were altogether about 1,600 objects in the Show. (Association of American Painters and Sculptors, Inc., New York. International Exhibition of Modern Art, February 17—March 15, 1913. A second edition with a supplement was published for the exhibition at the Chicago Art Institute, March 24—April 16, 1913, and reprinted for the Boston showing, April 28—May 19, 1913.) An attempt to recatalogue all these works and to trace their later history was made by Miss Chloe Hamilton in a master's thesis, unpublished, at Oberlin College. ("The Armory Show: Its History and Significance," 1950), an excellent study that I was able to consult through the kindness of the library of the college. The late Walt Kuhn, one of the organizers of the Show, has recalled its history in an anniversary pamphlet: "Twenty-Five Years After: The Story of the Armory Show" (New York: 1938), and another of the participants, Mr. Walter Pach, who was especially active in recommending and borrowing European works for the Show, has written about it in *Queer Thing, Painting* (New York: 1938), ch. xvii. For accounts of the Show by later writers, see Jerome Mellquist, *The Emergence of an American Art* (1942), and Oliver W. Larkin, *Life and Art in America* (1949). For contemporary opinions and criticisms, see the pamphlet edited by James Gregg, "For and Against" (1913), and the March 1913 issue of *Arts and Decoration*, III, pp. 149–84; *The Nation*, Vols. XCVI–VII (1913), pp. 174, 240–3, 281 (including the review by Frank Jewett Mather); *Life*, Vol. LXI (1913), pp. 531, 572, 577, 675, 680, 688, 740, 827, 838; *Century Magazine*, Vol. LXV (1913–14), pp. 825 ff.; *Current Opinion*, Vol. LIV (1913), pp. 316 ff. Collections of clippings about the Show from newspapers and magazines are preserved at the Museum of Modern Art in New York, and at the New York Public Library.

For the ideas about modern art at the time of the Show, see Willard Huntington Wright, *Modern Painting* (New York: 1915), and, on a lower level, Arthur J. Eddy, *Cubists and Post-Impressionists* (Chicago: 1914);

Roger Fry, preface to the Catalogue of the Second French Post-Impressionists Exhibition at the Grafton Galleries (London: 1912), reprinted in *Vision and Design* (London: 1920); Clive Bell, *Art* (London: 1914); *Blast*, edited by Wyndham Lewis, Review of the Great English Vortex, No. 1 (London, New York, and Toronto: June 20, 1914). Influential writings by European artists, translated into English, were Wassily Kandinsky, *Concerning Spiritual Harmony* (London: 1913); Albert Gleizes and Jean Metzinger, *Cubism* (London: 1913); Guillaume Apollinaire, *The Cubist Painters* (New York: 1944). Very important as an organ of American modernist taste was the periodical of photography, *Camera Work* (New York: 1902–17), inspired mainly by Alfred Stieglitz. On his personality and work, see Waldo Frank and others, *America and Alfred Stieglitz: A Collective Portrait* (New York: 1934). The great collection of John Quinn, who was closely associated with the history of the Show, has been catalogued: "John Quinn, 1870–1925, Collection of Paintings, Water Colors, Drawings and Sculpture" (Huntington, New York: 1926). [On the occasion of the Fiftieth Anniversary Exhibition of the Armory Show at the Munson-Williams-Proctor Institute in Utica, New York, and at the same Armory in New York City, was published the book by Milton W. Brown, *The Story of the Armory Show* (The Joseph H. Hirshhorn Foundation, 1963). Besides many previously unpublished documents of the Show, Professor Brown reprinted the original catalogue with revisions and annotations.]

IX. Gorky: *Diary of a Seducer*, Collection Mr. and Mrs. A. M. Burden, New York. (Photo, Eric Pollitzer)

X. Rothko: *Deep Red on Maroon*, Estate of Mark Rothko.

XI. Mondrian: *Broadway Boogie-Woogie,* Collection, The Museum of Modern Art, New York. Given anonymously.

ARSHILE GORKY

(1957)

An artist rarely has the good fortune to be the subject of a study by one who has known him well and has loved his art with as much understanding as the exquisitely sensitive author of this book.[1] She was Gorky's pupil and friend throughout the greater part of his career as a painter.

My own memories and impressions of Gorky are less precise than Ethel Schwabacher's. I met him most often in the museums and galleries fixed in rapt contemplation of pictures with that grave, searching look which was one of the beauties of his face. As some poets are great readers, Gorky—exceptional among painters—was a fervent scrutinizer of paintings. No interesting touch or invention of form escaped his eye. He was equally at home in the Metropolitan Museum and the Museum of Modern Art, keen in discerning what was good in the arts of many ages and styles. He possessed a rare power of artistic recognition founded on a noble concept of art, an aristocratic feeling for quality. He championed the original and the great while most artists around him were contented with much less.

Among the painters in New York, Gorky stood out for years as the masterly apprentice. His career was remarkable as a development from what seemed a servile imitation of other painters to a high originality. For almost twenty years he produced obviously derived pictures, versions of Cézanne, Picasso, Léger, Miró, Kandinsky and others; and suddenly he flowered as an imaginative artist whom cer-

179

tain admirers class with the very great. That prolonged period of imitation might be regarded as a voluntary and humble discipleship leading to original work; but to those who disparage his last pictures and point to the earlier stage as the measure of a limited, dependent talent, it can be said that never in his fidelity to the masters he loved was Gorky conventional or academic like the conservative and hybrid artists these same critics find it more easy to approve. The painters he followed were his personal discoveries, much like the ancient works copied by the masters of the Renaissance. To be a disciple of Picasso in New York in the 1920's and early '30's was an act of originality and, for a young artist in the solitude of his exceptional taste, an enormous risk.

If we study the young Gorky's "imitations" in themselves, without asking what they copy, we are bound, I think, to recognize their considerable virtues. In an exhibition of the art of the time they would hold up as works of a true artist: beautiful in color, of an appetizing substance, well constructed, robust, with an air of completeness. Few artists in this country in the 1920's and '30's painted so seriously. To Gorky the great painters of our century were like the old masters, and he gave them his unwavering attention, consulting their pictures with a profoundly searching eye. In imitating Picasso, he wished to possess Picasso's language; his own version was a test of his insight and degree of mastery. In Gorky's picture (Fig. 1), which resembles the Spaniard's still life with musical instruments in the collection of G. David Thompson, shown at the Museum of Modern Art (Fig. 2), he was able to use those foreign forms with an amazing sureness. It is hard to believe that this painting was done in New York by an artist who had never been in Paris and knew only the few works of Picasso that had been shown here. We do not find in Gorky's early painting the typical reductions of a more complex or accomplished style that we expect in imitations made at a distance from the home of the original work. There is no trace here of confusion of forms or mark of a previous method of the copyist contaminating the new style—in short, no foreign accent. He belonged then to the School of Paris more surely than many painters living in France. The difference

Fig. 1 Gorky: *Still Life*, 1929–32. Oil on canvas, 47″ x 60″. Estate of Arshile Gorky. Courtesy Sidney Janis Gallery.

Fig. 2 Picasso: *Musical Instruments*, 1923. Oil, 38″ x 51″. Private Collection.

Fig. 3 Gorky: *Agony*, 1947. Oil on canvas, 40″ x 50½″. Collection, The Museum of Modern Art, New York. A. Conger Goodyear Fund.

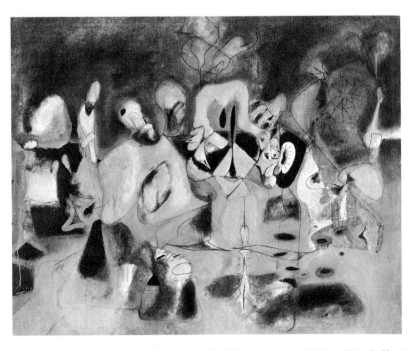

Fig. 4 Gorky: *Diary of a Seducer*, 1945. Oil on canvas, 50″ x 62″. Collection Mr. and Mrs. William A. M. Burden, New York.

from Picasso lay not so much in the intonation or in the syntax and vocabulary of motifs, which Gorky possessed fully, as in subtler qualities which only an attentive scrutiny will disclose. There is in this imitative phase of Gorky's art a great pride and a great humility, like that of the Renaissance painters and sculptors who thought of the ancients as their true models and did not believe they could surpass them; if their art today seems to us in many respects unclassic, it was not so from a deliberate striving for the new. Gorky was as far from his beloved modern classics in space as the Renaissance artists were remote from the ancients in time. For years surprising Picassos, Braques and Mirós turned up on 57th Street or at the Museum of Modern Art and in books and magazines, as Roman statuary had emerged from the ground in the fifteenth century to join the standing objects in the ruins. Until one day, Europe itself was exiled to America and Gorky found himself at last among his own kind. Here his life as an original artist began.

In his career of imitation, he had been attracted by successively younger and lesser artists, although always highly individual ones. From Cézanne he had gone to Picasso, from Picasso to Miró, and finally, among the surrealists, from Masson and Tanguy to the youngest of all: Matta. The artist he admired now was a brother rather than a father, and a younger brother. In Matta he found for the first time a painter whose language, once mastered, he could use as freely himself. From Matta came the idea of the canvas as a field of prodigious excitement, unloosed energies, bright reds and yellows opposed to cold greys, a new futurism of the organic as well as of mechanical forces. Gorky could draw his own conclusions from Matta's art without waiting for the inventor; he was able to build upon it independently as Braque did upon the forms created jointly by Picasso and himself. The encounter with Matta was, it seems to me, a decisive point in Gorky's liberation from copying.

In the advanced American art of the 1940's one cannot stress too much the importance of the influx of European artists in New York during the war, and most of all the surrealists, in spite of the barrier of language. Gorky had known their work before and his painting had

responded already to the imagery of Miró and Picasso's fantasy about primitive bodily forms. But in the war years Gorky accepted the undiscipline of surrealism (which had also its requirements of harmony); and this released in him qualities he had perhaps not suspected in himself before. His painting had been a homage to stable order, deliberation, substance; in his last works how tenuous, loose and scattered are the playful forms! But also how refined the tones and surface, how elegant the calligraphy of the bodiless linear shapes, sometimes to the point of the precious and prolix! In the first pictures he kept the spectator at a distance, as before a high mural which must be seen from afar if its architecture is to be grasped and the full effect of its primary colors enjoyed. Afterwards he is caressing and graceful, inviting us to a close view of secret detail, the vagrant lines and thin washes of mysterious color melting into each other and into the canvas grain. The novelty of his style lies in part in his creation of the atmospheric in an art which had been until then airless and precise. In Miró's painting there is something of this filmy ambience, but it is most often the clear air of Mediterranean landscape or the transparent depth of an ocean or aquarium, the home of floating creatures. Gorky discovered an atmosphere suited for the objects of modern fantasy, primitive, visceral and grotesque, as Corot had created an atmosphere for nostalgic revery, a sweet mythical world that might have been seen directly. Gorky's atmosphere, veiling the hard opaque wall of the canvas, evokes a nocturnal void or the vague, unstable image-space of the day-dreaming mind. But beyond the appeal of the painting as a secretion of symbols or as a track of feeling, Gorky's work has usually the grace of art—it is beautifully made.

Here in exile in New York the surrealists of the Old World found their last original disciple. Gorky, as I said, had been prepared for their visit years before. He had known and loved their vein of revolt and their flair for the instinctual in poetry, painting and wit. In the '30's he had admired Dali both as writer and imager, in spite of his own high scruples about art. Admitted to the fold, Gorky yielded to the seduction of surrealist poetics, accepting and soliciting others' titles for his works—which as improvisations had no predetermined

sense. He once said that he did not wish his pictures to have faces; but he sometimes gave them what are artificial faces, the masks of borrowed allusions, poets' titles. Yet in the best of his last pictures, very beautiful ones like *Agony* (Fig. 3), and the *Diary of a Seducer* (Pl. IX, Fig. 4), he seems to us truer to himself than in his most austerely considered early work; at least he was able to realize then in a delicate style an important, perhaps feminine, part of his nature—feelings of love and fragility and despair—for which there had been little place in his art before.

NOTES

[1] This essay was written as an introduction to *Arshile Gorky*, a book on the artist by Ethel Schwabacher: Whitney Museum of Modern Art, Macmillan, New York (1957).

NATURE OF
ABSTRACT ART
(1937)

I

Before there was an art of abstract painting, it was already widely
believed that the value of a picture was a matter of colors and
shapes alone. Music and architecture were constantly held up to
painters as examples of a pure art which did not have to imitate
objects but derived its effects from elements peculiar to itself. But
such ideas could not be readily accepted, since no one had yet seen a
painting made up of colors and shapes, representing nothing. If pic-
tures of the objects around us were often judged according to qualities
of form alone, it was obvious that in doing so one was distorting or
reducing the pictures; you could not arrive at these paintings simply
by manipulating forms. And in so far as the objects to which these
forms belonged were often particular individuals and places, real or
mythical figures, bearing the evident marks of a time, the pretension
that art was above history through the creative energy or personality
of the artist was not entirely clear. In abstract art, however, the pre-
tended autonomy and absoluteness of the aesthetic emerged in a con-
crete form. Here, finally, was an art of painting in which only aesthetic
elements seem to be present.

Abstract art had therefore the value of a practical demonstration.
In these new paintings the very processes of designing and inventing
seemed to have been brought on to the canvas; the pure form once
masked by an extraneous content was liberated and could now be
directly perceived. Painters who do not practice this art have wel-

comed it on just this ground, that it strengthened their conviction of the absoluteness of the aesthetic and provided them a discipline in pure design. Their attitude toward past art was also completely changed. The new styles accustomed painters to the vision of colors and shapes as disengaged from objects and created an immense confraternity of works of art, cutting across the barriers of time and place. They made it possible to enjoy the remotest arts, those in which the represented objects were no longer intelligible, even the drawings of children and madmen, and especially primitive arts with drastically distorted figures, which had been regarded as artless curios even by insistently aesthetic critics. Before this time Ruskin could say in his *Political Economy of Art*, in calling for the preservation of medieval and Renaissance works that "in Europe alone, pure and precious ancient art exists, for there is none in America, none in Asia, none in Africa." What was once considered monstrous, now became pure form and pure expression, the aesthetic evidence that in art feeling and thought are prior to the represented world. The art of the whole world was now available on a single unhistorical and universal plane as a panorama of the formalizing energies of man.

These two aspects of abstract painting, the exclusion of natural forms and the unhistorical universalizing of the qualities of art, have a crucial importance for the general theory of art. Just as the discovery of non-Euclidian geometry gave a powerful impetus to the view that mathematics was independent of experience, so abstract painting cut at the roots of the classic ideas of artistic imitation. The analogy of mathematics was in fact present to the minds of the apologists of abstract art; they have often referred to non-Euclidian geometry in defense of their own position, and have even suggested an historical connection between them.

Today the abstractionists and their Surrealist offspring are more and more concerned with objects and the older claims of abstract art have lost the original force of insurgent convictions. Painters who had once upheld this art as the logical goal of the entire history of forms have refuted themselves in returning to the impure natural forms. The demands for liberty in art are no longer directed against a fettering

tradition of nature; the aesthetic of abstraction has itself become a brake on new movements. Not that abstract art is dead, as its philistine enemies have been announcing for over twenty years; it is still practiced by some of the finest painters and sculptors in Europe, whose work shows a freshness and assurance that are lacking in the newest realistic art. The conception of a possible field of "pure art"— whatever its value—will not die so soon, though it may take on forms different from those of the last thirty years; and very likely the art that follows in the countries which have known abstraction will be affected by it. The ideas underlying abstract art have penetrated deeply into all artistic theory, even of their original opponents; the language of absolutes and pure sources of art, whether of feeling, reason, intuition or the sub-conscious mind, appears in the very schools which renounce abstraction. "Objective" painters strive for "pure objectivity," for the object given in its "essence" and completeness, without respect to a viewpoint, and the Surrealists derive their images from pure thought, freed from the perversions of reason and everyday experience. Very little is written today—sympathetic to modern art—which does not employ this language of absolutes.

In this article I shall take as my point of departure Barr's recent book,[1] the best, I think, that we have in English on the movements now grouped as abstract art. It has the special interest of combining a discussion of general questions about the nature of this art, its aesthetic theories, its causes, and even the relation to political movements, with a detailed, matter-of-fact account of the different styles. But although Barr sets out to describe rather than to defend or to criticize abstract art, he seems to accept its theories on their face value in his historical exposition and in certain random judgments. In places he speaks of this art as independent of historical conditions, as realizing the underlying order of nature and as an art of pure form without content.

Hence if the book is largely an account of historical movements, Barr's conception of abstract art remains essentially unhistorical. He gives us, it is true, the dates of every stage in the various movements, as if to enable us to plot a curve, or to follow the emergence of the art year by year, but no connection is drawn between the art and the con-

ditions of the moment. He excludes as irrelevant to its history the nature of the society in which it arose, except as an incidental obstructing or accelerating atmospheric factor. The history of modern art is presented as an internal, immanent process among the artists; abstract art arises because, as the author says, representational art had been exhausted. Out of boredom with "painting facts," the artists turned to abstract art as a pure aesthetic activity. "By a common and powerful impulse they were driven to abandon the imitation of natural appearance" just as the artists of the fifteenth century "were moved by a passion for imitating nature." The modern change, however, was "the logical and inevitable conclusion toward which art was moving."

This explanation, which is common in the studios and is defended by some writers in the name of the autonomy of art, is only one instance of a wider view that embraces every field of culture and even economy and politics. At its ordinary level the theory of exhaustion and reaction reduces history to the pattern of popular ideas on changes in fashion. People grow tired of one color and choose an opposite; one season the skirts are long, and then by reaction they are short. In the same way the present return to objects in painting is explained as the result of the exhaustion of abstract art. All the possibilities of the latter having been explored by Picasso and Mondrian, there is little left for the younger artists but to take up the painting of objects.

The notion that each new style is due to a reaction against a preceding is especially plausible to modern artists, whose work is so often a response to another work, who consider their art a free projection of an irreducible personal feeling, but must form their style in competition against others, with the obsessing sense of the originality of their work as a mark of its sincerity. Besides, the creators of new forms in the last century had almost always to fight against those who practiced the old; and several of the historical styles were formed in conscious opposition to another manner—Renaissance against Gothic, Baroque against Mannerism, Neo-classic against Rococo, etc.

The antithetic form of a change does not permit us, however, to

judge a new art as a sheer reaction or as the inevitable response to the spending of all the resources of the old. No more than the succession of war and peace implies that war is due to an inherent reaction against peace and peace to a reaction against war. The energies required for the reaction, which sometimes has a drastic and invigorating effect on art, are lost sight of in such an account; it is impossible to explain by it the particular direction and force of the new movement, its specific moment, region and goals. The theory of immanent exhaustion and reaction is inadequate not only because it reduces human activity to a simple mechanical movement, like a bouncing ball, but because in neglecting the sources of energy and the condition of the field, it does not even do justice to its own limited mechanical conception. The oppositeness of a reaction is often an artificial matter, more evident in the polemics between schools or in the schemas of formalistic historians than in the actual historical change. To supply a motor force to this physical history of styles (which pretends to be antimechanical), they are reduced to a myth of the perpetual alternating motion of generations, each reacting against its parents and therefore repeating the motions of its grandparents, according to the "grandfather principle" of certain German historians of art. And a final goal, an unexplained but inevitable trend, a destiny rooted in the race or the spirit of the culture or the inherent nature of the art, has to be smuggled in to explain the large unity of a development that embraces so many reacting generations. The immanent purpose steers the reaction when an art seems to veer off the main path because of an overweighted or foreign element. Yet how many arts we know in which the extreme of some quality persists for centuries without provoking the corrective reaction. The "decay" of classical art has been attributed by the English critic, Fry, to its excessive cult of the human body, but this "decay" evidently lasted for hundreds of years until the moment was ripe for the Christian reaction. But even this Christian art, according to the same writer, was for two centuries indistinguishable from the pagan.

The broad reaction against an existing art is possible only on the ground of its inadequacy to artists with new values and new ways of

seeing. But reaction in this internal, antithetic sense, far from being an inherent and universal property of culture, occurs only under impelling historical conditions. For we see that ancient arts, like the Egyptian, the work of anonymous craftsmen, persist for thousands of years with relatively little change, provoking few reactions to the established style; others grow slowly and steadily in a single direction, and still others, in the course of numerous changes, foreign intrusions and reactions preserve a common traditional character. From the mechanical theories of exhaustion, boredom and reaction we could never explain why the reaction occurred when it did. On the other hand, the banal divisions of the great historical styles in literature and art correspond to the momentous divisions in the history of society.

If we consider an art that is near us in time and is still widely practiced, like Impressionism, we see how empty is the explanation of the subsequent arts by reaction. From a logical viewpoint the antithesis to Impressionism depends on how Impressionism is defined. Whereas the later schools attacked the Impressionists as mere photographers of sunshine, the contemporaries of Impressionism abused it for its monstrous unreality. The Impressionists were in fact the first painters of whom it was charged that their works made as little sense right side up as upside down. The movements after Impressionism take different directions, some toward simplified natural forms, others toward their complete decomposition; both are sometimes described as historical reactions against Impressionism, one restoring the objects that Impressionism dissolved, the other restoring the independent imaginative activity that Impressionism sacrificed to the imitation of nature.

Actually, in the 1880's there were several aspects of Impressionism which could be the starting points of new tendencies and goals of reaction. For classicist painters the weakness of Impressionism lay in its unclarity, its destruction of definite linear forms; it is in this sense that Renoir turned for a time from Impressionism to Ingres. But for other artists at the same moment Impressionism was too casual and unmethodical; these, the neo-Impressionists, preserved the Impressionist colorism, carrying it even further in an unclassical sense, but also in

a more constructive and calculated way. For still others, Impressionism was too photographic, too impersonal; these, the symbolists and their followers, required an emphatic sentiment and aesthetic activism in the work. There were finally artists for whom Impressionism was too unorganized, and their reaction underscored a schematic arrangement. Common to most of these movements after Impressionism was the absolutizing of the artist's state of mind or sensibility as prior to and above objects. If the Impressionists reduced things to the artist's sensations, their successors reduced them further to projections or constructions of his feelings and moods, or to "essences" grasped in a tense intuition.

The historical fact is that the reaction against Impressionism came in the 1880's before some of its most original possibilities had been realized. The painting of series of chromatic variations of a single motif (the *Haystacks*, the *Cathedral*) dates from the 1890's; and the *Water Lilies*, with their remarkable spatial forms, related in some ways to contemporary abstract art, belong to the twentieth century. The effective reaction against Impressionism took place only at a certain moment in its history and chiefly in France, though Impressionism was fairly widespread in Europe by the end of the century. In the 1880's, when Impressionism was beginning to be accepted officially, there were already several groups of young artists in France to whom it was uncongenial. The history of art is not, however, a history of single willful reactions, every new artist taking a stand opposite the last, painting brightly if the other painted dully, flattening if the other modelled, and distorting if the other was literal. The reactions were deeply motivated in the experience of the artists, in a changing world with which they had to come to terms and which shaped their practice and ideas in specific ways.

The tragic lives of Gauguin and Van Gogh, their estrangement from society, which so profoundly colored their art, were no automatic reactions to Impressionism or the consequences of Peruvian or Northern blood. In Gauguin's circle were other artists who had abandoned a bourgeois career in their maturity or who had attempted suicide. For a young man of the middle class to wish to live by art meant

a different thing in 1885 than in 1860. By 1885 only artists had freedom and integrity, but often they had nothing else. The very existence of Impressionism which transformed nature into a private, unformalized field for sensitive vision, shifting with the spectator, made painting an ideal domain of freedom; it attracted many who were tied unhappily to middle class jobs and moral standards, now increasingly problematic and stultifying with the advance of monopoly capitalism. But Impressionism in isolating the sensibility as a more or less personal, but dispassionate and still outwardly directed, organ of fugitive distinctions in distant dissolving clouds, water and sunlight, could no longer suffice for men who had staked everything on impulse and whose resolution to become artists was a poignant and in some ways demoralizing break with good society. With an almost moral fervor they transformed Impressionism into an art of vehement expression, of emphatic, brilliant, magnified, obsessing objects, or adjusted its coloring and surface pattern to dreams of a seasonless exotic world of idyllic freedom.

Early Impressionism, too, had a moral aspect. In its unconventionalized, unregulated vision, in its discovery of a constantly changing phenomenal outdoor world of which the shapes depended on the momentary position of the casual or mobile spectator, there was an implicit criticism of symbolic social and domestic formalities, or at least a norm opposed to these. It is remarkable how many pictures we have in early Impressionism of informal and spontaneous sociability, of breakfasts, picnics, promenades, boating trips, holidays and vacation travel. These urban idylls not only present the objective forms of bourgeois recreation in the 1860's and 1870's; they also reflect in the very choice of subjects and in the new aesthetic devices the conception of art as solely a field of individual enjoyment, without reference to ideas and motives, and they presuppose the cultivation of these pleasures as the highest field of freedom for an enlightened bourgeois detached from the official beliefs of his class. In enjoying realistic pictures of his surroundings as a spectacle of traffic and changing atmospheres, the cultivated rentier was experiencing in its phenomenal aspect that mobility of the environment, the market and

of industry to which he owed his income and his freedom. And in the new Impressionist techniques which broke things up into finely dis-criminated points of color, as well as in the "accidental" momentary vision, he found, in a degree hitherto unknown in art, conditions of sensibility closely related to those of the urban promenader and the refined consumer of luxury goods.

As the contexts of bourgeois sociability shifted from community, family and church to commercialized or privately improvised forms— the streets, the cafés and resorts—the resulting consciousness of indi-vidual freedom involved more and more an estrangement from older ties; and those imaginative members of the middle class who accepted the norms of freedom, but lacked the economic means to attain them, were spiritually torn by a sense of helpless isolation in an anony-mous indifferent mass. By 1880 the enjoying individual becomes rare in Impressionist art; only the private spectacle of nature is left. And in neo-Impressionism, which restores and even monumentalizes the figures, the social group breaks up into isolated spectators, who do not communicate with each other, or consists of mechanically repeated dances submitted to a preordained movement with little spontaneity.

The French artists of the 1880's and 1890's who attacked Im-pressionism for its lack of structure often expressed demands for salvation, for order and fixed objects of belief, foreign to the Impres-sionists as a group. The title of Gauguin's picture—"*Where do we come from? What are we? Where are we going?*"—with its interroga-tive form, is typical of this state of mind. But since the artists did not know the underlying economic and social causes of their own disorder and moral insecurity, they could envisage new stabilizing forms only as quasi-religious beliefs or as a revival of some primitive or highly ordered traditional society with organs for a collective spiritual life. This is reflected in their taste for medieval and primitive art, their conversions to Catholicism and later to "integral nationalism." The colonies of artists formed at this period, Van Gogh's project of a communal life for artists, are examples of this groping to reconstitute the pervasive human sociability that capitalism had destroyed. Even their theories of "composition"—a traditional concept abandoned by

the Impressionists—are related to their social views, for they conceive of composition as an assembly of objects bound together by a principle of order emanating, on the one hand, from the eternal nature of art, on the other, from the state of mind of the artist, but in both instances requiring a "deformation" of the objects. Some of them wanted a canvas to be like a church, to possess a hierarchy of forms, stationed objects, a prescribed harmony, preordained paths of vision, all issuing, however, from the artist's feeling. In recreating the elements of community in their art they usually selected inert objects, or active objects without meaningful interaction except as colors and lines.

These problems are posed to some extent, though solved differently, even in the work of Seurat, whose relation to the economic development was in many ways distinct from that of the painters of the Symbolist and Synthetist groups. Instead of rebelling against the moral consequences of capitalism he attached himself like a contented engineer to its progressive technical side and accepted the popular forms of lower class recreation and commercialized entertainment as the subjects of a monumentalized art. From the current conceptions of technology he drew the norms of a methodical procedure in painting, bringing Impressionism up to date in the light of the latest findings of science.

There were, of course, other kinds of painting in France beside those described. But a detailed investigation of the movement of art would show, I think, that these, too, and even the conservative, academic painting were affected by the changed conditions of the time. The reactions against Impressionism, far from being inherent in the nature of art, issued from the responses that artists as artists made to the broader situation in which they found themselves, but which they themselves had not produced. If the tendencies of the arts after Impressionism toward an extreme subjectivism and abstraction are already evident in Impressionism, it is because the isolation of the individual and of the higher forms of culture from their older social supports, the renewed ideological oppositions of mind and nature, individual and society, proceed from social and economic causes

which already existed before Impressionism and which are even sharper today. It is, in fact, a part of the popular attraction of Van Gogh and Gauguin that their work incorporates (and with a far greater energy and formal coherence than the works of other artists) evident longings, tensions and values which are shared today by thousands who in one way or another have experienced the same conflicts as these artists.

The logical opposition of realistic and abstract art by which Barr explains the more recent change rests on two assumptions about the nature of painting, common in writing on abstract art: that representation is a passive mirroring of things and therefore essentially non-artistic, and that abstract art, on the other hand, is a purely aesthetic activity, unconditioned by objects and based on its own eternal laws. The abstract painter denounces representation of the outer world as a mechanical process of the eye and the hand in which the artist's feelings and imagination have little part. Or in a Platonic manner he opposes to the representation of objects, as a rendering of the surface aspect of nature, the practice of abstract design as a discovery of the "essence" or underlying mathematical order of things. He assumes further that the mind is most completely itself when it is independent of external objects. If he, nevertheless, values certain works of older naturalistic art, he sees in them only independent formal constructions; he overlooks the imaginative aspect of the devices for transposing the space of experience on to the space of the canvas, and the immense, historically developed, capacity to hold the world in mind. He abstracts the artistic qualities from the represented objects and their meanings, and looks on these as unavoidable impurities, imposed historical elements with which the artist was burdened and in spite of which he finally achieved his underlying, personal abstract expression.

These views are thoroughly one-sided and rest on a mistaken idea of what a representation is. There is no passive, "photographic" representation in the sense described; the scientific elements of representation in older art—perspective, anatomy, light-and-shade—are

ordering principles and expressive means as well as devices of rendering. All renderings of objects, no matter how exact they seem, even photographs, proceed from values, methods and viewpoints which somehow shape the image and often determine its contents. On the other hand, there is no "pure art," unconditioned by experience; all fantasy and formal construction, even the random scribbling of the hand, are shaped by experience and by nonaesthetic concerns.

This is clear enough from the example of the Impressionists mentioned above. They could be seen as both photographic and fantastic, according to the viewpoint of the observer. Even their motifs of nature were denounced as meaningless beside the evident content of romantic and classicist art.

In regarding representation as a facsimile of nature, the abstract artist has taken over the error of vulgar nineteenth century criticism, which judged painting by an extremely narrow criterion of reality, inapplicable even to the realistic painting which it accepted. If an older taste said, how exactly like the object, how beautiful!—the modern abstractionist says, how exactly like the object, how ugly! The two are not completely opposed, however, in their premises, and will appear to be related if compared with the taste of religious arts with a supernatural content. Both realism and abstraction affirm the sovereignty of the artist's mind, the first, in the capacity to recreate the world minutely in a narrow, intimate field by series of abstract calculations of perspective and gradation of color, the other in the capacity to impose new forms on nature, to manipulate the abstracted elements of line and color freely, or to create shapes corresponding to subtle states of mind. But as little as a work is guaranteed aesthetically by its resemblance to nature, so little is it guaranteed by its abstractness or "purity." Nature and abstract forms are both materials for art, and the choice of one or the other flows from historically changing interests.

Barr believes that painting is impoverished by the exclusion of the outer world from pictures, losing a whole range of sentimental, sexual, religious and social values. But he supposes in turn that the aesthetic values are then available in a pure form. He does not see,

however, that the latter are changed rather than purified by this exclusion, just as the kind of verbal pattern in writing designed mainly for verbal pattern differs from the verbal pattern in more meaningful prose. Various forms, qualities of space, color, light, scale, modelling and movement, which depend on the appreciation of aspects of nature and human life, disappear from painting; and similarly the aesthetic of abstract art discovers new qualities and relationships which are congenial to the minds that practice such an exclusion. Far from creating an absolute form, each type of abstract art, as of naturalistic art, gives a special but temporary importance to some element, whether color, surface, outline or arabesque, or to some formal method. The converse of Barr's argument, that by clothing a pure form with a meaningful dress this form becomes more accessible or palatable, like logic or mathematics presented through concrete examples, rests on the same misconception. Just as narrative prose is not simply a story added to a preexisting, pure prose form that can be disengaged from the sense of the words, so a representation is not a natural form added to an abstract design. Even the schematic aspects of the form in such a work already possess qualities conditioned by the modes of seeing objects and designing representations, not to mention the content and the emotional attitudes of the painter.

When the abstractionist Kandinsky was trying to create an art expressing mood, a great deal of conservative, academic painting was essentially just that. But the academic painter, following older traditions of romantic art, preserved the objects which provoked the mood; if he wished to express a mood inspired by a landscape, he painted the landscape itself. Kandinsky, on the other hand, wished to find an entirely imaginative equivalent of the mood; he would not go beyond the state of mind and a series of expressive colors and shapes, independent of things. The mood in the second case is very different from the first mood. A mood which is partly identified with the conditioning object, a mood dominated by clear images of detailed objects and situations, and capable of being revived and communicated to others through these images, is different in feeling tone, in relation to self-consciousness, attentiveness and potential activity, from a mood that

is independent of an awareness of fixed, external objects, but sustained by a random flow of private and incommunicable associations. Kandinsky looks upon the mood as wholly a function of his personality or a special faculty of his spirit; and he selects colors and patterns which have for him the strongest correspondence to his state of mind, precisely because they are not tied sensibly to objects but emerge freely from his excited fantasy. They are the concrete evidences, projected from within, of the internality of his mood, its independence of the outer world. Yet the external objects that underlie the mood may re-emerge in the abstraction in a masked or distorted form. The most responsive spectator is then the individual who is similarly concerned with himself and who finds in such pictures not only the counterpart of his own tension, but a final discharge of obsessing feelings.

In renouncing or drastically distorting natural shapes the abstract painter makes a judgment of the external world. He says that such and such aspects of experience are alien to art and to the higher realities of form; he disqualifies them from art. But by this very act the mind's view of itself and of its art, the intimate contexts of this repudiation of objects, become directing factors in art. When personality, feeling and formal sensibility are absolutized, the values that underlie or that follow today from such attitudes suggest new formal problems, just as the secular interests of the later middle ages made possible a whole series of new formal types of space and the human figure. The qualities of cryptic improvisation, the microscopic intimacy of textures, points and lines, the impulsively scribbled forms, the mechanical precision in constructing irreducible, incommensurable fields, the thousand and one ingenious formal devices of dissolution, penetration, immateriality and incompleteness, which affirm the abstract artist's active sovereignty over objects, these and many other sides of modern art are discovered experimentally by painters who seek freedom outside of nature and society and consciously negate the formal aspects of perception—like the connectedness of shape and color or the discontinuity of object and surroundings—that enter into the practical relations of man in nature.

We can judge more readily the burden of contemporary experience that imposes such forms by comparing them with the abstract devices in Renaissance art, especially the systems of perspective and the canons of proportion, which are today misunderstood as merely imitative means. In the Renaissance the development of linear perspective was intimately tied to the exploration of the world and the renewal of physical and geographical science. Just as for the aggressive members of the burgher class a realistic knowledge of the geographical world and communications entailed the ordering of spatial connections in a reliable system, so the artists strove to realize in their own imaginative field, even within the limits of a traditional religious content, the most appropriate and stimulating forms of spatial order, with the extensiveness, traversability and regulation valued by their class. And similarly, as this same burgher class, emerging from a Christian feudal society, began to assert the priority of sensual and natural to ascetic and supernatural goods, and idealized the human body as the real locus of values—enjoying images of the powerful or beautiful nude human being as the real man or woman, without sign of rank or submission to authority—so the artists derived from this valuation of the human being artistic ideals of energy and massiveness of form which they embodied in robust, active or potentially active, human figures. And even the canons of proportion, which seem to submit the human form to a mysticism of number, create purely secular standards of perfection; for through these canons the norms of humanity become physical and measurable, therefore at the same time sensual and intellectual, in contrast to the older medieval disjunction of body and mind.

If today an abstract painter seems to draw like a child or a madman, it is not because he is childish or mad. He has come to value as qualities related to his own goals of imaginative freedom the passionless spontaneity and technical insouciance of the child, who creates for himself alone, without the pressure of adult responsibility and practical adjustments. And similarly, the resemblance to psychopathic art, which is only approximate and usually independent of a conscious imitation, rests on their common freedom of fantasy, uncontrolled by

reference to an external physical and social world. By his very practice of abstract art, in which forms are improvised and deliberately distorted or obscured, the painter opens the field to the suggestions of his repressed interior life. But the painter's manipulation of his fantasy must differ from the child's or psychopath's in so far as the act of designing is his chief occupation and the conscious source of his human worth; it acquires a burden of energy, a sustained pathos and firmness of execution foreign to the others.

The attitude to primitive art is in this respect very significant. The nineteenth century, with its realistic art, its rationalism and curiosity about production, materials and techniques often appreciated primitive ornament, but considered primitive representation monstrous. It was as little acceptable to an enlightened mind as the fetishism or magic which these images sometimes served. Abstract painters, on the other hand, have been relatively indifferent to the primitive geometrical styles of ornament. The distinctness of motifs, the emblematic schemes, the clear order of patterns, the direct submission to handicraft and utility, are foreign to modern art. But in the distorted, fantastic figures some groups of modern artists found an intimate kinship with their own work; unlike the ordering devices of ornament which were tied to the practical making of things, the forms of these figures seemed to have been shaped by a ruling fantasy, independent of nature and utility, and directed by obsessive feelings. The highest praise of their own work is to describe it in the language of magic and fetishism.

This new responsiveness to primitive art was evidently more than aesthetic; a whole complex of longings, moral values and broad conceptions of life were fulfilled in it. If colonial imperialism made these primitive objects physically accessible, they could have little aesthetic interest until the new formal conceptions arose. But these formal conceptions could be relevant to primitive art only when charged with the new valuations of the instinctive, the natural, the mythical as the essentially human, which affected even the description of primitive art. The older ethnologists, who had investigated the materials and tribal contexts of primitive imagery, usually ignored the subjective and

aesthetic side in its creation; in discovering the latter the modern critics with an equal one-sidedness relied on feeling to penetrate these arts. The very fact that they were the arts of primitive peoples without a recorded history now made them all the more attractive. They acquired the special prestige of the timeless and instinctive, on the level of spontaneous animal activity, self-contained, unreflective, private, without dates and signatures, without origins or consequences except in the emotions. A devaluation of history, civilized society and external nature lay behind the new passion for primitive art. Time ceased to be an historical dimension; it became an internal psychological moment, and the whole mess of material ties, the nightmare of a determining world, the disquieting sense of the present as a dense historical point to which the individual was fatefully bound—these were automatically transcended in thought by the conception of an instinctive, elemental art above time. By a remarkable process the arts of subjugated backward peoples, discovered by Europeans in conquering the world, became aesthetic norms to those who renounced it. The imperialist expansion was accompanied at home by a profound cultural pessimism in which the arts of the savage victims were elevated above the traditions of Europe. The colonies became places to flee to as well as to exploit.

The new respect for primitive art was progressive, however, in that the cultures of savages and other backward peoples were now regarded as human cultures, and a high creativeness, far from being a prerogative of the advanced societies of the West, was attributed to all human groups. But this insight was accompanied not only by a flight from the advanced society, but also by an indifference to just those material conditions which were brutally destroying the primitive peoples or converting them into submissive, cultureless slaves. Further, the preservation of certain forms of native culture in the interest of imperialist power could be supported in the name of the new artistic attitudes by those who thought themselves entirely free from political interest.

To say then that abstract painting is simply a reaction against

the exhausted imitation of nature, or that it is the discovery of an absolute or pure field of form is to overlook the positive character of the art, its underlying energies and sources of movement. Besides, the movement of abstract art is too comprehensive and long-prepared, too closely related to similar movements in literature and philosophy, which have quite other technical conditions, and finally, too varied according to time and place, to be considered a self-contained development issuing by a kind of internal logic directly from aesthetic problems. It bears within itself at almost every point the mark of the changing material and psychological conditions surrounding modern culture.

The avowals of artists—several of which are cited in Barr's work —show that the step to abstraction was accompanied by great tension and emotional excitement. The painters justify themselves by ethical and metaphysical standpoints, or in defense of their art attack the preceding style as the counterpart of a detested social or moral position. Not the processes of imitating nature were exhausted, but the valuation of nature itself had changed. The philosophy of art was also a philosophy of life.

1. The Russian painter Malevich, the founder of "Suprematism," has described his new art in revealing terms. "By Suprematism I mean the supremacy of pure feeling or sensation in the pictorial arts. . . . In the year 1913 in my desperate struggle to free art from the ballast of the objective world I fled to the form of the Square and exhibited a picture which was nothing more or less than a black square upon a white ground. . . . It was no empty square which I had exhibited but rather the experience of objectlessness" (Barr, pp. 122–23).

Later in 1918 he painted in Moscow a series called *White on White*, including a white square on a white surface. In their purity these paintings seemed to parallel the efforts of mathematicians to reduce all mathematics to arithmetic and arithmetic to logic. But there is a burden of feeling underlying this "geometrical" art, which may be judged from the related paintings with the titles *Sensation of Metallic Sounds*, *Feeling of Flight*, *Feeling of Infinite Space*. Even in the work labelled *Composition* we can see how the formal character

of the abstraction rests on the desire to isolate and externalize in a concrete fashion subjective, professional elements of the older practice of painting, a desire that issues in turn from the conflicts and insecurity of the artist and his conception of art as an absolutely private realm. Barr analyzes a composition of two squares (Fig. 1), as a "study in equivalents: the red square, smaller but more intense in color and more active in its diagonal axis, holds its own against the black square which is larger but negative in color and static in position." Although he characterizes this kind of painting as pure abstraction to distinguish it from geometrical designs which are ultimately derived from some representation, he overlooks the relation of this painting to a work by Malevich reproduced in his book—*Woman With Water Pails* (Fig. 2), dating from 1912. The peasant woman, designed in Cubist style, balances two pails hanging from a rod across her shoulders. Here the preoccupation with balance as a basic aesthetic principle governing the relations of two counterpart units is embodied in an "elemental" genre subject; the objects balanced are not human, but suspended, non-organic elements, unarticulated forms. Although the human theme is merely allusive and veiled by the Cubist procedure, the choice of the motif of the peasant woman with the water pails betrays a sexual interest and the emotional context of the artist's tendency toward his particular style of abstraction.

The importance of the subjective conditions of the artist's work in the formation of abstract styles may be verified in the corresponding relationship between Cubist and pre-Cubist art. Picasso, just before Cubism, represented melancholy circus acrobats, harlequins, actors, musicians, beggars, usually at home on the fringes of society, or rehearsing among themselves, as bohemian artists detached from the stage of public performance. He shows in one picture two acrobats balancing themselves, the one mature and massive, squared in body, seated firmly on a cubic mass of stone shaped like his own figure; the young girl, slender, an outlined, unmodelled form, balancing herself unstably on tiptoes on a spherical stone (Fig. 3). The experience of balance vital to the acrobat, his very life, is assimilated here to the subjective experience of the artist, an expert performer concerned

with the adjustment of lines and masses as the essence of his art—a formalized personal activity that estranges him from society and to which he gives up his life. Between this art and Cubism, where the figure finally disappears, giving way to small geometrical elements formed from musical instruments, drinking vessels, playing-cards and other artificial objects of manipulation, there is a phase of Negroid figures in which the human physiognomy is patterned on primitive or savage faces and the body reduced to an impersonal nudity of harsh, drastic lines. This figure-type is not taken from life, not even from the margins of society, but from art; this time, however, from the art of a tribal, isolated people, regarded everywhere as inferior and valued only as exotic spectacles or entertainers, except by the painters to whom they are pure, unspoiled artists, creating from instinct or a native sensibility.

In the light of this analysis we can hardly accept Barr's account of Malevich's step to abstraction: "Malevich suddenly foresaw the logical and inevitable conclusion towards which European art was moving" and drew a black square on a white ground.

2. In his book *Ueber das Geistige in der Kunst*, published in 1912, the painter Kandinsky, one of the first to create completely abstract pictures, speaks constantly of inner necessity as alone determining the choice of elements, just as inner freedom, he tells us, is the sole criterion in ethics. He does not say that representation has been exhausted, but that the material world is illusory and foreign to the spirit; his art is a rebellion against the "materialism" of modern society, in which he includes science and the socialist movement. "When religion, science and morality (the last through the strong hand of Nietzsche) are shaken, and when the outer supports threaten to fall, man turns his gaze away from the external and towards himself." In his own time he respects, as interests parallel to his own and similarly motivated, occultism, theosophy, the cult of the primitive and experiments of synesthesia. Colored audition is important to him because perception is then blurred and localized in the perceiver rather than identified with an external source. His more aesthetic comments are usually of a piece with these attitudes. "The

Fig. 1 Malevich: *Suprematist
Composition: Red Square and Black
Square*, 1914–16. Oil on canvas,
28″ x 17½″. Collection, The
Museum of Modern Art, New York.

Fig. 2 Malevich: *Woman with Water Pails: Dynamic Arrangement*, 1912.
Oil on canvas, 31⅝″ x 31⅝″. Collection, The Museum of Modern Art, New
York.

Fig. 3 Picasso: *Circus Acrobats*, 1905. Oil. Pushkin Museum, Moscow.

green, yellow, red tree in the meadow is only . . . an accidental materialized form of the tree which we feel in ourselves when we hear the word tree." And in describing one of his first abstract pictures he says: "This entire description is chiefly an analysis of the picture which I have painted rather subconsciously in a state of strong inner tension. So intensively do I feel the necessity of some of the forms that I remember having given loud-voiced directions to myself, as for instance: 'But the corners must be heavy.' The observer must learn to look at the picture as a graphic representation of a mood and not as a representation of objects" (Barr, p. 66).

More recently he has written: "Today a point sometimes says more in a painting than a human figure. . . . Man has developed a new faculty which permits him to go beneath the skin of nature and touch its essence, its content. . . . The painter needs discreet, silent, almost insignificant objects. . . . How silent is an apple beside Laocoon. A circle is even more silent" (*Cahiers d'Art*, vol. VI, 1931, p. 351).

3. I will now quote a third avowal of artists tending toward abstraction, but this time of aggressive artists, the Italian Futurists, who can hardly be charged with the desire to escape from the world.

"It is from Italy that we launch . . . our manifesto of revolutionary and incendiary violence with which we found today *il Futurismo*. . . . Exalt every kind of originality, of boldness, of extreme violence. . . . Take and glorify the life of today, incessantly and tumultuously transformed by the triumphs of science. . . . A speeding automobile is more beautiful than the Victory of Samothrace" (Barr, p. 54).

Barr, who overlooks the moral, ideological aspect in Malevich and Kandinsky, cannot help observing in the Italian movement relations to Bergson, Nietzsche and even to fascism; and in analyzing the forms of Futurist art he tries to show they embody the qualities asserted in the manifestos.

But if Futurism has an obvious ideological aspect, it is not a pure abstract art for Barr. It is "near-abstraction," for it refers overtly to a world outside the canvas and still retains elements of representation.

Yet the forms of "pure" abstract art, which seem to be entirely without trace of representation or escapist morbidity—the Neo-Plasti-

cist works of Mondrian and the later designs of the Constructivists and Suprematists—are apparently influenced in their material aspect, as textures and shapes, and in their expressive qualities of precision, impersonal finish and neatness (and even in subtler informalities of design), by the current conceptions and norms of the machine.

Neither Futurism nor the "purer" mechanical abstract forms can be explained, however, as a simple reflection of existing technology. Although machines have existed since ancient times and have had a central place in production in some countries for over a century, this art is peculiar to the last twenty-five years. In the middle of the 19th century when the machines were already hailed as the great works of modern art, superior to the paintings of the time, the taste of progressive industrialists was towards a realistic art, and Proudhon could celebrate as the real modern works the pictures of Courbet and the newest machines. Not even the personal preoccupation with machines necessarily leads by itself to a style of mechanical abstract forms; the inventors Alexander Nasmyth, Robert Fulton and Samuel Morse were fairly naturalistic painters, like Leonardo, one of the fathers of modern technology. The French art of the period of mechanistic philosophy, the 17th century, was dominated by idealized naturalistic human forms. And the conception of man as a machine current in France during the predominance of the unmechanical rococo style was identified by its defenders and critics with a matter-of-fact sensualism. The enemies of La Mettrie, the author of *Man the Machine*, were pleased to point out that he died of over-eating.

More significant, however, is the fact that in recent times the advanced industrial countries with the most developed technologies, the United States and England, did not originate styles of mechanical abstraction; they are also the most backward in functionalist abstraction of forms in architecture. On the other hand, the development of such arts takes place in Russia, Italy, Holland and France, and only later in Germany. Hence the explanation of the arts as a reflection of existing machines is certainly inadequate. It could not explain, above all, the differences in "machine-styles" from place to place at a moment when technology has an international character. In Detroit,

the murals of machines by Rivera are realistic images of the factory as a world operated by workers; in Paris Léger decomposes the elements of machines into Cubist abstractions or assimilates living things to the typical rigid shapes of machines; the Dadaists improvise a whimsical burlesque with robots or reconstructed men; in Holland the Neo-Plasticists construct their works of quasi-architectural units; in Germany the Constructivist-Suprematist forms ape the drawings and models of the machine designer, rather than the machines themselves. And the Futurists, in distinction from all these, try to recapture the phenomenal aspect of moving mechanisms, of energy and speed.

These differences are not simply a matter of different local artistic traditions operating on a common modern material. For if this were the case, we should expect a Mondrian in Italy, the country of Renaissance tradition of clarified forms, and the Futurists in Holland and England, the pioneer lands of Impressionism.

A similar criticism would apply to the corresponding derivation of abstraction in art from the abstract nature of modern finance, in which bits of paper control capital and all human transactions assume the form of operations on numbers and titles. Here again we observe that the United States and England, with the most highly developed financial capitalism, are among the last countries to produce abstract art.

Mechanical abstract forms arise in modern art not because modern production is mechanical, but because of the values assigned to the human being and the machine in the ideologies projected by the conflicting interests and situation in society, which vary from country to country. Thus the modern conception of man as a machine is more economic than biological in its accent. It refers to the human robot rather than to the human animal, and suggests an efficient control of the costly movements of the body, a submission to some external purpose indifferent to the individual—unlike the older mechanistic views which concerned the passions, explained them by internal mechanical forces, and sometimes deduced an ethics of pleasure, utility and self-interest.

Barr recognizes the importance of local conditions when he

attributes the deviations of one of the Futurists to his Parisian experience. But he makes no effort to explain why this art should emerge in Italy rather than elsewhere. The Italian writers have described it as a reaction against the traditionalism and sleepiness of Italy during the rule of Umberto, and in doing so have overlooked the positive sources of this reaction and its effects on Italian life. The backwardness was most intensely felt to be a contradiction and became a provoking issue towards 1910 and then mainly in the North, which had recently experienced the most rapid industrial development. At this moment Italian capitalism was preparing the imperialist war in Tripoli. Italy, poor in resources yet competing with world empires, urgently required expansion to attain the levels of the older capitalist countries. The belated growth of industry, founded on exploitation of the peasantry, had intensified the disparities of culture, called into being a strong proletariat, and promoted imperialist adventures. There arose at this time, in response to the economic growth of the country and the rapid changes in the older historical environment, philosophies of process and utility—a militant pragmatism of an emphatic anti-traditionalist character. Sections of the middle class which had acquired new functions and modern urban interests accepted the new conditions as progressive and "modern," and were often the loudest in denouncing Italian backwardness and calling for an up-to-date, nationally conscious Italy. The attack of the intellectuals against the provincial aristocratic traditions was in keeping with the interest of the dominant class; they elevated technical progress, aggressive individuality and the relativism of values into theories favorable to imperialist expansion, obscuring the contradictory results of the latter and the conflicts between classes by abstract ideological oppositions of the old and the modern or the past and the future. Since the national consciousness of Italy had rested for generations on her museums, her old cities and artistic inheritance, the modernizing of the country entailed a cultural conflict, which assumed its sharpest form among the artists. Machines as the most advanced instruments of modern production had a special attraction for artists exasperated by their own merely traditional and secondary status, their mediocre outlook in a backward provincial

Italy. They were devoted to machines not so much as instruments of production but as sources of mobility in modern life. While the perception of industrial processes led the workers, who participated in them directly, toward a radical social philosophy, the artists, who were detached from production, like the petit bourgeoisie, could know these processes abstractly or phenomenally, in their products and outward appearance, in the form of traffic, automobiles, railroads, and new cities and in the tempo of urban life, rather than in their social causes. The Futurists thus came to idealize movement as such, and they conceived this movement or generalized mobility mainly as mechanical phenomena in which the forms of objects are blurred or destroyed. The dynamism of an auto, centrifugal motion, the dog in movement (with twenty legs), the autobus, the evolution of forms in space, the armored train in battle, the dance hall—these were typical subjects of Futurist art. The field of the canvas was charged with radiating lines, symbolic graphs of pervading force, colliding and interpenetrating objects. Whereas in Impressionism the mobility was a spectacle for relaxed enjoyment, in Futurism it is urgent and violent, a precursor of war.

Several of the Futurist devices, and the larger idea of abstract and interpenetrating forms, undoubtedly come from Cubism. But, significantly, the Italians found Cubism too aestheticized and intellectual, lacking a principle of movement; they could accept, however, the Cubist dissolution of stable, clearly bounded forms. This had a direct ideological value, though essentially an aesthetic device, for the stable and clear were identified with the older Italian art as well as with the past as such.

Outside Italy, and especially after the World War, the qualities of the machine as a rigid constructed object, and the qualities of its products and of the engineer's design suggested various forms to painters, and even the larger expressive character of their work. The older categories of art were translated into the language of modern technology; the essential was identified with the efficient, the unit with the standardized element, texture with new materials, representation with photography, drawing with the ruled or mechanically traced line,

color with the flat coat of paint, and design with the model or the instructing plan. The painters thus tied their useless archaic activity to the most advanced and imposing forms of modern production; and precisely because technology was conceived abstractly as an independent force with its own inner conditions, and the designing engineer as the real maker of the modern world, the step from their earlier Expressionist, Cubist or Suprematist abstraction to the more technological style was not a great one. (Even Kandinsky and Malevich changed during the 1920's under the influence of these conceptions.) In applying their methods of design to architecture, printing, the theatre and the industrial arts they remained abstract artists. They often looked upon their work as the aesthetic counterpart of the abstract calculations of the engineer and the scientist. If they admitted an alternative art of fantasy—in some ways formally related to their own—it was merely as a residual field of freedom or as a hygienic relaxation from the rigors of their own efficiency. Unlike the Futurists, whose conception of progress was blindly insurgent, they wished to reconstruct culture through the logic of sober technique and design; and in this wish they considered themselves the indispensable aesthetic prophets of a new order in life. Some of them supported the Bolshevik revolution, many more collaborated with the social-democratic and liberal architects of Germany and Holland. Their conception of technology as a norm in art was largely conditioned, on the one hand, by the stringent rationalization of industry in post-war Europe in the drive to reduce costs and widen the market as the only hope of a strangling capitalism threatened by American domination, and, on the other hand, by the reformist illusion, which was especially widespread in the brief period of post-war prosperity during this economic impasse, that the technological advance, in raising the living standards of the people, in lowering the costs of housing and other necessities, would resolve the conflict of classes, or at any rate form in the technicians habits of efficient, economic planning, conducive to a peaceful transition to socialism. Architecture or Revolution! That was in fact a slogan of Le Corbusier, the architect, painter and editor of the magazine *L'Esprit Nouveau*.

With the approach of the crisis of the 1930's critics like Elie Faure called on painters to abandon their art and become engineers; and architects, in America as well as Europe, sensitive to the increasing economic pressure, though ignorant of its causes, identified architecture with engineering, denying the architect an aesthetic function. In these extreme views, which were shared by reformists of technocratic tendency, we can see the debacle of the optimistic machine-ideologies in modern culture. As production is curtailed and living standards reduced, art is renounced in the name of technical progress.

During the crisis the mechanical abstract styles have become secondary. They influence very few young artists, or they tend toward what Barr calls "biomorphic abstraction," of a violent or nervous calligraphy, or with amoeboid forms, a soft, low-grade matter pulsing in an empty space. An anti-rationalist style, Surrealism, which had issued from the Dadaist art of the 1917–23 period, becomes predominant and beside it arise new romantic styles, with pessimistic imagery of empty spaces, bones, grotesque beings, abandoned buildings and catastrophic earth formations.

NOTE

1 Alfred H. Barr, Jr., *Cubism and Abstract Art* (New York 1936). 248 pages, 223 illustrations. It was published by the Museum of Modern Art as the guide and catalogue of its great exhibition held in the spring of 1936.

2 This article was originally published in *Marxist Quarterly*, January-March 1937, pp. 77-98.

RECENT
ABSTRACT PAINTING
(1957)

II

I n discussing the place of painting and sculpture in the culture of our time, I shall refer only to those kinds which, whether abstract or not, have a fresh inventive character, that art which is called "modern" not simply because it is of our century, but because it is the work of artists who take seriously the challenge of new possibilities and wish to introduce.into their work perceptions, ideas and experiences which have come about only in our time.

In doing so I risk perhaps being unjust to important works or to aspects of art which are generally not comprised within the so-called modern movement.

There is a sense in which all the arts today have a common character shared by painting; it may therefore seem arbitrary to single out painting as more particularly modern than the others. In comparing the arts of our time with those of a hundred years ago, we observe that the arts have become more deeply personal, more intimate, more concerned with experiences of a subtle kind. We note, too, that in poetry, music and architecture, as well as in painting, the attitude to the medium has become much freer, so that artists are willing to search further and to risk experiments or inventions which in the past would have been inconceivable because of fixed ideas of the laws and boundaries of the arts. I shall try to show, however, that painting and sculpture contribute qualities and values less evident in poetry, music and architecture.

It is obvious that each art has possibilities given in its own medium which are not found in other arts, at least not in the same degree. Of course, we do not know how far-reaching these possibilities are; the limits of an art cannot be set in advance. Only in the course of work and especially in the work of venturesome personalities do we discover the range of an art, and even then in a very incomplete way.

In the last fifty years, within the common tendency towards the more personal, intimate and free, painting has had a special role because of a unique revolutionary change in its character. In the first decades of our century painters and sculptors broke with the long-established tradition that their arts are arts of representation, creating images bound by certain requirements of accord with the forms of nature.

That great tradition includes works of astounding power which have nourished artists for centuries. Its principle of representation had seemed too self-evident to be doubted, yet that tradition was shattered early in this century. The change in painting and sculpture may be compared to the most striking revolutions in science, technology and social thought. It has affected the whole attitude of painters and sculptors to their work. To define the change in its positive aspect, however, is not easy because of the great diversity of styles today even among advanced artists.

One of the charges brought most frequently against art in our time is that because of the loss of the old standards, it has become chaotic, having no rule or direction. Precisely this criticism was often made between 1830 and 1850, especially in France, where one observed side by side works of Neo-Classic, Romantic and Realistic art —all of them committed to representation. The lack of a single necessary style of art reminded many people of the lack of clear purpose or common ideals in social life. What seemed to be the anarchic character of art was regarded as a symptom of a more pervasive anarchy or crisis in society as a whole.

But for the artists themselves—for Ingres, Delacroix and Courbet—each of these styles was justified by ideal ends that it served, whether of order, liberty or truth; and when we look back now to the

nineteenth century, the astonishing variety of its styles, the many conflicting movements and reactions, and the great number of distinct personalities, appear to us less as signs of weakness in the culture than as examples of freedom, individuality and sincerity of expression. These qualities corresponded to important emerging values in the social and political life of that period, and even helped to sustain them.

In the course of the last fifty years the painters who freed themselves from the necessity of representation discovered wholly new fields of form-construction and expression (including new possibilities of imaginative representation) which entailed a new attitude to art itself. The artist came to believe that what was essential in art—given the diversity of themes or motifs—were two universal requirements: that every work of art has an individual order or coherence, a quality of unity and necessity in its structure regardless of the kind of forms used; and, second, that the forms and colors chosen have a decided expressive physiognomy, that they speak to us as a feeling-charged whole, through the intrinsic power of colors and lines, rather than through the imaging of facial expressions, gestures and bodily movements, although these are not necessarily excluded—for they are also forms (Pl. X, Fig. 2).

That view made possible the appreciation of many kinds of old art and of the arts of distant peoples—primitive, historic, colonial, Asiatic and African, as well as European—arts which had not been accessible in spirit because it was thought that true art had to show a degree of conformity to nature and of mastery of representation which had developed for the most part in the West. The change in art dethroned not only representation as a necessary requirement but also a particular standard of decorum or restraint in expression which had excluded certain domains and intensities of feeling. The notion of the humanity of art was immensely widened. Many kinds of drawing, painting, sculpture and architecture, formerly ignored or judged inartistic, were seen as existing on the same plane of human creativeness and expression as "civilized" Western art. That would not have happened, I believe, without the revolution in modern painting.

The idea of art was shifted, therefore, from the aspect of imagery to its expressive, constructive, inventive aspect. That does not mean, as some suppose, that the old art was inferior or incomplete, that it had been constrained by the requirements of representation, but rather that a new liberty had been introduced which had, as one of its consequences, a greater range in the appreciation and experience of forms.

The change may be compared, perhaps, with the discovery by mathematicians that they did not have to hold to the axioms and postulates of Euclidian geometry, which were useful in describing the everyday physical world, but could conceive quite other axioms and postulates and build up different imaginary geometries. All the new geometries, like the old one, were submitted to the rules of logic; in each geometry the new theorems had to be consistent with each other and with the axioms and postulates. In painting as in mathematics, the role of structure or coherence became more evident and the range of its applications was extended to new elements.

The change I have described in the consciousness of form is more pronounced in painting and sculpture than it is in any other art. It is true that music and architecture are also unconcerned with representation—the imaging of the world—but they have always been that. The architect, the musician and the poet did not feel that their arts had undergone so profound a change, requiring as great a shift in the attitude of the beholder, as painting and sculpture in the beginning of our century. Within the totality of arts, painting and sculpture, more than the others, gave to artists in all media a new sense of freedom and possibility. It was the ground of a more general emancipation.

Even poets, who had always been concerned with images and with language as a medium that designates, poets too now tried to create a poetry of sounds without sense. But that movement did not last long, at least among English-speaking poets, although it was strong at one time in Russia and exists today in Holland and Belgium.

That sentiment of freedom and possibility, accompanied by a new faith in the self-sufficiency of forms and colors, became deeply rooted in our culture in the last fifty years. And since the basic change

had come about through the rejection of the image function of painting and sculpture, the attitudes and feelings which are bound up with the acceptance or rejection of the environment entered into the attitude of the painter to the so-called abstract or near-abstract styles, affecting also the character of the new forms. His view of the external world, his affirmation of the self or certain parts of the self, against devalued social norms—these contributed to his confidence in the necessity of the new art.

Abstraction implies then a criticism of the accepted contents of the preceding representations as ideal values or life interests. This does not mean that painters, in giving up landscape, no longer enjoy nature; but they do not believe, as did the poets, the philosophers and painters of the nineteenth century, that nature can serve as a model of harmony for man, nor do they feel that the experience of nature's moods is an exalting value on which to found an adequate philosophy of life. New problems, situations and experiences of greater import have emerged: the challenge of social conflict and development, the exploration of the self, the discovery of its hidden motivations and processes, the advance of human creativeness in science and technology.

All these factors should be taken into account in judging the significance of the change in painting and sculpture. It was not a simple studio experiment or an intellectual play with ideas and with paint; it was related to a broader and deeper reaction to basic elements of common experience and the concept of humanity, as it developed under new conditions.

In a number of respects, painting and sculpture today may seem to be opposed to the general trend of life. Yet, in such opposition, these arts declare their humanity and importance.

Paintings and sculptures, let us observe, are the last hand-made, personal objects within our culture. Almost everything else is produced industrially, in mass, and through a high division of labor. Few people are fortunate enough to make something that represents themselves, that issues entirely from their hands and mind, and to which they can affix their names.

Most work, even much scientific work, requires a division of labor, a separation between the individual and the final result; the personality is hardly present even in the operations of industrial planning or in management and trade. Standardized objects produced impersonally and in quantity establish no bond between maker and user. They are mechanical products with only a passing and instrumental value.

What is most important is that the practical activity by which we live is not satisfying: we cannot give it full loyalty, and its rewards do not compensate enough for the frustrations and emptiness that arise from the lack of spontaneity and personal identifications in work: the individual is deformed by it, only rarely does it permit him to grow.

The object of art is, therefore, more passionately than ever before, the occasion of spontaneity or intense feeling. The painting symbolizes an individual who realizes freedom and deep engagement of the self within his work. It is addressed to others who will cherish it, if it gives them joy, and who will recognize in it an irreplaceable quality and will be attentive to every mark of the maker's imagination and feeling.

The consciousness of the personal and spontaneous in the painting and sculpture stimulates the artist to invent devices of handling, processing, surfacing, which confer to the utmost degree the aspect of the freely made. Hence the great importance of the mark, the stroke, the brush, the drip, the quality of the substance of the paint itself, and the surface of the canvas as a texture and field of operation—all signs of the artist's active presence. The work of art is an ordered world of its own kind in which we are aware, at every point, of its becoming.

All these qualities of painting may be regarded as a means of affirming the individual in opposition to the contrary qualities of the ordinary experience of working and doing.

I need not speak in detail about this new manner, which appears in figurative as well as abstract art; but I think it is worth observing that in many ways it is a break with the kind of painting that was

most important in the 1920's. After the first World War, in works like those of Léger, abstraction in art was affected by the taste for industry, technology and science, and assumed the qualities of the machine-made, the impersonal and reproducible, with an air of coolness and mechanical control, intellectualized to some degree. The artist's power of creation seems analogous here to the designer's and engineer's. That art, in turn, avowed its sympathy with mechanism and industry in an optimistic mood as progressive elements in everyday life, and as examples of strength and precision in production which painters admired as a model for art itself. But the experiences of the last twenty-five years have made such confidence in the values of technology less interesting and even distasteful.

In abstraction we may distinguish those forms, like the square and circle, which have object character and those which do not. The first are closed shapes, distinct within their field and set off against a definite ground. They build up a space which has often elements of gravity, with a clear difference between above and below, the ground and the background, the near and far. But the art of the last fifteen years tends more often to work with forms which are open, fluid or mobile; they are directed strokes or they are endless tangles and irregular curves, self-involved lines which impress us as possessing the qualities not so much of things as of impulses, of excited movements emerging and changing before our eyes (Fig. 1).

The impulse, which is most often not readily visible in its pattern, becomes tangible and definite on the surface of a canvas through the painted mark. We see, as it were, the track of emotion, its obstruction, persistence or extinction. But all these elements of impulse which seem at first so aimless on the canvas are built up into a whole characterized by firmness, often by elegance and beauty of shapes and colors. A whole emerges with a compelling, sometimes insistent quality of form, with a resonance of the main idea throughout the work. And possessing an extraordinary tangibility and force, often being so large that it covers the space of a wall and therefore competing boldly with the environment, the canvas can command our attention fully like monumental painting in the past.

It is also worth remarking that as the details of form become complicated and free and therefore hard to follow in their relation to one another, the painting tends to be more centered and compact—different in this respect from the type of abstraction in which the painting seems to be a balanced segment of a larger whole. The artist places himself in the focus of your space.

These characteristics of painting, as opposed to the characteristics of industrial production, may be found also in the different senses of the words "automatic" and "accidental" as applied in painting, technology and the everyday world.

The presence of chance as a factor in painting, which introduces qualities that the artist could never have achieved by calculation, is an old story. Montaigne in the sixteenth century already observed that a painter will discover in his canvas strokes which he had not intended and which are better than anything he might have designed. That is a common fact in artistic creation.

Conscious control is only one source of order and novelty: the unconscious, the spontaneous and unpredictable are no less present in the good work of art. But that is something art shares with other activities and indeed with the most obviously human function: speech. When we speak, we produce automatically a series of words which have an order and a meaning for us, and yet are not fully designed. The first word could not be uttered unless certain words were to follow, but we cannot discover, through introspection, that we had already thought of the words that were to follow. That is a mystery of our thought as well.

Painting, poetry and music have this element of unconscious, improvised serial production of parts and relationships in an order, with a latent unity and purposefulness. The peculiarity of modern painting does not lie simply in its aspect of chance and improvisation but elsewhere. Its distinctiveness may be made clear by comparing the character of the formal elements of old and modern art.

Painters often say that in all art, whether old or modern, the artist works essentially with colors and shapes rather than with natural objects. But the lines of a Renaissance master are complex forms

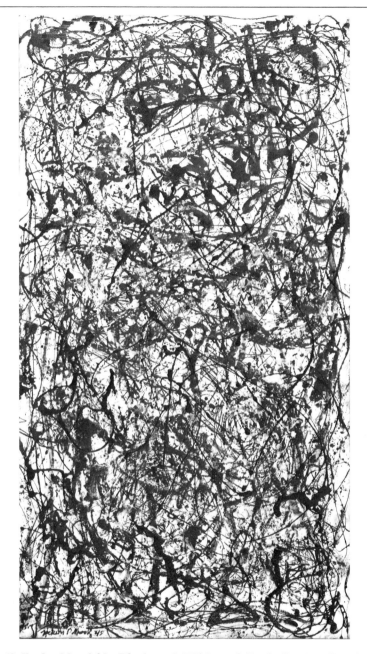

Fig. 1 Pollock: No. 26A: *Black and White*, 1948. Collection Lee Krasner Pollock.

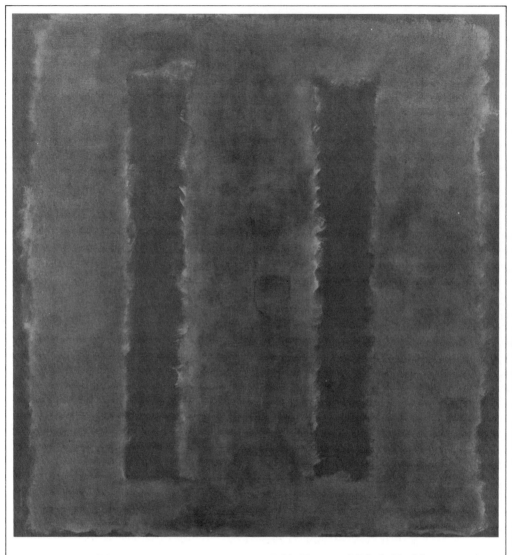

Fig. 2 Rothko: *Deep Red on Maroon*, 1954, Estate of Mark Rothko.

which depend on already ordered shapes in nature. The painting of a cup in a still-life picture resembles an actual cup, which is itself a well-ordered thing. A painting of a landscape depends on observation of elements which are complete, highly ordered shapes in themselves —like trees or mountains.

Modern painting is the first complex style in history which proceeds from elements that are not pre-ordered as closed articulated shapes. The artist today creates an order out of unordered variable elements to a greater degree than the artist of the past (Fig. 1).

In ancient art an image of two animals facing each other orders symmetrically bodies that in nature are already closed symmetrical forms. The modern artist, on the contrary, is attracted to those possibilities of form which include a considerable randomness, variability and disorder, whether he finds them in the world or while improvising with his brush, or in looking at spots and marks, or in playing freely with shapes—inverting, adjusting, cutting, varying, reshaping, regrouping, so as to maximize the appearance of randomness. His goal is often an order which retains a decided quality of randomness as far as this is compatible with an ultimate unity of the whole. That randomness corresponds in turn to a feeling of freedom, an unconstrained activity at every point.

Ignoring natural shapes, he is alert to qualities of movement, interplay, change and becoming in nature. And he provokes within himself, in his spontaneous motions and play, an automatic production of chance.

While in industry accident is that event which destroys an order, interrupts a regular process and must be eliminated, in painting the random or accidental is the beginning of an order. It is that which the artist wishes to build up into an order, but a kind of order that in the end retains the aspect of the original disorder as a manifestation of freedom. The order is created before your eyes and its law is nowhere explicit. Here the function of ordering has, as a necessary counterpart, the element of randomness and accident.

Automatism in art means the painter's confidence in the power of the organism to produce interesting unforeseen effects and in such

a way that the chance results constitute a family of forms; all the random marks made by one individual will differ from those made by another, and will appear to belong together, whether they are highly ordered or not, and will show a characteristic grouping. (This is another way of saying that there is a definite style in the seemingly chaotic forms of recent art, a general style common to many artists, as well as unique individual styles.) This power of the artist's hand to deliver constantly elements of so-called chance or accident, which nevertheless belong to a well defined, personal class of forms and groupings, is submitted to critical control by the artist who is alert to the rightness or wrongness of the elements delivered spontaneously, and accepts or rejects them.

No other art today exhibits to that degree in the final result the presence of the individual, his spontaneity and the concreteness of his procedure.

This art is deeply rooted, I believe, in the self and its relation to the surrounding world. The pathos of the reduction or fragility of the self within a culture that becomes increasingly organized through industry, economy and the state intensifies the desire of the artist to create forms that will manifest his liberty in this striking way—a liberty that, in the best works, is associated with a sentiment of harmony and achieves stability, and even impersonality through the power of painting to universalize itself in the perfection of its form and to reach out into common life. It becomes then a possession of everyone and is related to everyday experience.

Another aspect of modern painting and sculpture which is opposed to our actual world and yet is related to it—and appeals particularly because of this relationship—is the difference between painting and sculpture on the one hand and what are called the "arts of communication." This term has become for many artists one of the most unpleasant in our language.

In the media of communication which include the newspaper, the magazine, the radio and TV, we are struck at once by certain requirements that are increasingly satisfied through modern technical means and the ingenuity of scientific specialists. Communication, in

this sense, aims at a maximum efficiency through methods that ensure the attention of the listener or viewer by setting up the appropriate reproducible stimuli that will work for everyone and promote the acceptance of the message. Distinction is made between message and that which interferes with message, i.e. noise—that which is irrelevant. And devices are introduced to ensure that certain elements will have an appropriate weight in the reception.

The theory and practice of communication today help to build up and to characterize a world of social relationships that is impersonal, calculated and controlled in its elements, aiming always at efficiency.

The methods of study applied in the theory of communication have been extended to literature, music and painting as arts which communicate. Yet it must be said that what makes painting and sculpture so interesting in our time is their high degree of non-communication. You cannot extract a message from painting by ordinary means; the usual rules of communication do not hold here, there is no clear code or fixed vocabulary, no certainty of effect in a given time of transmission or exposure. Painting, by becoming abstract and giving up its representational function, has achieved a state in which communication seems to be deliberately prevented. And in many works where natural forms are still preserved, the objects and the mode of representation resist an easy decipherment and the effects of these works are unpredictable.

The artist does not wish to create a work in which he transmits an already prepared and complete message to a relatively indifferent and impersonal receiver. The painter aims rather at such a quality of the whole that, unless you achieve the proper set of mind and feeling towards it, you will not experience anything of it at all.

Only a mind opened to the qualities of things, with a habit of discrimination, sensitized by experience and responsive to new forms and ideas, will be prepared for the enjoyment of this art. The experience of the work of art, like the creation of the work of art itself, is a process ultimately opposed to communication as it is understood now. What has appeared as noise in the first encounter becomes in the end

message or necessity, though never message in a perfectly reproducible sense. You cannot translate it into words or make a copy of it which will be quite the same thing.

But if painting and sculpture do not communicate they induce an attitude of communion and contemplation. They offer to many an equivalent of what is regarded as part of religious life: a sincere and humble submission to a spiritual object, an experience which is not given automatically, but requires preparation and purity of spirit. It is primarily in modern painting and sculpture that such contemplativeness and communion with the work of another human being, the sensing of another's perfected feeling and imagination, becomes possible.

If painting and sculpture provide the most tangible works of art and bring us closer to the activity of the artist, their concreteness exposes them, more than the other arts, to dangerous corruption. The successful work of painting or sculpture is a unique commodity of high market value. Paintings are perhaps the most costly man-made objects in the world. The enormous importance given to a work of art as a precious object which is advertised and known in connection with its price is bound to affect the consciousness of our culture. It stamps the painting as an object of speculation, confusing the values of art. The fact that the work of art has such a status means that the approach to it is rarely innocent enough; one is too much concerned with the future of the work, its value as an investment, its capacity to survive in the market and to symbolize the social quality of the owner. At the same time no profession is as poor as the painter's, unless perhaps the profession of the poet. The painter cannot live by his art.

Painting is the domain of culture in which the contradiction between the professed ideals and the actuality is most obvious and often becomes tragic.

About twenty-five years ago a French poet said that if all artists stopped painting, nothing would be changed in the world. There is much truth in that statement, although I would not try to say how much. (It would be less true if he had included all the arts.) But the same poet tried later to persuade painters to make pictures with political messages which would serve his own party. He recognized then

that painting could make a difference, not only for artists but for others; he was not convinced, however, that it would make a difference if it were abstract painting, representing nothing.

It was in terms of an older experience of the arts as the carriers of messages, as well as objects of contemplation, that is, arts with a definite religious or political content, sustained by institutions—the Church, the schools, the State—that the poet conceived the function of painting. It is that aspect of the old art which the poet hoped could be revived today, but with the kind of message that he found congenial.

Nevertheless in rejecting this goal, many feel that if the artist works more from within—with forms of his own invention rather than with natural forms—giving the utmost importance to spontaneity, the individual is diminished. For how can a complete personality leave out of his life work so much of his interests and experience, his thoughts and feelings? Can these be adequately translated into the substance of paint and the modern forms with the qualities I have described?

These doubts, which arise repeatedly, are latent within modern art itself. The revolution in painting that I have described, by making all the art of the world accessible, has made it possible for artists to look at the paintings of other times with a fresh eye; these suggest to them alternatives to their own art. And the artist's freedom of choice in both subject and form opens the way to endless reactions against existing styles.

But granting the importance of those perceptions and values which find no place in painting today, the artist does not feel obliged to cope with them in his art. He can justify himself by pointing to the division of labor within our culture, if not in all cultures. The architect does not have to tell stories with his forms; he must build well and build nobly. The musician need not convey a statement about particular events and experiences or articulate a moral or philosophical commitment. Representation is possible today through other means than painting and with greater power than in the past.

In the criticism of modern painting as excluding large sectors of life, it is usually assumed that past art was thoroughly comprehensive.

But this view rests on an imperfect knowledge of older styles. Even the art of the cathedrals, which has been called encyclopedic, represents relatively little of contemporary actuality, though it projects with immense power an established world-view through the figures and episodes of the Bible. Whether a culture succeeds in expressing in artistic form its ideas and outlook and experiences is to be determined by examining not simply the subject-matter of one art, like painting, but the totality of its arts, and including the forms as well as the themes.

Within that totality today painting has its special tasks and possibilities discovered by artists in the course of work. In general, painting tends to reinforce those critical attitudes which are well represented in our literature: the constant searching of the individual, his motives and feelings, the currents of social life, the gap between actuality and ideals.

If the painter cannot celebrate many current values, it may be that these values are not worth celebrating. In the absence of ideal values stimulating to his imagination, the artist must cultivate his own garden as the only secure field in the violence and uncertainties of our time. By maintaining his loyalty to the value of art—to responsible creative work, the search for perfection, the sensitiveness to quality— the artist is one of the most moral and idealistic of beings, although his influence on practical affairs may seem very small.

Painting by its impressive example of inner freedom and inventiveness and by its fidelity to artistic goals, which include the mastery of the formless and accidental, helps to maintain the critical spirit and the ideals of creativeness, sincerity and self-reliance, which are indispensable to the life of our culture.

NOTES

[1] This essay is the text of an address delivered to the Annual Meeting of the American Federation of Arts in Houston, Texas, April 5, 1957, on "The Liberating Quality of Avant-Garde Art."

ON THE HUMANITY OF ABSTRACT PAINTING

(1960)

III

The notion of humanity in art rests on a norm of the human that has changed in the course of time. Not long ago only the heroic, the mythical and religious were admitted to high art. The dignity of a work was measured in part by the rank of its theme.

In time it became clear that a scene of common life, a landscape or still life could be as great a painting as an image of history or myth. One discovered too that in the picturing of the non-human were some profound values. I do not mean only the beauty created by the painter's control of color and shapes; the landscape and still life also embodied an individual's feeling for nature and things, his vision in the broadest sense. Humanity in art is therefore not confined to the image of man. Man shows himself too in his relation to the surroundings, in his artifacts, and in the expressive character of all the signs and marks he produces. These may be noble or ignoble, playful or tragic, passionate or serene. Or they may be sensed as unnameable yet compelling moods.

At the threshold of our century stands the art of Cézanne, which imposes on us the conviction that in rendering the simplest objects, bare of ideal meanings, a series of colored patches can be a summit of perfection showing the concentrated qualities and powers of a great mind. Whoever in dismay before the strangeness of certain contemporary works denies to the original painting of our time a sufficient significance and longs for an art with noble and easily-read figures and gestures, should return to Cézanne and ask what in the appeal of his

weighty art depends on a represented human drama. Some of his portraits, perhaps—although to many observers, accustomed to the affability of old portraiture, Cézanne's appeared only a few decades ago mask-like and inhuman, a forerunner of the supposed loss of humanity in twentieth-century art. But are those portraits of Cézanne greater for us, more moving, even more dramatic, than his pictures of fruit and rumpled cloth?

The humanity of art lies in the artist and not simply in what he represents, although this object may be the congenial occasion for the fullest play of his art. It is the painter's constructive activity, his power of impressing a work with feeling and the qualities of thought that gives humanity to art; and this humanity may be realized with an unlimited range of themes or elements of form.

All this has been said often enough; it is granted, and still one clings to Cézanne's apple and doubts in principle that high accomplishment in art is possible where the imagination of colors and forms is divorced from the imaging of the visible world.

Architecture, which represents nothing, is a permanent challenge to that theoretical belief. If a building communicates the values of the home or temple, it is through the splendor of its freely invented forms. However bound to materials and functions, these forms are an expression, not a representation, of the familial or sacred.

The charge of inhumanity brought against abstract painting springs from a failure to see the works as they are; they have been obscured by concepts from other fields. The word "abstract" has connotations of the logical and scientific that are surely foreign to this art. "Abstract" is an unfortunate name; but "non-objective," "non-figurative," or "pure painting"—all negative terms—are hardly better. In the nineteenth century, when all painting was representation, the abstract in art meant different things: the simplified line, the decorative or the flat. For the realist Courbet, a militantly positive mind, it was the imaginary as opposed to the directly seen; to paint the invisible, whether angels or figures of the past, was to make abstract art. But Constable could say: "My limited and abstracted art is to be found under every hedge and lane."

Abstract painting today has little to do with logical abstraction

or mathematics. It is fully concrete, without simulating a world of objects or concepts beyond the frame. For the most part, what we see on the canvas belongs there and nowhere else. But it calls up more intensely than ever before the painter at work, his touch, his vitality and mood, the drama of decision in the ongoing process of art. Here the subjective becomes tangible. In certain styles this quality may be seen as a radical realization of the long-developed demand in Western art for the immediate in experience and expression, a demand which, in the preceding art, had found in landscape and still life, and even portraiture, its major themes. If mathematical forms are used, they are, as material marks, elements of the same order of reality as the visible canvas itself. And if a painter ventures to paste on the surface of the canvas bits of objects from without—newsprint and cloth—these objects are not imitated but transported bodily to the canvas, like the paint itself.

An abstract painter entering a room where a mathematician has demonstrated a theorem on the blackboard is charmed by the diagrams and formulas. He scarcely understands what they represent; the correctness or falsity of the argument doesn't concern him. But the geometrical figures and writing in white on black appeal to him as surprising forms—they issue from an individual hand and announce in their sureness and flow the elation of advancing thought. For the mathematician his diagram is merely a practical aid, an illustration of concepts; it doesn't matter to him whether it is done in white or yellow chalk, whether the lines are thick or thin, perfectly smooth or broken, whether the whole is large or small, at the side or center of the board—all that is accidental and the meaning would be the same if the diagram were upside down or drawn by another hand. But for the artist, it is precisely these qualities that count; small changes in the inflection of a line would produce as significant an effect for his eye as the change in a phrase in the statement of a theorem would produce in the logical argument of its proof.

For the artist these elementary shapes have a physiognomy; they are live expressive forms. The perfection of the sphere is not only a mathematical insight, we feel its subtle appearance of the centered and evenly rounded as a fulfillment of our need for completeness, con-

centration and repose. It is the ecstatically perceived qualities of the geometrical figure that inspired the definition of God as an infinite circle (or sphere) of which the center is everywhere and the circumference nowhere. In another vein, Whitman's description of God as a square depends on his intense vision of the square as a live form:

> Chanting the square deific, out of the one advancing, out of the sides;
> Out of the old and new—out of the square entirely divine;
> Solid, four-sided (all the sides needed) . . . from this side Jehovah am I.

The same form occurred to Tolstoy in his *Diary of a Madman* as an image of religious anguish: "Something was trying to tear my soul asunder but could not do so. . . . Always the same terror was there—red, white, square. Something is being torn and will not tear."

I shall not conclude that the circle or square on the canvas is, in some hidden sense, a religious symbol, but rather: the capacity of these geometric shapes to serve as metaphors of the divine arises from their living, often momentous, qualities for the sensitive eye.

This eye, which is the painter's eye, feels the so-called abstract line with an innocent and deep response that pervades the whole being. I cannot do better than to read to you some words written from the sensibility to uninterpreted forms by an American over fifty years ago, before abstract art arose.

"How does the straight line feel? It feels, as I suppose it looks, straight—a dull thought drawn out endlessly. It is unstraight lines, or many straight and curved lines together, that are eloquent to the touch. They appear and disappear, are now deep, now shallow, now broken off or lengthened or swelling. They rise and sink beneath my fingers, they are full of sudden starts and pauses, and their variety is inexhaustible and wonderful."

From the reference to touch some of you have guessed, I'm sure, the source of these words. The author is a blind woman, Helen Keller. Her sensitiveness shames us whose open eyes fail to grasp these qualities of form.

But abstract art is not limited to the obvious geometric forms. From the beginning it has shown a remarkable range. It includes whole families of irregular shapes—the spontaneous mark and the

patched or spreading spot—elements that correspond in their dynamic character to impulse and sensation and act upon us also by their decided texture and color. Abstract painting shares this variety with modern representational art, and like the latter has already a broad spectrum of styles which recall the Classic, Romantic and Impressionist by their structure of color and form. The objections to the masters of abstract painting are much like those that have been addressed to the great masters of the nineteenth century: they are too dry, too intellectual, too material, too decorative, too emotional, too sensual and undisciplined. In general, those who reject abstract painting reject, for the same reasons, the newer kinds of representation as well.

Abstract painting is clearly open to a great span of expression; it is practiced differently by many temperaments, a fact that by itself challenges the idea of its inhumanity. We recognize the individual in these works no less than in representations. And in some the artist appears as an original personality with an impressive honesty and strength.

In recent work, puzzled and annoyed observers have found an artless spontaneity which they are happy to compare with the daubings of the monkey in the zoo. This monkey is the fated eternal companion of the painter. When the artist represented the world around him, he was called the ape of nature; when he paints abstractly, he is likened to the monkey who smears and splatters. It seems that the painter cannot escape his animal nature. It is present in all styles.

Although this art has given up representation, it cannot be stressed enough that it carries further the free and unformalized composition practiced by the most advanced artists at the end of the last century in their painting from nature. In older figurative art with complex forms, the composition could be seen as an implicit triangle or circle, and indeed this habit of regarding structure as a vaguely geometric design was responsible for much of the weakness and banality of academic art. In abstract painting such large underlying schemes are no longer present. Even where the elements are perfectly regular, the order of the whole may be extremely elusive. The precise grid of black lines in a painting by Mondrian, so firmly ordered, is an open and unpredictable whole without symmetry or commensurable parts. The

example of his austere art has educated a younger generation in the force and niceties of variation with a minimum of elements.

The problem of abstract art, like that of all new styles, is a problem of practical criticism and not of theory, of general laws of art. It is the problem of discriminating the good in an unfamiliar form which is often confused by the discouraging mass of insensitive imitations. The best in art can hardly be discerned through rules; it must be discovered in a sustained experience of serious looking and judging, with all the risks of error.

The demand for order, through which the new is condemned, is often a demand for a certain kind of order, in disregard of the infinity of orders that painters have created and will continue to create. I do not refer here to the desire for a new order, but rather to the requirement of an already known order, familiar and reassuring. It is like the demand for order in the brain-injured that has been described by a great physician and human being, the neurologist Kurt Goldstein: "The sense of order in the patient," he writes, "is an expression of his defect, an expression of his impoverishment with respect to an essentially human trait: the capacity for adequate shifting of attitude."

Looking back to the past, one may regret that painting now is not broader and fails to touch enough in our lives. The same may be said of representation, which, on the whole, lags behind abstract art in inventiveness and conviction; today it is abstract painting that stimulates artists to a freer approach to visible nature and man. It has enlarged the means of the artist who represents and has opened to him regions of feeling and perception unknown before. Abstraction by its audacities also confirms and makes more evident to us the most daring and still unassimilated discoveries of older art.

The criticism of abstract art as inhuman arises in part from a tendency to underestimate inner life and the resources of the imagination. Those who ask of art a reflection and justification of our very human narrowness are forced in time to accept, reluctantly at first, what the best of the new artists have achieved and to regard it in the end as an obvious and necessary enrichment of our lives.

MONDRIAN
Order and Randomness
in Abstract Painting
(1978)

1.

M ondrian's abstract paintings appeared to certain of his contemporaries extremely rigid, more a product of theory than of feeling. One thought of the painter as narrow, doctrinaire, in his inflexible commitment to the right angle and the unmixed primary colors. We learn that he broke with a fellow-artist and friend who had ventured to insert a diagonal in that fixed system of vertical and horizontal lines. "After your arbitrary correction of Neo-Plasticism," he wrote to van Doesburg, "any collaboration, of no matter what kind, has become impossible for me," and withdrew from the board of the magazine *De Stijl*, the organ of their advanced ideas.[1]

Yet in the large comprehensive shows of his art one discovers an astonishing range of qualities, a continuous growth from his twenties to his last years in fertile response to the new art of others and to a new milieu. Even while holding strictly to the horizontal and vertical in the painted lines, Mondrian brought back the abhorred diagonal in the frequent diamond shape of a square canvas. Diagonal axes are implicit too in his placing of paired colors. And in his late work he deviated from his long-held principle of the single plane by interlacing the lines to suggest a layered grid in depth. If his abstract paintings of the 1920s and 1930s seem dogmatically limited in their straight forms, these constant elements, through carefully pondered variation of

233

length, thickness, and interval, compose a scale of forces that he deploys in always individual combinations. When studied closely, the barest works, with only a few units, reveal his canny finesse in shaping a balanced order; that variety in the sparse and straight is a ground of their continuing fascination. One need not analyze that structure, however, to sense its precision and strength. These qualities come to the eye directly like the harmony of a Greek temple. His gravely serious art unites in its forms the large regularities of architecture as a canonical constructed order with a complexity of relations inherited from the painting of nature and the city scene. The persisting white field, in heightened contrast to the black lines, is a luminous ground —it has what may be called after Keats: "the power of white Simplicity"—and, in its division by those lines, provides a measure of the rhythm of the enclosing rectangles.

Like Picasso's art, Mondrian's would have to be characterized very differently according to one's choice of a particular phase as typical. Before the constructive abstract art by which he is best known, his works had been in turn impressionistic, romantic, lyrical, visionary, and symbolic; and in his last years, at seventy, after that severely intellectual style, his paintings became surprisingly sensuous and elated. In assimilating before 1914 the most advanced art of his time, he stood out unmistakably as a painter with his own qualities and powers. Moving from Holland to Paris and later to London and New York, this ascetic artist reacted to each new environment with a quiet enthusiasm, inventing new features that transformed the face of his art. When he worked in the style of Picasso and Braque in 1911 to 1913, he was not far behind them, having absorbed the most recent stage of their rapidly evolving art, and was soon able to move on to more strictly abstract forms of his own invention. Mondrian's warm embrace of Cubism was the more surprising since he was forty then, with a long-matured practice that would have seemed to discourage the change to a style so different in principle from his own. Even more remarkable is that in adopting this challenging art from painters younger than himself, he derived from it conclusions still more radical, which were to stimulate and guide painters in Europe and Amer-

ica in the following decades. His later work was an outcome of reflection and a firm will to rigor, in keeping with a philosophizing habit and long meditated ideals. Few artists in our century have displayed so ardent a growth.

2.

Mondrian wrote in more than one article that his goal was to achieve an art of "pure relations." These, he believed, had been "veiled" in older painting by the particulars of nature which could only distract the viewer from the universal and absolute in art, the true ground of aesthetic harmony.

I wish in this essay to explore closely several of his abstract works in order to bring into clearer sight the character of those "pure relations" and to show their continuity with structures of representation in the preceding art. For this a minute analysis is necessary. It may be tedious or seem superfluous to one who grasps with feeling the order of a work of Mondrian on immediate view. I shall risk it in the belief that it will also bring us nearer to his sensibility and thought.

In a painting of 1926 in the Museum of Modern Art labeled *Composition in White and Black* (Fig. 1), what seems at first glance a square set within a diamond square—a banal motif of decorators and doodlers—becomes to the probing eye a complex design with a subtly balanced asymmetry of unequal lines. We see the square as partly covered and extending into an imaginary field beyond the diamond canvas. If modeling and perspective have been given up, another cue for depth comes into play in this flat painting on the impenetrable plane of the canvas: the overlapping of forms. The intercepting edge advances and the intercepted square recedes as if passing underneath the edge. The whole appears then as a cropped representation of an object in a three-dimensional space. The missing parts are cut off from view at the limits of the diamond field. Only at the upper left corner of the square is the angle closed; but its vertical and

horizontal lines cross at that point and are prolonged just enough for us to suppose that what we first perceived as a partly masked square belongs to a larger whole, a lattice or grid formed by bars of varied thickness.[2] We are induced by that single crossing to imagine a similar completion of the other bars and their continuity beyond the square. The black grid seems to exist in a space between the plane of the diamond and the white voids enclosed by the painted bars.

Even if we fix our attention on the canvas as a limited plane surface with a painted set of flat marks complete in themselves as a balanced asymmetric design, another mode of spatial intuition is soon aroused: our habitual response to recognizably incomplete forms. The black bars are envisioned unreflectively as parts of a whole continuing beyond the limits of the overlapping diamond field, although no familiar object has been depicted (unless we regard the thick lines of the "abstract" square as a concrete object like the surface of the canvas itself). Each black line is seen then as an intercepted side of a complete square, just as in a perspective view we identify a partly covered object with its whole. The diamond form of Mondrian's canvas reinforces this effect by the strong contrast of its diagonal edges with the painted lines of the square and by providing between the angles, and especially those above and below, a much greater span than between the parallel lines of the inscribed form. The latter stands out even more decidedly from a larger field in which two lines of the square cross and four triangles are marked as opposing shapes.

Besides, the white surface of the canvas appears to recede as a ground of the salient black grid. We tend to reinforce in perception the separateness of canvas surface and grid and to see the central white field, bounded by the black lines and the intervening edges of the canvas, as a square rather than as the irregular figure it really is. We complete the square because the black bars—as similar, although discontinuous, parts of a familiar configuration—are so much more pronounced than the diagonal corners of that white field, which form coherent parts of a larger pattern of diagonals.

We have before us then the intriguing, in part imagined—one may even say, illusory—appearance of an erect square overlapped at

three of its angles by a complete square, a contrasting tilted form. The first square is all verticals and horizontals; the other, all diagonals, an enclosing diamond shape. From this overlay of regular forms results a major figure with seven unequal sides composed of the painted bars and of segments of the unmarked sloping sides of the diamond; and around this unexpected polygon are what appear to be four triangles of unequal area. Two of these have in fact three sides, but the upper and left ones are odd, four-sided figures.[3] The vertical and horizontal bars, too, end in beveled edges. The cropping of an imagined square by a true square yields a whole that is strangely irregular in its varied polygonal parts, yet looks regular, rhythmic, and strictly balanced. The shifting of the square slightly to the right is enough to determine at the other side, at the intersection of the upper horizontal and left vertical bars, a little triangle of black, unique in the work—a shape that resembles, however, the residual white triangles in the right and lower corners of the diamond. That revealing shift, I have noted, marks the sides of the inset square as segments of an extended grid of crossing lines, masked in part by the boundary of the diamond opening or frame. It is not the grid that is asymmetric but the appearance of an externally cropped part of its larger suggested whole. We are led to imagine a viewer so close to the plane of the grid that he can sight only an incomplete segment of one rectangular unit and a corner of a second. The enclosing diamond may be likened to an eye or eyepiece of the beholder, which isolates and frames a visual field; it, too, consists of rectilinear elements like the object sighted, but with contrasted axes. This work of pure design on a flat surface, devoid of representation, does not abolish the illusion of extended space beyond the plane of the canvas or its boundaries, nor the ambiguities of appearance and reality. Nor do its regular features and strictly balanced order exclude the aspect of the incomplete, the random, and contingent.

If Mondrian holds to a set of rules restricting the elements to verticals and horizontals on a single plane and allowing only black and white and the three primary colors which must be contained between those lines and never overflow them, these requirements are not enough to define the structure of the work as an *appearance*. What

determines the actual length, position, and thickness of the material lines and the intervals between them? We understand that choice not only through the painter's ardent pursuit of variation; there is also his commitment to an openness and asymmetry that take us beyond the concreteness of the elements and suggest relationships to a space and forms outside the tangible painted surface. Although the lines which are straight bars of considerable thickness seem to belong to a square, measurement will disclose a difference in length between the vertical and horizontal sides. We shall note also that the left and upper lines are thinnest, the bottom line is thicker, the right bar thickest of all. It is as if the square were visualized from the right in a near perspective that gave greater prominence to those two thicker sides.[4] Reading the lines separately as painted black bands on the white surface, we would not say for certain they are segments of one closed figure intercepted by the diagonal edges of the canvas. But no matter how strongly we resolve to see the black bars only as separate painted marks on that limited plane—complete in themselves, unequal, and irregular—we cannot help envisioning a square when we look at them as a whole.[5] The geometric lines together appear then as parts of a virtual object in a larger and deeper space. In this art which seems so self-contained and disavows in theory all reference to a world outside the painting, we tend to complete the apparent forms as if they continued in a hidden surrounding field and were segments of an unbounded grid. It is hard to escape the suggestion that they extend in that virtual space outside.

3.

The root of Mondrian's conception of asymmetrically grouped, segmented forms spanning the field will not be found, I believe, in his earlier paintings from nature nor in his Cubist works in which we see already the reduction of complex natural shapes to a few elementary forms. Picasso and Braque, who had been his inspiring models during

the years 1911 to 1913, concentrated in the middle of the canvas a dense, often intricate play of drawn lines—straight, tilted, and curved —with sketchy passages of flecks; together these shape and bind the segments of planes and contours of a reconstituted figure or still-life objects as freely joined and disjoined elements of a painterly whole. The simple forms loosen, become sparse, and dissolve towards the edges of the field. If certain lines are carried to the frame and appear to pass behind it, they belong to the background, not to the salient construction. It is rather in the most advanced painting of the late nineteenth century—in works by Monet, Degas, Seurat, and Lautrec —that we find precedents for the pronounced asymmetries in Mondrian's paintings and his extension of foreground lines to the boundary on all sides, with their implied continuation beyond. By novel close-up views and by the cropping of objects, those painters make us aware of the actuality of a near and often peripheral observer, as in later photographs and films with odd perspectives which evoke the determining presence of a viewing eye. The spectator is intimated at a localizable point at the side through the angular perspective. Monet has alluded more directly to this sense of a picture as of an encountered scene by representing a figure on a high balcony in the foreground, looking at the crowded street below.[6] By sighting the prominent foreground objects from nearby and cutting them abruptly at the edges of the canvas, painters brought the viewer close to the picture space—as if a participant—and marked the resulting strange silhouettes of the very near and incompletely seen as a truth to vision. They produced through those perceptions new patterns of shape and color, almost fanciful in their irregular spottings and arabesques.

An illuminating example is Degas's picture of a scene in a milliner's shop (1882) (Fig. 2). A woman trying on a hat looks intently at an image of herself on the surface of a mirror, as we ourselves look at Degas's pastel. It is a theme of seeing, and more specifically of aesthetic seeing. The woman studies her reflection to judge how the hat composes with her head, how she looks in it, how it looks on her, how each relates to the other. In the background a *modiste*, immobile and detached, holds two other hats for trial. The frame cuts the long

mirror below and above. The woman's figure is cut only below and in turn intercepts the baseboard of the wall; the *modiste*, whose features we cannot see, is covered and divided by the mirror and by the vertical edge of the frame at the right—her hand and a hat are incomplete there. What is rendered is a segment of a larger space, as beheld by a very near observer at the right. It has been excerpted by an artist so close to his objects, relative to their size, that with a slight shift of his position they will form a quite different whole. We see the woman looking at the (to us invisible) mirror image which has been excluded from our sight by the painter's viewpoint. Two distinct acts of seeing are projected here: one of a viewer inside the picture, the second of an implied outer viewer—the first without the object she sees, the other no less actual than the first through the near perspective of the depicted objects of his glance. All of these are incomplete, covered in part by the frame and by each other.

Degas's picture of seeing may be taken as a simile of the aesthetic perceptions and self-consciousness that preceded abstract art and prepared its way. The woman at the milliner's is the artist-critic of her own appearance; her object of contemplation—the hat she adjusts on her head—is itself a work of art visualized through its projection on the plane surface of a mirror. Degas's conception is significant for the art of a later time when the painter's need to declare the freedom and self-sufficiency of his art, together with his reflections on an ideal of pure aesthetic seeing and his confidence in the intrinsic plasticity and expressiveness of his medium when freed from all resort to likeness, inspired what in a misleading, but now established metaphor, is called "abstract·art." In Degas's pastel the woman is testing the fitness of a work of art that is not at all a representation, yet as a part of her costume will symbolize her individuality and taste in shape and color.

The segmenting of foreground objects at the edges of a field was practiced, of course, in much older Western and Middle Eastern art. But its specific form in the later nineteenth century, with pointed reference to a nearby spectator whose perspective position determines an incomplete and sometimes oddly silhouetted form of a primary object, was something new.[7] It was a mode of painterly vision Mondrian had

rarely employed in his landscapes. Before his picture of a mill or tower we hardly think of the viewpoint as that of an ambulant spectator; the arresting object is confronted there in the middle of the canvas. The painter has stationed himself straight before it in nature and calls for a corresponding central position of the attentive viewer of the picture. Although we look at a framed image as a balanced whole from a point opposite its central axis, for Degas the pattern of a scene changed decidedly with the artist's distance and his angle of vision in sighting the objects. His virtual presence in the perspective of the pictured scene suggests an attitude towards what catches his eye, whether of detachment or aesthetic interest or cool curiosity in a casual encounter. The objects beheld in the painting intimate in their form both the boundary of that viewer's vision and their own existence in a larger field than is framed, including a space between the canvas and the implied spectator of the original scene. The painting embodies the contingent in a momentary envisionment of the real world, and requires for its reading our fuller knowledge of objects and the conditions of sighting.

I have digressed so long in comparing Mondrian's composition with certain features of Degas's in order to show the continuity of abstract painting with the preceding figurative art, a connection that is generally ignored. If, as Mondrian wrote, he wished to disengage the relations of form that in older art were veiled by a vestment of the material world, how do his "pure relations" differ from the previously masked ones? Are the latter an underlying structure that can be abstracted by divesting a picture of the shapes of particular objects? Are they simply a schematic armature, like the triangle or circle to which an artist adapts his highly articulated natural forms, as disclosed didactically in analytic diagrams of the old masterpieces? No one who has marveled at the beauty of Cézanne's paintings will suppose that their admired relations of form are "veiled'" by the less pure forms of material things observed in nature. The effective relations are all there on the surface in the unique strokes of color and are inseparable from the complex shapes given to the represented objects, although we do not analyze the forms in detail any more than we

respond to abstract paintings by scanning their structure minutely. Mondrian was surely aware that in those venerated works the old masters considered every detail a necessary part in the order and harmony of the whole.

Yet one may speak of certain relations of the geometric units in Mondrian's paintings as "abstracted" or transposed from the previous art of representation, without assuming that the units themselves are reductions of complex natural forms to simple regular ones. These elements are indeed new, as concrete markings of pigments on the tangible canvas surface with distinctive qualities—straightness, smoothness, firmness—which may be called physiognomic and are grasped as such, rather than as illustrative presentations of the ideal concepts of mathematical or metaphysical thought, although we may use the terms of geometry in talking about them. The position of Mondrian's straight line (which on the diamond field is a bar with mitred ends), its length and thickness, its precise distance from a neighboring line, are no more nor less constitutive of the painting as a unique aesthetic whole than are the complex image-forms that Mondrian wished to supplant by his "pure relations." The new abstract elements of his art are disposed on the canvas in asymmetric and open relationships that had been discovered by earlier painters in the course of a progressive searching of their perceptions of encountered objects in the ordinary world and had been selected for more than aesthetic reasons. In that art of representation, the asymmetry and openness of the whole, which distinguished a new aesthetic, also embodied allusively a way of experiencing directly and pointedly the everyday variable scene—a way significant of a changing outlook in norms of knowledge, freedom, and selfhood. So too one may ask whether Mondrian's use of those compositional relations, although applied to particular geometric units with a characteristic aspect of the elementary, the rigorous, and impersonal as features of an innovating rational aesthetic, perhaps springs from a positive attitude towards that liberating outlook. One cannot read Mondrian's writings without becoming aware of his desire to integrate in a utopian spirit his theory of art with the whole of social life and the promise of a more general emancipation through an advancing modernity.

4.

Mondrian applied the principle of an open asymmetric grid also on his more usual oblong canvas, but with a decidedly architectural effect through the strict accord of the painted lines and the parallel edges of the field. The example I show here was done in 1935 (Fig. 3) and then redone on the same canvas a few years later (Fig. 4).[8] In both states two long lines reaching from top to bottom divide the surface into three subfields like the bays of a tall façade. One of these lines is in the middle of the canvas; with the line at the left, it bounds a central space open at the upper and lower ends. The three bays are successively narrower from right to left, as on a façade seen in perspective from the right. The effect may also be read as a schema of two separate neighboring constructions with an open space between them, each extending indefinitely on three sides and intercepted asymmetrically in the view by an imposed windowlike frame. In either reading, a symmetry latent in the central vertical line is revoked by the partitioning of the canvas into three unequal fields. The division of the lateral bays by shorter horizontal bars that bound rectangular spaces of distinctly contrasted areas and proportions reinforces the asymmetry while serving also to balance the inequalities of the two halves of the canvas. All these subrectangles are open at one or two sides.

Mondrian was dissatisfied, I suppose, with the first state, for in undertaking to change it towards 1942 he did not simply compose a variant on another canvas, but retouched the original (Fig. 4). In adding horizontals—one at the right and two at the left—he brought the divisions of both bays into closer alignment and introduced a more legible rhythmic order in the proportions of the white spaces on the two sides. The horizontal has been reinforced relative to the vertical, as in other paintings of his last years. A new factor of asymmetry and contrast in the balance of the two halves of the canvas is the accenting of the rectangles in diagonally opposite corners by the addition of color.

This work, too, like the square in the diamond square, may be set instructively beside a composition from the preceding figurative art: a

lithograph made in 1895 by Bonnard, an artist of Mondrian's genera-
tion who remained faithful to painting from the visible until the end
of his life (Fig. 5). In the balanced rendering of beheld objects, all
straight-lined, Bonnard's work marks an advanced stage in the passage
to an abstract style with asymmetry and open, intercepted forms. Here
again the subject is taken from the sphere of art. It is a window view
of buildings, geometric in form, which appears as a segment of an
extended grid, and which includes the observer's space. In that vision
of architecture, some details are cropped; others, like the upper win-
dows of the distant house, are complete. Although not composed with
Mondrian's economy and rigor, the vertical and horizontal are felt
throughout as distinct elements of a constructed pattern as well as of
the perceived reality. The field is partitioned by the lines of the case-
ment and its sill and by the walls and roofs of the buildings beyond.
Both the grid of the large window and the small panes in the distance
are contrasted with the white surface between those black lines and
spots. There are, however, beside the diagonals of the casement and
the emerging roof in the lower left corner of the window view, some
loose freehand touches and streaks, a gradation and blending of small
picturesque detail, while Mondrian admits in his armature only strict
orthogonals, the firm lines of his basic directions.

I do not mean to imply by this comparison that Mondrian's
work is a stylized reduction of his vision of an actual scene with build-
ings. It is a new construction on the canvas, independent of a particu-
lar building or site, and has its own canonical elements subject to rules
of design he has set himself. But these requirements entail for him, as
I have said, certain relationships of form already conceived in recent
figurative art. At the same time Mondrian shares with advanced archi-
tects an ideal of form supposedly inherent in the nature of their art,
its materials, and goals, together with a taste for the simple, the regu-
lar, and the asymmetrically balanced as the rational outcome of those
inherent conditions. In opposing the "pure" relations in his art to the
"veiled" ones in representations, Mondrian agreed with the purist
architects who wished to exclude from their buildings all ornament
and preconceived symmetry as a concealment of the working struc-

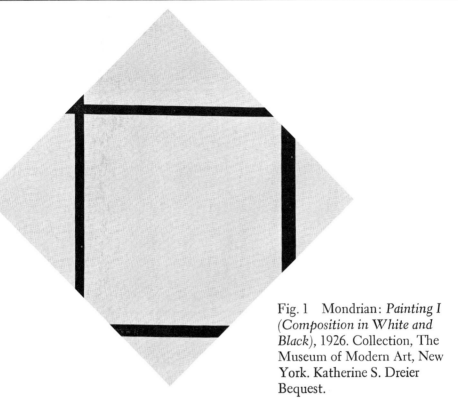

Fig. 1 Mondrian: *Painting I (Composition in White and Black)*, 1926. Collection, The Museum of Modern Art, New York. Katherine S. Dreier Bequest.

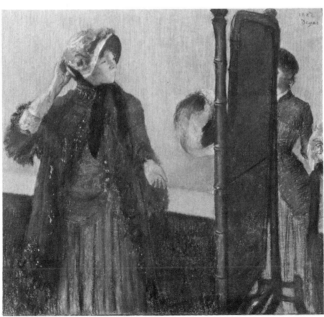

Fig. 2 Degas: *At the Milliner's*, 1882. The Metropolitan Museum of Art, New York. Harris Brisbane Dick Fund, 1932.

Fig. 3 Mondrian: *Composition*, 1935. (First state of
Fig. 4.) Reproduced in *Cubism and Abstract Art*
(Museum of Modern Art, 1936).

Fig. 4 Mondrian: *Composition*, 1936–1942.
Collection of Mr. and Mrs. Burton Tremaine,
Meriden, Connecticut.

Fig. 5 Bonnard: *View from Window*, 1895. Lithograph. The Metropolitan Museum of Art. Harris Brisbane Dick Fund, 1932.

Fig. 6 Monet: *Poplars*, 1891. The Metropolitan Museum of Art.

Fig. 7 Mondrian: *Trees in Moonlight (Trees on a River Bank)*. Escher Foundation, Haags Gemeentemuseum, The Hague.

Fig. 8 Mondrian: *The Red Mill*, 1911. Gemeentemuseum, The Hague.

ture—the truly effective elements and relations that made for beauty in their art. The affinity of Mondrian and the modern architects was recognized by both.

The extension of parallel verticals to the upper and lower edges of the canvas was also a device of Monet; it fixed for the viewer the artist's close sighting position in the fore-space of his pictured object. In several of his paintings of the façade of Rouen Cathedral the high wall, seen at an angle from nearby, is cut by the frame at the top and sides.[9] The grid effect is more pronounced in his *Poplars* (1891) at the Metropolitan Museum (Fig. 6), although it lacks the asymmetry of the Cathedral views. It is a type of subject that had attracted Mondrian in his earlier years. I have no doubt that Mondrian was acquainted with Monet's art, but he was perhaps unaware of that particular canvas of Monet when he painted in 1908 a mysterious expressionistic moonlight scene with five trees aligned in one plane at a river bank (Fig. 7).[10] The slender forms are reflected in the water, parallel to the picture surface. Today an observer who knows Mondrian's abstract style cannot help thinking of it when he sees Monet's painting with its evident natural grid intercepted on all four sides, in spite of the difference of mood and Monet's shaggy silhouettes and ever-present brushstrokes and nuanced tones. But in Mondrian's landscape the trees and their reflections are fully contained on the canvas; the forms are more pliant and irregular than Monet's which seem to continue beyond the edges of the picture-field in a pattern of endless verticals and horizontals.

Other paintings of Mondrian from the time of his versatile experimentation with advanced modern styles—Neo-Impressionist, Fauve, Expressionist, and Symbolist—shortly before his turn to Cubism in 1912, foreshadow the geometric units of his abstract work but not their segmentation, openness, and asymmetry.[11] It seems to me unlikely, however, that he could have moved from that earlier phase to his compositions of the 1920s and 1930s without having absorbed later, besides Cubist art, the croppings and asymmetries of the Impressionists and their direct successors in near-views and eccentric angular perspectives. His *Red Mill* (Fig. 8) and *Church Tower of*

Domburg (1911) are exceptional among his early works in the marked cutting of a tall structure by the upper edge of the canvas.[12] But in those pictures the dominating architectural object looms symmetrically in the middle of the field. In the triptych *Evolution* (Figs. 9, 10, 11),[13] painted that same year, the rigid centralized figures with the geometric patterning of bodily details and of the symbolic forms in the background recall the *Mill*. The style of that Symbolist triptych may be regarded as an example of Mondrian's growing interest in geometric elements of drawing, which led him perhaps to the curious, whimsical rendering of the nipples and navels as triangles and lozenges.[14] More likely, the stylized treatment of the stiffly frontal, dark, cold-toned nudes, surprising after his intensely colored, impassioned lyrical paintings from nature, was not a purely aesthetic idea. It was deliberately chosen, together with the solemn postures and geometric emblems, to bring out a symbolic content. Besides the distinction of three evolving stages of spirit through the different postures of the three nudes, certain small accompanying features—the erect, inverted, and fused or intersecting triangles—owe their place here less to artistic necessity than to their meaning in the Theosophical doctrine to which he adhered then. But the angularities in the drawing of the female nudes, so oddly masculine, and the reduction and concealment of their hands and feet, may be ascribed as much to inhibitions with regard to the naked body as to a spiritualistic ideal of the fusion or balance of the masculine and feminine, or to his theories about the vertical and horizontal as similes of spirit and matter embodied in the two sexes. However one interprets the change to cold angular forms in this strange triptych, one ought not to ignore in it the will to a consistent geometric style that converts both the large and small details of nature into regular elemental units. It lacks, however, the distinctive asymmetry and openness of his later abstract works, qualities that relate more to the empirical than to speculative thought.

Yet, if Mondrian's step to Cubism was prepared by his quest for a metaphysical absolute in paintings which were so far from the radical new art of Picasso and Braque in method and idea, it is all the more remarkable that he grasped their aims so surely at the rapidly

changing stage of their work when he first encountered it. More perti-
nent, I believe, in Mondrian's quick response was his earlier practice
of Neo-Impressionist and Fauve styles, with the brushstroke as the dis-
crete unit of painting, whether as a small regular touch or a large
emphatic spotting. But in assimilating the Cubist approach he turned
away for good from Expressionist pathos and Fauve intensity as well
as from Symbolism and its rhetoric of demonstrative postures,
emblems, and spiritualistic dualities, although he retained for a short
while such affect-laden subjects as the high church façade and the
intricate, wide-branching skeletal tree. If, as has been supposed, the
dogma of the exclusive balanced vertical and horizontal in the later
work was based on a Theosophist conviction formed during his earlier
years, its strict application had to wait for his experience of Cubism,
an art that freed him from overt symbolic imagery, as well as from
lyrical renderings of nature, and turned his mind to a conception of
his art as, in essence, a constructive operation with elementary, non-
mimetic forms. It was an astonishing conversion for an accomplished
painter of nature at the age of forty.

5.

Between that Cubist experience and the abstract style with the
open grid, intervened a stage of abstraction in which Mondrian
reverted to features of his pre-Cubist art. In the years 1914 to 1917 he
painted a series of works formed of short vertical and horizontal units,
many of them tangent or crossed.[15] These black lines or bars, more
graphic than painted, fill the surface compactly although with a more
scattered effect than the array of parallel colored strokes of his earlier
landscapes in a quasi-pointillist technique. Together they shape para-
doxically an oval or ellipse without a single curved or diagonal line. In
the titles Mondrian gave to certain of those paintings: *Ocean, Pier
and Ocean*, and in the traces of perspective vision, he avowed a tie
with direct perception of nature. In an example of 1915 the discrete

units become progressively smaller toward the top of the field, and on the central vertical axis of the lower half a distinct series of somewhat longer parallel verticals retains the look of a pier extending into the ocean.[16] Mondrian has translated into his own signs a Neo-Impressionist notation for a view of the sea from a central viewpoint; the dots or strokes of color, which in the paintings of Seurat and his followers were units of both sensation and construction, have been transformed with a delicate calligraphic touch into thin black lines on a white ground with a fine flicker worthy of Seurat's art. Different values of light result from the varying densities of those little marks that suggest the distant wavelets, movement, and texture of the sea. Many years later Mondrian could write of these abstractions: "I felt that I still worked as an Impressionist, and expressed a particular feeling, not reality *as it is*."[17]

The reference to nature disappears in an example of 1917 with thicker, more distinct units (Fig. 12). The rounded space is virtually outlined by a staggered succession of single bars, mainly vertical at the left and right and horizontal at the top and bottom. No straight unit is intercepted by the curved boundary which is like a round eyepiece through which one sights a field of orthogonal elements. The intermittent contour, flattened at the poles, appears as a sum of the solid rectilinear units. While the single ones at opposite sides of the perimeter form symmetric sets, the bars inside that boundary differ more in length and look chaotically strewn, unordered with respect either to a center or to implicit radii or chords of the circle. Some bars occur singly, some are paired as equal parallels, some touch or cross one or two others, and in several places four and even five or six are in contact, as in *Pier and Ocean*, but with a weight of black that changes the impact of the whole and the strength of contrast to the white ground. These clusters are like molecules each with a varying number and size of the two kinds of atoms. Yet certain regularities will be found in their seemingly random occurrence. Throughout, one meets only black vertical and horizontal bars (and a few tiny squares) on a common white ground. These fill the space with an almost uniform density, except for a notable decrease towards the flattened top—a

lightening most marked along the central axis of the upper half with its loose alignment of single, small units. There is also a long file of vertical bars in the lower half, a little to the right of the central axis, and larger than the irregularly grouped units above. Together, these two sets of verticals reinforce the symmetry of the bars at the rounded edge. Exceptional too is the series of single vertical bars in diagonal file at the lower left, that parallels a similar set on the contour nearby. One cannot say, however, where the varied clusters will turn up. Most of them are asymmetric and some appear highly irregular as composite forms, although built of verticals and horizontals alone. With the single bars, their spotting of the surface determines relatively shapeless, open ground intervals that we do not measure separately by eye, but see together as the common circular field of the assembly of distinct black units, unlike the definite, rhythmically proportioned, white areas enclosed between the black bars in the later abstract works (Fig. 4). Still, there is a statistical order in the clusters as a set. A rough count shows that the frequency of a type of cluster varies inversely as the number of its bars. The singles are the most common; next are the doubles and triples; the clusters of five and six are the fewest of all. There is also a bias in their frequencies in the different horizontal sections of the circle. The largest clusters are almost all in the middle and lowest zones.

In this carefully pondered, yet seemingly random composition of hundreds of variants of a basic unit, we see a novel interplay of contrasts: the vertical and horizontal, their regular and irregular combinations, symmetric and scattered groupings, the qualities of the small unit and the summated whole. Nothing in the form and little in the distribution of the elements inside the contour suggest they are in a circular field. As in the painting of the square within the diamond square (Fig. 1) the simple and regular compose a surprisingly irregular design, so here the elementary vertical and horizontal units shape an aggregate with an irreducible complexity of which the large form approximates a circle. It is a mysterious, fascinating unity. The random and the regular have been balanced so that the random maintains its interest as a quality of the whole, while the elements,

small and large, are all visibly constructed of the same kind of regular units, some of them in symmetric relation.

It is hard to imagine how in shaping and filling this circle with several hundred small units Mondrian judged the weight of each one separately in relation to every other in the field and to the simultaneously given whole, as he could do in deciding the precise lengths, intervals, and positions of the few long bars in his later sparse abstractions. He wrote in 1914 of his use of only vertical and horizontal lines that he "constructed *consciously*, though not by *calculation*, and directed by higher intuition . . . ; *chance* must be avoided as much as *calculation*."[18] Guided by already fixed general constraints on the permitted elements and their relations, the painter could realize experimentally, in a process of trial and error, the balance, order, and harmony of so densely populated a field in appraising by eye with that critical intuition the progressively emerging summated effect or resultant of the immense number of black elements and the indeterminate confluent shapes of the maze of open intervals. His approach to unity was not unlike that of the Impressionists and Neo-Impressionists in achieving the coherence and harmony of a microstructure of countless indistinct points of color. Although Mondrian, in this work of 1917, has cut all evident ties with the natural scene that had supplied him for his painting of *Pier and Ocean* with a model or framework of an order in the perspective and objects of the seascape, he still retained from that older art an experience of composition with very small scattered units. Their density, randomness, and variation recall the Impressionists' free play with contrast, color, and texture in tiny, juxtaposed, and overlaid, sometimes chaotic, touches.

Long before that phase, while still practicing an old-fashioned style in browns and grays, although with an increasingly free sketchy hand, he would dose a greenish meadow with scattered accents of dark and light strokes.[19] Later, towards 1910, in pictures of a tower, a windmill, a lighthouse, and haystacks, and also of a single wide-branching tree, the sky and earth and sometimes the main object are a loose array of multiplied impasto strokes of red and blue aligned in contrasted horizontal and vertical sets.[20] During the same years his

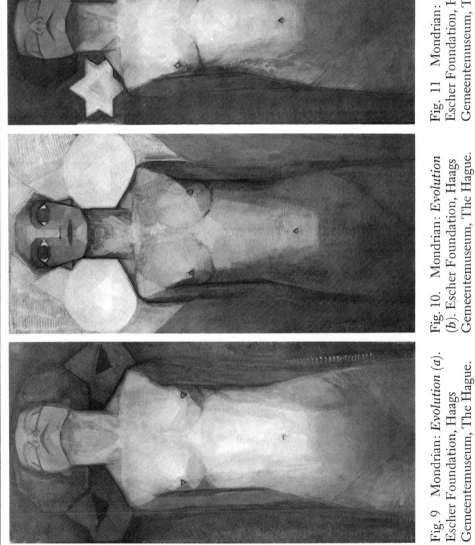

Fig. 9 Mondrian: *Evolution* (*a*).
Escher Foundation, Haags
Gemeentemuseum, The Hague.

Fig. 10. Mondrian: *Evolution*
(*b*). Escher Foundation, Haags
Gemeentemuseum, The Hague.

Fig. 11 Mondrian: *Evolution* (*c*).
Escher Foundation, Haags
Gemeentemuseum, The Hague.

Fig. 12 Mondrian: *Composition with Lines*, 1917. Rijksmuseum
Kröller-Müller, Otterlo.

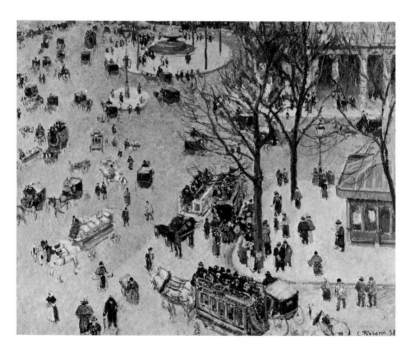

Fig. 13 Pissarro: *Place du Théâtre Français*, 1898. Los Angeles County
Museum of Art, Los Angeles.

Fig. 14 A. Michael Noll: *Computer Composition with Lines*, 1964.
© AMN, 1965.

Fig. 15 Mondrian: *Broadway Boogie-Woogie*. Collection, The Museum of Modern Art, New York. Given anonymously.

Fig. 16 Saenredam, P., *Interior of the Church of Saint Bavo in Haarlem*, 1635. The National Gallery, London.

beautiful paintings of the *Dunes* show a more minute and refined mosaic technique, obviously indebted to Seurat or his followers.[21]

Although Mondrian's composition of bars suspended in a circle lacks precisely that compactness of the units in Impressionist and Neo-Impressionist paintings where the surface is so often an unbroken weave or crust of tiny overlaid touches of color, there is a type of Impressionist subject that occasioned for Monet and Pissarro patterns of larger scattered elements on a light ground, more like the aspect of Mondrian's circle. I have in mind their spectacular views of the Paris streets, the first truly modern pictures of a city as a world of crowds in random motion.[22] Pissarro's perspective of the human and wheeled traffic circulating in the irregular *Place du Théâtre Français* (Fig. 13) presents an accidental strewing of figures and vehicles analogous to the multitude of single and clustered bars in Mondrian's abstraction. But on Pissarro's canvas we sense also the motion of the artist's hand and the intentness of his eye scanning the site for its varied tones and contrasts. His sketchy strokes seem to reenact the intermittent movement of the crowd, the carriages, and buses, halting or advancing in their different directions toward and away from us. It is a freshness and liberty of touch in keeping with the nature of the scene as perceived by Pissarro with enjoyment of its changing face, a liberty once valued by Mondrian too but deliberately replaced by a smooth, impersonal execution and strict adherence to the regular vertical and horizontal bars as theoretically grounded, necessary elements of his new art.

We are able to reconstruct, at least in part, certain steps of the process in the painting of 1917 by comparing the final work with an earlier state known through a photograph.[23] The elements then were thinner and longer, not yet solid rectangular bars but graphic lines. The outermost ones were less distinctly a circular contour; they include many complex clusters of crisscrossed lines and are spiky in effect, with loose sections of scaffolding from a phase of Mondrian's Cubist style.[24] While closer in some features to *Pier and Ocean*, the whole lacks altogether the lightness, the delicacy of detail, and perspective suggestions that make the latter so imaginative and lyrical a work. Knowing the direction of Mondrian's growth in the early

1920s towards sparseness and clarity of elements and legible relations, we are interested to note that Mondrian could not rest with that bristling assembly of crossed lines. It was perhaps in reshaping this unsatisfying state that he came to invent the new forms of the composition of 1917. In that change he participated with other leaders of European art in creating the new trend towards the distinctness and legibility of single elements that was to dominate both abstract and figurative painting in the 1920s.

A computer simulation of Mondrian's circular painting permits us to see more sharply by comparison his distinctive order and refinement as a composer. A physicist at the Bell Laboratories, Dr. A. Michael Noll, produced that computer version for a test of artistic perception and judgment with the technical and office staffs as subjects.[25] Analyzing the components of the work with respect to their variable size and position, he programmed the instrument to shape a "reasonably similar" composition—what he regarded as an "equivalent," although admittedly more random. Xerox reproductions of photographs of the original and the simulation (Fig. 14) were shown to the subjects who were asked to indicate their feeling towards abstract art, whether of like, dislike, or indifference, and to answer two questions: which of the works is the computer's? and, which of the two do you "most strongly like or prefer?" Of the hundred members of the combined staffs, only 28 percent identified the computer product correctly and 59 percent preferred it to the other. That judgment of the computer picture was shared by lovers of abstract art—they made up 75 percent of the respondents—and by those indifferent to it, as well as by some who admitted their distaste for that art. The subjects as a group had little or no artistic training. The highest percentage of any subgroup preferring the computer version—76 percent— was of subjects who expressed a liking or even a strong liking for abstract art. Some who preferred the simulation and judged it to be the original described it as "neater," more "varied," "imaginative," "soothing," and "abstract" than Mondrian's work. There was no significant difference between the aesthetic responses of the office employees (one-third of the subjects) and the scientists and engineers

of the technical staff, although the latter did somewhat better in identifying the machine-made picture, perhaps because of their familiarity with computers. The ones that liked abstract art and those indifferent to it had the same success in this game of recognition, but from an aesthetic point of view the subjects who disliked the art were the most successful; theirs was the lowest percentage of preference for the simulation.

I believe Dr. Noll was right in explaining the taste for the relatively shapeless computer version by the frequency of randomness in recent abstract paintings and the association of that feature with an idea of the creative in general.[26] The more clearly ordered structure of the true Mondrian appeared then as the attribute of a machine-made work. The vogue of Abstract Expressionist painting which was often identified with the more impulsive, spontaneous-looking products of this varied group of artists, despite some distinctly different individual styles, fixed in the receptive public's mind an image of that art as a heroic formlessness exemplifying a noble inner freedom and resistance to constraints.[27] One ignored the serious concern for coherent form and color among the best of the artists.

The experiment is an evidence of a now common but usually ignored response to abstract painting. While Mondrian and other pioneers of this new art saw the portrayal of objects as an obstacle to experience of purely artistic relations and looked to abstraction as the way to a purified art, we learn from this trial of judgment that the randomness of strewn forms, without likeness to particulars of nature, could be enjoyed as a positive quality in art and preferred in a less accomplished simulation, just as in the past certain features of a represented subject—the various sentiments and associations suggested by them—were attractive to the viewer uneducated in art and blind to the weakness and banality of the work. Randomness as a new mode of composition, whether of simple geometric units or of sketchy brushstrokes, has become an accepted sign of modernity, a token of freedom and ongoing bustling activity. It is alluring in the same degree that technical and aesthetic features in figurative art, found in the works of the masters—microscopic minuteness of detail, smoothness of finish,

virtuoso rendering of textures—besides an agreeable subject, could satisfy in mediocre paintings a taste which was insensitive to relationships of a finer order. The artistically immature taste for the imitative, cliché-ridden, often skillful kind of painting, called *kitsch*, is now directed also to the widely publicized abstract art.

6.

In his last years Mondrian transformed his abstract art through features that revived qualities of Neo-Impressionist painting and its successors—of their color above all. He did not return, however, to the painterly brushstroke or to representation. It was still with his regular constructive elements and dispassionate touch that he created the new style. But he reintroduced also a randomized play of small units and a symmetry of the large as a stabilizing force.

The masterpiece of this final stage he called *Broadway Boogie-Woogie* (Pl. XI, Fig. 15). The title points to the inspiration of music and dance; but without knowing the title, one would think of music in seeing this wonderfully lively, colorful, jazzy canvas.

It is founded on a grid of vertical and horizontal bars, more varied than before in spacing and length. The firm black bands that had been a mainstay for so many years become trains of speckled color; they are divided into small units like the tesserae of a mosaic, mainly yellow alternating with red, grey, and blue. Mondrian, after Monet and Seurat, now excludes black from his palette. The bands appear filmy, bright, and vibrant in the changing sequence of those colors on the white ground and in the recurring contrasts of deep blue and red with the lighter yellow and gray, which on some bars are expanded as longer notes. Even by close scrutiny and with the help of a notation, one cannot transcribe an obvious scheme or rule in the rhythmic succession of those colored notes. One senses only a perpetual permutation, as of beads of the same four colors held together on a common string. The order of the four (and even the coupling of

two) on any segment is rarely repeated on the same track. If a particular sequence reappears on a neighboring band—and this is rare—it is in a staggered diagonal relation to the first. Each band is individual through a unique order of the continually permuted colors. We do not discern at a glance the sequence that makes for the difference; the number of units on each complete band—between thirty and forty—is too great to permit one to read the whole distinctly. The notes have been thoroughly shuffled throughout to yield a maximum randomness, while keeping their likeness and coherence as oblong or square units of the same width and family of four colors. Their confinement to the parallel tracks of the grid is a means of order as well as movement.

In contrast to that regularity of axis, larger rectangular blocks of color are inserted, like a syncopating staccato accompaniment, in the intervals of the grid, partly or wholly in contact with it. Certain ones are single units of solid red or blue; some are partitioned by two or three colors; in others a small square of contrasting color is inlaid on the main hue as a ground. In several places a color of the larger unit extends across the slender, neighboring bar as if bonded with it. At the lower left, a square of yellow with a central gray spot is mortised into the adjoining bands by its continuity with the yellow squares on the grid. The bonding of the grid with the larger colored rectangles appears at other points and differently in each. The colors of these blocks are the same four as those on the grid; by their greater mass they contribute single forceful beats, like strong chords, to the animation of the whole, and stand out from the grid by their discoordinate grouping and rhythm. They also diversify the white-ground intervals which are broken up rhythmically into smaller, oblong spaces by the encroachments of the inserted blocks. These solid units of color are frequent in the left half of the painting and in the upper part, and fewer but more massive at the right where they are aligned in stepped diagonal sequence.

Although spaced less evenly than in any previous work, the grid as a whole has a somewhat closed and nearly centralized symmetric effect. The corresponding sets of four vertical bars at each side are more compact than the rest of the field which is distinguished by its

broader spaces and is divided by a pair of verticals slightly off-center. Some bars are discontinuous, arrested in midcourse or sooner. It is worthwhile retracing these variations and breaks; they are examples of Mondrian's method as a highly conscious composer. Among the verticals (reading from left to right) the first ends at the third horizontal from the top; the third at the lowest horizontal from the bottom; the sixth stops at the third horizontal, but starts again at the fourth and descends to the lower edge of the canvas; a vertical bar is inserted between the fourth and sixth horizontal; the eighth vertical, too, ends short at the third horizontal; the ninth is interrupted, is resumed twice, and ends well before reaching the eighth transverse band. Among the horizontals the main break is of the seventh which extends from the second vertical to the sixth; one will notice also, in the lower left, three short bars between the second vertical and the canvas edge. Counting the bars whose ends touch or nearly touch an edge of the canvas, one discovers that there are ten such contacts on the upper edge and eleven at the left, eight at the right and seven below—a choice that effects a diagonal symmetry, in contrast to the dominant vertical symmetry of the grid.

I would not trouble to cite these observations if I did not believe they bring one to see better Mondrian's vigilant planning for variation, balance, and interest. His were not just the moves of an intellectual game or *tour de force* of painterly construction. Through the rhythm of differences and contrasts of a few colors and lines, with an appearance of both freedom and control in the opposition of the regular and the random, he effects a stirring expression of his delight in sensation and movement.

In this culminating work Mondrian has drawn on his past styles. We see again the stabilizing grid; the molecular scattered units; the repeated arrays of primary color as in his Neo-Impressionist phase; and the composition of large squares applied as separate planes of color in paintings of 1917.[28]

There is also in this work a striking departure from Mondrian's long commitment to the single plane. At certain crossings of the grid, he has extended the color of the square unit to a neighboring unit of

one or the other band. Distinguished by this accent, one band seems to come forward in crossing its perpendicular. The grid appears then as a network of interlaced bands that follows no regular scheme; it is an arbitrary, occasional entwining like the elusive intersection of planes in Cubist paintings of Picasso and Braque in 1911 and 1912.[29]

While Mondrian's abstract paintings of the 1920s and 1930s have an architectural effect with an impressive stability and strength, the surprise of *Broadway Boogie-Woogie* lies in its movement and colorful visual music. The reversion to his earlier styles clearly served a new expressive intent.

In conceiving *Broadway Boogie-Woogie,* Mondrian could well have been inspired by the sights of New York, the dazzling night spectacle of its high buildings with their countless points of light, and in particular the moving illumined signs at Times Square. He had been prepared for this new conception by his enjoyment of Paris where, on first encountering jazz and modern popular dance in the 1920s, he defended them against detractors. In Paris he discovered, besides Cubist painting, the beauty of a big city as a collective work of art and its promise of greater freedom and an understanding milieu. Shortly before coming to New York he had disclosed a new inspiration in paintings with more complex grids, which he called *Place de la Concorde* and *Trafalgar Square*—the forerunners of the interwoven grid in *New York City* and *Broadway Boogie-Woogie.* But his pleasure in the spotting of bright colors had been awakened before his Paris days. I have noted earlier that in 1909 and 1910, in rural scenes of Holland, often with a single dominant object, he had practiced a style of distinct touches of intense colors, less compact and less regular in form, to be sure, and in some works a more dense mosaic derived from Seurat. In his writings he had acknowledged the importance of Neo-Impressionism for the growth of abstract art. It appears that in his old age a warmer side of his nature, emotion suppressed in his search for an intellectual absolute, was released with a new freedom through his experience of a welcoming American milieu.

The elated spirit of the last paintings reminds one of the last works of Matisse in the 1950s. The convergence of these two masterly

artists of the same generation, so different in temperament and culture, invites us to meditate on the old age of the two men. For Matisse it was a rejuvenation, while Mondrian achieved then a youthfulness he had not shown as a young painter. Both had been attracted by jazz and had admired the American city, but it was Mondrian who shaped in *Broadway Boogie-Woogie* a captivating pictorial equivalent of the stirring rhythms and sounds of the mid-Manhattan scene. Matisse, from another standpoint, found in geometrical abstraction and in floral plant patterns a new expression of his abiding delight in color and exotic decorative forms. Those designs, despite some ingenious small deviations from regularity, preserve the traditional syntax of ornament as a system of symmetries and repeats. Mondrian was never more free and colorful, and closer to the city spectacle in its double aspect of the architectural as an endless construction of repeated regular units and of the random in the perpetual movement of people, traffic, and flashing lights.

NOTES

*This paper is an enlarged version of a talk on Mondrian at the symposium at the Guggenheim Museum on October 9, 1971 during the centennial exhibition of the painter's works. The essential points go back to lectures on Mondrian and other abstract painters in my courses on twentieth-century art at Columbia University and in lectures elsewhere since the late 1930s.

[1] The letter of 1924 is quoted by Michel Seuphor, *Piet Mondrian, Life and Work*, Abrams, New York, n.d. (1956), p. 149.

[2] In some later paintings of the square on the diamond field no line of the square crosses another, so that a grid is not suggested. See Seuphor, p. 392, nos. 408, 410, and the catalogue of the *Centennial Exhibition*, Guggenheim Museum, New York, 1971, p. 193, no. 111 (1930); p. 196, no. 114 (1933). (The catalogue is cited hereafter: *Centennial*, 1971.)

[3] With a rotation of 90° the diamond will appear as an erect square; the enclosed square will assume the appearance of a cropped diamond; and the residual triangles will form a nearly symmetric set with respect to a vertical axis.

[4] In another painting of a square in a diamond (*Composition with Yellow Lines*, 1933, Gemeentemuseum, The Hague, reproduced by Seuphor, p. 392, no. 410), it is the upper and left bars that are thickest and longest, as if in a perspective from above and the left.

⁵ To test the effect of interception and openness on the appearance of the painted bars on their white ground, replace the diamond by an erect square of the same size. The bars with their beveled ends will seem then to float on that surface as separate units. As a set of discrete elements they will lack the expansiveness and tension arising from the appearance of a square intercepted by an enclosing form, and the composition as a whole will lose its compactness and strength of contrast.

⁶ In the painting of the *Boulevard des Capucines* in the Marshal Field III Collection, reproduced in color by William C. Seitz, *Claude Monet*, New York, 1960, frontispiece.

⁷ An approach to this modern use of perspective will be found in paintings of interiors by Dutch artists of the seventeenth century. An example is Vermeer's *Love Letter* in the Rijksmuseum, Amsterdam (see Lawrence Gowing, *Vermeer*, New York, 1953, pl. 62) where the two figures are seen fully enough through a doorway whose cropped sides, without visible top or bottom, frame the subject in the room beyond. More like the modern conception is a picture of the *Interior of the Church of Saint Bavo in Haarlem* (Fig. 16), painted by Pieter Saenredam (1597–1655) in 1635. In the near foreground he represents the great round pillars of the nave from a position in the aisle directly in front of the left-most pillar and so close that we see of it only a short segment spanning the height of the broad canvas. It is also cut abruptly by the frame at the left and, with two other pillars beside it, blocks much of the interior space. Those two pillars, segmented and unevenly spaced in the middle and at the right—like the verticals in Mondrian's rectangular canvases (see Figs. 3 and 4)—repeat the strong vertical of the first. The smooth, white walls of the church, the cool light, the clear contrast and balance of the dominant verticals and horizontals, and the unornamented Gothic forms, could lead one to invoke the name of Saenredam as a native ancestor of Mondrian's abstract taste (as has been done by Jean Leymarie in his book, *La Peinture Hollandaise*, Skira, Geneva and Paris, 1956, p. 150; it is interesting to note also that H.P. Bremmer, one of the first Dutch critics to appreciate Mondrian's abstract works, was later to write a monograph on Saenredam; that painting of Saint Bavo's church has been reproduced by Thomas Hess in his book *Abstract Painting, Background and American Phase*, New York, 1951, p. 22, fig. 12, as an example of an older Dutch artist's taste for abstract form). A large diamond plaque hangs from the middle pillar; it is the escutcheon of a deceased, common in Dutch church interiors in the seventeenth century.

Saenredam seems not to have repeated this daring perspective which remains exceptional among the paintings of church interiors by Dutch artists. But it is a noteworthy anticipation of an artistic idea of nineteenth-century painters, in accord with advanced tendencies of other Dutch artists towards the near-view and the theme of sighting. Jantzen, in his thoughtful, ground-breaking study of the painting of architectural views in the Netherlands in the seventeenth century, judged that work of Saenredam to be a bungled experiment: "an arbitrary slice of space, something accidental and unstructured. How unsuccessful is the whole in its wide format! The three pillars look as if they were beheaded with a sickle . . . Saenredam himself recognized the failure of this solution" (Hans Jantzen, *Das niederländische Architekturbild*, Leipzig, 1910, p. 81). In the next year he painted another view of the same interior as a tall narrow composition framed symmetrically by two pillars and their arch, with a central view from a greater distance (Jantzen, pp. 81–82 and pl. 33). I may call attention also to diamond-shaped escutcheons in later pictures of church interiors by Emanuel de Witte (Jantzen, pls. 61, 62), with a single vertical bar at the left of center crossed by a horizontal, which recall a painting by Mondrian reproduced by Seuphor, p. 392, no. 492.

[8] The first state was reproduced in Alfred Barr's pioneering catalogue of the great exhibition of *Cubism and Abstract Art* held at the Museum of Modern Art in 1936, p. 152, no. 158 (186).

[9] Cf. the example in the Boston Museum, *Façade at Sunset*, reproduced by W. C. Seitz, *Claude Monet*, p. 143 (color plate), and one in the Metropolitan Museum, Seitz, p. 38, fig. 49.

[10] See *Centennial*, 1971, p. 106, no. 22, and also p. 15 for a photograph of the site, with the treetops cut by the upper edge of the print, as in Monet's *Poplars*.

[11] It is interesting to note also in his pre-Cubist paintings examples of the grid as a represented form. Looking back from his abstractions to a picture in the Museum of Modern Art of a windmill painted about 1900 (Seuphor, p. 228), one is struck by the crisscross of the mill vane, a fence, the window of a door, and of their reflections in the water. But these are minor elements in the rendering of a landscape where larger shapes, sketchy and patched, are more pronounced. The grid here is a pattern of single, isolated objects, not an organizing principle of the entire painting.

[12] Seuphor, p. 128 and p. 127; cf. also *Church at Zouteland* (1909–1910) p. 124 (color plate). He had already painted windmills in this precisely centralized position in 1908 (p. 111, nos. 27, 28), but they lack the evident formality of placing that distinguishes the later examples.

[13] Ibid., p. 129, color plate.

[14] The triangular nipples and navel of the first nude point downward like the large pair of triangles above her shoulders; they are presumably attributes of the material, the earthy. In the second figure, with large, wide-open, staring eyes—signs of spirit—all the triangles are erect. In the third nude, who apparently symbolizes the fusion of matter and spirit or their balance and holds her head high with tightly closed eyes as if to signify inwardness and contemplation, the three little triangles have become lozenges. Above her shoulders are paired the intersecting triangles, a Theosophist emblem.

[15] Reproduced by Seuphor, nos. 223–239, pp. 376–377.

[16] Ibid., no. 239, p. 377; for a color plate, see *History of Modern Painting from Picasso to Surrealism*, Skira, Geneva, 1950, p. 117. It is *Composition No. 10*, in the Kröller-Müller Museum, Otterlo.

[17] *Towards the True Vision of Reality*, an autobiographical essay, quoted by Seuphor, p. 120. See also *History of Modern Painting*, p. 199.

[18] From a letter to H. P. Bremmer quoted by Joop Joosten in *Centennial*, 1971, p. 61.

[19] Seuphor, p. 49, color plate (c. 1902).

[20] Illustrated in *Centennial*, 1971, catalogue nos. 31, 32, 34, 37–39, 41, 42, 44, and by Seuphor, pp. 75, 95.

[21] Seuphor, p. 376, no. 219; cf. also nos. 218–221 and p. 375, nos. 210, 212; *Centennial*, 1971, p. 120, no. 37 and p. 121, no. 38.

[22] I have in mind particularly Monet's paintings of the *Boulevard des Capucines* and the *Boulevard des Italiens*. See note 6 above.

[23] It is reproduced by Joop Joosten in his article in *Centennial*, 1971, p. 65, fig. 15.

[24] This work also brings to mind his minutely detailed studies of single flowers, drawn between 1906 and 1910, mainly chrysanthemums with a circle of densely packed, slender, raylike petals seen *en face*, overlapping, and often unkempt. (Seuphor, pp. 368–371, nos. 128–152, 158–171, 177–178, 187–191, 196–204, 235–243, 249–262, 294–301.)

25 A. Michael Noll, "Human or Machine: A subjective comparison of Piet Mondrian's *Composition with Lines* (1917) and a computer-generated picture," *The Psychological Record* 16, 1966, pp. 1–10.

26 An example is the figure preference test for "creativeness," published by Frank Barron ("The Psychology of Imagination," *Scientific American* 199, Sept. 1958, p. 150ff.). Subjects were shown two sets of "abstract" drawings, one with neatly traced, regular geometric forms, the other with sketchy, impulsive lines and dark strokes in asymmetric compositions. "Creative" personalities preferred the latter. This set looked pictorial and contained dozens of rapidly drawn lines, while in the first set, preferred by subjects chosen at random, the drawings were meager with a few thin ruled lines rendering a single unit or segment of ornament in the center of the field. One would like to know how the subjects would have responded had they been offered drawings with regular elements in a balanced asymmetric composition as complex as that of the sketchy examples.

27 I have tried to characterize the individual artists in that spectrum of styles in an article, "The Younger American Painters of Today" in *The Listener*, London, Jan. 26, 1956—a talk for a B.B.C. program in December 1955 on the exhibition at the Tate Gallery (see in this Volume Figs. 1, 2 and Pl. x between pp. 220–221).

28 They are reproduced in *Centennial*, 1971, pp. 153–56, nos. 71–74 (74 in color), and by Seuphor, pp. 381–82, nos. 285–291.

29 Mondrian had already intertwined the grids in his painting, *New York City* (1942). It is reproduced in color by Seuphor, p. 183. In a late work of 1943 (ibid., p. 297), he has ingeniously inserted in a diamond field what appears to be an overlay of two grids formed by intersecting and intercepted rectangles in successive parallel planes in depth. This idea in both works was perhaps suggested by his use of tapes in planning a composition. For an example of his working procedure see the unfinished version of that picture (No. 3), illustrated in Seuphor, p. 299.

Index

To facilitate use of index, note page numbers of the articles in table of contents.